libertarian NATION

How the statist power grabs of the Obama, Bush
and Clinton administrations hasten economic and
political reckoning . . . and a return to America's
founding princples

James Walsh

SILVER LAKE PUBLISHING

ABERDEEN, WA • LOS ANGELES, CA

Libertarian Nation
How the statist power grabs of the Obama, Bush and Clinton
administrations hasten economic and political reckoning. . . and a return to
America's founding principles.

First edition, 2009
Copyright © 2009 James Walsh

Silver Lake Publishing
101 West Tenth Street
Aberdeen, WA 98520

For a list of other publications or for more information from Silver Lake
Publishing, please call **1.360.532.5758**. Find our Web site at
www.silverlakepub.com.

Library of Congress catalogue number: Pending

James Walsh
Libertarian Nation
How the statist power grabs of the Obama, Bush and Clinton
administrations hasten economic and political reckoning. . . and a return to
America's founding principles.
Pages: 288
ISBN: 978-1-56343-8868

Printed in the United States of America.

LibertarianNation

Table of Contents

LibertarianNation

Author's Note

I started working on this book in 2006. At that point, it looked like a good time to develop a book on libertarian political philosophy in the United States after George W. Bush's administration. But the process of putting out a thorough and coherent book is a slow one; and many things have changed since I started this one.

Some things haven't changed.

The end of conventional Republican/Democrat and "conservative"/"liberal" politics has been a theme of mine both in books (2005's *Liberty in Troubled Times*) and periodicals (primarily, since 2007, *Liberty* magazine). I remain convinced that the real, useful political thinking that goes on in the United States has given up on those stale frames. You may still see and hear and read about American politics cast in those terms. But what you see and hear and read is more mass entertainment than real politics.

The real political debate that's emerging, although slowly, is between libertarians and statists. I am approached by people who've read my earlier books (or who pop up online) often enough that I'm confident the new political paradigm is taking hold.

A conversation with a person who'd read *Liberty in Troubled Times* is what planted the seed of this book in my mind. The reader was clever enough to track down the number I use for work, even though it had just recently changed. He wouldn't give me his name (actually, this is fairly normal for calls that I get); but I could see from his telephone number that he was calling from Scottsdale or somewhere else in the suburbs of Phoenix.

Scottsdale was a straightforward man. Even a little abrasive. He had things to say, so he talked fast. First, he asked me a series of questions. From the slight tremor in his baritone, I figured he was an older fellow—in his 70s or better. When he was satisfied that I

was the James Walsh he wanted, he said (as I recall. . .and cleaned up slightly):

> *I've read all the libertarian books that are out there. Your book is better than most but it's too pessimistic. You assume these bastards have control of the government and will never give up. We need a book that talks optimistically about American liberty. We need a book that puts it all together from the start, without just selling that bitch's agenda.*

He referred to "that bitch" several times. A long way into the call, I assumed that he meant Hillary Clinton. Eventually, dullard that I am, I realized the "bitch" was Ayn Rand.

Scottsdale told me that he'd given a copy of *Liberty in Troubled Times* to his daughter. But she hadn't gotten very far in because she'd found it depressing:

> *That's the problem. Young people have no idea what they're getting stuck with. No idea. They'll wise up eventually but by then it will too late. The United States will be a pauper nation. And they'll be stuck in the basement, waiting for their parents to die. Fifty-year-old men playing video games. You need to give them something to be for, not just against.*

When he was finished, he rather formally thanked me for my time and hung up. Didn't wait for me to thank him for calling or, really, say anything.

I thought about keeping his phone number but decided it was better to let him fade back into the mists from which he'd called. There was an existential perfection in his anonymity.

So, I thought about how to make a positive case for negative liberty. I sketched outlines for a book that wouldn't mention the horrors of statism and collectivism. I tried outlines that didn't identify public figures by name. I tested writing about politics in the second person, like Victorian letter-style novels—addressing everything to "you." That started well but was hard to keep up. I tried beginning and ending each chapter with a positive-thinking-style affirmation. That sounded like a bad campaign speech.

Essentially, I agreed with most of what Scottsdale had said (except some his angrier opinions about the Federal Reserve and women in politics). I just couldn't figure out the right way to structure an optimistic argument.

When the 2008 presidential election cycle started, conventional wisdom held that Hillary Clinton and John McCain would square off in the general. There, despite his weak flank on the political Right, McCain would squeak out a win. And he'd carry on the Republican statism that W. Bush had begun. Not a pretty picture.

Then things started to change. McCain didn't do well in the early caucuses. And, in a hopeful turn, Rep. Ron Paul did better than most people expected. No one thought Paul would be elected president; but a credible campaign and a speech at the GOP convention could do a lot of good for principled limited government.

At that point, I thought this book might end up being an analysis of Paul's campaign.

Hillary Clinton was having trouble, too. Although she's sewn up the support of most of the Democrat Party Establishment, Barack Obama was hitting her hard from the Left with a campaign that seemed little more than carefully-scripted speeches and the words "hope" and "change."

The media loved Obama. And it gushed endlessly about how his optimism attracted the passionate support of young people.

I imagined Scottsdale clutching his chest as he watched these reports. Barack Obama was definitely *not* the solution he'd had in mind for his daughter's political ennui.

Ron Paul ended up peaking too early and crashing before the GOP convention (I consider some of the reasons for this in Chapter 11 ahead.) Instead of speaking to the Republican faithful, he ran his own "alternative" rally across the street. The rally was well attended; but its imagery sent the wrong message to those who had hoped he'd bring the GOP back to a limited-government focus.

McCain recovered from his early stumbles and won his Party's nomination. He chose Alaska Gov. Sarah Palin as his vice presidential nominee. Palin has some libertarian *bona fides*, but she never got to express them on the campaign trail. She flubbed a couple of early interviews and the mainstream media gleefully labelled her a moron. After that, the McCain campaign made sure she stuck to their scripts.

In meantime, Obama displaced Hillary. He ran one of the least substantive presidential primary campaigns in recent years; all he had to do was step aside and let her unappealing personality torpedo her ambitions. That strategy (plus heavy support from government-employee labor unions) worked.

Remembering what Scottsdale had said—separately—about Obama and women in politics, I assumed he'd moved to Costa Rica.

Then, the general election. Years of reckless borrowing (both governmental and individual) sent the economy into a steep recession. Economic issues weren't McCain's strength; Obama successfully continued his almost substance-free campaign. Would the words "hope" and "change" be enough to get an empty statist suit from Chicago elected president?

Some days before the November vote, I was in a barber shop waiting my turn when Obama came on a teaser ad for that evening's news. The shop quieted down to hear the candidate. When the ad was done, someone (I didn't see who) hissed "sanctimonious."

That hiss gave me my focus for this book. No literary tricks. No complex arguments. Just a simple, straightforward case for why liberty is essential to the American experience. No sanctimony; that's my optimism.

Statists condescend because their political philosophy is, ultimately, not good for the country or its citizens. But the nation and its citizens are strong enough to survive the statists' mistakes.

The political debate that you see on TV and online is not a real exchange of ideas. It's bread and circuses. They say that generals are always fighting the last war; well, the same is true for TV producers and the few newspaper editors that are left. This nation has spent and borrowed its way to a crisis point. We're losing our position as a world leader. And we need to get back the philosophical roots on which the nation was founded. This won't be good news for smirking neocons or self-righteous liberals. They're yesterday's partisans.

I believe there will be a political and economic reckoning of the spendthrift policies the United States has followed since before World War II. . .and maybe since before World War *I*. (The recession that started in 2008 is probably *not* that reckoning.) I also believe the nation will survive that reckoning, because it is comprised of strong individuals.

Think of this book as a blueprint for minimizing, surviving and succeeding trouble in the meantime.

James Walsh, March 2009

Chapter 1:

Why You Deserve Liberty

You exist.

You think, you dream. You have consciousness. The fact that you're reading this is proof of that.

Your existence is the only thing of which you can be absolutely sure. It may be a good or bad existence, happy or sad. Whatever the qualities of your experiences, they are the essential truth of your life.

Everything else that you know comes to you in either of two ways: through logical deduction based on your existence or through the hard lines of the world and universe outside of your existence as interpreted by your senses. Each of these channels has limitations and imperfections. Logic has to be learned and is subject to all kinds of manipulation; senses are flawed, sometimes even actively misleading.

So, what do you do with your existence and your imperfect knowledge of the world outside you?

You can withdraw and focus on yourself. Or you can reach out— try to understand and experience the external world, including other beings like you, that logic and your senses tell you exist beyond the limits of you.

Your senses tell you that you live in a world, full of physical things and the physical laws that those things seem to follow. You can measure the things and test the laws. Your measurements and test results are as imperfect as the senses that bring them to you; but you can make some conclusions that help you reach out to the world.

How effectively you reach out to others, without forgetting their individuality, is the most satisfying measure of your life's achievement.

The world your senses observe may be chaotic and confusing. The observable details of people and things seem to be constantly

changing. The best that you can do is to try to make sense of the chaos. Logic can help here.

The details of people and things may change, but the patterns and rules that people and things follow remain fairly constant. These patterns and rules make it possible to anticipate actions and reactions and to modify your behavior to get the best response from others.

You can't experience existence of other people directly, as you do your own; but your senses help you perceive their physical properties—their looks, how they feel, their smells, the sounds they make. And their properties (or at least the properties of some of them) are like yours; they will seem familiar to you.

Still your senses and logic suggest that other people exist as you do. What do you do about *this*?

To understand and appreciate fully the existence of others is the greatest challenge of your existence. It isn't easy. But, if you manage to do it, your existence changes. It becomes more vivid and rich.

This richer existence creates challenges of its own. You'll probably find—as many before you have—that the closer you come to other people, the more you feel emotions. Good and bad emotions—affection, happiness, love, anger, jealousy, resentment.

The challenges of experiencing others, both in the struggle to experience them and the emotions that follow when you come close, account for much of trouble in the world.

The Challenge of Reaching Beyond Yourself

If reaching out toward other people is difficult and creates problems even when you achieve it, why bother? Why not just go back to withdrawing into yourself?

Because that withdrawn existence is shallow and unsatisfying. It's cowardly. It's boring. It lacks what philosophers call *transcendence*, the heightened perspective you gain when your consciousness moves beyond the limits of your own existence.

Some people experience transcendence with ideas. You may experience transcendence in a mathematical formula, a piece of music, a painting or sculpture or image. But, for most people, transcendent experience comes from physical sensations and with other people.

Most people want transcendent experience. Some find spiritual or religious practices help; others focus on their physical bodies as

the tools of transcendence. Some people claim that transcendent experiences come easily; others become jaded or resentful because they don't come at all.

It doesn't matter care how bright or intuitive you are; it doesn't matter how much formal schooling you have. Experiencing others' existence meaningfully (whether you call it "transcendent" or something else) is the hardest thing you'll ever do. If you work hard and fortune favors you, you may experience a few others meaningfully—people in your family, loved ones, close friends.

Appreciating the existence of other people becomes even more difficult when you look across a population of millions...or billions...of people. Most shy away from this complexity. They look for shortcuts and rules that they can follow so that they seem to be reaching beyond themselves without having to think so hard.

Living peaceably in a large population can seem an impossible task. Many people make destructive, violent choices; even your own choices can seem fraught with unintended consequence. Your effort to cultivate one close friend alienates several others; your desire to follow a simple moral code antagonizes others who find your morality repugnant.

Individuals are complex. Large numbers of individuals are so complex that the human mind has trouble understanding them in even a limited way. So, for many people, individuals in large numbers blur together. They stop being distinct beings and start being members of groups. Lazily-drawn clumps. Blue collar workers. Red staters. White trash. Greedy CEOs. Ivy League elitists. Racists. Religious nuts. Single mothers. Republicans. Democrats. Jews. Niggers.

The murderous Russian dictator Josef Stalin took this lazy blurring to its logical extreme when he mumbled, infamously, "One death is a tragedy; a thousand deaths is a statistic."

Like most tyrants, Stalin reveled in people's limits and weaknesses. He capitalized on the laziness into which most minds withdraw when faced with the complexity that large numbers of individuals create. He emerged from (and mastered) a system that denied people's individuality. And their basic, unalienable rights.

You can do better than that.

Once you make the decision to do better—to experience life beyond your own limits—you have to find ways to live with a lot of

complexity. People have been working on this for a long time. Some of the ways they've developed don't do much; but some are useful.

Society as a Tool for Handling Complexity

The most useful way that people have developed for dealing with human complexity is to enter agreements with other people to form societies based on common beliefs and rules for interacting with one another.

Societies reward specialization. Adam Smith, the father of modern economics, wrote about pin factories—and how the best pin makers should focus on what they do well and barter or trade their product for the other necessities of life.

Most of these agreements—these Social Contracts—were made before you were born. They shaped the society that shaped you. But, every day, you make the choice to *remain* in your society. You honor its customs and laws; this honoring usually means giving up some of your individual freedoms and checking some of your desires in exchange for an orderly existence. That's the fair trade-off of a legitimate Social Contract; you give up some of your freedoms in exchange for stability and other tools for interacting with others.

In a functional society, this is a good deal. The freedoms you give up are relatively minor and the stability that you get in return allows you to live peacefully with others.

If God exists, our best glimpse of Him comes in the complexity of the human experience—that's difficult for some people to understand.

Complexity is an important part of the practical philosophy of liberty.

What is liberty? It's the context in which you can maintain your existence while living among others. It's ordered freedom; it's a system of rights that allows you to control, within some broad limits, your existence.

Tyrants and other statists don't understand—or don't appreciate the significance of—complexity. (And they surely don't value *liberty*.) They can't process the complexity, so they pretend it doesn't exist and act as if crudely-drawn solutions can apply to complex situations.

Egocentrism makes this bad situation worse. The tyrant, unable to appreciate the complexity of others, assumes that his experience is universal.

Billions of people together are almost inconceivably complex. A few people can be difficult; millions create complexity that even the most brilliant minds struggle to understand.

The slippery slope to totalitarianism follows this line. People in positions of power created by a Social Contract lose sight of the complexity of other people.

What "Libertarian" Means

I've mentioned the practical philosophy of liberty. This practical philosophy goes by a couple of names in contemporary America. Some people call it "classical" or Lockean liberalism; others call it libertarianism. Both names have flaws. The first causes problems because—especially in America—the word "liberalism" has taken on collectivist and other anti-individualist connotations. The second is confusing because a minor political party in the U.S. uses "libertarian" as its name.

But most people recognize the word "libertarian" as meaning a political philosophy that emphasizes individual liberty over the collective interest of the state. So, I'll use that word here.

As you might expect from a political philosophy that emphasizes individualism, there are lots of arguments—even among self-defined libertarians—about what "libertarian" means. So, it's probably a good idea to consider some basic terms and definitions.

Generally, there are two types of libertarianism: moral and consequential.

1) Moral (sometimes called "natural rights," "a priori" or "deontological") libertarians believe that all attempts by one individual to coerce the thoughts or acts of another individual are immoral—that it's a basic function of human dignity that a person shouldn't be forced to do anything. These people see liberty as an end in itself.

2) Consequential (also called "pragmatic" or "result") libertarians see liberty as a tool to other ends—things like efficiency and human happiness. They don't see liberty as an end in itself but as the best way to achieve other values.

Moral libertarians are not pragmatic. They tend to be romantics; they form close attachments and feud viciously. Politically, they're closer to anarchists, because they believe that all forms of state require taxation—and taxation violates the non-coercion principle.

Philosophically, the moralists have clarity and strength of belief; but they tend to see the world in simplistic terms.

Consequential libertarians are more interested in "real world" solutions. They're often economists or come from a background formed by economics. They tend to be less rigid and bickering that the moralists; they see justification for a state with minimal power. (Some consequentialists call themselves "minarchists"—as opposed to *an*archists.)

The consequentialists have some philosophical problems, too. Taken to its logical conclusion, consequentialism blurs into communitarianism—a philosophy that believes actions which benefit more people always are always better than actions which benefit fewer. That can move a long way from a focus on the individual.

The important point is that libertarians, whatever their stripe, distrust the collectivist state and want to keep it limited to the minimum size and shape needed to allow peaceful interactions among individuals. Libertarians also agree about the importance of what they call the "non-coercion" principle. This principle holds that no individual should be forced to take any action, surrender any property or *refrain from* any action against his or her will—unless he or she is directly harming another individual.

What libertarians disagree about is (usually) whether or where there are legitimate exceptions, when coercion is justifiable.

You can agree with the non-coercion principle but not treat it as a categorical imperative. Not all moral principles are categorical imperatives—rules that must be followed in all circumstances, regardless of consequence. Some moral principles (maybe the *best* moral principles) are guidelines—suggestions about behavior, not rigid rules.

The Nature of the State

Why do libertarians distrust the state?

The shortest answer is that states are, by their nature, highly coercive. The most common form of statist coercion is forcing individuals to surrender lawful property through taxes. After taxation, the most common form of statist coercion is the prohibition of various behaviors that are not directly harmful to anyone...or anyone other than the person engaging in them.

States compel specific action less often and less directly than they

tax and prohibit. But, when they compel action, it is usually some form of service to the state (military service, etc.).

Another reason to distrust states is that they are intensely selfish.

States are like corporations (in some cases, they literally *are* corporations). States and corporations are both legal fictions that operate as artificial "people" for the sake of business and contracts. They're designed to transfer power and liabilities away from individuals. Both are vilified by critics and opponents who react against them emotionally and even passionately...but not very intelligently.

It's unfortunate that the critics are so often clouded by their emotions; their instincts have some truth. States and corporations pose problems. Legal fictions lack the natural restraint, the courtesy and the social graces that define real people. States and corporations act more selfishly and expand more aggressively than a well-adjusted real person would; their ruthlessness and self-interest would be pathologies in a real person.

This ruthlessness, self-interest and growth are why the great philosopher David Hume called the state a leviathan—a sea monster. States are rapacious. This isn't because they're ill-intentioned; the people working within the state often mean well. It's because states, as legal fictions, lack the ability and feedback mechanisms necessary for self-correction. They lack the mechanisms of accountability that result from the cycle of birth, life and death that individuals follow.

The German philosopher Hannah Arendt wrote well about how the excesses of government results in the denial of individual liberty...and even individual *existence*. She started with the ultimate statist excess of the 20th Century—the concentration camps run by the German Nazis during World War II—and worked back from that to smaller, daily problems. She asked penetrating questions about how and why such horrors could come into being.

Arendt's conclusion was that the state often seeks what she called "total domination" of the individual. (And, from this, political scientists developed the term "totalitarianism.") Total domination required more than just superiority over the individual—it required a denial that the individual had ever existed.

From the perspective of the collectivist state, individual liberty is a sort of infection (we see this same instinct among more-extreme environmentalists, who see humans as an insult to pristine nature).

One of Arendt's central arguments was that the purpose of the Nazi concentrations camps was not merely to kill perceived enemies on a massive scale. It was to establish to everyone else that Jews (and others) as individual people with individual rights *didn't exist.*

This is the supreme evil.

It's a short slide down a slippery slope of logic from well-meaning programs to collectivist evil. The state invariably values itself above individuals. And, once citizens allow that preference to take root in the apparatus of their government, bad things follow.

The same collectivist impulse that argues "it takes a village to raise a child" leads to ethnic cleansing among Hutus and Tutsis—and to Auschwitz and Buchenwald.

You Can't "Reform" the State

The apparatus of the state is so large that the notion of change or reform within it is laughable; the system is inherently selfish. And it's operated by careerist bureaucrats, long-tenured legislators and their permanent staffs.

States resist reform.

The Social Contract can be an inexact thing; it's a compromise, after all. If my right not to be killed means a right to have the state stop you from killing me, the state can stumble forward, taking action—coercing—you to act a certain way. It can tell you that you can't own a gun; it can tell you that you can't speak in a threatening manner. And, in some cases, it can make you go to church and pray that I don't kill you.

States tend toward coercion because they are born of a compromise among individuals. The individuals trade their natural freedom for civil discourse and the stability created by the rule of law. But the state's entire existence is a battle against the slippery slope of its coercive tendencies. Corrupt states lose the battle and slide down into totalitarianism and tyranny.

The libertarian writer and social *provocateur* Ayn Rand wrote an essay on the ethics of emergencies. She said that you don't build your ethics for lifeboat situations—because we don't normally live in lifeboats. Her followers cling to this comment.

But the truth is that Rand's comment misses the mark slightly. The problem isn't the lifeboat rules themselves; it's the fact that, once the lifeboat rules are written, *every* situation becomes a lifeboat. A

crisis. An emergency. So, we have a national security emergency or a homeless emergency or an energy emergency.

This is the same process as the constant stream of "wars" that we face. A war on poverty, war on drugs, war on terrorism. These aren't really wars, of course. They aren't emergencies. They are excuses that the state uses to expand its powers.

So, why do corrupt states exist? Why do people tolerate them? Why don't individuals call out the statist power grabs that pass as crises and emergencies? There a couple of reasons.

First, statist politicians and policy makers are often very good at portraying today's circumstances as exceptional. The greatest danger in modern history, the biggest challenge in 100 years. This conforms to the exceptionalism that most people feel about themselves, their countries and their times.

Second, people make bad choices. And most people understand this about themselves. They are drawn, in part, to the Social Contract because they believe they'll get more from it than they're forced to give. The venal wealthy man believes the social order that the state provides comes more cheaply than the private security he'd otherwise have to hire; the lazy poor man believes that it will provide him more material benefits than private charity otherwise would.

This cynicism is inherent in the state. Some people—perhaps a *large number* of people—choose to live under systems that libertarians find intolerable. Cynically, they think they're gaming the system; but they don't understand that the system is just other individuals.

Statist politicians and policy makers welcome this cynicism, because it advances their causes and careers. They underestimate its corrosive effects.

Liberty, State and Elitism

The inability to appreciate an individual's existence—his dignity—is the reason that statists are almost always hypocrites, applying one set of rules to the masses and another to themselves. Remember the last version of the sign in *Animal Farm*: "All animals are equal. But some are more equal than others." Remember Timothy Geithner's excuses for not having paid his income taxes—on the way to becoming Secretary of the *Treasury*.

This hypocrisy is the statist's great vulnerability. People who valuable liberty need to point it out whenever they can.

Gun control is an easy example of the natural blend of statist elitism and hypocrisy. In order to erode the biggest challenge to their gain, statists portray gun owners as uneducated, paranoid illiterates prone to violence.

In 1985, New York Gov. Mario Cuomo described gun owners as "hunters who drink beer, don't vote and lie to their wives about where they were all weekend." Two decades later, comfortably ensconced among friends at a San Francisco fund raiser, then-presidential candidate Barack Obama famously said:

> *You go into some of these small towns in Pennsylvania, and like a lot of small towns in the Midwest, the jobs have been gone now for 25 years and nothing's replaced them. …and each successive administration has said that somehow these communities are gonna regenerate and they have not. So it's not surprising then that they get bitter, they cling to guns or religion or antipathy to people who aren't like them…*

The stereotype is false. By various measures, American gun owners and churchgoers living in rural areas have a higher quality of life than their opposites living in big cities.

But you don't need statistics about gun ownership and education or church-going and family stability to prove the cynicism and hypocrisy of statists like Cuomo and Obama. There's something else going on in these quotes. Statists live by the feud. They seek out separation from and contempt for the individuals they govern.

The statist elite believe that ordinary people can't manage their own lives justly and effectively. The elite believe that ordinary people are ignorant bigots—racist, sexist, homophobic, gun-toting religious nuts. The elite believe that, by enforcing laws that they deem "progressive," they can fool the ignorant bigots into living better lives.

This is coercion in its final form.

The statist elite believe that liberty (more often conceived of as "civil liberties") is an allowance that the state makes to its citizens. The elite has a groggy notion—if any notion at all—of Jefferson's "unalienable rights."

To the statist elite, all rights are highly alienable.

What does all this talk of liberty mean to the average person, struggling to make a living and have a life that means…something?

It's a common criticism of libertarians and people interested in political philosophy that the "common man" would have contempt for the highfalutin jibber-jabber.

Most so-called "common folk" have a pretty strong sense of when they're being condescended. And most Americans—common or not so—have a strong desire to be left alone.

The distinguishing characteristic of human beings is not their rationality but their adaptability and perseverance.

It's remarkable that human beings live in the wide range of physical environments that they do. No other animal lives everywhere from icy arctic conditions to steamy tropics...and every place in between. Man is the only one that manages it.

In a free society, there is satisfaction in survival. If a person can support a family, do his part in a job...or several jobs...he can have the satisfaction of having faced the obstacles of life and succeeded. He can look back on his life with pride. If he has children, *they* can look back on his life with pride.

In a welfare state, that satisfaction is stripped away. The person who survives has achieved nothing.

Positive Versus Negative Liberty

Libertarians struggle against the activist tendencies of the state. But they also struggle *for* something: Your unalienable rights as a living, conscious individual.

Rational people have always had to protect these against the state.

To the ancient Greeks, the concept of liberty was not based on the individual. They thought about a person's liberty in terms of his participation in a Social Contract. This participatory concept of liberty—called *positive* or *active liberty* by modern political philosophers—provides for democracy but doesn't protect individuals against the tyranny of the majority. In Athens, decent people were sometimes punished or ostracized for nothing more than irritating their fellow citizens. Later, Roman lawyers like the great Cicero spent most of their careers arguing for or against high-profile people being banished (a fact that historians often overlook in their focus on Roman political and military writing).

These injustices, the tyranny of popular consensus, limited democracy as a political system.

Two thousand years after the glories of Periclean Athens,

philosophers like David Hume, John Locke and Thomas Jefferson solved democracy's excesses by developing and popularizing the principle of *negative liberty*—the idea that each person has certain rights that no one, not even a political majority, can deny.

The practical effects of negative liberty are relatively easy to define and describe; they make democracy a viable system. The practical effects of positive liberty are not so simple. They're broader and more subject to manipulation. Positive liberty includes essential rights as well as not-so-essential ones.

A basic negative liberty is that each person has the right not to be killed—which means every other person has an obligation not to kill. This is probably *the* essential negative liberty.

Positive liberty takes this essential effect in various directions, some that make sense and many that don't.

People of a statist perspective deduce, from the right not to be killed, an obligation to protect others from being killed. *My* right not to be killed requires positive action on *your* part. So, taxes are justified; they pay for the police.

Maybe you can follow the logic of positive liberty as far as justifying a police force. But statists don't stop there. Some extend the right not to be killed into so-called "rights" to things like medical services, housing and employment. Just like the ancient Athenians who ostracized people they didn't like, democratic tyrants twist the right not to be killed into a right to what they consider "quality of life." Libertarians stay wary of democracy's excesses.

Culture Influences the State

While it takes some reading and thinking and talking to understand the concept of *liberty*, most people have an understanding of *freedom* from an early age. Humans don't like to be constrained or controlled. This was true when humans were nomadic hunter-gatherers, just developing early societies; it's true when humans are masters of technology and complexity.

Freedom is your natural state. Your existence, by itself, resists control and constraint. Philosophers say that the human understanding of freedom is *a priori*—it doesn't require knowledge of economics or public policy.

In a perfect world, you would move and live as you wish—unconstrained by societal limits. But this isn't a perfect world. So, you

make a reasonable compromise with other people—with society—under which you give up absolute freedom in exchange for ordered interaction with others.

If that exchange is effective, it limits your freedom slightly and keeps order with minimal interference. This good exchange is liberty: a kind of freedom that allows order.

If that exchange is not effective, it quickly devolves into slavery. The state's promise of security becomes all; citizens make themselves children, with demands of food and housing and education and social affirmation.

It's important to note the difference between liberty and democracy: Liberty presumes certain unalienable rights; democracy doesn't always. This gets to a reason that statism appeals to social elites. Elites believe in the rule of the stronger—because they believe they are the stronger.

American statism (which, in contemporary jargon, calls itself both "progressive" and "neoconservative") embodies this phenomenon. Statists see their beliefs as "just" and "right" when in fact they are hostile to individualism and dynamic society.

Progressive politics—like all statist movements—is built by elites and sold to the masses, not the other way around. A progressive government would be a democracy programmed and operated by experts. It's rule by a government elite in the name of the people. This was the tyranny of philosopher kings that dates back at least as far as Aristotle's *Politics*.

The notions that the state should push society into a more "just" form is a delusion. The state cannot improve society or the individuals who constitute it; the state is a by-product of individuals. It is their servant, not their master.

"Progressive" Rigidity, Contempt and Stupidity

Because their political philosophy takes so many shortcuts around human individuality, delusional "progressives" become the Pharisees of our day. Rigid, doctrinaire, humorless. And they burrow themselves into institutions—government bureaucracies, labor unions, back office functions of large corporations, college administrations.

Individualists and libertarians made a mark on the popular culture when, in the 1980s, they coined the term "political correctness" for

the rigid statist orthodoxy. But that term has been used so widely that it has lost its particular meaning. Now, most Americans think that "politically correct" applies to any pompous person.

Statists propose, support and enforce the programs of small-minded, humorless people: speech codes, invasive laws, self-serving policies. Some petty tyrants are drawn to these systems by temperament more than politics; statism is the only political philosophy that actually *encourages* such anti-humanist rigidity.

This last point leads to an important observation: statists frequently twist words into knots of Orwellian inversion. Many statists call themselves "secular humanists" as they promote policies and regimes that deny human individualism.

The most brazen and bizarre inversion is the statist's abuse of the word "tolerance." To the statist, tolerance is the justification for dogmatic narrow-mindedness. "Tolerance" becomes a code word for socially-approved behavior from which citizens in good standing cannot diverge. This behavior also includes positive affirmation of certain groups and activities. And, in the final twist, this "tolerance" outlines thoughts and actions which will not be, er, tolerated.

In June 2008, the *Los Angeles Times* published a text-heavy advertisement from the American Society for the Defense of Tradition, Family and Property that outlined the group's support of California's Proposition 8 (which prohibited state recognition of same-sex marriage). The argument teetered tautologically on the presumption that homosexuality is immoral; but it was clearly struggling hard to express its circular logic within the bounds of polite discourse.

The *Times* received a torrent of angry responses, including this one posted to its ombudsman's weblog:

> *Such hate speech and bigotry directed towards homosexuals only results in intolerance and violence. The next time a gay person is harassed, abused, or killed you need only look to the issue of June 5th to see why.*

The advertiser was tautological; the poster was hysterical—the opposite of approved "tolerance" was violence and murder. The two were similar in a way that neither would likely admit: They shared severe limits in logic and reasoning skills.

(If you need more examples, visit any political Web site—of either Left or Right slant, though Leftists tend to be less tolerant in

their demands for "tolerance"—and read through the comments on any news story involving race, government benefits or sex.)

This institutionally-condoned stupidity is a good example of Hannah Arendt's distinction between "judging" and "thinking." Arendt considered judging to be a largely emotional process of reacting to external stimulus—which includes words but also images, sounds, smells, etc. Thinking, on the other hand, requires logical processes which have to be learned and a detachment from selfish impulses that comes naturally to some...but, more often, has to be developed over many years.

Most contemporary Americans are full of judgment; they have strongly-held opinions about popular culture, mainstream politicians, cars, sex, junk literature, money, religious faith. But they don't think so much or so deeply about anything. This makes them ripe targets for statist manipulation.

What Libertarianism Is Not

In U.S. politics, libertarianism has made an uneasy alliance with the American Right—specifically, the "conservative" wing of the Republican Party. Like most political alliances, this one has many faults.

In March 2005, journalist Robert Locke wrote an article published in *The American Conservative* magazine that criticized libertarianism is "the Marxism of the Right."

In the article, Locke rightly points out that Marxism laid the foundation for the totalitarian statism of Stalin's Russia and Mao's China. Marxism was ambitious—and rigid. Not moral... but moral*istic*, in its way. Facts or people that called its tenets into question were considered evil to be crushed and eradicated.

Marxism is largely dead; but modern statism, wrapped in positive liberty, retains many of its moralistic tendencies. Considering all this, is libertarianism really like Marxism? Locke thought so:

Free spirits...ex-socialists, drug users, and sexual eccentrics often find an attractive political philosophy in libertarianism, the idea that individual freedom should be the sole role of ethics and government. Libertarianism offers its believers a clear conscience to do things society presently restrains, like make more money, have more sex, or take more drugs.... If Marxism is the delusion that one can run society purely on altruism

*and collectivism, then libertarianism is the mirror-image delusion that
one can run it purely on selfishness and individualism.*

This analysis has a fatal flaw: Libertarianism doesn't believe that
any one can "run" society. Libertarians believe that societies work
best when local communities, families, businesses and individuals are
free to "run" *themselves*. They seek a system that respects individuals'
differences in the hope that conflicts may be resolved nonviolently.
Libertarians don't pose comprehensive programs for government and
ethics; they reject such stuff as coercion dressed up in intellectually
pretentious clothes.

A libertarian considers the state and the state's laws as imperfect,
human artifice based on deeper truths, unalienable rights and the
natural law that follows from the fact you exist.

There is one fundamental right, one axiom of natural law: You
can live your life in the manner you choose, so long as you don't
interfere with anyone else's right to do the same.

Everything else worthwhile in politics and philosophy is corollary,
deduction or extention from that. (And there's a lot in politics and
philosophy that *isn't* worthwhile.)

You exist. And your existence is valuable. Anything that
undermines or coerces you to undermine that value is inherently
suspect.

Chapter 2:

Self Ownership, Free Will and Privacy

The conclusion that follows directly from the fact you exist is that you own yourself.

No one can control your thoughts or dreams. No one can force you to say words or take actions that you have not decided to take. You can be coerced—and that's bad—but no one else can own you.

You control your body. You have free will.

Fashionable political philosophers complain that people who live in advanced economies focus too much on selfish interests. But the self ownership at the foundation of rational social interaction (and advanced economies) isn't the same thing as selfishness.

In fact, cooperation—or altruism or any selfless act—only has meaning if the person chooses it voluntarily, from a position of self ownership. Slaves can't cooperate or volunteer.

Of course, some societies allow slavery, the legal fiction stating that one person *can* own another. Societies allow legal slavery as means to short-term economic or political gain. In the long run, the fiction is too outrageous to be maintained. Societies that allow slavery become inefficient and weak and collapse or are overrun by others because they have to dedicate too many resources to supporting institutions that are fundamentally false.

Legal slavery is a perverse kind of government subsidy. It helps certain people or companies for a time but eventually creates economic inefficiency that, left uncorrected, becomes crippling.

In U.S. history, the Civil War followed this model. It pitted the breakaway Confederate States, which sought to maintain a system that included slavery, against the United States, which did not allow slavery. The U.S. was also more heavily industrialized and economically efficient. When the two sides came to war, the Union used its greater economic efficiency—and, in time, the moral clarity

of its citizens' opposition to slavery—to win. The Confederacy's position was untenable, economically and morally.

Any discussion of slavery eventually reaches a common critique of libertarian political philosophy. Namely: If people own themselves, can they choose to make themselves slaves (or should they *be allowed* to make themselves slaves)?

People who ask these question often point to socially-sanctioned forms of voluntary servitude—military service, contract-based employment, even marriage—as examples of how self ownership isn't absolute.

An emotionally-charged variation on this theme is addiction. Knowledgeable people, including psychiatric professionals, speak often about addiction to drugs or compulsive behavior as a form of slavery. Addicts in the throes of destructive acts lack the ability to think rationally and control their actions; they have made themselves slaves to compulsion.

(Other professionals disagree, arguing that addiction is not a matter of slavery or self ownership but of illness. However, these professionals tend to start from a position of skepticism about self ownership; so, they see limits and exceptions everywhere. They also tend to be advocates of psychiatric medication, so they have a professional interest in casting *all* afflictions as disease.)

So, does voluntary servitude—to military service or addiction or anything else—disprove self ownership?

No.

Self ownership is a categorical imperative—an absolute constant that can't be changed by circumstance. Unalienable rights are absolute. They can't be infringed. The infringement of an unalienable right that *seems* to exist is usually some kind of legal, political or social fiction. A person may willingly engage in the fiction, but it's still fictional.

A soldier agrees by contract to military service for a period of time; but, every day, he makes the decision whether to honor his commitment. He can always dessert—just as any person can always commit suicide. So, every day that he doesn't go AWOL—and every day any person chooses to stay alive—he exercises free will and confirms his earlier choice.

Voluntary servitude can be a rational choice, if the terms of the servitude are clearly drawn and the benefits of serving outweigh the

costs. Generally, this is a decision that every working person makes every day. If the benefits are greater than the costs, he keeps working.

Self Ownership Versus Dignity

Some people use the word *dignity* where a libertarian uses the phrase *self ownership*. In some ways, these words mean the same thing; each recognizes the integrity of a person controlling the direction and actions of his or her life. But *dignity* has some weaknesses; the most glaring of these is its tendency to be misused.

Mendacious politicians—including tyrants, dictators, statist bureaucrats and peddlers of identity politics—use the word *dignity* to mask the self-interest of their agendas. A totalitarian thug may scream that his brand of kingly commands best protects his people's dignity.

In his self-delusion, the thug may believe that his people's dignity includes loyalty to a strong leader. Him.

On the other hand, statists and tyrants shy away from the phrase *self ownership*. It's too precise; it's difficult to distort. It means that each individual control his or her own life.

Any legitimate state will realize its citizens' self ownership. This is the first and most important property right. It's the reason that libertarians focus so much on property rights.

All other practical rights flow from self ownership.

The manipulation of the word *dignity* is of fairly recent vintage. The totalitarians of the 20th Century started the slant. Left-wing western supporters of the Russian Bolsheviks used *dignity* to describe what a communist regime would provide the proletariat. (It surely wasn't going to provide any more food or clothes.)

In Germany, Nazi propagandists expanded on the theme. Hitler spoke often about how an international elite (including bankers and Jews) had conspired to rob the Fatherland of its dignity after the First World War. In the dying days of the Russian Soviet dictatorship, its diehard supporters kept repeating dignity as a virtue of the bankrupt regime.

Near the end of the 20th Century, as totalitarianism proved itself a fraudulent version of utopia, disheartened Western utopians cast about for a new place to direct their energies. Most headed in one (or both) of two directions—academia and so-called "New Age" spiritualism.

In both corners of Western culture, the twisting of *dignity* continued.

The word used to refer to the self-mastery and fortitude with which a person conducted himself in the face of life's trials; American statists turned that notion on its head. They created a definition of dignity that included a bunch of privileges and "rights" that would *insulate* a person from life's trials.

Traditionally, dignity had been something no one could take from you; statists twisted it into something the collective granted you.

And, pressed to its extreme, the statists' notion of dignity included protection from insults or boorish behavior by others. Campus speech codes in the United States and other countries assume that dignity requires never encountering a discouraging or ugly word.

Really, "dignity" should mean not allowing ugly words or ugly deeds to affect you.

The campus radicals confuse dignity with "self-esteem"—a lightweight notion favored by New Age spiritualists.

Religious Versions of Self Ownership

Some religious leaders argue that you don't, in fact, own yourself. God owns you. And He grants you "free will" as a kind of test; if you use your free will to choose belief and a life of religious piety, you can look forward to an eternity in Paradise after you die. If you use your free will for selfish and ungodly ends, you can look forward to eternal agony in Hell.

Albert Einstein famously said, "God doesn't play dice with the universe." However, according to some strict religious sorts, He *does* play dice with human free will.

Or maybe God doesn't play dice at all.

More sophisticated theologians argue that God assigns ownership of self to you during this life not as a test but as an essential part of making you in His image. Following this logic, all people are His children and must have some version of His omnipotence. It's not this reality that limits our version of God's power; it's our version of God's power that makes this reality.

In other words, the religious notion of free will is really just another way of describing *self ownership*. Just as statist academics prefer the less-precise (and too easily twisted) term *dignity*, religious

people prefer *free will*—because they have filled the phrase with subtle secondary meanings that suit their purposes. Sometimes, their purposes are open-hearted and inviting; other times they're close-minded and vengeful.

So, sometimes the religious person's notion of free will means the same thing as the libertarian's self ownership; other times, it's a pretext that hides a totalitarian agenda based on someone's interpretation of God's designs.

No one should have to play dice with those options.

Since God's existence remains an article of faith, His ownership of you and His gift of free will remain—at best—hypothetical propositions. It might be more accurate to say that, if you are a devout believer, you choose to surrender your self ownership back to God and the organization of your Church. This is a choice that you make. Like other forms of voluntary servitude, it only has meaning if you choose it freely and confirm that choice daily.

Religious piety doesn't always require giving up self ownership. Spiritual and political leaders from Moses to Jesus Christ to Locke to Gandhi have agreed that self ownership is an essential prerequisite to meaningful faith. You have to own a self to surrender.

Some religious leaders stress daily devotion—including making the choice each day to believe—as more important that surrendering free will and obeying blindly for the rest of your life. This is a religious practice that even a godless libertarian can appreciate.

So-called "Self Esteem"

Popular culture gives nominal encouragement to the importance of the individual—and to things like nonconformity, independent judgment and self-determination. But this encouragement is of dubious value. Often it focuses on so-called "self esteem"—which is, at most, a minor by-product of self ownership.

In popular terms, *self* esteem means to a have an image of yourself that is positive enough that it allows you to live your daily life with a pleasant demeanor. To statists, this is an important thing. A pleasant demeanor is a characteristic of you that's defined by people around you. It's an individual trait controlled by the collective—and an effectual tool for control.

People who make a priority of living their lives with a pleasant demeanor are often easier to order around than angry curmudgeons.

Libertarians are more often angry curmudgeons. (This doesn't mean that pleasant people are *always* easy to control. And it doesn't mean that angry curmudgeons always think for themselves. There are always exceptions to general observations.)

Self esteem is a fine thing...of relatively little importance.

The version of self esteem promoted by statists in the popular culture is an ersatz version of the pride that comes from self-ownership. It's a watered-down version that tries to separate the satisfaction an individual should feel about making a life for herself from the complexities and difficulties that such independence creates.

To statists, self esteem means that a person is a productive—and compliant—member of society. Statists (and their allies in the popular culture) advertise self esteem as an end in itself; in fact, they see self esteem as a means to force individuals to comply with a statist agenda.

Self ownership is in constant tension with social compliance. Self ownership isn't neat or easily-organized. And it challenges idealistic notions of equality among all people. For example: Some people make stupid decisions with the selves they own (compromising self ownership for drugs or sex or laziness).

Trouble doesn't only come from someone's stupidity and self destruction. A reasonably intelligent person who isn't self-destructive can be difficult or unpleasant to others. This person can be so hard to deal with that he creates problems and real damage in the wake of his daily living.

But, as I've mentioned before, complexity is unavoidable part of existing among people. To try to prevent stupid or problematic choices is to deny the dumb or difficult person's self ownership.

A person's demeanor doesn't matter unless it impacts another's existence in some real, physical way.

The only proper limit to a dumb or difficult person's destructiveness is when it impacts another person. Murder is wrong for lots of reasons. Congress says it's wrong. God (in most of His variations) says it's wrong. But, among free individuals, murder is wrong because it violates the victim's self ownership.

Self Ownership in the U.S. Legal System

Among the founding documents of the United States, the Declaration of Independence speaks eloquently about self

ownership. In fact, there may be no clearer definition of self ownership than Jefferson's famous lines:

> *We hold these truths to be self-evident, that all men are created equal, that they are endowed by their Creator with certain unalienable Rights, that among these are Life, Liberty and the pursuit of Happiness.*

Of course, the Declaration was the most philosophical—and least practical—of the major founding documents. The Constitution is the more practical "operating agreement" for law and government in the United States. Unfortunately, it's not so clear on the matter of self ownership.

As a result, the U.S. legal system tries to acknowledge the primacy of self ownership but, limited by its mechanistic focus, the legal system struggles to articulate philosophical truths. Generally, the U.S. legal system describes self ownership in terms of privacy. But even this concept can get a little fuzzy.

On matters of privacy, the precedent American court ruling is the U.S. Supreme Court's 1965 decision *Griswold v. Connecticut.* I'll come back to the details of the case later; for now, here's how Justice William O. Douglas described privacy in that decision:

> *…specific guarantees in the Bill of Rights have penumbras, formed by emanations from those guarantees that help give them life and substance. Various guarantees create zones of privacy. The right of association contained in the penumbra of the First Amendment is one, as we have seen. The Third Amendment in its prohibition against the quartering of soldiers "in any house" in time of peace without the consent of the owner is another ….*

The facts in *Griswold* dealt with a local chapter of Planned Parenthood selling contraceptive pills to a married couple. Connecticut state law outlawed sale of contraceptives. The *Griswold* decision outlawed the outlawing on the theory that it violated essential rights of privacy and self ownership.

Douglas's use of the terms *penumbra* and *emanations* in such a critical ruling has been reviled as vague and woolly-headed; but it reflects the Justice's belief that there are deeper unalienable rights that the mechanistic details (although, *important* mechanistic details) written in the Constitution.

The specific problem Douglas faced was not finding any language in the Constitution or Bill of Rights that explicitly prevented the kind of invasion that the state of Connecticut was making by telling people that they couldn't use contraceptives.

Most Americans agreed with Douglas's result. Indeed, it seems ridiculous that the state should enter the privacy of a married couple's bedroom.

As the long and woeful history of statist government shows, statists don't hesitate to do so.

The disturbing thing was that Douglas couldn't find firmer legal ground on which to build his reasonable conclusion. He had to "back out" the existence of an unalienable right to privacy that the Constitution didn't mention…but implied from the other rights that it did.

Self Ownership and Privacy…and Anonymity

Privacy and self ownership mean the same thing in some contexts—but, in some critical ones, they mean different things.

With the boom in identity theft and similar financial crimes in the early 2000s, people began to worry about "financial privacy"—that is, control of their personal financial information. In this context, the term *privacy* wasn't really precise. Or appropriate.

Personal financial information is not "you." It's no more fundamental to your existence than a picture of you is. Other people can own and control that information, just as they can own your picture.

Adding to this confusion, many people use the words *privacy* with *anonymity* interchangeably. As a result, some people foolishly expect to engage in complicated financial transactions that create no data trail. In fact, *anonymity* (the absence of identifying marks or data) has a much more specific meaning than *privacy* (the ability to control one's own personal marks or data).

It's more practical to think of financial privacy in terms of the ability to control your personal data than in terms of maintaining anonymity.

One of the great misunderstandings of the Internet is that it gives users anonymity. Just ask anyone who's lost his job because of e-mails exchanged or Web sites visited while at work. In fact, the Internet is closer to the *opposite* of anonymous. Every page view, every bit of text, every transaction is tracked and logged.

And there are even limits to how much you can expect to control your personal data.

If George Clooney makes a movie that you load onto your state-of-the-art phone, is the image of him that appears on your screen "him"? If a disturbed man inserts images of Angelina Jolie into a pornographic video and masturbates to those images, has he sexually assaulted her?

No. The images Clooney and Jolie make and sell are not part of their essential selves.

But, according to the U.S. legal system, Clooney and Jolie do have some right to control how their images are used. At least in a commercial sense. The masturbating man may be able to insert Jolie's image into a sexually-graphic video (or any video, for that matter) digitally—but he can't sell it without her permission.

Note something here: The U.S. legal system—like most reasonably effective ones—is better at dealing with commercial disputes than with profound philosophical questions. This is a theme that we'll come back frequently in this book.

Gun Ownership and Self Ownership

Philosophers as diverse as Niccolo Machiavelli, Thomas More and Jean-Jacques Rousseau have all written that an individual's right to possess arms is an essential element of self ownership and a check against tyranny.

To be disarmed forcibly by the state is the same as being enslaved by it. And *that* kind of servitude isn't voluntary.

If you own yourself, you should protect yourself.

Some people don't see things so plainly. They think, because police exist, they don't need to provide for their own personal security.

But police officers aren't bodyguards. They serve society as a *general* deterrent to crime.

A person who doesn't believe it's right to arm himself against attack does not value himself. A society that doesn't allow citizens to defend themselves is not civilized. It's not *functional*. It's totalitarian and dehumanizing. Dehumaniz*ed*.

An historical example: In 1906, the city of Atlanta experienced some violent race riots. After a series of crimes were exploited by opportunistic politicians, white mobs attacked black neighborhoods.

The residents fought back more effectively than expected. (Lighter-skinned blacks had gotten around selectively-enforced gun-control laws and "passed" as white in order to buy guns for themselves and their neighbors.)

Local police and state militia units responded with house-to-house searches in black neighborhoods for guns. The *Atlanta Journal* ran an editorial headlined "Disarm the Negroes," which read in part: "Should a collision between the races occur, it would be too late to deplore the fact that the negroes had been permitted to arm themselves."

If you own yourself and value dignity, in its older and deeper meaning, you will be inclined to retaliate when threatened with death or bodily harm. You won't rely on others for your security. You'll pay attention to your surroundings; you'll arm yourself reasonably against possible attack. And you'll defend yourself when faced with the risk of lethal violence.

The spontaneous order of individual security confers benefits on the entire population—regardless of how complex that population might be.

Economists speak of "free riders"—people who benefit from difficult economic choices that others make. Generally, free riders are supposed to be a problem that needs solving. They add indirect costs to the hard choices others make. For example, the property owner who doesn't pay property taxes but sends his children to public schools is a free rider on those property owners who do pay their taxes. The state solves this problem by taking the tax avoider's property and selling it at auction.

But there are some situations in which free riders aren't a problem. In fact, the fact that they are able to gain "free" benefits helps everyone. The best example of this sort of good free rider situation is gun ownership.

Leave side your specific feelings about gun ownership and consider the matter from an economic perspective.

In the United States, the fact that you own yourself leads directly to a right to own guns and other weapons to protect yourself from physical attacks, coercion or the threat of either. This right has wide effects.

The United States has fewer "hot" burglaries—break-ins that take place while residents are home—than developed countries that limit gun ownership (Great Britain and the Netherlands are two ready examples). In the U.S., burglars avoid breaking into homes when the

residents are there; only about 10 percent of burglaries are "hot."
In both Great Britain and the Netherlands, the percentage of "hot" burglaries is over 50 percent.

About half of all U.S. homes contain guns. Crooks don't know which half, so they tend to avoid all occupied homes. This is a positive general effect—what political economists call an *externality*—that self ownership...and its offshoot, gun ownership...creates.

Deterring home invasions is beneficial for the individual family that owns guns. But it's also beneficial to those families that don't. In this way, the household that owns guns contributes to the common defense of the general population by protecting itself.

James Madison, the founder who drafted the Second Amendment to the U.S. Constitution, was a crafty lawyer and politician who spent most of his professional life in the considerable shadow of his fellow Virginian, Thomas Jefferson. But Madison had an economist's mind. He understood that guaranteeing the individual right to own guns would create benefits for the whole population.

The June 2008 U.S. Supreme Court decision *District of Columbia et al. v. Heller* confirmed the idea that one of purposes of allowing citizens to arm themselves is the general deterrence to crime that individual gun ownership provides. Writing for the Court, Justice Antonin Scalia emphasized that the right to bear arms described in the Constitution's Bill of Rights was indeed an individual right (refuting the fashionable argument that it was a collective right belonging to the state). Scalia also suggested some of the reasons that an armed citizenry was important:

> *First, of course, it is useful in repelling invasions and suppressing insurrections. Second, it renders large standing armies unnecessary ….*
> *Third, when the able-bodied men of a nation are trained in arms and organized, they are better able to resist tyranny.*

The fact that many Americans own guns deters home invasions; but it does more than that. As Robert Heinlein famously wrote, an armed society is a polite society.

Selling Yourself, Part One: Organs

There are other benefits that specific aspects of self ownership convey on the general population. Some of these activities are even more controversial than gun ownership.

In the U.S., more than 80,000 people are on the waiting list for an organ transplant at any given time. Each year, thousands of people die while waiting for transplant organs to become available. This is a market in disequilibrium—because state laws prohibit the sale of organs. Transplant organs can only be *donated*.

The stated purpose of the laws against organ sales is to prevent economic exploitation of poor people. And the lawmakers underscored their worst-case scenarios with graphic, bloody detail.

Temptation isn't enough to justify the statist controls, though. Some advocates of "mandatory donation" argue that a free market in organs would *coerce* poor people to sell parts of their bodies. (The brighter statists understand that libertarians strongly oppose coercion…and enjoy turning this concept on its head.)

These condescending arguments fall apart quickly—by the same logic, jobs that poor people are coerced to take by their poverty should be outlawed.

Losing that argument, the condescending statists fall back on the rhetoric of exploitation and greed. But what they really oppose is the inexorable power of market pricing.

The price mechanism assures that the levels of supply and demand for any good or service are in equilibrium. This is the market element that statists most often try to manipulate and control. Their efforts rarely work…and, on the rare occasions that they do work, they don't work for very long. More often, the results are backlashes that the statists scramble to obscure.

When statist lawmakers limit the price of a good or service, the incentive to produce that thing disappears and greater shortages follow. In some cases, the statist lawmakers respond to the greater shortages with more dramatic market manipulations—more price controls, production subsidies and in extreme cases nationalization of industry segments.

In the case of transplant organs, the developed world has set a controlled price of zero. The resulting shortages are a logical consequence.

Struggling to obscure their culpability for organ shortages, statist prohibitionists fall back on handy shibboleths of racism and sexism.

Nancy Scheper-Hughes, a leader of the prohibitionist group Organs Watch has publicly decried the "fact" that free-market organs move "from South to North, from Third to First World, from poor

to rich, from black and brown to white and from female to male."

Well-meaning statist dopes also decry the "commodification" of human organs. In most cases, this means that wealthier people on donor lists should not be allowed to use their money or influence to secure the needed body part before others on the list. Again, the point is to prevent any market mechanisms from working in the transplant organ…market.

The logic of this argument is the opposite of the arguments against exploitation of the poor—which is that money shouldn't be allowed to coerce someone into harming himself physically. In this case, money shouldn't be allowed to assist someone in *helping* himself physically.

Whenever you hear a person say sadly that a relative is (or *was*) "On a donor list, but…," you hear an example a state-created problem.

Selling Yourself, Part Two: Prostitution

If a person owns herself, why can't she legally sell the use of her body for sex?

Most people take money for the use of their bodies. Some get good wages and some do not; some have a relatively high degree of control over their working conditions and some have little control; some have many employment options and some have very few. Some are socially stigmatized and some are not.

Most of the people who support legalized prostitution use various social-welfare arguments: Outlawing consensual transactions drives those activities into illegal channels, where contracts cannot be enforced by the rule of law. Instead, the most ruthless and violent types (that is, pimps) benefit from inflated profit margins due to restricted supply. These well-funded outlaws tend to defend their franchises violently.

These arguments are true and valid. But they are needlessly obscure. The libertarian argument for legalizing prostitution is simple and straightforward:

- it isn't anyone else's business how many or what kind of sex partners a competent adult chooses;
- government intrusion into private, voluntary exchanges should be limited to practices which produce demonstrable harm *to third parties*;

- penalizing people with few economic choices by removing one ready money-making option they have is perverse;
- legalization allows for organized STD testing among prostitutes and legal recourse for those who are beaten or otherwise abused.

On the other hand, the arguments for criminalizing prostitution are more emotional (and sometimes nonsensical) than rational. Here are some of these:

- stigmatizing promiscuous women is universal; it's an immutable fact of human psychology, shaped by evolution;
- an attractive young woman has more social capital than a middle-aged, middle-class man does; monetizing this social capital unfairly penalizes the man;
- a society that permits prostitution encourages a decline in private systems of morality puts more pressure on the state to provide public morality;
- prostitutes exhibit a marked lack of self-discipline and intelligence; they lack the foresight and discipline to plan ahead, so the state needs to plan their futures for them;
- even if prostitution is legal and regulated, there will still be an underground industry marked by abuse, violence and exploitation; some men will want to have sex with underage girls or have unsafe or abusive sex. Pimps, kidnappers and other criminals will provide the supply to meet this demand.

Statists bowing to tradtional cultural bigotry? Worried about "pressure on the state"? Quoting the iron laws of supply and demand? Well, consistency has never been one of their strong suits.

Self Ownership and Personal Responsibility

Self ownership requires people to take responsibility for themselves. And this notion of "personal responsibility" means more than just the relatively wealthy making politically-partisan "moral" judgments about the relatively poor. It means accepting the fact that some people make poor choices and have to live with the consequences.

It means tolerating things that you find objectionable or bad in others because they tolerate the same in you.

This should be a promising perspective to take into the pragmatic realm of U.S. presidential politics. But it's not. Since the second half of the 20th Century, American politics has been so dominated by benefits administration and capital redistribution that the value of the individual has been lost.

George W. Bush stumbled close to the libertarian notions of individual self ownership and personal responsibility when he articulated the goal of encouraging an "ownership society" in the United States.

Unfortunately, he didn't stick very closely to the principles. His interest in an ownership society was limited to privatizing certain Social Security benefits (which was, by itself, a reasonable objective); and he abandoned even this modest plan when it proved politically difficult. In retrospect, it looked like the right conclusion reached for the wrong reasons. Not a solid philosophical foundation.

W. was no libertarian. Despite occasional flashes of limited-government rhetoric, he seemed at heart a corporate statist—not much different in spirit from his most vicious critics.

Morality versus Legality

Of course, when talking about matters of coercion and life and death, the matter of morality comes up quickly and often. People will cry that this act or that is immoral. Someone will claim "moral outrage" at any death that involves a state action or policy. And various people insist that the state must behave in a moral manner.

This talk of state and morality is a lot of noise. A government is neither moral nor immoral—it is *a*moral. Only people can be moral or immoral. And even that is a sloppy way to think of morality. To be precise, *actions* taken by people are moral or immoral. That is, they either comply with a system of moral value or they don't.

States aren't sentient beings. Their actions can't be compared with actions of a sentient individual. Morality is an inherently individual matter. There is no such thing as collective morality. The closest thing to *that* is the Social Contract.

When people prattle on about government morality, they're confusing two issues. The first is the morality or immortality of actions taken by the people holding high government offices; the second is how closely or well the government is fulfilling its end of the Social Contract.

Murder and theft, which most people believe are immoral, are also illegal in most states. It's a common logical fallacy that they're illegal *because* they're immoral. Not so. The immorality and illegality of these actions are correlative—not causal.

Murder and theft are illegal because a society in which people's basic safety and property rights aren't protected by law isn't stable enough to last.

The Supreme Court and the "Right to Privacy"

Ellen Griswold was Executive Director of the Planned Parenthood League of Connecticut. The League operated a clinic in New Haven—where Griswold was arrested in November 1961 for violating a Connecticut law that banned the marketing or use of "any drug, medicinal article or instrument for the purpose of preventing conception." The arrest was something of a publicity stunt, since all the parties involved understood that it was going to be a test case on laws prohibiting birth control drugs and devices.

Griswold was found guilty and fined $100. The case was appealed through federal channels to the U.S. Supreme Court.

There, William O. Douglas wrote the decision *Griswold v. Connecticut*, which—in 1965—made contraception legal in America.

The philosophy behind Douglas's decision goes far beyond the topic of contraception. Specifically, he wrote:

the State may not, consistently with the spirit of the First Amendment, contract the spectrum of available knowledge. ...In other words, the First Amendment has a penumbra where privacy is protected from governmental intrusion. ...Various guarantees create zones of privacy. The right of association contained in the penumbra of the First Amendment is one.... The Third Amendment, in its prohibition against the quartering of soldiers "in any house" in time of peace without the consent of the owner, is another....

Douglas noted that the Fourth and Fifth Amendments were defined in an earlier Supreme Court decision as designed to provide a broad protection against state invasions "of the sanctity of a man's home and the privacies of life."

Although Douglas represented the majority opinion of the Court, not everyone agreed. Justice Hugo Black was especially opposed:

"Privacy" is a broad, abstract and ambiguous concept which can easily be shrunken in meaning but which can also, on the other hand, easily be interpreted as a constitutional ban against many things other than searches and seizures. …I like my privacy as well as the next one, but I am nevertheless compelled to admit that government has a right to invade it unless prohibited by some specific constitutional provision.

Black was correct. Not about the "right to invade" nonsense, but in observing that the Constitution makes no mention of a right to privacy. What it does provide are some specific protections against government search and seizure of body and property that—taken together—create an inference of something called, variously, a "zone of privacy" or "right created by Constitutional penumbra." (*Penumbra* is a fancy word for shadows.)

The phrase "right to privacy" became well-known after a much-cited 1890 Harvard Law Review article cowritten by future U.S. Supreme Court Justice Louis Brandeis.

Years later, on the Supreme Court, Brandeis dissented from the decision *Olmstead v. United States* and summarized the principles underlying the Constitution's guarantee of privacy:

The makers of our Constitution undertook to secure conditions favorable to the pursuit of happiness. They recognized the significance of man's spiritual nature of his feelings and of his intellect. They knew that only a part of the pain, pleasure and satisfactions of life are to be found in material things. They sought to protect Americans in their beliefs, their thoughts, their emotions and their sensations. They conferred, as against the Government, the right to be let alone—the most comprehensive of rights and the right most valued by civilized men.

Well played, sir.

Data Mining and Ownership of Personal Information

A recent privacy topic warrants discussion. Data mining is the broad search of public (and non-public) databases for personal information in the absence of a particular suspicion about a particular person. It looks for patterns of behavior and occurrence.

Government officials and some security experts say data mining is necessary to identify terrorists, "sleeper" agents and other enemies of the state who do not wear military uniforms.

In practice, data mining often takes place in a limbo between state and private action. Government agencies frequently rely on private-sector contractors and commercial databases to skirt existing privacy laws and gain access to personal data they would not see otherwise.

The critical question here is: How does self ownership apply to electronic data? Do you "own" the fact that you used a credit card to make a contribution to a terrorism-supporting charity? Or buy roses for your mistress? Or does your credit card company own that information? Maybe. Most credit card terms of use state that such data belongs to the card company.

Here, the George Clooney/Angelina Jolie example may be useful. Just as those celebrities can sign away the rights to specific pictures while retaining ownership of their more general public images, you may give up specific information to specific firms while retaining ownership of any larger "profile" that might be assembled from small bits of personal data.

So, *synthesis* becomes another invasion of privacy. Information from various commercial databases might be combined to create a profile of you that you never expected or permitted.

It's a short step from data mining to fundamental changes in expectations of privacy. When you hear someone talking about a method of surveillance being acceptable because no one should have an expectation of privacy, anyway, know you're listening to a statist.

Privacy is an important check on the state's excesses.

Chapter 3:

The Social Contract

Libertarian philosophy and unalienable rights like self ownership are important to understand; but they're abstract. Living peaceably among other people requires some practical guidelines. Some people might claim that those guidelines come from the state. They don't. They come from something deeper and larger than any state. They come from the Social Contract.

The state, unlike you, does *not* exist in its own right. It is a tool, the result of the implicit agreements that exist among people who agree to live with one another cooperatively. The purpose of the state is to encourage (and occasionally enforce) smooth interaction among those people.

"Government exists to protect us from each other," Ronald Reagan famously said. "Where government has gone beyond its limits is in deciding to protect us from ourselves."

Again, the Social Contract must exist *before* any state (or statist laws) can exist. The Social Contract emerges from a history of smaller agreements and compromises that individual members of a social unit have made. No one individual compromise controls the larger Contract, which will often be a cultural marker as distinctive as local arts or language. However, if it's effective, the Contract will reflect some universal traits—like a respect for unalienable rights.

The Social Contract is designed to manage conflicts. Rational individuals want a system that prevents other individuals from using coercive force. But, in order to protect *your*self from *my* initiation of force, you have to grant some third party a monopoly on that force in order to stop me. That third party is usually the state.

You have beliefs about what's right and wrong; so do I. You have property or the desire to acquire property; so do I. We create a Contract (which may look, to us, like a set of common-sense

guidelines) that encourages us to live peacefully with each other and among our fellow citizens.

The Social Contract is, ultimately, a peace treaty.

We can debate each other; we can fight with each other. But debate is often inconclusive and fighting is risky and expensive. In this context, the Contract and the state exist as tools to give individuals a reliable marketplace in which to trade their property and resolve their disputes without violence.

Anything more that a state tries to be (and states invariably try to expand their missions and size) creeps toward market disequilibrium that will—sooner or later—force inefficiency and hardship on the people who agreed to support the Contract in the first place.

An Allegory of the Social Contract

Imagine that you are a woman who bakes really good cookies. Working in your home, you develop several original recipes that involve the creative use of cinnamon and cocoanut. Your family and friends all love the cookies. Word spreads, and pretty soon friends of friends and neighbors are asking you to bake cookies for them—and offering to pay you to do it.

You decide to take the money you're making from the cookies and rent a stall at the local farmer's market.

The first weekend, you and your kids load cookies into the back of your minivan and drive into town for the farmers' market. You set up a simple table-front in your rented space and put out some samples. You stand out in front of the space and welcome people to try some samples; your teenage son keeps the cash box and handles the sales. In less than two hours, you've sold everything you brought.

Word spreads. The next weekend, you bring three times as many cookies. But there are more people than before. You never get to the point of standing out in front of your space. You sell out everything in *one* hour. At one point, your son says he can't keep up with the number of people pushing up to him with bags of cookies. He's worried that some people in the crowd may have gotten away without paying.

You're going to need a bigger space and a proper cash register.

The guy who runs the farmers' market sees what's been going on. He offers you a good deal on a better location if you'll agree to come every weekend for six months. The better location includes an

electrical outlet—so you can set up an oven and bake cookies on-site. (No fool, the guy figures the smell of cookies baking will draw foot traffic from all around.)

In the next few weeks, a buyer from a local grocery store chain leaves her card; she says she'll start with 100 bags of cookies a week. People start suggesting you open a permanent shop.

You have a real business going, which means you've got to pay taxes and be prepared for inspections from the local health department. The taxes and health inspections are worth the cost and hassle because, in exchange, the local government provides the following things:

- reasonable assurance that the ingredients you buy will be safe to use;
- a population confident enough that your cookies are safe to eat that it'll buy them;
- safe roads on which you can drive your minivan to the farmer's market;
- law enforcement robust enough that your cookies (and your profits from selling the cookies) will usually be safe;
- a legal system that will discourage other cookie makers from stealing your recipes.

One important point: The local government can't make specific assurances to you—that your stuff will *never* be stolen, that your ingredients will *always* be fresh, that *every* person will have enough money to buy cookies. Its provisions are of a general nature. What it really provides is the basic stability that allows you to do business.

You're a smart cookie baker. You don't expect the state to provide particular goods or services; you just want that stability. (You buy insurance against particular, unexpected losses; and you take precautions to protect your new shop against particular break-ins.)

Busy baking and selling cookies, you figure the state's role is to focus on the broad, general issues that make society run in a smooth and orderly manner.

The Social Contract Isn't Supposed to Be Inspiring

A state is formed among (and a constitution written for) people of fundamentally similar views. Although individuals will always differ on particulars, no society can last without a foundation of shared principles—a Social Contract.

Thinking of government in terms of providing simple externalities to a small business person isn't inspiring. It's not a vision that's likely to fuel lofty rhetoric or draw the best and brightest to participate. And that's as it should be.

Why is it important to think of the state in such limited, uninspiring and even grumpy terms?

Because they're limited, uninspiring, grumpy things. The Social Contract and the state it produces are compromises—intrusions upon the native freedom to which every individual person is entitled by the fact of his or her existence.

And there's another reason. To think of the Social Contract as anything more than a grumpy trade-off invites statist expansion and, ultimately, the infantilization of citizens. Statists are always looking for ways to grow the collectivist mechanisms of the state. If the Social Contract is seen by citizens as anything more than a compromise cautiously made, those statists will read assumptions into the deal that citizens didn't intend.

There's a saying in business that the sign of a fair contract is that both parties think they got the worse end of the deal.

This rule of disgruntled thumb should apply to the Social Contract, too.

Libertarians believe that it is always wrong to coerce others. This "non-initiative imperative" leads some libertarians toward anarchy—how can you have a government that does not initiate force, if only to collect taxes to finance its activities?

But anarchy raises more problems than it solves. A society without some form of government usually leads to armed conflict—and coercion—among its citizens. (And this doesn't even get to the problem that anarchic systems have with neighbors invading them.)

So, a rational person sees a trade-off. She gives up some her freedoms in exchange for a system that can assure a basic level of peaceful social interaction.

The task of political and legal thinkers is to minimize the coerciveness of the state.

Here's the Social Contract, defined simply: In exchange for stable, reliable access to marketplaces where you can sell your goods and/ or services, you agree to give up certain rights that—living outside of society—you would have.

You should be constantly checking your Contract…to make

sure that the state is complying with its end of the bargain. A state is inclined to do either or both of two things when dealing with the Social Contract: take more than it is entitled to under the deal; and provide less than it is supposed to.

Negative Liberty and the Social Contract

Libertarians and better legal minds talk about negative liberties as an essential part of the American system. The phrase "negative liberty" sounds like trendy academic jargon; what does it mean in terms of the Social Contract?

Just as the state is good at defining mechanical details but not good at interpreting deep philosophy, so it's good at defining the limits placed on people and the state by the Social Contract...but not so good at interpreting the privileges offered to individuals by society.

Said another way: the Social Contract involves rights and privileges. People confuse the two; and this confusion creates uncertain expectations. Ill-informed sorts will talked about "rights" when they mean "privileges" and vice-versa. The phrases *negative liberty* and *positive liberty* can help clear up this confusion.

Negative liberty is about rights. And rights are more limited things than most people realize.

When you enter a Social Contract, you give the state a general grant of power to use force to uphold the society's laws and maintain order. (This is usually a monopoly right. The state is the *only* entity that can initiate force; all individuals agree to give up the ability to do so—legally, at least.)

However, there are some powers and prerogatives that you take back from the general grant of power you give the state. These powers and prerogatives are rights. In the Declaration of Independence, Thomas Jefferson cribbed some language from John Locke when he called them "unalienable rights." Other political philosophers call these rights "first things." Whatever you call them, these rights are designed to keep the state's growth and institutional decadence in check.

Jefferson's "unalienable rights" were, of course, life, liberty and the pursuit of happiness. Life and the pursuit of happiness are affirmative rights; the state must acknowledge something (your existence and the existence of an emotional state called "happiness") in order to deliver these rights to its citizens.

Positive liberty has always been a difficult concept to bring into practice. Ideas like life and—especially—the pursuit of happiness lead down slippery slopes of affirmative promises and fuzzy notions of so-called "human rights."

The phrase *human rights* usually refers to a broadly-defined set of material assurances—of things like a home, a car and university-level education. These promises involve other subjective standards of "quality of life" or "standard of living."

Negative liberty is different. It doesn't require the state to acknowledge or affirm anything; it requires the state to check itself.

The best example of negative liberty is the U.S. Constitution's Bill of Rights. These are 10 amendments which specifically limit the state's actions—and reserve actions and behaviors for individual citizens. The Bill of Rights protects individual liberty by speaking clearly about what the state *can't* do.

That's negative liberty.

The Social Contract and Personal Choice

You live in the place that you do, under the circumstances that you do, by choice. This choice may be clear. You may have worked hard to move from the place and station of your birth. Or this choice may be less clear. You may simply have chosen to accept the place and circumstances others presented you.

You've chosen to accept the circumstances of your life by living…and living among people. If a social life were truly hateful to you, you could live alone in a cabin in the woods. Some do.

The chances are, though, that you live a more conventional life. And that means you've made a choice. By making that choice, you've entered into a Social Contract; you've agreed to follow societal norms. You've accepted societal conditions.

When individuals enter into a Social Contract, they give up certain rights and expectations—particularly the expectation of absolute freedom—and, in exchange, receive certain other rights and expectations from the state. An effective Social Contract should be one that people enter rationally. They should give up some of their freedoms in exchange for externalities that improve their lives.

The Social Contract is binding; but it's also voidable. If the society becomes dysfunctional or oppressive, you can leave it. Go live in that cabin in the woods.

Of course, some states don't allow citizens to leave—no matter how oppressive or dysfunctional the society has become. This is an excess and abuse. And sadly common. Not letting citizens leave is one of the hallmarks of a totalitarian state.

If the state doesn't honor its end of the Social Contract, people will rightly leave. Or revolt.

Moving from one system to another is usually the best option for an ordinary person and the best check on statist excess. That's why immigration is so important. A net inflow of people is the ultimate sign that your Social Contract is working.

Any nation that experiences a net exodus of residents or a revolution needs to examine how well it's honoring its Social Contract. It's most likely failing the agreement somehow. A working Social Contract is one that encourages the development of its subjects as individuals. It preserves essential rights and humbly sets basic ground rules that encourage fair interaction between subjects.

The great power of America comes from its vibrant economy and fair justice system. These things draw people to our shores. And the fact that they want to come isn't a burden…it's an honor.

Liberty and Culture

The Social Contract sees beyond the limits of the state. It is formed by the psychology and culture that shapes its citizens. So, these things matter.

The state may claim to value liberty; but, if the citizens have a totalitarian culture, liberty won't last. More optimistically, if the state attempts to create totalitarian rule—but the citizens value liberty—*that* state won't last.

The economist Friedrich Hayek spent the last part of his career studying the relationship between culture and state. He concluded that you can't force institutions—even the most enlightened, liberty-loving institutions—on a society whose *culture* isn't ready to accept them.

How can you tell that a nation is ready for liberty? When its cultural institutions encourage people not to destroy themselves. An effective Social Contract can be measured by how much it encourages individuals not to be destructive—how well it encourages the drug-addictive not to use…or the labor union not to strike. (This measure echoes the notion of "negative liberty" that most libertarians embrace.)

The political philosopher and Columbia University professor Robert L. Hale wrote some of the seminal libertarian works on how the state abuses the Social Contract. Hale's often-cited 1923 paper *Coercion and Distribution in a Supposedly Non-Coercive State* described the threat of inefficiency and destruction that lies behind coercive power:

> ...*what [some call] the "productivity" of each factor means no more nor less than this coercive power. It is measured not by what one actually is producing...but by the extent to which production would fall off if one left and if the marginal laborer were put in his place—by the extent, that is, to which the execution of his threat of withdrawal would damage the employer.*
>
> ...*The distribution of income, to repeat, depends on the relative power of coercion which the different members of the community can exert against one another. Income is the price paid for not using one's coercive weapons. ...By threatening to use these various weapons, one gets (with or without sacrifice) an income in the form of wages, interest, rent or profits. The resulting distribution is very far from being equal, and the inequalities are very far from corresponding to needs or to sacrifice.*

If this sounds like extortion, that's because it is.

Hale was talking about individuals; but state agencies are really the masters at getting paid (in the form of tax revenues) for not using their coercive powers. And, despite the riches gathered in this way, most states eventually use their monopoly on coercive power to transfer money from poorly-organized interest groups to well-organized interest groups and, in the process, take a another cut.

An Open Market for Court Systems

Despite the inherent shadows of coercion and extortion, rational people need a state that protects individuals from:

1) the initiation of coercive force by parties to the Social Contract (which requires some sort of police system and some sort of court system);

2) the initiation of coercive force by parties outside the Social Contract (which requires some provision for common defense among parties to the Contract).

Free people want to live in a society in which people's impulses to coerce or initiate force against others are governed. This is the

original meaning of "government." The core idea is supposed to involve limiting actions—so, the self-perpetuating growth to which governments tend is ironic.

The Social Contract, if it works well, should offer rational mechanisms for dealing with the non-compliance (complexities and difficulties) that follows from self ownership. One of the most important of these mechanisms is the system of trial by jury.

Juries offer a practical way for managing individuals' thorny interactions without resorting to invasive statist rules or totalitarian regulations.

If you've trampled on someone else's rights, the jury system gives you the opportunity to explain yourself; if your explanation makes sense, your peers—acting as the state—can make an allowance for what you did. The jury system is a pragmatic approach to dealing with the difficulty of people interacting with one another.

But does the state have to be the sole provider of courts and jury trials?

No.

One of the reasons the developed countries of the "West" are free is that there used to be a vibrant competitive market for courts of law. There were church courts, merchants' and guild courts, town or village…and regional variations on each of these.

These different courts of law meant that no one system had monopoly power (with the exception, eventually in the U.S., of the Supreme Court which presides over all). Each court had to be careful to maintain a reputation for fairness and thoroughness—otherwise, people would go to one of the other systems. This marketplace responsiveness was lost in the United States during the 20th Century. Power gravitated toward the federal courts—to the point that, today, Americans have little notion of any other system.

Why does it stay like this?

Some defenders of the federal monopoly say that most Americans lack the legal training to create viable alternatives to the current system. But you don't have to be an automobile engineer for the market to make good cars for you. You shouldn't have to be a law professor for the market to make good laws for you.

Why is the provision of law different from the provision of other services?

Attorneys and judges often complain about—and have systems in place to prevent—what they call "venue shopping." This is the tactic by which one side is a legal dispute lobbies to change the location of a trial because it believes the judges or juries somewhere else will be more sympathetic to its case. But venue-shopping can be seen as a kind of market response, just as moving your child from a public school with bad test scores to a public school with better test scores (to say nothing of moving your child to a private school).

A decentralized market approach to the enforcement of rights and the settlement of disputes is likely to result in fewer bad things happening and essential rights being abused less often.

What is the best hope, at this point in history, for a revival of the vibrant competition that used to exist among American courts? Perhaps massive multiuser computer games like Second Life could provide the competition that the U.S. federal court system needs.

Almost everything that a government does can be privatized; but even a limited state needs a supreme court with jurisdiction over competing private courts. America needs to get back to that stripped-down approach to legal systems.

Governments Trail Behind Social Contracts

A state has no inherent value or power. What value or power it does have comes from individuals who voluntarily trade their freedom for order.

This trade-off, the Social Contract, is more dynamic and responsive to individuals than states and state legal systems, which by their natures trail behind. When the Social Contract supporting a specific state ceases to provide value to its participants, the state starts to lose legitimacy. This loss will be manifest in various ways, including net emigration or other population decline, economic instability and a general contempt for the state's laws.

In this situation, desperate statists will often speak ominously about *anarchy*. To them anarchy means chaos.

It doesn't. Anarchy is just another kind of Social Contract. It can work in very small groups of people who have capital and access to lots of ready material resources. It doesn't work in larger populations, more crowded conditions.

Anarchy isn't just wasted rock-in-rollers screaming that everything should burn. It requires individuals to have what Adam Smith called

"Moral Sentiments." And this is a far cry from the conventional image of hipster anarchy. Smith argued that human beings have an innate desire for the approval of their fellows; and he said that people can rely upon that instinctive desire for approval and acceptance to succeed with very limited government.

Perhaps anarchy is an ideal state—and heaven is an anarchic place. But you don't live in heaven.

Governments are the product of temporal, practical agreements. They are only good at administering temporal, practical matters; they're bad at dealing with abstract philosophical or spiritual ones. To have any hope of operating effectively, state agencies should keep in mind the their inherent limitations. Rarely do they.

States are pretty good at building and maintaining roads. They can arbitrate simple material disputes. They are adequate, sometimes, at teaching children to read and add.

They are bad at teaching children to *think* clearly. They are terrible at solving an individual's loneliness or providing a sense of purpose—and, when they try to do these things, the results are usually disastrous. When governments try to reach beyond simple material goals—when they try to "raise" children or develop a new, perfect citizen—they fail spectacularly.

Citizens need to keep the Social Contract in mind all of the time because the state—like all corporations, partnerships and other legal fictions—takes on a life of its own. The state (like the people it employs) sees government as an end in itself. But it isn't. It's a product of the Social Contract, which has to make sense for all individuals who participate.

Public sentiment legitimizes the Social Contract and the state that follows from it. Public sentiment is also the only effective influence on the Social Contract and check on the state.

The most important promise that the Social Contract can keep (and the most important aspect of any state) is to give public sentiment the means to express itself.

Even if they lack the education and skills to speak or write their minds, individual citizens can always express their sentiments about a state with their feet—by emigrating.

No matter what a state's immigration policy may be, the ability to opt out is an essential part of any Social Contract. That ability trumps policy.

When the state twists its Social Contract so that it no longer encourages the development of the individual or actively undermines that development, a rational person should leave that state. If the state forbids the rational person to leave, he should work to overthrow the state.

Risk Plays a Big, Underappreciated Role

Risk (and the *perception* of risk) has a bigger part in the Social Contract than most people realize. Its role goes underappreciated because most citizens—and, seemingly, *all* public office holders— don't understand what risk is or how it works.

To simplify some complex concepts, risk is the incidence rate of loss for certain groups in certain situations. The specific meaning of *risk* can change according to several variables: the definition of *loss*, the size and/or characteristics of the subject group and the nature of the situations in which the group finds itself.

Best practices in risk management focus on reducing the net present value of catastrophic losses, transferring those risks (through insurance) when possible and preparing to absorb losses that can't be insured. Insurance companies and risk managers make their fortunes helping companies and individuals do these things.

These efforts can involve some counter-intuitive understanding of people and economics. The net present value of a catastrophic loss is something that few people understand; and it doesn't apply to all losses. For example, if the ultimate catastrophic loss is death, how do you calculate a net present value for *that*? Philosophers would argue you can't. Economists would argue that the net present value of death is...death. Full value.

The best minds in economics and insurance conclude that, while it can be managed, transferred and reduced, risk can't be eliminated. A large enough population will always suffer some losses; and, as J.M. Keynes pointed out, in the long run we all suffer the ultimate loss—we're dead. So, the smart decisions of insurance actuaries and risk managers—especially those having to do with risk *transfer*—don't apply to entire populations, as government policies usually have to.

Statist bureaucrats usually have little or poor command of these abstract concepts and terms. They butcher terms like *risk* and *insurance* when they articulate policy or draft regulations. Barack Obama did this during his presidential campaign (and in his woolly-

headed book *The Audacity of Hope*) when he sloppily used the word *insurance* to mean the state-administered distribution of medical care services.

This slipshod rhetoric plays to people's ignorance. Most Americas have been conditioned to think, as Obama apparently does, that insurance is the orderly administration of benefits, which it isn't—rather than a contractual transfer of risk between parties, which it is.

What does this have to with the Social Contract? A lot. If you believe that insurance means "benefit" instead of "risk," you're more likely to make foolish assumptions about what it provides you. You're more likely to behave as if the risks of medical costs you face have been transferred when they haven't.

You're more likely to fall victim to moral hazard, the poison fruit of statism.

And statists *want* this confusion. They would rather that citizens think like slaves than free individuals; and one of the signature characteristics of free individuals is the willingness and ability to assess risks and respond to them accordingly.

Can a Social Contract Last Forever?

Philosophers have been debating for centuries whether the Social Contract can last longer than a generation or two. The reason, some say, for the short lifespan is that parties to the Contract have to enter it willingly and affirmatively. They can't inherit it from their parents. In time, this theory goes, an inherited Social Contract becomes a tool for keeping people enslaved—they end up reciting meaningless pledges of allegiance or singing like zombies some vapid lyrics about The Dear Leader. Or being an Obama Girl.

Other deep thinkers make complicated arguments that people *can* accept the terms of a Social Contract, essentially by not moving away or rioting. A libertarian hopes these other guys are right; and that a country like the United States keeps its Social Contract with citizens in force by keeping things working well enough that people want to stick around. And away from the Molotov cocktails.

But there's a cyncial angle to this. Measuring a Social Contract's success by the contentedness of citizens can lead to choices made merely to placate the masses. Or mobs, when things get difficult.

This is one reason for the cliche of the big-talking politician who breaks all sorts of loosely-made promises.

From this angle, statism can be seen as the terminal combination of moral hazard and Keynes' observation about the long term. The statist strategy on dealing with the Social Contract is to promise citizens grand things…and then count on each citizen's death nullify the promises. It's a version of debasement—except it runs down people rather than currency.

Chapter 4:

Why Property Rights Are Critical to Liberty

Libertarians value property rights dearly.

Statists argue that this proves libertarians are materialistic and greedy. Like many statist arguments, that's simplistic. Excitable and emotional.

Property rights are important because they flow directly from the first principle of liberty, that you own yourself.

One way to understand the central role that strong property rights play in individual liberty is the tragedy of the commons. During the early days of colonial America, the new immigrants from England tried to replicate a distinctive element of English towns— the commons. This was land available to the public, on which anyone could plant and grow crops. In England, the rigid class structure and long-standing civic traditions meant that neighbors cooperated to keep the commons a viable source of food and supplies shared among a town's locals.

Outside of the quaint English countryside, the concept of a commons as a tool of agricultural production wasn't viable. Rules and roles weren't clear. The new immigrants in America couldn't raise crops collectively. They suffered. But they adapted.

They disbanded the commons and allotted parcels of farm land to individual owners. Private ownership led to better harvests.

Private property is also important because it's the most reliable tool for communicating market values. The *only* reliable way. And this practical concern may be the most important economic liberty in a world of increasingly complex and interconnected markets.

Self ownership is an abstract concept that can be hard to quantify. Since the state is a temporal and practical thing, it has a hard time recognizing or dealing with self ownership. But it's much more likely to understand and tax or regulate the ownership of property.

The state can *see* property. It can tax property. It can settle disputes over property. If it does these simple things humbly and effectively, it may be able to deal with more profound aspects of self ownership…adequately.

Limiting the state requires constant attention. If you let up even a little, ambitious politicians enact laws and promulgate regulations that change the way you live. But a state that respects private property tends also to respect individual civil liberties.

This isn't to say that states dedicated to capitalism *always* respect civil liberties. Sometimes they don't. But anti-capitalist states *never* respect civil liberties.

One of the hardest things to keep in mind about the interaction of the state and the individual is the recurring problem of state agents confusing many individuals for a monolithic whole.

Property and privacy are similar in some instructive ways. Both are things that individuals value highly but states value grudgingly, if at all. Both are things that states limit when they can. Consider regimes (and the United States is among these) that "nationalize" privately-held assets during times of "crisis." Nationalizing assets denies both privacy and property rights.

And some regimes actively hate private property and privacy— whether eccentric cranks like Venezuela's Hugo Chavez or psychopathic murderers like Cambodia's Pol Pot. These, too, have instructive similarities; they both have contempt for the individual.

And this contempt isn't limited to oddities of little worldwide import. There are statists within the U.S. government who share the same contempt. And some of those carry guns.

A Great Risk to Personal Property: Eminent Domain

More often, though, they carry briefcases. In the early 2000s, municipal politicians in the city of New London, Connecticut, were excited about convincing Pfizer Corp. to locate a major drug manufacturing facility in the area. But Pfizer executives wanted more than just land and well-kept infrastructure connected to the plant; they wanted the town to improve its overall profile.

The city fathers understood what this meant. They needed to clean up several marginal neighborhoods. So, they began the process of condemning sketchy neighborhoods under the theory of eminent domain in order to provide the "amenities" that Pfizer

execs expected. These amenities were loosely defined—there was no specific development plan. The condemned neighborhoods might be rebuilt as high-end condominiums, a hotel, office space...or anything else that developers might suggest.

This was a pretty vague basis on which to take away people's homes.

Susette Kelo, a nurse who lived in one of the condemned neighborhoods, didn't want to give up her home to hazy plans for urban improvement. She had spent several years restoring the house and wanted to stay in it. It wasn't a matter of money—by condemning the houses, the city of New London agreed to pay owners to leave. It was matter of principle.

Kelo and several other local homeowners got in touch with the Institute for Justice, a property rights foundation that had been looking for a good case to test eminent domain precedents in federal court.

Kelo and lawyers from IJ pressed her case through trial and appeal, losing all along, and eventually to the U.S. Supreme Court. According to IJ's Chip Mellor:

> *We knew we had an uphill fight in the Supreme Court. Sandra Day O'Connor had written one of the worst opinions on the issue back in 1986, and William Rehnquist had joined her, so that made it tough to figure out how we were going to get five votes. Nevertheless, we were there and we were going to make the best case. ...the good news for us came when O'Connor leaned forward during the argument of the opposing side, the city council side, and said, "Stop a minute, counsel. Let me see if I understand. Do you mean to say that it's your position that the City of New London could take a Motel 6 and give it to Ritz Carlton?" And he said what he had to say. He said yes, that's my position, and she had a look of utter disbelief on her face.*

O'Connor ended up writing an opinion defending Susette Kelo's home against vague eminent domain claims. But that opinion was a dissent. In June 2005, the Court ruled five to four in favor of the city's right to take people's homes in order to improve a marginal neighborhood.

Justices John Paul Stevens, David Souter, Ruth Bader Ginsburg, Stephen Breyer and Anthony Kennedy pointed to 19th Century decisions that had allowed government agencies to take property

for railroads and other for-profit businesses. These uses of eminent domain were justified, the judges concluded, because they contributed to the public welfare. Stevens wrote:

> *The disposition of this case turns on the question whether the City's development plan serves a "public purpose." Promoting economic development is a traditional and long accepted function of government.*

Not everyone agreed. Anger about the *Kelo v. New London* decision came from all over the political spectrum. Left-wing Rep. Maxine Waters (no ally of the Institute for Justice) complained that urban redevelopment plans usually seize property from poor and politically-weak homeowners and transfer it wealthy and connected developers. Several state legislatures began considering new ways to protect property owners from eminent domain abuse.

Various critics made the same observation: When the state has the power to redistribute property, eminent domain will become a prize in a political competition between concentrated groups with much to gain and widely-dispersed individuals who may not even be aware of the projects approved in their names.

Libertarians looking for a silver lining in the *Kelo* decision pointed out that the dissenters to the decision had held that the Constitution puts limits on the power of eminent domain. And that four Justices had agreed that the state shouldn't be in the business of redistributing property.

But it is. Although the Constitution says "nor shall private property be taken for public use without just compensation," a series of Supreme Court decisions—starting in the 1960s and continuing for some 40 years—have twisted the phrase "public use" to mean "public purpose." The second phrase is much less specific.

As a result, entire neighborhoods were razed. People, especially in minority neighborhoods, were displaced; horrible public housing projects were created.

The practice went from slums to blighted areas to not-so-blighted areas and ultimately to perfectly fine neighborhoods. A "public purpose" was deemed to be anything that increases a city's tax base and creates more jobs by tearing down whatever was in one spot and replacing it with something deemed more appropriate—usually at the behest of, or for the benefit of, politically-connected developers.

Coercion and Property

In the United States, California has been a major abuser of eminent domain. In the five years between 1998 and 2003, Golden State bureaucrats seized property for "redevelopment" in more than 220 cases—eight times as many seizures as Connecticut (where Susette Kelo's home had been condemned) made in the same period. This is part of the reason that the State isn't so Golden any more.

California's redevelopment laws limit condemnation to "blighted" property. But this limit is really a statist ruse; there's no black-letter law about what "blighted" means—so, a city can simply pass a resolution declaring a neighborhood to be "blighted" and then condemn it.

The criteria on which such resolutions can be based are vague. A neighborhood can be deemed blighted if it exhibits:

> *Factors that...substantially hinder the economically viable use... of buildings [including] substandard design, inadequate size given present standards and market conditions, lack of parking, or other similar factors. ...Adjacent or nearby uses that are incompatible with each other and which prevent the economic development of...the project area. ...The existence of subdivided lots of irregular form and shape and inadequate size for proper usefulness and development that are in multiple ownership.*

Ah, the familiar circular logic of statist weasel-words: "factors" that include "standards" that are "proper" or "similar factors."

Here's how aggressive developers use the threat of eminent domain: You're approached by an agent for the developer and given an offer for the sale of your home. You're surprised, because your house isn't for sale. But the agent says that, if you don't accept the offer, the developer will go to the city and seek an eminent domain ruling—and then you may get less.

Real estate developers and local politicians have a symbiotic connection in the redevelopment business. The politicians sell "their" eminent domain powers to the developers in exchange for political capital and *capital* capital. The pols get campaign contributions from the developers—but they also use the construction projects to burnish their reputations as visionaries and rainmakers.

The developers get cheap land and tax breaks.

This is just shady statist business as usual. The only real surprise in the redevelopment equation is the frequent presence of environmentalists, slow-growth advocates and other "good government" groups whose statist utopianism rationalizes eminent domain abuses as necessary tools for cleaning up blighted neighborhoods.

In his 1923 essay *Coercion and Distribution in a Supposedly Non-Coercive State*, Robert L. Hale wrote:

> ...the right of property is much more extensive than the mere right to protection against forcible dispossession. In protecting property the government is doing something quite apart from merely keeping the peace. It is exerting coercion wherever that is necessary to protect each owner, not merely from violence, but also from peaceful infringement of his sole right to enjoy the thing owned.

This sums up the statist threat to property—and other liberties.

Abuses of eminent domain aren't limited to the coasts. In March 2008, the Missouri state supreme court allowed the small (and non-chartered) city of Arnold to use eminent domain to condemn land owned by the uncooperative citizen Homer Tourkakis and transfer it to a private developer to construct a shopping center.

Tourkakis and his wife owned a residential building in Arnold that they had converted into a dentist's office. The Arnold city council subsequently adopted ordinances declaring the Tourkakises' property and the surrounding area to be "blighted" pursuant to the state's tax increment financing (TIF) act, approved a redevelopment plan for the area and began acquiring properties there.

The Tourkakises refused to sell their property, so the city sought to condemn it.

The Tourkakises challenged the city at trial and won. The trial judge ruled that Arnold was too small to exercise eminent domain condemnation rights under Missouri law. The city appealed.

At the state supreme court, the Tourkakises's lawyers made various arguments—including two main ones:

1) that there was no indication that Missouri law gave cities as small as Arnold eminent domain powers, and
2) state law didn't establish any defensible mechanism for condemnation.

The state supreme court responded to both arguments with a single sentence: "The City is authorized under several statutes…to exercise eminent domain." In greater detail, it wrote:

The tax increment financing act…permits tax abatements to be used to redevelop blighted areas. Specifically, it authorizes "municipalities"— which it defines as a city, village, incorporated town or county established before December 1996—to adopt a redevelopment plan for blighted areas and to use eminent domain to acquire property within the redevelopment area. The plain and unambiguous meaning of [the act] does not limit legislative enactments for non-charter cities. …The legislature has the right to authorize the exercise of the sovereign power of eminent domain. Unless restricted by the constitution, the power is unlimited and practically absolute.

Then, underscoring its ruling in favor of the city, the court cited the Missouri constitution which read:

Laws may be enacted, and any city or county operating under a constitutional charter may enact ordinances, providing for the clearance, replanning, reconstruction, redevelopment and rehabilitation of blighted, substandard or insanitary areas, and for recreational and other facilities incidental or appurtenant thereto, and for taking or permitting the taking, by eminent domain, of property for such purposes, and when so taken the fee simple title to the property shall vest in the owner, who may sell or otherwise dispose of the property subject to such restrictions as may be deemed in the public interest.

Following this logic, government agencies have broad powers to take your land and sell it (on favorable terms) to someone else. They also have the power to use regulations to reduce the market value of your property. The drift of U.S. law since the 1990s has been in favor of such land grabs. These "takings" are controversial. And rightly so.

Less Direct Assaults on Private Property

In *Tahoe Sierra Preservation Council v. Tahoe Regional Planning Agency* (2002), the U.S. Supreme Court held that a supposedly temporary moratorium on all construction in the Lake Tahoe area—which had lasted for more than two decades—was not a taking of property, despite the Court's previous decisions that taking the whole value

of a piece of property requires compensation (1992's *Lucas v. South Carolina Coastal Council*) and that temporary takings also require compensation (1987's *First English Evangelical Lutheran Church v. County of Los Angeles*).

Writing for the majority in *Tahoe Sierra*, Justice John Paul Stevens explained that the unexpected ruling was necessary because applying a just compensation requirement in a principled way would

> *undoubtedly require changes in numerous practices that have long been considered permissible. ...A rule that required compensation for every delay in the use of property would render routine government processes prohibitively expensive.*

In other words, the Fifth Amendment does not apply, because government can't afford to pay for all the things it wants.

This is sophistry at best, idiocy at worst. In either case, it described the circular thinking that supports state takings of all sorts—by eminent domain or other methods.

The *Tahoe Sierra* ruling was part of a series of statist decisions that marked the final term of Chief Justice William Rehnquist. Supposedly a constitutional "conservative," Rehnquist presided over a Court that struck several legal blows against individual privacy rights. These decisions, more than any others, proved Rehnquist little different than the "activist judges" he'd opposed earlier in his tenure.

Extraordinary Circumstances = Statist Weasel Words

Eminent domain is the tool that statists use to undermine property rights on a day-to-day basis. But, in the age of statist power grabs, a reasonable person has to be worried about how government agencies might use "extraordinary circumstances" as an excuse to seize your land or your person.

After the September 2001 terrorist attacks on New York and Washington, D.C., ambitious statists in the federal government began manipulating definitions of words like "combatant" and "war" to expand their powers of imprisonment and seizure.

These power grabs have made what once seemed like fairly ridiculous scenarios more likely.

For example, during an appearance before the Senate Appropriations Committee in April 2008, Attorney General Michael

Mukasey engaged in a surreal exchange with several senators—including California's Dianne Feinstein—on the subject of how the federal government would treat civilians in and around a battlefield.

In short, you should be worried about the government deciding that terrorist groups have brought war to American soil.

(There's *already* a exception to Fourth Amendment protections. If law enforcement agents can establish "exigent circumstances," they don't need to get a warrant to invade private property.)

During the questioning, Feinstein asked Mukasey whether government agents could simply skirt the Fourth Amendment under the exigent circumstances doctrine.

Mukasey's answer: "I'm unaware of any domestic military operations being carried out today" was not encouraging. He seemed to be using the image of the battle at Gettysburg to draw attention away from the problem Feinstein was describing: The Feds using military personnel to conduct surveillance on U.S. citizens that regular law enforcement agents couldn't get warrants to conduct.

The Fourth Amendment doesn't apply to military operations; and many searches incidental to military operations are *per se* reasonable—either because of exigent circumstances or some battlefield-specific Fourth Amendment exception.

But the flip side of this is that the President shouldn't be able to circumvent the Fourth Amendment by couching whatever law enforcement operation he or she wants to engage in as a "military operation." This is the logic trick that Mukasey was using to avoid answering Feinstein's questions.

Combat and law enforcement do not exist on a continuum. They are wholly separate systems, each with doctrines inapplicable to the other.

Winning a war means breaking the enemy's will to fight. You use overwhelming force, so that the enemy *wants* to surrender. If you don't use overwhelming force—if you try to use proportionate response or any other half measure—you're not likely to break your enemy's will. And you end up with long, drawn-out quagmires.

If America is at war, and if 9/11 was an attack in that war, the Fourth Amendment does not apply to the investigation and prosecution of al Queda operatives. If, on the other hand, America is investigating a criminal act, the Fourth Amendment *does* apply. This is why the "War on Terror" is more than just rhetoric.

To illustrate this point, consider the following scenario: You are a citizen and landowner in southern California during an invasion by Mexico. The Mexican armed forces establish a base in the town of San Ysidro. They locate their headquarters in several houses—next to but not including yours.

The U.S. Marines arrive in San Ysidro and engage the Mexicans. Do they need a warrant to capture the enemy command post? Does the Fourth Amendment apply? According to the U.S. Justice Department, they don't and it doesn't. But do the Marines need a warrant to invade *your* house—which they have no reason to suspect is a Mexican or Mexican-sympathizing facility.

The Justice Department wouldn't answer this question. Which is troubling. Most legal experts agree that the Marines would need to get a warrant before invading your house, which would mean they'd need to have some evidence that you were involved with the invaders.

Before you dismiss the Mexican-invasion example as farfetched, remember that al Queda cells have operated in houses and apartment buildings in the U.S. and Great Britain. And the Marines were called in to respond to the riots that ripped across Los Angeles after the Rodney King police-brutality acquittals in 1992.

Bent Unions Are Another Threat to Property Rights

Government agencies aren't the only threat to individual property rights. There are other forms of collectivist takings that pose threats—some of these other forms may pose more direct threats to an ordinary citizen's daily life. And they may threaten more than your possessions; they may threaten your ability to earn a living.

Any conversation about libertarian political philosophy and individual property rights should consider unionism—the collective bargaining of organized labor groups. Instinctively, unions seem like an affront to individual liberty and private property. But that instinct is wrong; it's been warped by the perversions and abuses of labor union tactics during the late 20th and early 21st Century.

While a libertarian usually prefers bilateral transactions to multilateral ones, there is a place for collective bargaining in segments of an economy that are growing fast, shrinking or otherwise having trouble maintaining efficient production.

Particularly in the case of work that is inherently risky or physically dangerous, organized labor can help maintain workplace

terms and standards that, in the long run, make enterprises more efficient. The righteous history of American organized labor comes out of those circumstances.

But not all work is physically dangerous. And it's been a long time since American organized labor contributed to economic efficiency— long-term or otherwise. Since the end of World War II and, particularly, since the 1970s, organized labor in the U.S. has stumbled from a central role on the front lines of economic development to back waters of government inefficiency.

It's a testament to unionism's decline that its leaders have changed from skilled laborers with hard-earned, real-world workplace wisdom to callow Ivy League graduates looking for left-wing authenticity by organizing groups they consider too feeble-minded to negotiate for themselves. Among these: janitors, government employees and teachers.

Skilled laborers can do better for themselves as economic free-agents than as dues-paying drones. And that's as it should be.

Contrary to the fuzzy logic of Marxist poseurs, labor is not always at a disadvantage to management. The relative power between the two sides is a factor of market conditions. Sometimes, laborers have greater negotiating power, sometimes they have less.

If market conditions make laborers relatively weak, individually, in their dealings with managers, it is a rational response that the laborers band together to negotiate the terms of their employment. If they cause is just—and their demands are reasonable—they will have no trouble organizing themselves and reaching workable contracts with their employers.

They won't need Harvard lawyers to organize them—though it's often useful to have a few sharp lawyers on retainer during a negotiation.

Yoo's Bruhaha

Statist contempt for individual property rights means more than just eminent domain business deals, hypotheticals about the Mexican army and labor union politics. It's a threat to more than just your money or your possessions. A government that lacks respect for your things will lack respect for your physical body and your life.

In the spring of 2008, the mainstream media formed a panic over a series of legal memoranda written some years earlier by W.

Bush Justice Department staffer John Yoo. Simply said, the memos enumerated what some called "The Yoo Doctrine"—an aggressive defense of very broad executive branch powers. These powers included the National Security Agency or other agencies conducting interrogations and investigations that other legal scholars considered violations of international law.

The Justice Department attracts some sleazy statists. But Yoo probably wasn't one. His justification of so-called "enhanced interrogation techniques" was too plain, too naive, to be sleazy.

Still, Yoo's memos crossed a line with the American people; their release coincided with W. Bush's lowest approval ratings. Americans may have tolerated the idea of torturing terrorists who'd been operating inside the U.S.; but Yoo seemed to argue that the same techniques could be used on a *citizen* with financial or political connections to Islamic terrorists in Afghanistan.

That was too much. Bush's approval ratings plummeted.

His defenders argued that Yoo was merely making an argument that the Fourth Amendment is restricted to criminal justice matters and does not apply to wartime military operations.

The pro-Yoo spin smacks of statism. It treats Constitutional amendments contemptuously, like minor annoyances. This isn't good.

The U.S. Supreme Court has ruled repeatedly that rights defined in the Bill of Right are not grants (*U.S. v. Cruikshank*) but are an enumeration of preexisting rights. In other words, your very existence gives you certain unalienable rights...including the right to own property and not have it taken by the state or its agencies.

Of course, this doesn't mean that individuals should bow before some tyranny of property rights.

An absolute property right might allow you to post a "No Trespassing under Penalty of Death" sign on your property and, if a little girl chases a butterfly onto your yard, shoot her. Most rational people, including libertarians, agree there are some limits to the right to property. The problem is that statists exercise don't usually exercise good judgment.

The progression from the ridiculous hypothetical of a landowner shooting a little girl to the reality of poorly-trained paramilitary forces invading your house because the government doesn't like your politics is shorter than most people realize.

The Toothless Posse Comitatus Act

Military actions inside the United States are supposed to be limited by the Posse Comitatus Act. This law was passed in 1878 after outgoing president Ulysses S. Grant deployed regular Army troops to Florida in the wake of the passionately-disputed 1876 U.S. presidential election.

That election was a clear historical precedent to the disputed presidential election of 2000 between Albert Gore, Jr., and George W. Bush.

In 1876, candidates Rutherford B. Hayes and Samuel J. Tilden campaigned to a virtual tie among voters. Tilden actually won narrowly in the popular vote but didn't have enough electoral votes to claim office. Several states (chief among these: Florida, Louisiana and South Carolina) had results so close that they performed recounts. The recounts would determine the next president. Officially, the army troops were deployed to prevent riots and protect the politicians and officeholders performing the recounts. In fact, Tilden's supporters argued, the army intimidated local officials and effectively swayed the recounts in Hayes' favor.

The 1876 election took place just 11 years after the end of the Civil War; so, U.S. Army troops deployed in southern states struck a different chord than if they'd been sent to keep the peace in Ohio or New York. Grant's decision helped his ally; Hayes won the recounts and a narrow electoral victory.

The deployments left such a bad taste in voters' mouths that congress passed the Posse Comitatus Act—which prohibited the president from deploying regular army troops within the U.S.

This is the reason that, to this day, governors deploy state-based national guard troops during natural disasters. And why they declare disaster areas before taking dramatic actions.

But, starting in the 1990s, agencies of the federal government chipped away at the terms and intent of the Posse Comitatus Act. This chipping away accelerated after 9/11. By the mid-2000s, the statists' strategy was complete and the Act had been amended so thoroughly, riddled with so many exceptions and work-arounds, that it had no practical effect.

What happened in the 1990s that marked the beginning of the decline of protections against statist arms?

Ruby Ridge.

In the summer of 1992, federal agents from the Bureau of Alcohol, Tobacco and Firearms (as well as some from a smattering of other agencies, including the U.S. Marshals Service, the Secret Service and the FBI), engaged in a ham-fisted standoff with a former Green Beret and alleged criminal arms dealer named Randy Weaver.

The confrontation took place at Weaver's farm—informally called Ruby Ridge—near the town of Naples in rural northern Idaho.

The ATF claimed that Weaver had been selling illegal weapons (specifically, sawed-off shotguns) to members of the Aryan Nations, a radical white-supremicist group with which Weaver may have had some sympathy. The Feds had been investigating Weaver since the mid-1980s, when he'd allegedly made threats against the life of then-president Ronald Reagan.

Weaver earned money buying and selling guns and, as a result, owned many. He was indicted in December 1990 by a federal grand jury on weapons charges related to the sale of sawed-off shotguns. Soon after, he and his wife, Vicki, were arrested by ATF agents. Weaver was informed of the charges against him (which he disputed, arguing that the shotguns he'd sold undercover agents posing as Aryan Nations members had been legal models) and was released on bail, awaiting trial.

There was some dispute over when Weaver's trial was scheduled to start. The trial court was set to begin on February 20, 1991. However, some documents—including a letter sent to Weaver by the U.S. Probation Office—had referenced a trial date of March 20. When Weaver failed to appear in court on February 20, the Feds arranged a warrant for his arrest.

The U.S. Marshals Service proceeded cautiously. Weaver was suspicious of government officials and believed that the confusion over his trial date had been a deliberate effort to make him appear uncooperative in order to bolster a weak case. He retreated to his farm, with his wife, four children and a trusted friend.

And a lot of guns.

U.S. Marshals surveilled Weaver's farm and decided it was a bad situation. Randy Weaver was a highly-trained and heavily-armed weapons expert. Plus, he had his wife and four children—ranging in age from the late teens to a toddler—in the cabin. Friends would visit, bringing food and supplies; but Weaver rarely went outside.

Instead of confronting Weaver, the Marshals contacted him through friends and other intermediaries and asked him to surrender peacefully to face the failure-to-show charges. He refused.

This went on for more than a year. Finally, the U.S. Attorney's office handling the case against Weaver ordered the Marshals to stop using intermediaries and channel all communications through Weaver's court-appointed attorney. Since Weaver didn't know and didn't trust this lawyer, the order effectively ended all communication.

In August 1992, at the request of the U.S. Attorney's office, the Marshals started making plans to capture Weaver.

From their ongoing surveillance, the Marshals knew that Weaver had trained his family to take armed positions within their cabin whenever people or vehicles approached. Any confrontation was likely to be bloody.

On August 21, a group of Marshals—dressed in camouflage, wearing night-vision goggles and carrying M-16s—approached the Weaver cabin. They threw stones at the cabin to provoke the Weavers' dogs. When the animals started barking, Weaver's 14-year-old son Samuel and a family friend came out to investigate.

Accounts differ over precisely what happened next. But the Feds shot the Weaver's dogs and a fire fight ensued. In the fire fight, one Marshal was killed and Samuel Weaver was killed, shot in the back while retreating to the cabin.

Over the next 12 days, the situation went from bad to disastrous.

Hundreds of federal agents flooded the area. Quickly, hierarchical bickering became an issue. FBI agents considered themselves the elite of the federal law enforcement troops and contemptuously asserted control over their "lessers" from ATF and the Marshal Service. (Ironically, decades earlier, Randy Weaver had taken college classes with the idea of becoming an FBI agent.)

One FBI agent, a sharpshooting specialist named Lon Horiuchi, ended up staining the Bureau's reputation (and, some say, self-image). Early in the standoff, Horiuchi was stationed with a view of the Weaver cabin's front door.

The Weavers had placed Samuel's body in a shed to the side of the cabin. Various family members, in turns, visited it. At one point, Randy Weaver, his teenage daughter Sara and family friend Kevin Harris, visited the shed. Horiuchi, acting on orders from senior FBI agents, fired on Weaver and Harris. He wounded each man and

chased them back into the cabin, where Vicki Weaver was watching while holding her 10-month-old youngest child.

Horiuchi fired at Weaver and Harris as they retreated into the cabin. Apparently by accident, he hit Vicki Weaver, standing just inside the front door. She was killed instantly. The baby was not hurt.

Horiuchi's actions violated the letter and spirit of standard rules of engagement for law enforcement officers. He did not at any point request that Weaver and Harris surrender. He fired on them repeatedly, even as they retreated for cover and posed no imminent threat. And he fired into the open door of the cabin, even though he admitted that he couldn't see inside.

Eleven days after Vicki Weaver's death, the rest of the family surrendered to the federal authorities.

Randy Weaver was eventually acquitted of the weapons charges. However, he was found guilty of missing the original trial date and a number of bail conditions.

The Weaver family filed wrongful death lawsuits against the various government agencies involved in Samuel and Vicki's deaths. Randy received a $100,000 settlement to drop his charges; his daughters Sara and Elishiba (the 10-month-old) each received $1 million. Horiuchi was indicted for manslaughter in Idaho court; the case was moved to federal court, where it was dismissed.

During congressional testimony on the matter, FBI Director Louis Freeh characterized the Ruby Ridge shootings as "synonymous with the exaggerated application of federal law enforcement" actions.

The U.S. Constitution (and, particularly, its Fourth Amendment) is supposed to prevent these exaggerated applications.

In their defense, some of the U.S. Marshals involved in the case did seem to understand this; apparently, they had suggested waiting out the Weavers. The "elite" FBI agents were ones who behaved arrogantly. And unprofessionally. And tyrannically.

The danger in the state's monopoly on the use of coercive power is that it requires wise agents to wield it responsibly. Not all agents are wise. One excitable moron—or one determined tyrant—can ruin everything. Because there are many excitable morons and at least a few determined tyrants, the power of the state has be restrained.

Respect for an individual's property rights is one good restraint.

Chapter 5:

Basic Literacy, the Most Important Externality

Basic literacy is a legitimate externality. Just as they benefit from national security and reliable access to markets, citizens benefit from living in a place where most people can read and do math at a basic and functional level.

Imagine, again, that you are the entrepreneurial cookie baker. What would happen if, when you brought your cookies to the marketplace, people didn't understand the concept of money or how to make change? Chaos would ensue and no cookies would be sold.

Put another way: Property rights are hard to enforce if ordinary people can't read "No Trespassing" signs.

At various points, even legitimate externalities are abused, expanded and exploited by ambitious statists. The abuse done in the name of literacy is particularly galling...and particularly political. The main mechanisms of this abuse have been public sector teachers' unions, which promote an agenda of spoils-seeking, constantly-expanding budgets and little (or no) accountability. The best chance of reining in these excesses is to keep the teachers' mission clearly focused.

A free society needs its citizens to be able to read well enough to fill out a ballot and do enough math to buy groceries. Anything more—post-modern literary theory, feminist victimology, Marxist political philosophy or technical training on Microsoft network software—is an individual's business.

The state has no place mandating (or prohibiting) higher or specialized education.

America has trouble distinguishing between basic, primary learning and higher learning. And this confusion doesn't come by accident. Statists who work in the education industry (and their union representatives) spend a lot of time and money lobbying legislators

and influencing political debate so that ordinary people think higher learning is a mandatory entitlement for all citizens.

Teachers' unions and collectivist university groups ruthlessly promote their self-interested spoils seeking as a fundamental part of the commonweal. Their selfishness may be admirable in a Randian philosophical sense in terms of political gamesmanship; but it's fundamentally troubling, from a perspective that values the individual liberty of a broad population.

A side note: Collectivist trade unions are inappropriate for government employees. In the private sector, the ruthlessness of spoils-seeking trade unions is balanced by an equal and opposite ruthlessness on the part of profit-seeking capitalists and their agents or managers. In the government sector, there is no equal and opposite force. Statist managers negotiating against statist employees is a rigged game that creeps toward the unchecked growth of employee entitlement.

Occasionally, an elected official will make political gain by interrupting this creep and opposing a government trade union. Ronald Reagan did this famously (or *in*famously, to union collectivists) in the early months of his first presidential term by battling the federal air traffic controllers' union. But few elected officials have Reagan's political instincts.

Back to the *teacher's* unions. Their ruthless selfishness has left the educational infrastructure in the United States a dysfunction mess. But, in truth, the teachers' unions aren't the only cause for concern here. The mechanics of funding public schoolsh combines bickering bureaucracies at the federal, state and local levels.

The result is a public education system that produces mediocrity that would be considered failure if it were held to the standards of most private-sector product launches.

According to the 2005 edition of a widely-referenced annual study by the Paris-based free-market advocacy group the Organization for Cooperation and Development (OECD):

Among adults age 25 to 34, the U.S. is ninth among industrialized nations in the share of its population that has at least a high school degree. In the same age group, the United States ranks seventh in the share of people who hold a college degree. ...The report bases its conclusions about achievement mainly on international test scores [which]

*show that, compared with their peers in Europe, Asia and elsewhere,
15-year-olds in the United States are below average in applying math
skills to real-life tasks.*

These below-average results followed despite the fact that the
U.S. spend more money per student on public primary and secondary
education than other developed nations.

Like any statistics, the OECD's can be debated and disputed.
(In a sign that argues for the report's validity, both teachers' unions
and school-choice advocates complained about its methodology
and conclusions.) But the fact remains that the American education
system has become a wretched hash of collectivist bargaining, statist
political agendas and old-fashioned socialist scheming.

We need to look at the whole prospect of public education from
a new perspective.

The Problem: No Personal Investment

Statist primary and secondary schools fail students for various
reasons—lousy teaching, weak discipline, crackpot ideology, etc.
Some people see malice in these failings; they believe that statist
partisans within the teachers' unions actively choose selfish interests
over students'.

But there's a simpler explanation. The failing of U.S. public
schools is a pedagogic version of the tragedy of the commons. None
of the various "stakeholders" (a wretched bit of bureaucratic jargon
that includes students, parents, teachers, administrators, taxpayers,
etc.) owns the system.

No one is responsible. In this uncertainty, two things flourish:
individual failure and the state.

No panel of experts—especially none dominated by activists and
organizers drawn from institutionally decadent teachers' unions—can
create a national template for good teaching. Like most externalities,
education is public good made up of individual efforts and
experiences that defy collectivism or institutional management.

There's a tension inherent between the public and individual
elements in these externalities.

An example of this tension: In Washington state, a political
controversy related to standardized testing raged through most of
the 2000s. The federal program No Child Left Behind mandated

that states test students each year to measure how effectively specific high schools performed. Washington implemented the Washington Assessment of Student Learning (WASL) to serve this purpose.

The WASL is a general scholastic aptitude test roughly similar to the SAT or ACT; most school districts make passing the WASL a requisite to graduating from high school. It's normally given to high school sophomores; but students who fail can retake the test in their third and fourth years.

Students aren't the only ones being tested. Schools that perform poorly over a period of time are subject to various penalties, including cuts in funding.

Local teachers' unions (lead by the Washington Teachers' Association, the local version of the National Education Association) followed their normal course and resisted the WASL. They enlisted political allies in think tanks and the media to argue against the test—relying on stale talking points about how the WASL was unfair to minority groups and that schools would be forced to "teach the test" rather focus on broader educational goals.

On a corresponding path, some parents of students having trouble with the WASL were quoted in local media saying that the test focused too much on college-bound learning. They asked for a standardized test that focused on more practical knowledge.

This scenario plays to the worst fears of political adversaries of self-interested teachers' unions. The unions plot a cynical course of opposing any form of performance measurement; and they align themselves politically with know-nothing rubes who don't trust book learning in the first place.

But this analysis is mired in the petty quibbles of rival bureaucracies. The truth is that standardized tests like the WASL, implemented as part of bureaucratic "reform" programs like No Child Left Behind, are not a real cure for the institutional corruption of teachers' unions. They are merely collectivism in different colors.

Good teaching is an intensely personal and local thing. No centralized policy can answer the needs of individual students in Tacoma, Toledo and Tampa. The nation's—*any* nation's—educational circumstances are complex because individual students and teachers are complex.

The iconic mathematics teacher Jaime Escalante, who produced scores of engineers and professionals from some of Los Angeles'

toughest schools, stressed to his students the importance of *ganas*—the desire or drive to succeed. But it's hard for people to have *ganas* if they don't think they have a personal interest in a system.

How do you instill a sense of personal investment where there is none? Liberate the marketplace for education services.

Parents should have the power to choose a school that meets their children's needs. One child may really need discipline—in which case a military school may be the place to send him. Another may need to get away from members of the opposite sex. An all-boys (or all-girls) high school might do the job.

It's ridiculous that some people who support cap-and-trade programs for dealing with environmental pollution do not support voucher programs for public schools. The solutions are, essentially, the same. If choice works for so-called "carbon footprints" why does it not work for schools?

Consumer choice demands accountability from service providers. It's a hard truth of modern educational (and medical...and financial) services that providers argue against consumer choice because providers like to hide in a fog of hazy accountability.

Consumer choice also demands efficiency. If parents can choose where their children go to school, bloated bureaucracies will become less...bloated. Too many public school districts are flabby with consultants, advisors, social-justice shakedown artists, self-styled experts and semi-literate Ph.D.'s—the lampreys attached to the educational leviathan. They have to go; and they never will as long as school districts can count on captive markets.

The Solution: Real Choice

Maybe, beneath all of the political manipulations, the know-nothing rubes who don't trust book learning have a point. Maybe practical knowledge is more valuable than standardized tests appreciate. But, to apply any wisdom in this practicality, the U.S. needs to wipe away layers (and generations) or educational statism and liberate local school districts and local parents to make their own choices in school policies and programs.

And, if a local school or district screws up, local parents need to be free to move their kids away.

Americans have reasonably competitive markets to produce food, housing, clothing, transportation and most consumer goods. So, why

do Americans tolerate a centralized, planned economy for education? Because, for generations, teachers' unions have claimed that education is "different" and requires extensive marketplace controls.

This is false. Education isn't different. And it doesn't require a controlled market.

What is the alternative? Create a free market for education. Encourage consumer choice and competition among educators.

What would happen with true competition in the market for educational services, with students and parents becoming empowered consumers instead of rubes who've been cynically played?

For one thing, controversies over trivial matters like the WASL would evaporate. Parents who preferred practical knowledge could choose vocational programs that provide it. And those who valued college-bound education could move their kids to the schools with the highest average test scores.

School Vouchers

The libertarian economist Milton Friedman first developed the idea of school vouchers as a way to create free-market competition in a controlled economy. (Friedman was also one of the brains who conceived of the cap-and-trade schemes for managing pollution that environmentalists advocate so strongly, which again underscores the point that someone who supports cap-and-trade plans ought to support school choice.)

Over the years, vouchers have become a staple of politics among American conservatives—but there's no reason that the idea should be considered "conservative" or partisan. It could just as easily be labeled "progressive" or "reform."

With a voucher system, parents would have to approach their kids' schooling as customers (something private-school parents already do). They would have to decide what they wanted in education for their kids and then find it—rather than begging the state to provide it. This would make even the most addled parents more active providers of their children's education.

Who doesn't want parents to be active in the selection of education? Teachers unions. Collectives like the National Education Association are purveyors of shoddy services; and they've been spoiled by generations of markets regulated and controlled by statist education bureaucrats. The NEA doesn't want parents to have

choices because it fears they would choose non-NEA controlled educational options.

Again, some consumers would shy away from traditional college-track education. And that might be a good thing. The United States has moved away from meaningful vocational and technical education. Most of *that* training is—effectively—privatized, with employers left to teach marketable job skills to the semi-literate graduates of high schools and public universities.

Practical Effects

Schools boards bicker over false issues: teaching evolution or the content of sex education courses. This is like bread and circuses in Ancient Rome—as diversion meant to keep the people's minds off of more troubling reality.

And the American schools don't just have problems with reading, writing and 'rithmatic. They also fail when it comes to teaching students practical skills—managing their personal finances, managing a household, basic business communications.

The schools' strategy seems to be to prepare some students for academic careers…and to entertain the others until they go away.

A handful of students are prepped for achievement at the university level and the rest are left uneducated dolts. New customers for statist regimes.

In March 2008, AT&T's CEO told a group of business leaders gathered in San Antonio that his company was finding it hard to find skilled U.S. workers. A few months earlier, Randall Stephenson had folded to public pressure and agreed to relocate a customer service center that employed about 5,000 people from India back to the U.S.

But AT&T was having a hard time completing the relocation—because it couldn't find enough qualified job candidates to staff the center. Stephenson said:

> *We're having trouble finding the numbers that we need with the skills that are required to do these jobs. If I had a business that half the product we turned out was defective or you couldn't put into the marketplace, I would shut that business down.*

Stephenson said he was especially distressed that in some U.S. communities—and among certain groups—the high school dropout

rate is as high as 50 percent. He pointed out that these statistics had real, immediate effect on AT&T's hiring and location decisions:

> *We're able to do new product engineering in Bangalore as easily as we're able to do it in Austin, Texas. I know you don't like hearing that, but that's the way it is.*

Stephenson said that his company was coming up short finding enough Americans capable of filling the 5,000 entry-level customer service jobs it had promised to bring back to the U.S. from India. At the time of his speech, about 1,400 of those positions had been returned. Stephenson said AT&T still planned to reach its 5,000-job target…but he wasn't certain about how long that would take.

California Statists Attack Home-Schoolers

The most desperate way to pursue school choice is for parents to remove their kids from government schools and teach them at home.

This is a major affront to teachers' unions. These unions are an essential part of most statist schemes. In many states, the unions work in close collusion with statists in state agencies or on the bench.

A ruling by the California Court of Appeals in February 2008, held that home schooling was illegal in the State of California— unless the parents have teaching credentials.

The state court took the unusual step of warning parents who didn't comply that the juvenile courts had the power to remove home-schooled children from their homes or jail their parents.

Justice H. Walter Croskey, who wrote the decision, stated that the

> *primary purpose of the educational system is to train school children in good citizenship, patriotism and loyalty to the state and the nation as the means of protecting the public welfare.*

No, it's not! This is outrageous. Teaching children to be loyal to the state and nation isn't a school's job any more than is teaching them to believe in Vishnu or L. Ron Hubbard. An educational system protects the public welfare by giving children the tools to protect their private, *individual* welfare.

The growth of the home schooling movement is fueled by decisions like Judge Croskey's. And, in a consequence that Croskey surely didn't anticipate, this growth has made teachers unions

nervous. And they count on their allies in government to slap down the threat.

The unions count on judges like Croskey to force parents to send their kids to failing schools.

What's the cost of all this scheming? A widely-cited study written by economists Eric Hanushek of Stanford University and Ludger Woessmann of the University of Munich concluded that the costs to the U.S. economy of mediocrity in science and math education was 2.0 percent of the nation's annual GDP—or $291 billion in 2008. And, if the same mediocrity continues, the cost could be 4.5 percent of GDP by 2015. That would be over $1 trillion. Each year. All, so that preening teachers' unions can maintain their corrupt influence in state capitals.

Statists Prefer Bureaucratic Policy to Sound Judgment

The ongoing dance among Americans courts, teacher's unions and education bureaucrats defies the well-intended pieties of "school reform." Reform efforts are ground into dust by the hard combination of ambitious jurists and collectivist educators.

In June 2007, the U.S. Supreme Court decided *Morse v. Frederick*, which upheld the right of a school administrator to punish a student who displayed a "Bong Hits 4 Jesus" banner.

Libertarians hoped that the decision would be interpreted narrowly. It had been based on a 5-4 vote and splintered opinions that provided a little support for suppressing student speech. Justice Samuel Alito had taken pains to limit *Morse* to speech advocating illegal drug use. And most of his fellow justices echoed support for the older precedent decision *Tinker v. Des Moines Independent Community School District*, which confirmed students' right to engage in expressive activity that does not "substantially disrupt" school activities.

But, just a few months later, the 5th U.S. Circuit Court of Appeals extended *Morse* in a Texas case to allow school administrators to apply ham-fisted "zero tolerance" rules to threats of violence and—potentially—other subjects of student speech.

The facts in *Ponce v. Socorro Independent School District*:

- Enrique Ponce, a high school sophomore, kept a diary in which he described creating a pseudo-Nazi group, committing several acts of violence against homosexual and minority

students and planning shootings at several schools.

- Ponce described the notebook to another student, who reported it to a teacher. Ponce eventually was questioned by an assistant principal and said the notebook was a work of fiction. Ponce's mother, herself a student of creative writing, also maintained that her son's notebook was fiction.

- The assistant principal was not persuaded; he determined that Ponce posed a "terroristic threat" to other students. He suspended the sophomore for three days and recommended he be placed in the school's alternative education program.

- The assistant principal reported the notebook to the El Paso Police Department, which—following standard policy on such matters—arrested Ponce. After reviewing the case, local prosecutors declined to press charges against Ponce.

Ponce's parents sued, alleging the school district had violated their son's First Amendment rights. The trial court agreed, holding that, under *Tinker*, the school district had failed to show the notebook had caused or was likely to cause a substantial disruption.

On appeal, the 5th Circuit reversed the district court, saying it was "follow[ing] the lead" of the Court in *Morse*. As the appeals court interpreted *Morse*, the substantial-disruption standard of *Tinker* does not apply if speech "potentially foments" harm to students. Such speech falls entirely outside the protection of the First Amendment.

The court stumbled to this conclusion:

> *School administrators must be permitted to react quickly and decisively to address a threat of physical violence against their students, without worrying that they will have to face years of litigation second-guessing their judgment as to whether the threat posed a real risk of substantial disturbance.*

Here comes the inverted logic of unintended consequences: The language of the court's ruling seems to value the professional judgment of local teachers and administrators. But the effect of the ruling was to place bureaucratic policy above local judgment.

Of course, school administrators should take threats of violence seriously. But part of taking a threat seriously is evaluating it rationally and making informed conclusions. In the *Ponce* case, no evidence existed that the student intended any real violence. But the

court decision compelled schools to apply so-called "zero tolerance" rules to *any* speech about violence against students.

The threat of violence need not be credible, imminent or even possible. It need not be widely disseminated—or disseminated at all. According to the *Ponce* decision, any speech about violence against students, even if clearly fiction or fantasy, is without First Amendment protection.

And so, despite the apparent intent of the *Ponce* court, this conclusion doesn't serve the individual judgment of local authorities. It encourages adherence to rigid bureaucratic policy.

College Follies

Beyond high school, things don't get much better. The American university system has become a stone thrown around among interest groups with conflicting political agendas. Meanwhile, university administrators who should stand firmly for free speech and fearless intellectual inquiry are reduced to feckless cowards dependent on court decisions and money from the federal government to keep their facilities operating like resorts.

How warped are the politics of the American university system? Consider this excerpt from the connected 2003 U.S. Supreme Court decisions *Grutter v. Bollinger* and *Gratz v. Bollinger*—which involved race-based affirmative action admissions to the University of Michigan and its law school:

> *Race-conscious admissions policies must be limited in time. The Court takes the [Michigan] Law School at its word that it would like nothing better than to find a race-neutral admissions formula and will terminate its use of racial preferences as soon as practicable. The Court expects that 25 years from now, the use of racial preferences will no longer be necessary to further the interest approved today.*

According to this tortured logic, race-based admissions programs a bad but, because they are a short-term bad, they are acceptable.

What does this legal jibber-jabber have to do with the interest that a rational individual has in the externality of public education—namely, that all citizens know enough to pay their taxes and read enough to fill out a ballot? Not much.

College professors and federal judges share the assumption that "higher education" is a "right." It's not. It's a commodity service that

adds economic value or personal enrichment for many people in many circumstances. It's not a *right* in either the negative or positive sense of that word.

Higher education is a good thing, just as a Porsche convertible is a good thing. But, like a Porsche, the costs of higher education don't make sense for everyone. And the state has no business subsidizing the purchase of either college degrees or German sports cars.

If education bureaucrats were honest, they would acknowledge that they believe their services are a "right" because their guild subscribes to watered-down Marxist pabulum about using the classroom as a method of collectivist indoctrination.

Or maybe, if they were *really* honest, the bureaucrats would admit they believe their services are a "right" because that assures them job security and social status without having to work hard.

Functional levels of literacy and numeracy are, taken together, an externality. A college degree isn't. A law degree *definitely* isn't. Beyond fundamental functional literacy and numeracy, education is an option that should be available only to those who actively pursue it. Universities shouldn't be warehouses for young adults who don't know what to do with their lives. But that's what they've become.

Childish Politics on College Campuses

The primary and secondary education systems in the U.S. are designed as if all students should matriculate to universities. This isn't fair to the many who may not have the mental or emotional skills for higher education.

And the ones who are inclined for college need plenty of mental and emotional strength once they arrive on campus.

The political extremes of college campuses have been well documented. If you've set foot on a college campus—as a student, parent or innocent bystander—in the last decade, you have probably seen the sanctimonious self-righteousness that many teachers and administrators exhibit.

And maybe it's always been like this. Part of the college experience's charm is the ivory-tower focus that academics can give matters of small importance in the wider world. In theory, their emphasis on obscure bits of history or literary theory gives students insight into patterns of thought and understanding. In other words, the classes on Marx and Foucault are supposed to teach young adults

how intellectuals think—so that they can go out in the world and think for themselves.

The archetypal left-wing professor isn't a problem; he plays his part in an educated person's development.

But the screeching statists outside of the classroom are another matter. Administrators and college employees in the operational bureaucracies of academia are the ones who try to control other people's lives with misleading jargon and ham-fisted tyranny.

In the fall of 2007, the College of William & Mary made news when part of its Internet Web site devoted to campus social policy caught the attention of the general public.

An official college web page titled "What is Bias?" defined a "bias incident" as any "hostile behavior" including words (whether spoken or written) that were

> *directed at a member of the William and Mary community because of that person's race, sex (including pregnancy), age, color, disability, national or ethnic origin, political affiliation, religion, sexual orientation, or veteran status.*

The page—and, by implication campus policy—concluded that "harassment or expressions of bias or hate aimed at individuals that violate the college's statement of rights and responsibilities" was not protected as free speech. This seemed to suggest that any statement labeled a "bias incident" was punishable.

Sorting through the stilted rhetoric of the William and Mary web site, UCLA law professor Eugene Volokh noted:

> *William and Mary should be faulted for seemingly instituting a speech code that potentially forbids a wide range of protected and important speech—or, at best, leaving students unclear about what speech is allowed....*

About the same time, the University of Delaware was stumbling through a similar situation. A group of older students working with a handful of radical administrators and junior instructors had promulgated some ridiculous social policy in the school's name. Like many larger universities, Delaware uses a system of Resident Assistants (RAs)—upperclassmen who live in dormitories and act as counselors to younger students.

Well-meaning but feckless RAs are a standard part of the college experience. But the Delaware statists wanted to turn RAs into some mid-Atlantic version of Khmer Rouge or Stasi agents.

The statists developed a program of ideological reeducation referred to, in the University's *own* materials, as a "treatment" for incorrect attitudes and beliefs. The program required students living in Delaware dorms to parrot officially-sanctioned views on issues ranging from politics to race, sexuality, sociology, moral philosophy and environmentalism. RAs would schedule mandatory training sessions, floor meetings and one-on-one meetings with students. In these meetings, RAs would require students to repeat post-modern pabulum, including this gem:

> *[a] racist is one who is both privileged and socialized on the basis of race by a white supremacist (racist) system. The term applies to all white people (i.e., people of European descent) living in the United States, regardless of class, gender, religion, culture or sexuality.*

The program suggested that, in the one-on-one meetings with younger students, RAs should ask personal questions such as "When did you discover your sexual identity?" The purpose of the questions was to test ideological resistance and provoke prohibited responses.

Students who expressed discomfort with the questions would be "written up" in reports that the RAs were to provide to their supervisors. One student identified in a report as an RA's "worst" one-on-one session was a young woman who stated that she was tired of having "diversity shoved down her throat."

According to training materials supplied to Delaware RAs, the goal of the residence life education program was for students to achieve certain university-dictated "competencies." Among these:

- "Students will recognize that systemic oppression exists in our society,"
- "Students will recognize the benefits of dismantling systems of oppression," and
- "Students will be able to utilize their knowledge of sustainability to change their daily habits and consumer mentality."

There's a surreal quality to such arrogance and stupidity. The combination of sweeping generalizations with strict behavioral rules sounds like a parody of campus political correctness. It also sounds

like a parody of hipster radicalism from the 1960s. And like a parody of Soviet-era state propaganda. But it's not.

Someone in a position at the University of Delaware was really stupid enough to write these things—and other people at Delaware were stupid enough to agree with it.

The program required students to take actions that implied their agreement with school-sanctioned *diktat*s. They had to display specific door decorations, commit to reduce their "carbon footprints" by at least 20 percent or do advocacy work in support of the spoils claims of an "oppressed" campus organization.

In a letter sent to Delaware President Patrick Harker, the campus watchdog group Foundation for Individual Rights in Education (FIRE) pointed out the contradiction between the residence life education program and the values of a free society. According to FIRE's Greg Lukianoff:

> *The University of Delaware's residence life education program is a grave intrusion into students' private beliefs. The university has decided that it is not enough to expose its students to the values it considers important; it must coerce its students into accepting those values as their own.*

The University of Delaware is a public university, operating on taxpayer money. Using that money to coerce young adults into political action is statism run amok. As it usually does.

Eventually, media scrutiny of the Delaware indoctrination program caused embarrassment for the school. It backed away from the program, changing its *diktat*s to suggested guidelines.

Modernism Versus Post-Modernism in Academia

There's another reason college campuses The failure of Soviet-era totalitarianism (or, as some call it, "socialism") caused a crisis of faith among statists in American academia. Their ideal of collectivism had proved corrupt and unworkable. Their investment in big-government altruism was shown more emotional than rational. They were embarrassed (just like the University of Delaware was, after its indoctrination program was exposed).

They had to find new systems to believe in. And they found two: environmentalism and post-modernism. I discuss the statist refuge in environmentalism elsewhere. Here, briefly, I'll discuss post-modernism.

What *is* post-modernism?

There's no simple answer to that question. But a consensus seems to emerge around the idea that it's a political philosophy opposed to modernism.

The "post" in post-modernism is really a smart piece of rhetoric. The ideology might more accurately be called "anti-modernism." But, as any good or marketing consultant will attest, it's bad business to be perceived as "anti" anything.

Post-modernists are against modernism. But they're cagey about their opposition. So…what's modernism?

Modernism is the political philosophy spawned by the Enlightenment and embraced by most developed nations. It follows the scientific process of defining objective reality based on physical evidence, hypotheses and investigation. It advocates individualism, religious tolerance and democracy. It supports free markets.

Post-modernists are against all of this.

Philosophically, they are anti-realist; they believe that the physical universe is not definable in objective terms. They claim that the "world" is what the people in it believe. And they're collectivist; they believe that groups (based on race, gender, ethnicity, etc.) create reality based on their collective identity.

If reality isn't objective, how can things like skin pigment or chromosome mix be trusted to define reality? Well … post-modernism isn't consistent. It's chaotic; it's relativistic. And those are supposed to be its strengths.

Post-modernism has had a major impact in academia.

In literary theory, it rejects the idea that texts have objective meanings open to better or worse interpretation. It argues instead that a text is simply a vehicle for the reader to express his or her own racial, class or gender biases. And the author's.

In education theory, post-modernism rejects the idea that school should develop a student's cognitive abilities or impart factual knowledge. It argues instead that education should mold the student's racial, class and gender identity.

Post-modernism is a political philosophy designed for people who've never ventured beyond the walls of university academia. It may work—maybe—for a tenured radical who needs a world view to replace religion in his life. It doesn't work for anyone else.

But academia has a big influence on mainstream culture.

Statists Mix Education and Race

Local elementary and high school education is held hostage by selfish teachers' unions and college education is dominated by post-modern charlatans. Where's the outrage? Why do citizens tolerate the abuse of a basic externality…and the manipulation of a major cultural influence? Race.

Statist partisans have infused the externality of a functionally literate and numerate population with various racial undertones. This is crafty. The infusion allows the manipulation and abuse.

And American courts have enabled this. *Brown v. Board of Education*—perhaps the essential Supreme Court decision dealing with race in America—was, at its core, a fight over public education policy.

The post-World War II history of race and law in the United States is dominated by court decisions involving education policy. (Among these: *Brown*, the University of Mississippi integration case, *Bakke v. UC Regents*, and the Michigan law school case I mentioned several pages back.)

These court decisions focus on different fine points and aspects of race and education; but they share one common trait. They contradict one of the essential constitutional concepts embraced by the founders: States' rights.

The U.S. Constitution calls for a kind of federalism in which individual states are granted maximum independence to make their own policy on managing externalities for their residents.

Federalism and states rights are supposed to create a marketplace in which laws and policies are tested and compared. If one state makes bad policy, other states are supposed to profit. In this marketplace, individual states act as laboratories for regulation and policy. The post-World War II race and education court rulings trampled over this elegant concept.

They replaced the marketplace of ideas with bureaucratic commands from Washington D.C. This isn't how policy in the U.S. is supposed to work.

In the 1960s, statist partisans used the social upheaval that surrounded the early years of the Civil Rights movement to give cover to their power grab over education policy.

And they got an unplanned assist in this process. A motley collection of bigots and unapologetic racists hijacked the term

"states' rights" to argue against the legitimate aims of ending government-sanctioned racial discrimination. These bigots gave "states' rights" a racist connotation; and they had little understanding of how this played into the political goals of their enemies.

(This has been a larger problem for the libertarian movement, too. Bigots—racists, but also anti-gay and anti-Semitic crackpots—have at various times used classical liberal and libertarian rhetoric to worm their ways into political debates. Libertarians haven't always done enough to flush these people out. Bigots have no place in a movement that focuses on self ownership and the integrity of the individual.)

The 1960s "education policy" power grab was every bit as bad as the post-9/11 "security" power grab. And it may have been worse, since it didn't draw as much critical attention.

Is there a rational, libertarian response to more than two generations of statist entrenchment in public education?

Yes.

Vouchers for primary and high school grades. Less government financing and a smaller, more focused structure to university-level education.

Functional *literacy* and *numeracy*, not open-ended "education," are the critical externalities. Beyond basic literacy and numeracy (which we aren't achieving in all corners of America today), education is a series of choices an individual has to make for himself.

Chapter 6:

Medical Care and the Environment: Externalities? Or Something Else?

Quothe Hillary Clinton on the 2008 presidential campaign trail: "Quality health care isn't a privilege. It's a right." Barack Obama quickly cribbed the line.

Like most statists, Obama and Clinton confuse the word *right* with the phrase *positive externality*. Why the confusion? Are two of the world's best-known Ivy League law school graduates as feeble-minded as some emoting, celebrity utopian? Those who know them both insist they're not stupid. Maybe they're just cynical.

Is quality health care an externality? Are other desirable things— for instance, a pristine natural environment—externalities? In the course of answering these questions, we can reach some useful conclusions about how medical services and clean air might be delivered to Americans most efficiently.

In the previous chapter, I stated that basic literacy *is* a legitimate externality. But, before we can drill down to the details health care and the environment, we need to consider the question "What is an externality?" Other than a much-abused thing.

An externality is a shared experience or phenomenon that benefits (or harms) all members of a society at once and in a general way. Literacy is an externality. Reasonably safe food and drinking water are externalities. A reliable level of public health is an externality. Not all externalities are good things: a tradition of corruption may be an externality. A negative one.

Some externalities occur naturally, without any help or hindrance from the state. A beautiful sunset and a culture's emphasis on literacy…or on filial piety…are externalities that the state can't affect very much or very quickly. Other externalities—a reliable highway system or a *non*-corrupt legal tradition—are positive externalities that the state controls.

A specific person's supposed "right" to a specific medical procedure delivered immediately and with some vaguely-defined (or manipulatively-defined) level of "quality" does not flow from any legitimate externality. Neither does a city's coercive ordinance demanding that citizens organize their garbage.

While managing externalities is an essential (perhaps *the* essential) purpose of the state, the state isn't the only entity that manage externalities. In a perfect world, states wouldn't be necessary; individuals would form ad hoc groups—what some call "small societies"—to manage externalities. But we don't live in a perfect world.

And Americans have confused the belief that managing externalities is one of the state's central responsibilities with the belief that *only* the state can manage externalities. This is what philosophers call a logical inversion. The first belief is consistent with liberal notions that most of the founders shared; the second is anathema to them.

Defining Terms in the Medical Services Debate

Despite the insipid babbling of mainstream politicians, access "quality" medical care is neither a right nor a privilege. It's a service; and a commodity service, at that. It's something you pay a negotiated rate to purchase, just as you purchase the services of an auto mechanic, a beautician or an attorney.

Through the second half of the 20th Century and the first decade of the 21st, the United States has concocted a quasi-socialist system for delivering medical services. This hodgepodge has obscured the basic economic realities of how professional services are normally provided. Statist bureaucrats, insurance industry apologists and a burgeoning army of "health care administrators" have enabled and continued this mess, signaling one another at critical points to assure pricing inefficiencies from which they can all profit.

The solution to the question of the state's role in medicine is relatively simple. It comes down to a critical distinction: *Public health* is a legitimate externality; *individual health care* is not. The challenge to debating public policy on medicine—at least to debating it usefully— is navigating between public health and individual health care.

The "problem" with access to medical services in the U.S. has nothing to do with greedy insurance companies. It has to do with a government-created contraption by which the person buying a

service (usually, your employer) is disconnected from the person using that service (namely, you). This is a system that only a statist bureaucrat could love.

State interference—in the form of tax subsidies, managed insurance pools or direct "single-payer" government control—only muddies the matter. No matter what some eloquent charlatan says, the state will never do a more efficient job of providing medical services for you than you could do by purchasing them for yourself.

If you don't know enough about doctors, hospitals and insurance to make an informed choice in how you buy medical services, you should either: a) educate yourself; or b) pay a fee for advice from someone who knows the marketplace.

When the state becomes the centralized provider of any good or service, it is overstepping its bounds. And inefficiency follows.

If you doubt the folly of single-payer programs, look to the experience in the United Kingdom, where government-dictated waiting periods for certain medical procedures outrage citizens who believe they've been promised "free" state-run system.

If you're too lazy to click to British health care Web sites, just watch a few episodes of "Prime Minister's Question Hour" on C-SPAN. A large portion of the questions posed during that hour consists of complaints about too-long waiting periods and too-low hospital bed counts.

Some firms have taken the debate over access to medical services straight to the consumer. But they're probably not who you're expecting. Starting in the early 1990s, big American pharmaceutical companies started running ads for prescription drugs on TV and in popular magazines. Prior to that, drug ads had usually run in technical journals read by doctors and pharmacists.

Why the sudden appeal to readers of *Time* and watchers of bloviating characters like Bill O'Reilly? After all, many of the drugs being advertised couldn't be purchased without a prescription.

The answer is in the ads themselves—*Ask your doctor if Lunesta is right for you.* The drug companies were tired of shoveling money at doctors to peddle their products. So, they decided to create demand for their products among the end users.

This is what advertising experts call "pull marketing." It's something that toy companies and cereal companies use when they market to kids; they create strong enough demand for their goods

among end-users that intermediaries who are supposed to act as filters or gate-keepers have no choice but to supply the desired thing.

Applied to pharmaceuticals, end-users are the children. Physicians and (really, more so) insurance plan administrators are the parents. Big Pharma executives expect that government bureaucrats will eventually join the parental ranks, so they want to keep the "pull" strong. The makers of Lunesta want to be sure the single payer will pay for their sleeping pills.

Some consumer-advocacy groups gripe about the pull-marketing drug ads. But these gripes are mired in the presumption that medical services (which include drugs) aren't supposed to marketed to individuals because such stuff is difficult to understand.

In this sense, the ads were a breath of free-market air in the stale environs of the medical services marketplace. At least the drug companies were targeting their ads to actual end-users.

Americans need to be reminded, constantly, that medical care is a service they buy.

"Fairness" and the Nature of Medical Care

Professional services of *any* sort are hard things to buy. Prices resist easy or clear determination. "Quality" is often spread unevenly within a geographic area or a specialization, tied to factors like local facilities (universities, hospitals, etc.) or the traits of local markets.

Quality can also be tied to subtle and subjective factors like a service provider's relationships with other professionals. And *these* factors are difficult for an ordinary consumer to determine. (In this regard, the griping consumer advocates have a point.)

This difficulty rewards intelligent and aggressive consumers— people who aren't intimidated by jargon, ask a lot of questions, process information well and have good judgment about people and facilities. As a result, it may seem to the feeble-minded that buying medical services is inherently "unfair." Smart and pushy people get the best deals; the rest sit in the waiting room, confused and scared.

Welcome to the real world. Smart and pushy people *always* get the best deals. Even (or *especially*) in single-payer medical care systems.

Statists refuse to acknowledge these market realities. Instead, they argue that government-run health care will simplify the pricing problems and distribute quality evenly. There may be some merit to the first argument; setting prices for health care services will

create two things, a government-sanctioned price structure and an unregulated and presumedly fluctuating black (or maybe "gray") market. This kind of bifurcated pricing structure might be more efficient that the patchwork status quo; but it's not the solution that single-payer statists are selling.

The second argument is pure bullshit, though. A government-run medical services delivery system doesn't make the distribution of high-quality care any more even. It doesn't add any service to the commercial equation. It doesn't provide more doctors or x-ray machines—in fact, it may *reduce* the number of each to comport with bureaucratic budget goals. It doesn't guarantee outcomes that are either efficient or fair.

A quick note on "fair." In this chapter, and elsewhere in this book, I usually assume this over-used word means the "even distribution of a good or service." But different people use the word in different ways; and many people use it mendaciously.

Statists politicians often use the word "fair" a code word for redistributing wealth—to whomever they're addressing and from ... everyone else.

Statists use various other rhetorical tricks when they discuss or write about a government-run medical services market. They use obfuscating terms like "single-payer plan" and "universal coverage" to oversimplify mechanics and overestimate outcomes. They rant about inefficiency and waste in the current system, without acknowledging that much of the inefficiency results directly from the half-steps the state has *already* made into running medicine. They focus on anecdotes about individual suffering that are often overwrought…and always chosen carefully to play upon the emotions of uneducated voters.

These sob stories will still be around, even if Americans surrender to a single-payer plan; they'll simply shift in focus from the down-trodden family worried whether it has insurance to the down-trodden family waiting 18 months for little Susie's heart transplant.

The stories may change but the inefficiency and uneven distribution of medical care will stay the same.

The Politics of "Public Health" and "Health Care"

The political biases of public health officials can be hard to take; they are often devout statists, pushing collectivist agendas and blind

to any other solutions. But the role that public health agencies play in even a free society is important.

Why should a libertarian support the work of agencies that are almost always staffed with reflexive statists? Because a reliable level of public health is essential to bringing your goods and services to market.

This is a little like the difference between true tolerance and affirmation, which I've discussed in detail elsewhere. Public health—that is, a reliable level of hygiene and disease prevention—is a legitimate, positive externality. Specific, government-subsidized medical procedures are not.

It's not for the sake of the poor and oppressed that public health is important. It's not to support the stammering single mother who demands experimental therapies for her sick child. Or her 14 bastard children born through in vitro fertilization. Or the self-righteous social justice advocate arguing on the single mother's behalf. Public health is a benefit that the population in general shares.

The importance of this externality traces it origins back to the Social Contract. You trade absolute freedom in exchange for some basic assurances—including the assurance that you can bring your products to market with a reasonable belief that you won't get bubonic plague.

The Creep to Socialized Medicine Started Years Ago

"Single-payer plan" may be a relatively new phrase; but statists have been pushing the United States toward socialized medicine for decades. Through the Medicare and Medicaid programs, it's been a big part what most Americans think of as "Social Security." And it's the part of Social Security heading first toward insolvency.

Which is a big reason some statist are pushing so hard for "universal health coverage." They think they can hide Medicare and Medicaid's insolvency within the loose clothes of a larger program.

And it's not just career politicians looking to lose their troubles in the forgiving folds of federal bureaucracy. Some decision-makers in corporate America have realized that their debt loads will be lightened by a government takeover of medical services, hospital and prescription drug markets.

This is especially true of manufacturing firms with heavy pension obligations and legacy costs. Companies like the Big Three

auto makers and many of their parts suppliers have become—essentially—pension plan administrators working for labor unions.

According to General Motors Corp., $1,500 of the sales price for each vehicle it sells goes to cover health insurance costs of present and former employees. (And, truth told, GM was using that statistic from 2005 through 2009; it's likely the real cost has risen.)

You may think that "corporate America" opposes statist health plans; if so, you're wrong. A government-run "single-payer" or "universal health" system would come as a relief—and financial boon—to companies (like GM) saddled with legacy labor costs.

The great libertarian economist Friedrich Hayek wrote extensively about the ways in which corporate executives were similar to bureaucratic statists. Today's GM is final proof of his theories about the fatal conceit that all statists share.

And the boardroom statists aren't limited to staggering car companies. Insurance companies are often vilified by ambitious politicians. Self-righteous crusaders will screech something like: "The first step is to take American health care out of the hands of the insurance companies."

This is because statists (and, perhaps, all citizens—after decades of regulation and the publication of hundreds of half-wit legal thrillers) have a fuzzy idea of what insurance companies are.

Insurance companies are not sovereign nations. They aren't repositories of billions of dollars. They aren't guilds or cartels. They aren't even market makers. They don't set prices or dictate terms of payment. They collect money, manage it, pay it out—and keep a percentage as a fee. They are, by design, market *followers*.

Proof of the insurance industry's weakness is its desire to get out of its own business. Beginning in the 1990s, many insurance companies developed divisions that focused on what industry insiders called "Third Party Administration." In this new business model, the third party administrator (TPA) handles the "back office" business functions of an insurance company—generating invoices, managing payment accounts, paying bills—but leaves the risk analysis and risk-taking, the traditional heart of insurance, to its clients.

Why don't insurance companies want to underwrite medical insurance risks? Because, like the Big Three auto makers, they realize that they can't match the accountancy tricks the state uses; if they tried, their executives would end up in jail. This is yet another

example of Gresham's law: Medicaid and Medicare are the "bad money" that's pushing private-sector medical insurance coverage (the "good money") out of the marketplace.

Unintended Consequence: Fewer New Drugs

As I've noted, the best argument against the American drift toward government-run medical services focuses on the distinction between *public health* and individual, personal *health*.

Public health is largely preventive; its success is defined by the diseases, infections and outbreaks that never spread into the general population. Its metrics are fairly objective—incidence rates, disease vectors, mortality and morbidity statistics, etc.

By contrast, individual health is positive; it's about more than juts not getting sick. Individual health includes things like eating a healthy diet, exercising, getting enough sleep and keeping a hopeful demeanor. Its metrics are subjective—literally, how a person *feels*.

The justifications for government-run medicine willingly confuse these difference realms of health. Bad diets, sedentary lifestyle and substance abuse do far more damage to individuals than bad luck or lack of "quality" health care services. But the proponents of a single-payer plan hope you'll confuse those risks and responses.

The preventive nature of public health programs makes for a poor approach to individual health. Ultimately, it leads to a system in which individuals are considered helpless or unqualified to manage their own health. Instead, they're encouraged to rely on expensive professionals and exotic pharmaceuticals.

The government can pay for huge amounts of medical care; but there's not enough money in the federal budget to buy medical care that's as good as an informed individual's own health maintenance.

Through the 1990s and 2000s, a big part of the sharp increase in total cost of medical care was a wave of expensive new drugs that came on the market during those years. As they did in response to the "pull marketing" television drug ads, some statists dressed themselves in pro-consumer clothes and complained that these costs were exploitive and…here it comes…unfair.

These phony public tribunes ignore the fact that the pricey drugs were developed specifically for high-demand purposes: lowering cholesterol counts for overweight Americans, helping them sleep and relieving their stomach problems.

They also ignored the downward pressure that big retailers like Walmart put on drug prices overall. These retailers offere programs (like Walmart's so-called "$4 Formulary") that supply generic drugs for less than cost of most health insurance plan pharmaceutical co-payments.

According its proponents, a single-payer health care services delivery system would operate in a middle ground between Big Pharma's high-end products and Walmart's cut-rate generics. But, without the discipline of market competition, it's a safe bet that the government drug plan would adapt the worst of both—Big Pharma's prices and Walmart's (lack of) innovation.

Americans are accustomed to the high prices that bureaucratic inefficiency adds to goods and services. What they aren't used to is the lack of innovation that government administration usually produces. And they're *particularly* not used to lack of innovation when it comes to drugs and medical services.

A single-payer, government medical care system will cause a slowdown in innovation because less money will be dedicated to long-term medical research (currently paid for by the "unfair" prices that Big Pharma charges). The history of government programs suggests that research will quickly be sacrificed to the budget limitations of a command economy.

This gets back to the basic flaw of government-run medicine: Personal health is not merely the absence of disease (which *public health*, essentially, is). Personal health and well-being are individual responsibilities. Doctors can't assume these responsibilities. Nor can bureaucratic "experts" controlling a single-payer health care system.

Statists believe that common citizens are too stupid to take responsibility for their own health; they need credentialed experts to step in and control things. For their own good. This is, of course, nonsense.

You own you body, so you're responsible for maintaining it. Public policy and state programs have little effect on such intimate, individual qualities.

The Environment and the "Green" Movement

It's hard for me to write dispassionately about the "environmental" or "Green" movement. It is, in my opinion, one of the great frauds of the current age. A triumph of marketing that

allows consumer products companies to charge outrageous prices for products with traditionally low profit margins. But many people take this fraud seriously, so I'll do my best to consider it seriously.

Is a clean environment a legitimate, positive externality?

Speaking generally, the answer is *yes*. The natural environment meets the general definition of an externality. All of us benefit from a clean environment—that is, one that's not poisonous. And its maintenance is beyond the capacity of any one person.

But that *yes* isn't so easy to execute. As with the conflicts between public health and individual health (and as perhaps with *all* externalities), the day-to-day management of a clean environment is complicated. Some of this complexity follows from the nature of people and politics; some of it follows from the intentional mendacity of those who would manage those natures.

Said another way, there's a big difference between clean water and the Clean Water Act.

The environmental movement has done some good—helping improve the quality of the air that many big city residents breathe. But a question lingers: Have the movement's bad elements (useless recycling programs, elitist contempt for poor countries and poor people, zealotry bordering on the religious) outweighed its good? Sadly, for smug tree-huggers, the answer to that question is also *yes*. While they've done some good, their net effect has been bad. In various ways.

Delusional Radicals Want the World to Be "Pristine"

There's a significant difference between a clean environment and the "pristine" environment that radical, anti-humanist environmentalists want. As in other hot-button public policy matters (abortion, war, race), radicals define the environmental debate

In November 2007, environmental scientists from Canada's McGill University and the University of Maryland, Baltimore County, produced what they called an "anthropogenic" map of the world—which factored the density of human population into how the environment existed. This immediately met with complaint from the radical fringe of the environmental movement, which sought a "pristine" world in which *no* traces of mankind could be found.

Radical environmentalists may be the least rational actors involved in mainstream American politics. Their policy arguments

and proposals are often solipsistic and hysterical. The people themselves are notable for childlike manic emotions and—very often—the inability to participate productively in larger social groups.

As others have noted, radical environmentalists look and sound a lot like the religious fundamentalists. They are horrified when someone provides alternative views to their core beliefs.

(Scandinavian journalist Bjørn Lomborg's 2001 book *The Skeptical Environmentalist* was extremely valuable for poking holes of lucidity in the woolly-headed blanket of doctrinaire environmentalism. Doctrinaire enviro's hate him for this.)

The manifesto of these self-loathing maniacs is the so-called "Kyoto Protocol," an incoherent anti-American screed drafted in the late 1990s by some *haute bourgeois* frauds affiliated with the United Nations. The Protocol (technically, a multilateral anti-pollution treaty) was designed to punish wealthier countries with various jury-rigged fees and financial penalties that had little purpose other than to funnel money to poorer countries. Through a massive bureaucracy.

Here's an illustrative quote:

> *This sensitivity and thought differs from modern thinking, wherein humanity is at the center of all things. Quite the opposite, it reflects a notion of "transience," a perception of the uneasy and uncertain existence of humanity changing as part of nature. Let it be said this thinking was in fact behind the 1997 Kyoto Protocol, which underlined the crisis in coexistence of global environment and humankind.*

This comes from the official Web site of the 2008 meeting of the "G8" finance ministers from the most economically developed countries in the world.

The Kyoto Protocol was such a sham that Bill Clinton, normally sympathetic to multilateral schemes, refused to sign it while he was president; W. Bush wanted no part of it. But, like a ghost of collectivist venom from decades past, the treaty lingered on the political scene for years. The erratic Al Gore used it as a centerpiece of his error-filled 2006 documentary film *An Inconvenient Truth.*

The final proof of the Kyoto protocol's deluded political basis? The countries that signed the thing have polluted more, faster than the countries that didn't sign.

According to the International Energy Association, approximately three-quarters of the projected increase in carbon

dioxide emissions over the 25 years ending in 2030 will come from developing countries—with as much as 40 percent coming from China alone.

And you don't have to take their word for it. According to the U.S. Census Bureau, between 1997 and 2004, carbon dioxide emissions worldwide increased 18.0 percent. Emissions from countries that signed the Kyoto Protocol increased 21.1 percent; emissions from non-signers increased 10.0 percent—and emissions from the U.S. increased only 6.6 percent.

You'd never guess this, from the rhetoric of doctrinaire enviro's. In January 2008, some of these—based at Yale University and Columbia University—released their annual Environment Performance Index (EPI). The document toed the doctrinaire, anti-American line. It placed Switzerland and three Scandinavian nations atop its ranking of countries; and it put the U.S. about a third of the way down, below Russia and Albania.

In order to place the U.S. so poorly, the report's authors had to assemble data in mendacious ways. They manipulated the metrics so that carbon dioxide emissions counted more heavily as a penalty than water or air quality counted as credits. And, even within their crooked formulae, the statists gamed the numbers: they downplayed ozone pollution (which had improved markedly in the U.S. and other wealthy countries) and used a nonsensical measurement of sulfur dioxide which worked against the U.S.

Always eager to regurgitate Ivy League utopina pieties masquerading as science, the *New York Times* reported:

> *"We are putting more weight on climate change," said Daniel Esty, the report's lead author, who is the director of the Yale Center for Environmental Law and Policy. "Switzerland is the most greenhouse gas efficient economy in the developed world," he said, in part because of its use of hydroelectric power and its transportation system, which relies more on trains than individual cars or trucks.*

Some of the most penetrating criticisms of the EPI came from the writers at the legal affairs Web site Volokh.com. While normally occupied with constitutional and judicial matters, the lawyers and law professors couldn't resist slamming the document's faulty methodology. Jonathan Adler wrote:

...the EPI seems to be something of a hybrid, undermining the usefulness of the results as much more than a cudgel to use against U.S. policymakers for their failure to adopt more aggressive climate measures. Further, the EPI could still be subject to the criticism that its various climate measures are somewhat redundant, and ignore the impact of non-regulatory mitigation efforts.

A separate, damning fault: Esty and the other EPI authors claimed that their study emphasized human health; but this claim was inconsistent with the report's focus—which downplayed actual ambient pollution concentrations to which actual people were exposed. These problems were easy to spot in the document; it included an Environmental Health subindex. On this subindex, the U.S. scored 98.5 out of 100 and ranked near the top of the list of countries. (Practically *all* of the world's wealthy countries scored above 95 on the Environmental Health metric.)

A third significant fault: The EPI didn't account for the population growth—or even the population *density*—of the countries it ranked. Switzerland and the Scandinavia nations that topped the main index all have static or declining populations; that makes energy demand a relatively easy public policy matter.

Countries with growing populations have a harder time managing energy supplies; not only do they have to find more energy all the time, they have to build and expand infrastructure to transmit the joules and watts.

Bad Logic = Bad Law = Government Takings

The fashionable kerfuffle over so-called "carbon footprints" is based more on emotion than logic. Trivial people are drawn to making gestures, even if those gestures have little practical effect. The truth is that higher levels of carbon emissions, by themselves, don't mean much.

Some reputable climate scientists believe that the higher levels of carbon dioxide in the earth's atmosphere may be caused by increases in solar radiation, a cyclical phenomenon that reaches back, deep into geologic history. (This theory also explains periods of global warming and cooling from before human existence.)

Other scientists point out that the geological record shows that some historical increases in atmospheric carbon dioxide were *preceded*

by temperature increases and, therefore, could not have been the cause of those temperature increases.

These "alternative" theories and observations suffer from several political disadvantages to statist environmentalism. For one thing, their authors tend to be actual *scientists* bound by scientific method.

A responsible scientist might say: "The chance of virus X becoming epidemic is growing significantly. " In saying this, he is making a scientific statement. And his statement will usually (and boringly) call for further study. If, instead, he says: "Virus X is about to explode! Catastrophically! Anyone who questions this is evil. We have to stop Virus X immediately, no matter what the cost," he's rushed into areas that science doesn't support…or even address.

But more people will buy tickets to his documentary film.

Some climate scientists stumble into agreement with doctrinaire enviro's by concluding that higher carbon dioxide levels in the atmosphere have a human stamp—but then go off logic's rails by assuming that all the other tenets of radical, statist environmentalism follow axiomatically.

Radical, statist environmentalism slams together assumptions, presumptions and methods that go beyond the limits of hard science—including methods taken from history, economics and political theory. And it gives the whole thing a patina of morally-charged judgment.

Political hack work with scientific pretensions, like the Kyoto protocol and the EPI, debase meaningful debate over the role of environmental management in American politics. At least some of the proponents of these worthless documents *realize* they cheapen public discourse. They consider their actions a kind of civil disobedience; they win every time a Hillary Clinton spews nonsense about quality "health care" and pristine nature being "rights."

This nuttiness has allowed passage of laws like the Federal Water Pollution Control Act, also known as the Clean Water Act (CWA).

Some readers may be familiar with the CWA's depravities. One of the worst is little-known. The CWA started a nauseating trend in American law: It used illustrative lists rather than clearly-stated logic to define critical terms. The law's application and administrative oversight was *designed* to be left to the courts.

The CWA puts a lot of importance in the term "wetlands" but fails to define that term clearly. So, courts have defined it to mean just

about any body of water, including underground water, that occurs anywhere.

The practical effect of this feeble-minded approach to lawmaking has been some absurd government takings. In one notorious case, a private landowner was told by local environmental protection agencies that a quicksand pit on his land was a "wetland" and that he couldn't build there…or anywhere else on that parcel.

Greens and Nukes: Whatever It Is, They're Against It

In order to have a useful discussion about clean air as a legitimate externality, we have get past the thick underbrush of empty rhetoric and political posing that surrounds the topic. Maintaining environmental sustainability is in the collective best interest of everyone. The important question is: How is it best achieved? How much does it cost? What policy trade-offs does it require?

At this point, it's relevant to point out that some people consider a reliable supply of cheap, clean energy a more important externality than pristine air and water.

The radical environmentalists' doctrinaire opposition to nuclear power *and* the use of domestic oil resources enables people who hate liberty to flourish around the world.

This is yet another problem with carbon emissions as the holy hand-grenade of radical, statist environmentalism: It leads to some inconvenient conclusions.

For example: If your great goal is the reduction of carbon emissions, you will support nuclear energy. Nuclear fission power plants create practically no carbon dioxide pollution.

But nuclear power is anathema to the self-righteous priests of the Green movement.

Why? Because the waste that nuclear power plants do produce, primarily "spent" radioactive power rods, are hard to handle. The best solution is to dig very deep holes in unpopulated areas and bury the radioactive waste. This offends Green sensibilities.

Radical environmentalists killed nuclear power in the United States back in the 1970s. (Al Gore was involved in the 1994 termination of the Integral Fast Reactor program—which was based on an ultra-safe reactor that would have virtually eliminated the problem of nuclear waste through extremely efficient reprocessing.)

Today, the contemporary offspring of the Greens don't want to admit a possibility that is fraught with irony: They may be a big cause of the problem that bothers so much. Namely, political restrictions on the amount of cheap energy available to people and companies.

This is the point at which the Green movement turns from idealism to absurdity. A reasonably clean environment is a legitimate externality; radical environmentalism and the demand for a return to pristine nature are politically-biased frauds.

If you want to live in a pristine paradise, earn enough money to buy enough land in a distant enough place to live as you please. You shouldn't rely on cheap melodrama to make yourself feel superior to others—or to coerce money from naive dupes.

Chapter 7:

God *Wants* You to Be a Libertarian

If you're a religious person, you should want to live under the smallest possible government. It's the best assurance of your freedom to practice your faith as you choose.

If you're not a religious person, you shouldn't mind the belief of the faithful. And you might value the social utility that religious devotion can offer (we'll consider that in this chapter), as long as the devout don't interfere with your life as you choose to live it.

Whether you're religious or not, don't be seduced by co-religionists—or fellow nonbelievers—who talk about creating a devout—or agnostic—government. Throughout mankind's history, statist governments can't resist getting involved in religion, either endorsing it or banning it. And these two opposite responses have a lot in common.

Intense interest and intense aversion to churches both reflect the state's fundamentally competitive relationship with religion. The healthiest government policy on religion *should* be a benign detachment. Anything else makes a mess of things, both Godly and secular.

In the early part of the current century, we don't have to look very far for proof of this mess. The violence caused by the international jihad group al Queda is part of a misguided plan to create a "godly" Islamic government in the Middle East and, ultimately, the rest of the world.

You may hear politicians from developed countries talk about al Queda in secular terms as a terrorist organization. But this talk fails to appreciate the organization's distinctly religious brand of statism. In the dim minds of al Queda's suicidal pawns, bloody deaths in India, Spain, the U.K. or the U.S. are justified as means to the righteous end of restoring a fundamentalist Islamic Caliphate.

Why is this misguided (aside from the fact that Godly ends don't justify ungodly means)? Because it's cynical. Al Queda's fundamentalist zealots don't trust their orthodoxy enough to believe that reasonable people would willingly *choose* it. They believe that reasonable people have to be terrorized into accepting a new Caliphate—which will, in turn, terrorize people into faith.

This strategy isn't much different than Josef Stalin's plan to terrorize people into believing in Bolshevism. The common fault: States can enact laws and enforce them against simple crimes; but they're no good at dealing with spiritual transgression.

If you want to discourage sin, look to private dogma. Not statute.

Said another way: Do you want someone like Osama bin Laden or Hillary Clinton telling you what version of God or good to hold in your heart? They'll do it, if you give their villages the chance.

To everyone's detriment.

On the other hand, a limited state doesn't fear letting individuals find their own ways to better ends. It counts on strong families, strong businesses and strong social networks—including strong churches—to maintain societal stability. This stability follows a free market in systems of social order.

The Proper Order of Things

Religious belief can be a profound and beneficial thing. It can be a filter for making sense of life's chaos. It can be a means of seeing and understanding transcendent truths. It can encourage personal responsibility and the recognition of individual human dignity. The Judeo-Christian religious tradition has contributed great things to Western Culture as result of its emphasis on the individual person's unique relationship to God.

The Judeo-Christian tradition has also been used to justify some wretched abuses—usually when governments or secular political groups have dressed themselves in religious robes to support tactical or economic interests. Here, again, al Queda is a useful example: It uses the language and imagery of Islamic fundamentalism as cover for its secular goal of shuffling existing political power centers.

A limited state shouldn't try to compete with religion…or to enforce a particular sect…as a tool of social order. It should simply recognize religion as one—perhaps the most important—of many means of social order. In this sense, religion is more than just an

expression of personal faith. It's a fundamental element of a Social Contract on which other parts of the Contract can be built.

As long as your religion allows a separate place for secular order, your government should leave your religion alone.

One of America's historical strengths has been its tolerant approach to alternate Social Contracts. Especially in its early years, the United States assumed that churches and other non-government groups played a central role in maintaining social order. One example of this cooperation: Early states allowed religious courts to exist in parallel with its state courts. This created a sort of free market in the administration of justice, a notion that many Americans today might find troubling and strange.

America's founders welcomed competing court systems. Even competing forms of social order. These arrangements emphasized the free choice of citizens with regard to both courts and churches.

The present-day notion of inherent incompatibility between church and state reflects the statist's lack of confidence in his or her own beliefs. It's also based on some crude misunderstanding of the Establishment Clause of the First Amendment to the U.S. Constitution.

The Establishment Clause is, in fact, an important check on al Queda's Caliphate, Hillary's villages and various other self-righteous totalitarians.

What the Establishment Clause Means

The First Amendment's guarantee that "Congress shall make no law respecting an establishment of religion, or prohibiting the free exercise thereof" is not exactly the same thing as a "wall of separation" between church and state.

The "wall" imagery was Thomas Jefferson's; but it came from a private 1802 letter, not the Declaration, Constitution or any other founding document.

The founders wanted the government to keep away from religion. But they fully expected religion to shape the social order of the nation.

They were skeptical about any sort of official government involvement with churches because they knew 17th and 18th Century European history; a succession of governments in the U.K. and the Continent had used religion as an excuse for various political abuses.

In some cases, they abused polity by banning certain religions; in others, they did it by requiring government officials...or *all* citizens... to join a particular church.

Either form of coercion lead bad results.

A religion's moral authority comes from the fact that reasonable people willingly choose to believe its dogma and tenets. If a government interferes in any way with this free choice, it sullies religion's power and appeal.

The Establishment Clause of the U.S. Constitution seeks to prevent that sullying.

Polygamy, Human Rights and Religious Freedom

As I've note in other contexts, a lot of the contemporary debate over the role of religion in public life comes from confusion over *tolerance* and *endorsement*. Woolly-headed spoils-seekers say they want tolerance when, in fact, they want endorsement or subsidy.

Tolerance is a virtue. But it doesn't mean as much as most spoils-seekers think.

Some spoils-seekers are religious...and some are dogmatically *anti*-religious. And the faulty political assumptions of both sides are quite similar; they both want the state to take an active role for or against religion.

A useful clarifying test of faulty assumptions about religion is how a government deals with polygamy. In the late 2000s, polygamy arose as a public issue in the U.S. on two fronts. And the federal government didn't fare well on either one.

First, the statist-leaning "progressive" media churned out a sequence of similar stories reporting that a number (the *actual* number was hotly disputed) of American Muslim families were polygamous. As a group, these households—and, in some cases, *individual* households—included a mix of recent immigrants and native converts to Islam.

"Progressive" commentators tried to strike a worldly tone in discussing these households. They condescendingly deigned that multiple-wife households were normal in some cultures; and then they shifted gears to point out that many converts to Islam were American blacks who came from a culture of few intact nuclear families. Following this weak (and, frankly, borderline racist) logic, a polygamous family might not be so bad.

Other commentators argued for tolerance on the dubious grounds that polygamous Muslim households ask little of the state. Muslim men normally take second or third wives in so-called "nikah" ceremonies conducted by traditionalist imams. These arrangements have no legal standing in the U.S.; the multiple wives enjoy none of the rights guaranteed to legal spouses.

Of course, their extra-legal marital status doesn't preclude—and, in fact, usually strengthens—claims by the second or third wives for child support benefits *from the state*. In the eyes of the bureaucrats, the women are single mothers; and the American welfare bureaucracy is designed to serve single mothers.

Second, about the same time, the Fundamentalist Church of Latter-Day Saints (FDLS) made the news. FDLS is a radical offshoot of mainstream Mormonism that maintains the practice of polygamy in Texas, Utah and a few other locations in the western U.S. In 2008, the sect drew the government's attention when allegations of sexual abuse of young FDLS girls resulted in mass arrests of the sect's members. The tabloid media covered the story breathlessly.

Some libertarian groups defended FDLS against the overzealous law enforcement measures taken while police and prosecutors investigated the allegations, which turned out to be weaker than first thought. As odious as the FDLS lifestyle might be, sect members were badly treated by government agencies. Families were forcibly separated and children placed in state custody while law enforcement investigators fished for evidence of wrongdoing inside FDLS's main walled compound.

What's so wrong with polygamy that it elicits racist condescension from the politically-correct and jack-booted Fourth Amendment violations from the long foot of the law?

In both cases, the practice was endorsed by a non-mainstream religion, which made condescension and persecution easier.

That's unfortunate because polygamy is really bad, regardless of its religious connections. It denies the individual dignity of the multiple spouses (usually, though not always, women) and their children. Reasonable people may define "marriage" differently; but it usually involves the central notion of sanctifying…and sanctioning… procreation within stable family units. Human reproduction requires one female and one male; marriage has traditionally followed that model.

Traditional marriage has also involved some notion of moral and legal equality between spouses. This notion is aspirational; it compensates for the hard rule of nature that, while a man and woman are both necessary to conceive a child, the weight of bearing and raising that child falls disproportionately on the woman.

Most functional societies make equality between married spouses important so that the woman has some social and economic protections against being abandoned to child-bearing and -rearing hardships.

Those who would rationalize polygamy argue that it, too, gives women these protections. And it does offer some; but the protections polygamy offers second and third wives are meager stuff. And it doesn't offer them equality with their husband.

Instead, polygamy offers an often brutal social and financial hierarchy among multiple spouses and children. In these ways, it codifies *in*equality. A second wife remains second—and her children, seconds—no matter how fair-minded her husband intends to be. And children of polygamous families grow up with the message, implicit and explicit, that one husband is the equal of several wives.

Debating polygamy on moral or philosophical terms is a slippery slope that slides inexorably to stripping marriage of its traditional social meanings. And this may be one slippery slope that's worth sliding down.

The ultimate solution to debate over polygamy (and, for different reasons, same-sex marriage) is that governments shouldn't be in the business of defining, recognizing or subsidizing *any* form of marriage. It is a private, usually religious, matter.

Bad Outcomes Overwhelm Good Intentions

The defense of marriage as a state interest usually involves some form of the argument that intact nuclear families are the best mechanism for raising healthy and well-adjusted children. Therefore, the state should subsidize intact nuclear families.

Intact nuclear families are important. But confusion of tolerance and subsidy causes trouble for good intentions. Despite their rhetoric, spoils seekers are usually not satisfied with mere *tolerance* of non-traditional families; they seek the legal and tax advantages given intact nuclear families for *all* families. A race to the bottom ensures; and the only logical conclusion is to end marital subsidies entirely.

The debate over government tolerance of polygamy and other non-mainstream religious practices ultimately turns on taxes and state benefits more than on spiritual piety.

The state sends mixed signals by, on one hand, subsidizing intact nuclear families with the legal advantages of marriage and, on the other hand, encouraging single-parent households with its policies on child-welfare benefits. These mixed signals cause public policy quagmires.

The government-aid status of polygamous Muslim families came to a particularly fine point in the United Kingdom, where multicultural guidelines required welfare benefits to be given away in a "culturally neutral" manner. This supposed neutrality was not really neutral at all; it tacitly recognized polygamy and, in a fine example of unintended consequence, offered a government imprimatur to the resulting gender discrimination.

On a similar point, in the western U.S., one of the underreported aspects of FDLS was that it regularly cast out children and older teenagers that it considered insubordinate. These kids—occasionally girls, but usually boys—were abandoned to live on the streets. And, eventually, on state aid.

Why the regular dump of FDLS youth? The sect's practice of polygamy required a population with more women than men; so, the "extra" boys had to be weeded out along the way. And the group's elders were content for the government to raise these outcast children.

This phenomenon may explain the ease with which groups like al Queda recruit suicide bombers. Institutional polygamy creates legions of outcast young men who are ripe for radicalization. This is a good, practical argument against the practice; but the best argument against polygamy is that it undermines the Social Contract's respect for the personal dignity of multiple wives and their children.

Any religion or religious practice that does this is suspect. When the suspect practice also involves state subsidies (and, arguably, *all* religious practices do this because U.S. law grants tax-free status to churches) it becomes a matter of political concern.

So, this is the real issue behind the tabloid outrage over socially-deviant religious practices like polygamy: government subsidy of the practices. As with the question of what constitutes marriage, the question of tax treatment of churches forces a race to the public-

policy bottom. The best logical conclusion is the same: the state really has no place getting involved. And, in the case of the tax treatment, this means subsidies should end.

Take away their special tax status (or, truer to libertarian philosophy, *expand* churches' tax-free status to every group) and churches can be free to pursue whatever spiritual practices—profound or peculiar—they choose. The state only needs to get involved with a church's practices if individuals have been harmed or secular laws broken.

The Role of Religion in the Political World

A discussion of religion that focuses on the Establishment Clause and revoking tax-free status may seem miserly. But this is a book about public policy, not spiritual salvation; its aims are ecclesiastically modest.

Likewise, spiritual leaders should exhibit modesty when discussing politics. Attention-starved "Reverends" like Jesse Jackson and Pat Robertson aside, most do. (And, in defense of Jackson and Robertson, each has shown a sophisticated knowledge of the American political system at critical points in his career.)

The stereotype of the Elmer Gantry-style religious huckster preaching politics from the pulpit less true than atheist partisans wish. More often, secular intellectuals show ignorance of faith than the faithful show of intellectualism.

In a 2007 profile of Roman Catholic theologian John Haught, the "progressive" internet magazine Salon.com posed the stunningly ignorant question: "How can an intellectually responsible person of faith justify that faith—and even belief in a personal God—after Darwin and Einstein?"

Salon.com went on to confirm its ignorance of religion in its fawning treatment of Haught (a teacher at Georgetown University who has carved out a successful academic niche as atheism's favorite theologian).

Haught is a media-savvy guy. He's made nuanced arguments that balance trendy fields of study like evolutionary biology with middle-brow Catholic theology. He's nimbly exploited the biases of "progressive" media types that people who believe in God have never read A.O. Wilson. And he made his reputation in the media when he testified during the high-profile 2005 case *Kitzmiller v. Dover (PA) Area*

School District that ruled against teaching so-called "intelligent design" in public schools. During the trial, Haught slammed intelligent design, arguing that it was both bad science *and* bad theology.

But Haught has also slammed the so-called "new atheists" (a group that includes writers Richard Dawkins, Daniel Dennett and Christopher Hitchens). He argues that both sides—intelligent design enthusiasts and the new atheists—put too much faith in science.

Haught argues that "older" atheists (writers like Friedrich Nietzsche, Albert Camus and Jean-Paul Sartre) were more philosophically rigorous that the new breed. The older ones looked hard at the prospect that existence has no transcendent meaning; they concluded that the only logical end of this prospect was nihilism. And nihilism was an impossible basis for any Social Contract—or any productive life.

For religious people who seek libertarian polity, Haught's most useful idea is the "layered explanation." This is the idea that reality can have a three-dimensional-chess quality, with multiple truths going on at once. In the Salon.com profile, he explained:

> ...*if a pot of tea is boiling on the stove, and someone asks you why it's boiling, one answer is to say it's boiling because H2O molecules are moving around excitedly, making a transition from the liquid state to the gaseous state. And that's a very good answer. But you could also say it's boiling because my wife turned the gas on. Or you could say it's boiling because I want tea.*

To explicate Haught's metaphor: The state's perspective on the Social Contract is the water molecules moving around heatedly; faith's understanding of the Social Contract is that someone wants tea.

Teilhard and the Complexity of Existence

John Haught is useful to libertarians for another reason. (And this may, in fact, be the *best* reason.) He's a student and advocate of Pierre Teilhard de Chardin, a French Jesuit priest who wrote books on religious philosophy and was dismissed as an occultist by some critics.

Teilhard had many useful things to say about complexity. And how much difficulty humans have comprehending the complexity of existence. He was a religious man who spent his life trying to find a connection between the evolutionary character of life on Earth and

115

his Christian faith. This lead him to a belief in a cosmic evolution starting with the Big Bang and the ongoing emergence of what he called "more."

Teilhard's *more* can be seen as consciousness. But also a kind of collective consciousness that is the only complete perspective on the complexity of the universe. And, to simplify a bit, that complete perspective is God. These arguments, which Teilhard makes most effectively in his book *The Phenomenon of Man*, are obtuse at times. But they are important to a libertarian understanding of the primacy of the individual and the complexity of existence.

Many philosophers ask the question: What is the purpose of existence? Teilhard's answer is *more*—which he also describes as the intensification of consciousness. Something with which no state or collectivist apparatus should interfere.

But most try.

Haught explains Teilhard's complex notion of complexity in admirably clear terms:

> there's something about mind that does transcend, while at the same time fully dwelling incarnately in the physical universe. I see that as a microcosmic example of what's going on in the universe as a whole. … Once radiation came about early in the universe, why didn't the universe say, "Well, we're just fine here. This is a pretty good universe." Instead, there's a restlessness, a tendency of the cosmos to go beyond itself. Why does the universe transcend itself from purely material to living and then to conscious phenomena? Teilhard said that what science left out was nature's most important development—human phenomena.

This is something that statists fail to appreciate. Individual human existence is essential to scientific reality. Any scientific (or political) system that denies the essential role of the individual is built on a weak foundation.

Stalin may have justified the famines he engineered as scientific management of some unruly constituents. (He was also interested in "scientific" ideas like blending human and ape genes to breed super soldiers.) But these so-called "scientific" approaches condemned his system to moral decline.

God, complexity, intensified consciousness or Teilhard's *more* are basically irreconcilable with "science" as defined by the state. Trying to combine the two systems is folly. When 18th Century theologians

tried to place God in the physical realm that Newton and others had defined, they reduced transcendent truth to just one link in a chain of physical causes and effects. Bad move.

Atheists then concluded, logically, that God was unnecessary.

A citizen's religious beliefs, his understanding of reality and transcendent truth, are important tools that he brings into public life and even public office. But the state has no place embracing or denying these beliefs; it cheapens them when it tries to do either.

Albert Einstein is relevant in this context. The great physicist called himself a "religious nonbeliever;" he described transcendent feelings when he considered the inherent order and harmony of the universe. But he thought that the concept of a God who controlled specific natural events or intervened directly in the lives of individual humans was preposterous. (This led to his famous quote that God doesn't "play dice with the universe.")

Teilhard's God can answer prayers without violating the laws of physics. He answers prayers by creating spiritual humans and setting the universe on the path toward *more*. He exists in a realm outside of Einstein's physical laws.

The great anthropologist and writer Stephen Jay Gould called this version of God's realm and Einstein's as "nonoverlapping magisteria." In his version, both realms could influence the direction of the humans and the world—and they might even influence each other—but they wouldn't necessarily follow the same rules. Most importantly, they come together in the rule-defying singularity of human consciousness.

The relationship between church and state should be like that: Separate realms that come together, despite the limits of their own rules, in humans. That's what makes humans so special and individual dignity so important.

Backing into Church/State Conflicts

The state isn't equipped to comprehend things like layered explanations, Teilhard's *more* and nonoverlapping magisteria. When small-minded politicians and judges try to keep church and state separate, they often stumble into conclusions that combine the two in awkward ways. Result? More unintended consequences.

In 2004, the California Supreme Court ruled that Catholic Charities, the social action wing of the Catholic Church, had to

include contraception in the prescription drug benefits it offered employees—even though the Catholic Church believed that the use of contraception is a sin.

The California case was remarkable for the lack of outrage that surrounded it. Statist groups like the American Civil Liberties Union, which are normally keen about keeping church and state separate, seemed to take a pass on the case because it involved the state enforcing politically correct conclusions on a politically-incorrect organization.

This deafening silence underscores the hypocrisy of self-styled "civil libertarian" groups. Nominally, their agenda advocates freedom of religion *and* freedom from religion. In practice, they get involved more often in legal arguments that limit the role of religious expression in the public sphere.

When the state forces a religious organization to act in opposition to its core beliefs, religious liberty suffers. *All* liberty suffers. It wouldn't be a stretch for the California court, following its logic in the Catholic Charities case, to force public policy that followed a particular religious belief on nonbelievers.

The ACLU might get involved then. Following its one-sided perspective on church/state interaction, it's quick to object to any intrusion of religious expression into government policy though not so concerned with intrusion of government policy into religious expression.

But this latter conflict—the intrusion of state into religion—is what the founders meant to prevent with the Establishment Clause.

Judged by their actions with regard to religious expression, groups like the ACLU echo the anti-clerical fervor of Marxism's fellow travelers and useful idiots during the early and middle 1900s. This shouldn't come as a surprise; the ACLU was founded by Marxist poseurs and retains a sympathy for totalitarianism deep in its institutional DNA.

In a time when the government meddles in a growing portion of citizens' private lives, bent notions of "the separation of church and state" becomes a tool to suppress the very thing—free religious expression—it was intended to protect.

A case brought by the New York branch of the ACLU against the Salvation Army further illustrates this warping. The New York group argued that, because the Salvation Army had received

approximately $89 million in federal funding as a part of W. Bush's Faith-based Initiative, it had lost the right to promote its religious beliefs.

With every extension of state, there comes a corresponding reduction in the scope of private life. And this shift fairly begs more church/state conflicts. Groups like the ACLU argue that government activity—and government money—requires the complete absence of religious expression. Religious groups complain that government financing of organizations like Planned Parenthood and restriction of funding to groups like Catholic Charities or the Salvation Army amounts to an anti-religious agenda.

These conflicts were, in part, an unintended consequence of the policies of a president who called himself a devout Christian. George W. Bush's faith-based initiative was intended to use government more efficiently by channeling it to private-sector (often church-affiliated) charities that provided social services. In practice, the initiative blurred the line between state and church activities ... and gave groups like the ACLU a legal position from which to regulate religious organizations that accepted government money.

One by-product of these conflicts was the discouragement of private charity, a result that wouldn't bother the ACLU spokesperson who stammered in one TV interview that groups like the Salvation Army and Catholic Charities were providing services that the *government* should be doing.

This is a statist axiom: Voluntarily doing good is inferior to forcing people to do good, via taxation and bureaucracy.

The Inherent Tension between Church and State

Religion is an intensely personal thing. For this reason, religious freedom is inherently incompatible with a totalitarian state. So, statists respond to religion in one of two ways: banning any religious expression or adopting and perverting religious organizations.

In a free society, there's still tension between church and state; and this tension is a good thing. It keeps ambitious statists in check. On a basic level, religion and government are competitors: for money, for social status and for the claim to being the most effective tool of social good.

This church/state tension is the reason that American Christians have historically been motivated in their politics by the fear that the

state's monopoly on coercive power might be turned against them. And this fear is reasonable. As government courts of law force Catholics to fund contraception and define marriage to include same-sex couples, they move closer to penalizing or restricting churches that don't abide by their edicts.

If the federal courts can force Catholic Charities to pay for contraceptive drugs and devices, how far are they from forcing the Catholic Church to ordain women priests?

Churches should reject such meddling. And, by extension, they should oppose *other* forms of statist meddling. No matter how devout, religious groups should oppose laws against victimless crimes—statist favorites like laws against drug use, gambling, prostitution, sodomy (or other consensual acts), blue laws, anti-usury laws and seat belt and motorcycle helmet laws.

Some American churches, particularly evangelical Christian sects in the South and Southwest, looks more favorably on secular political action. These evangelicals criticize the state for permitting abortion and trying to permit gay marriage; but they believe that, if their fellow believers hold public office, the coercive power of the state can be used for good.

There's something almost charmingly naïve in this belief.

The state is no friend of religion or freedom of religious expression; it's jealous of intense personal appeal that faith can have. When church and state are combined, bad things usually happen. The Islamic nations of the Middle East and central Asia have experienced this. Their governments are constrained by Islam and Islam is reduced by their governments.

The leviathan state wants to tell citizens how they should live. Telling them how they should pray at to which gods helps this process; it makes everything else seem like minor details.

Of course, the state shouldn't try to do *any* of that.

This position follows the libertarian premise that experiencing other people transcendentally (whether through shared religious faith or any other consensual transaction) is the most important thing a person can do in this life. Consensual transactions are a physical example of transcendence and should, usually, be allowed. Even encouraged.

The best way to do this is to keep government ambitions in check. Organized religion is a useful tool in that effort.

Religion, the State and Coercion

Of course, there are limits to how that tool can be used. History is full of episodes in which organized religion becomes a tool of violence—often in the hands of statists. Bad people do use religion to oppress others. The founders wanted to avoid that.

To that end, the U.S. Supreme Court developed a religious "coercion test" in its 1992 ruling *Lee v. Weisman*. In the decision, the Supreme Court held that the prayers "bore the imprint of the state and thus put school-age children who objected in an untenable position." The test is intended specifically to prohibit "the practice of including invocations and benedictions" in public school events.

No one should stand for some local school superintendent using religious invocations to indoctrinate children, That said, the *Lee v. Weisman* decision goes a little too far. It's an example of statist paranoia over *any* religious expression in the public forum.

Atheists and anti-cleric activists often claim that their constitutional objections are not to religious belief in general but to religion in public life. However, their positions sometimes amount to a pretext for anti-religious bigotry; and, even as a pretext, it's ignorant on several levels.

First, "public life" is not the same thing as government activities, which should be only a small piece of public life. Second, the U.S. Constitution doesn't say anywhere that religion must be kept out of public life or even out of government institutions or activities.

What the Constitution says is that the U.S. government can't establish an *official* religion. All religious sentiments (including the rejection of religious belief) are supposed to have equal footing in the public forum.

Statists rarely get this point right. In the weeks leading up Christmas 2008, Washington state Gov. Christine Gregoire—whose political career defies all common sense—screwed it up famously. In an effort to placate her anti-cleric supporters, Gregoire allowed a statement of atheist beliefs to be posted in the state capitol building, alongside the creche, menorah and other holiday symbols.

This wasn't the stupid part, yet. The atheist statement read:

There are no gods, no devils, no angels, no heaven or hell. There is only our natural world. Religion is but a myth and superstition that hardens hearts and enslaves minds.

Some religious people walking through the capitol building were offended by the statement, which was surely its purpose. A handful of radio and TV talk show buffoons got wind of the atheist sign, ginned up calculated outrage and created a controversy.

Then Gregoire's dull colors showed through. She issued a poorly-written press release, full of pseudo-legal jargon, that defended her policy of "allowing individuals or groups to sponsor a display regardless of that individual's or group's views." (Notice the plural/ singular agreement problems in the phrase; the whole statement was like that.)

Sensing a moron at the ship of state's helm, various groups rushed to sponsor displays. Most of there were sarcastic, culminating in an application to erect a Festivus pole in the capitol. (Festivus was a made-up holiday from an episode of the TV comedy *Seinfeld* which lampooned the competitiveness that some people exhibit during the holiday season.)

Not getting the joke, Gregoire's staffers started reviewing the applications. Finally, alerted by local media about the jokes that some of the applications were playing, Gregoire made an about-face and said no new applications for holiday displays would be reviewed.

You *Can* Be a Religious Libertarian

A common misconception about libertarianism is that it's inherently antireligious. That's not so.

Statist efforts to manage religion, either by banning it or requiring it, usually erode religion's metaphysical integrity. The best relationship between state and religion is respectful distance.

America's founders knew this. They—and rationalists of all sorts at that time—were focused on protecting religion from government, not government from religion. They had vivid experience with states trying to co-opt religion in order to shore up their authority.

The United States enjoys freedom of religion because the Constitution clearly says, "Congress shall make no law respecting the establishment of religion." So, government should do nothing that could be seen as an endorsement of a particular religious creed.

The founders never intended that government officials police against the religious expression of Americans. They simply wanted to ensure that the government did not force any particular religion *on* the people.

The libertarian approach to religion is to trust every person to find his or her own metaphysical beliefs…and reconcile those beliefs with citizenship. It is not frightened or intimidated by the prospect of fellow citizens practicing religion. Or abstaining from religion completely.

So a libertarian doesn't need to panic at a team prayer before a high school football game or a benediction during a graduation ceremony. No one will suffer lasting harm by hearing a few reverent words from a minister, priest or rabbi.

There's something else, though, that does test a libertarian's patience for mingling church and state: so-called "faith-based initiatives."

Faith-based initiatives and the faith-based organizations that carry them out have been described by partisans on the American Right as a cost-effective alternative to the delivery of social services. These arguments are designed, in part, to appeal to libertarians; they defend faith-based initiatives as a kind of privatization. And faith-based organizations (often called FBOs) as a private-sector version of public-sector agencies.

The idea is that private groups with religious ties or orientations can deliver social services more efficiently than massive, centralized bureaucracies. Sounds good.

But the hand of the state is corrupting, with conflicting interests and scores of unintended consequences. At best, FBOs are a mixed proposition; at worst, like the Islamic nations, they diminish both church and state.

FBOs aren't particularly new. They played a small role in Lyndon Johnson's Great Society federal power-grab. Ronald Reagan thought well of them. But, as the federal government has gotten in worse financial shape through the 1990s and 2000s, "faith-based" has become a more popular phrase at the White House and in the halls of Congress. George W. Bush was a big supporter and, to the distaste of some his supporters, Barack Obama has described a big role for FBOs in his domestic policy plans.

But it's not clear that FBOs really are more efficient than government bureaucracies. Bush's first director of the Office of Faith-based and Community Initiatives, Pennsylvania academic John DiIulio, resigned unexpectedly after less than a year in the job. He didn't say much about the reasons for his sudden departure (DiIulio

is a deep thinker on crime prevention and other policy matters—and apparently a discrete man). But he did say this much to the Cox Newspaper syndicate: "I hate the nonsense that goes on here. We had every possible criticism from every possible side. Left, right, all sides."

There was much speculation for a short time in Washington about the "real reasons" that DiIulio had left. Few of the dedicated statists there could understand the problem that an outsider would have with bickering bureaucrats who would rather have meetings that get anything accomplished.

In DiIulio's case, it seems that the statist interests of the W. Bush administration had consumed the private-sector focus that the FBOs might have given their mission. A triumph of politics.

Faith-based initiatives remain an intriguing idea that the statist establishment can't use well. They're a microcosm of all the problems that come up when church and state mix. Statists either try to exploit religion or recoil from it in overwrought horror. There's no balance, no wisdom…no humanity…in either response.

Jesus Christ put things in better perspective when He said: "Render unto Caesar that which is Caesar's. Render unto God that which is God's." Nonoverlapping magisteria. Two different realms that a rational person should be able to keep in his mind at the same moment (even if he has questions or doubts about the godly realm).

A libertarian should be able to do that.

Chapter 8:

Money, Currency and Taxes

Step back into the shoes of the entrepreneurial cookie baker. You had some success; you've built up pretty good regional distribution, hired a good core of employees and keep getting rave reviews for your product.

Big, national retailers are interested in your baked goods—but meeting their orders means serious expansion. Which requires serious money. But the economy isn't doing so well. The nation's in the midst of recession.

Your local bank, which has helped with some financing, can't raise the millions of dollars you need to go national. And the regional stock brokerage with which your local bank has a relationship isn't looking for new "corporate finance" clients until the economy turns around.

Your contact at the local bank suggests that you get in touch with what he calls "hard money guys." These turn out to be venture capital lenders from big cities on the coasts. Your first couple of phone calls with them don't go very well. The VCs are full of fast talk about points and EBITDA and equity escalators. They sense your hesitation and don't like it.

You call your lawyer, who says "in this economy" you should just keep doing what you're doing; stay regional and wait for the big money players to come to you. You see the wisdom in this advice. But you can't shake the feeling that you're missing your best opportunity to make it big.

Debt Is Debt...and It Means Something

The United States is a debtor nation. And not a humble one.

The rest of the world holds more IOUs from the United States than the U.S. holds from the world; and most of the rest of the world

lives less richly than Americans do. The countries that loan money to the U.S. (and, in the late 2000s, those include China and several petroleum-rich Arab states) do so because their governments think that the loans assure their access to U.S. markets. That access allows them continued economic growth.

This strategy won't work forever.

Markets, and especially capital markets, seek efficiency. At some point, it won't be efficient for states whose citizens have a lower standard of living to finance a state whose citizens have a higher standard of living. Either the citizens of the lending countries will revolt or, more likely, global capital and currency markets will make the loan strategy unbearable. These pressures will be too much for even the most powerful tyrants or oligarchs to resist.

The only way to fix this trend in the long term is for Americans to spend less than they earn and save the difference. That savings will, ultimately, allow the state to repay its debt.

But U.S. monetary policy—formulated and primarily implemented by the Federal Reserve—has been to keep interest rates low as a means of preventing or minimizing the effects of economic recession. It's a kind of short-term cheat that keeps things heading in a bad direction.

Low interest rates discourage people from saving. But low interest rates alone aren't the reason Americans don't save. There are cultural reasons. For some 50 years, and particularly since the 1980s, the United States government has followed economic policies that are dishonest and arrogant. It has used its position an economic superpower to create and exploit disequilibrium in the world capital markets.

This isn't something to get angry about. Arrogant and dishonest monetary policy is the logical conclusion of statism. Greedy statists often think that they can outmaneuver the money markets. But the statists are never as smart as they think; and their supposedly brilliant economic strategies usually boil down to a single tactic: debasement. Running down their currency to create inflation that makes their debts relatively cheap.

The dollar fell by almost 50 percent against the euro during the years that George W. Bush was president. And, if W.'s Middle East policy is any indication, the United States responds to this collapse in its currency by hiring itself out as the world's rent-a-cop.

In the late 2000s, the U.S. is in the position of having to borrow from Europe, China and Japan to defend…Europe, China and Japan (or their access to Middle East oil). And the U.S. borrows from Middle East oil monarchs to neutralize Iraq and Iran as threats in their region.

All the while, the dollar drops in value.

Debasement is a debtor's game. It seems easier than actually saving and repaying debts. But it undermines the foundations of a nation's economy. And even its culture.

The people who are hurt worst in the recessions or depressions that result from debasement are those who have the least to start with. So, statist politicians who claim that their tricky financial games are designed to help out the poorest citizens aren't telling the truth.

The important thing to remember is that we don't have to *do* anything to right the economy. It's really just one massive marketplace…and will correct itself when disequilibrium occurs. The public policy question a rational libertarian should ask is: What can the state do to help the economy move efficiently?

The answer is usually some variation on "stay out of the way."

The Subprime Mortgage "Crisis"

The U.S. recession of the late 2000s started with a so-called "crisis" in what was euphemistically called the "subprime mortgage market." This market serves as a useful lesson about the bad effects of statist monetary policy.

What is the subprime mortgage market? There's no one answer to that question. Subprime mortgages include various kinds of home loans: loans with interest rates higher than twice whatever the prime lending rate is at the moment; loans whose payments cover only the interest owed and never repay any principal; loans whose payments *don't even cover* the interest and therefore increase the principal amount owed over time; loans equal to or greater than the appraised value of the underlying property; loans whose interest rates adjust on terms unfavorable to the borrowers.

The common thread running among all of these loans? They are designed to appeal to borrowers with poor credit and a weak sense of financial consequence.

During the 2000s, these loans became commonplace. Even people with not-so-bad credit agreed to the bad terms—usually

because real estate prices where they lived (or where they were buying investment property) were rising so quickly that they couldn't qualify for conventional loans. And they figured they'd make money despite the bad deals.

And some people seemed to live off of the fast appreciation. They could refinance property…and refinance again…taking out cash each time. And they'd spend the cash on everything from travel to Sony Playstations to extended time off between jobs.

This happens a lot during the late stages of bull market or during a market bubble. People appear to be "making" money when, in fact, all they are doing is borrowing against assets.

You don't "make money" by borrowing against assets. You make money by creating value—and paying off any debts that your assets secure.

Who was responsible for the bubble and eventual collapse of the easy-credit, subprime mortgage market? Lots of people:

- lenders who have lent money to people so they could live above their means
- people who bought into thinking they could live above their means
- brokers who were living off of the idea that the market will always go up
- sellers who thought they would be able flip houses for fast profits every few years.

This started in the 1980s, when Americans' perception of real estate shifted from a uniquely personal long-term investment to a short-term speculative bet. All parties are to blame—buyers, sellers, real estate brokers, appraisers, lenders—they all got hooked on "turning over" one's house every few years.

The late 1980s and early 1990s saw the passage and refinement of various government "reforms" designed to subsidize home ownership among Americans. Individual home ownership is a noble goal, taken by itself. But government policies don't operate in vacuums. The effect of the housing-friendly policies was to signal to the capital markets that the U.S. government was "guaranteeing" mortgages (although this was true only in a very few cases). Housing prices soared; the building and construction trades flourished.

About the same time, most U.S. banks adjusted their business models away from making money by collecting interest on loans

and toward making money by charging fees for transactions. The new business model changed the nature of the banking relationship; bankers were no longer conservative trustees of wealth. They became fee-seekers, little better than drug dealers whose "product" was debt. Rather than acting as gatekeepers, bankers encouraged transactions— repeated refi's, home equity-backed lines of credit, services like overdraft protection.

All of these things made borrowing easier and saving less likely.

If they considered macroeconomic effects at all, most bankers seemed to believe that the federal government would clean up whatever mess followed. In the meantime, statists in the federal government followed a pattern of promoting "reforms" that caused "crises" that required more and broader "reforms."

This is a destructive cycle that Ludwig von Mises and Friedrich Hayek each, separately, predicted would be the final result of statist economic programs.

It's worth noting that the destructive cycle turned through numerous presidential administrations aligned with both major U.S. political parties. Its foundations reached back to Ronald Reagan and even Jimmy Carter. Its early stages occurred during the elder George Bush and Bill Clinton's terms; its late stages, during the younger George Bush's. Both parties supported the cycle.

And both parties supported Alan Greenspan as Chairman of the Federal Reserve. Greenspan was central to the continued easy-credit monetary policies.

The Bubble Bursts

Along the way, there were signs of trouble coming. Reforms of government investment regulations passed after the collapse of Texas-based Enron Corp. chased many investors into the loosely-regulated world of hedge funds. The federal government bailout of Connecticut-based Long-Term Capital Management encouraged moral hazard among hedge fund operators. They believed that losses didn't matter because the Feds would step in during any crisis; so, the hedge fund guys made riskier investments.

With banks moving away from holding onto loans, hedge funds stepped into the business of collateralizing groups of mortgages. This meant buying mortgages from originating banks, slicing and dicing them into investment-grade pieces and selling them to

individual investors. (Many of these investors were from outside of the U.S.) It was a swashbuckling, private-sector version of the collateralizing that the government-sponsored entities Fannie Mae and Freddie Mac did in a more limited way.

To most investors, the collateralized mortgage securities carried an implicit version of the explicit government guarantee Fannie Mae and Freddie Mac enjoyed. But this assumption was wrong.

Trouble finally arrived in early 2007. Several swashbuckling hedge funds (including two managed by the Wall Street investment bank Bear Stearns & Co.) that had been collateralizing mortgages made by some swashbuckling loan originators (including California-based New Century Financial Corp.) started having cash flow problems.

Borrowers were paying late and getting into default. The hedge funds had figured on *some* defaults when slicing and dicing the loans; but the early 2007 problems were greater than projected. And the cash flow pains spread quickly through the system.

This is an underappreciated side-effect of debt (or "leverage" in Wall Street jargon): The debtor has little margin for error. Lenders expect money to be repaid promptly and reliably. Delays or shortfalls—let alone defaults—cause panic. And penalty. And failure.

The Bear Stearns hedge funds stopped buying New Century loans, which caused the mortgage company's cash flow to dry up. New Century's executives looked around for other collateralization services…or short-term loans to keep their doors open. They couldn't find either. In April 2007, they announced that they would be filing for bankruptcy protection.

Some effects were immediate. Even though New Century had been a niche player, specializing in loans to poor credit risks buying homes in pricey markets, other financial institutions treated it like a canary in coal mine. Its death was a sign of more deaths coming.

Lending dried up everywhere. People (and companies) with sterling credit, operating in locations far from California, saw loan applications denied and existing lines of credit reduced or cancelled.

Other effects took a few months. The broader economic ramifications followed through the fall of 2007 and early 2008. Housing prices fell. Spending slowed. Companies laid off workers. These were the expected sign of recession.

But there was more afoot. People working in the financial sector spoke ominously of collateralized debt obligations, debt swaps and

structured investment vehicles—exotic derivative securities that banks and other financial institutions had been buying and selling as a kind of insurance against mortgage defaults. As some mortgages started to default, it became clear that the derivatives were so complicated, no one was sure whether or how they were supposed to work.

What *was* clear was that the CDOs, SIVs and other tricky derivative investments were losing value. Fast. And, in some cases, completely. Banks and financial institutions (including Fannie Mae and Freddie Mac) were stuck with paper losses in the billions. And tens of billions. Some of the derivatives required payments to other firms…and the banks or hedge funds holding the things didn't have enough cash on hand to cover those obligations.

The banks appealed to the Federal Reserve for help. New chairman Ben Bernanke (who'd replaced Greenspan in February 2006), had already been keeping interest rates low. In this way, he was following Greenspan's strategy of using a gradual and indirect debasement of the currency soften other bad effects. But, in early 2008, he needed to do more.

His plan was to start printing money (hastening the debasement of the dollar) and giving it to banks. Here's an excerpt from a Federal Reserve press release from late March 2008:

> *The Federal Reserve announced it will auction another $100 billion in April to cash-strapped banks as it continues to combat the effects of a credit crisis. …The central bank said it would make $50 billion available at each of two auctions, on April 7 and April 21.*

Through the end of that March, Bernanke had provided $260 billion in short-term loans to commercial banks through the "auction" process. The Fed had also employed Depression-era provisions to provide money directly to investment firms that weren't, strictly speaking, banks. These actions drew criticism— rightly—that the central bank, and ultimately U.S. taxpayers, could be financing a bailout of Wall Street firms that had engaged in ill-advised lending and investment practices.

The Statists Step In

This would be moral hazard all over again: Risk takers insulted from the effects of their bad decisions by subsidies coerced by state from citizens.

The term "bailout" would get heavy use through 2008.

Just as New Century's insolvency became public knowledge suddenly, the effect of the exotic mortgage derivatives on Wall Street firms grew urgent quickly. Treasury Secretary Henry Paulson (a former head of Wall Street investment bank Goldman Sachs) became the point man for the financial industry's appeal to congress. Unless the U.S. government made more hundreds of billions of dollars available—immediately—a massive financial crisis would follow.

And, not only did the money have to come quickly, it couldn't come with any strings attached. Paulson had to be free to dole out the cash as he deemed necessary.

No person, no agency, no court could question his decisions.

To justify these demands, Paulson and his staff used some of the tactics the Bush administration had used in the days after the 9/11 terrorist attacks. They spoke ominously about what would follow if their terms weren't met. And, just as after 9/11, congress followed the Bush administration's lead. To appear to be doing "something," it voted to borrow over $800 billion to fund a Troubled Asset Recovery Program and gave Paulson most of the conditions he'd demanded.

The result was a Treasury Secretary that financial media outlets dubbed "King Henry." They did so with some reason. Paulson's demeanor during congressional testimony was haughty and demanding. His characterizations of the financial-services marketplace showed a contempt for ordinary citizens. He infamously decreed that subprime borrowers would "become renters again" when the mortgage market finally stabilized.

This analysis was probably correct, in fact. Mortgage borrowers who'd put no money down or taken interest-only loans—or *both*— were little more than renters, anyway. But the tone of Paulson's voice was the objectionable part: He sounded like a medieval lord deigning to discuss the fate of his serfs.

A better man would have focused on the market forces that needed to reach equilibrium again. People and banks needed to treat home ownership as a long-term investment, based on reasonable down payments and established means of servicing the debt load.

A better man would have pointed out that government efforts to subsidize home ownership, which sounded reasonable in congressional committee meetings, had confused market signals and encouraged the real estate bubble.

A better man would have noted that rational decision-makers look for market signals from market-leading institutions. Said another way: It's understandable (not *good*, just understandable) that ordinary people signed questionable loans—because they trusted banks' assessments of what they could afford.

King Henry wasn't that better man. No visionary. He was, as his background suggested, a highly-paid process manager. A corporate bureaucrat. A Bismarckian sausage-maker. He believed that what was good for Wall Street firms would be good for America. As congress was approving the TARP bailout funds, Paulson was changing his strategy. The original plan had been that he'd use the money to purchase exotic derivatives that the government would hold until the economy recovered (and, in theory, the derivatives had regained some of their value). But he changed his focus to buying shares in troubled banks; this would give them capital and prop up their share prices.

It would also make the U.S. government an active investor in financial institutions it regulated.

There were some voices that questioned Paulson's corporate statist approach. They argued, instead, that any bailout or economic stimulus efforts should focus on consumers rather than institutions. In February 2008, the governor of a big East Coast state published an opinion column in *The Washington Post*. The piece claimed that a Wall Street-friendly regulatory environment had enabled and encouraged the subprime lending crisis. The governor drew on his experience as a crusading prosecutor to blame institutional corruption at regulatory agencies like the Office of the Comptroller of the Currency:

> For 140 years, the OCC examined the books of national banks to make sure they were balanced, an important but uncontroversial function. But a few years ago, for the first time in its history, the OCC was used as a tool against consumers. ...In 2003, the OCC invoked a clause from the 1863 National Bank Act to issue formal opinions preempting all state predatory lending laws, thereby rendering them inoperative. The OCC also promulgated new rules that prevented states from enforcing any of their own consumer protection laws against national banks.

The governor who wrote this criticism of statist compliance with predatory lending: New York's Eliot Spitzer. Within a few months,

his regular use of high-priced prostitutes would become public, ending his career in public office and blunting his populist criticism of federal bureaucrats.

How the Fed Works—and Why That's Bad

A libertarian shouldn't be surprised at the involvement of corporate and government statists in both the causes of and supposed solutions to the 2007-2008 subprime mortgage "crisis." The U.S. Treasury Department has been favoring New York money-center banks since the days of Alexander Hamilton.

But the real wrench in the free working of U.S. capital markets is the Federal Reserve.

The conventional wisdom among libertarian economists is that central banking is merely the modern method by which governments continue their traditional policy of debasement—using inflation as a means of public finance. The government prints money and spends it. The result is price inflation.

In 1913, Congress passed the Federal Reserve Act, creating the Federal Reserve System and granting it power to control interest rates by increasing or constricting the supply of money. As a result, interest rates, at least in the short term, are controlled by the Fed.

The Federal Reserve System is made up if 12 regional banks (sometimes called, inexactly, "branches"). Each regional bank is a separate corporation; its stockholders are its member banks, who must join. The member banks' ownership of the Fed is often described as "quasi" or nominal. Why? Because owning stock in a Federal Reserve regional bank doesn't provide the usual benefits of equity ownership.

Federal Reserve banks aren't like ordinary corporations. Member institutions own shares equal to 3 percent of their capital and can't buy or sell shares that would alter that ratio. Members also can't do anything to encumber those shares—like pledging them as collateral for loans, etc. With ordinary corporations, the board of directors decides if and when to pay dividends on common stock—based in part on how the company performs during a given period. But Federal Reserve banks fix their dividends at 6 percent per year. Any additional profit goes to the U.S. Treasury.

There are seven members of the central Fed's Board of Governors, each appointed to a 14-year term by the president of

the United States. The Federal Reserve chairman is appointed by the president and approved by the U.S. Senate for a four-year term.

So, the Federal Reserve is capitalized by private-sector member banks...but run by the federal government appointees. Why would the private-sector banks agree to such a tortured system of central banking? Because it gives them government backing without direct government supervision.

To be sure, the Fed exists in a gray area between the private and government sectors of the economy. This allows it to draw on the best aspects of each sector—or, according to some libertarian critics, the worst.

Money, Money, Money

Just as it exists in a gray area between private-sector banks and the government, the Federal Reserve operates unusually ... according to rules that seem to be of its own making.

The language of the Federal Reserve Act implies that lending money to member banks at favorable rates would be the main mechanism of the U.S. government's monetary policy. However, that tactic has long since been superseded by so-called "open market operations"—the purchase and sale of government bonds by the Federal Reserve.

The Federal Reserve Open Market Committee directs these transactions. The Committee is made up of the seven members of the Board of Governors and five regional Fed presidents. The president of the New York Federal Reserve is always on the Committee; the other four slots rotate among the other 11 regional presidents.

When the Open Market Committee sets a target for the Federal Funds rate, it is also determining the primary and secondary credit rates for loans made by Federal Reserve banks.

The Fed also controls the money in your wallet. Literally. It is the entity that issues Federal Reserve notes, though it doesn't actually print currency; it contracts with the U.S. Treasury Department to handle that.

This arrangement between the Fed and Treasury is often (and inexactly) compared to the relationship between you and whoever prints the checks that you use with your checking account. The process and cost of printing the checks don't have much to do with

the balance in the account…and whether the checks will be valid when they are eventually used.

From a statist bureaucrat's perspective, this decentralized approach to printing money has certain political advantages. Chief among these: It obscures the ultimate responsibility for monetary policy.

Federal Reserve accounting is a little counter-intuitive. The Fed counts Federal Reserve notes (that is, currency) as a liability. Technically, it's a debt of one of the regional Fed banks.

This method of accounting made more sense back in 1913, when the Fed was formed. In those days, the United States currency was on a gold standard; the Fed was obligated to redeem its notes on demand with lawful U.S. money—mostly gold coins or gold (or silver) certificates. Since Richard Nixon took American currency off of the gold standard in 1971, the Fed no longer has to pay off its notes with…anything. This is why some limited-government advocates, gold enthusiasts and persnickety economists call today's dollars "fiat money." It's not redeemable in any real commodity; it's only valuable because the government says it is.

Still, the Fed continues to account for the notes as liabilities.

This doesn't make sense by generally-accepted accounting standards. While the Fed accounts for its notes as liabilities, the U.S. government guarantees them. Fully. If a Federal Reserve bank were to fail, the U.S. government—specifically, the Treasury Department— would pay off the outstanding currency.

So, in this critical way, the relationship between the Fed and Treasury is *not* so much like the one between you and the company that prints your checks.

When the United States left the gold standard, there was no longer any possibility of the Fed defaulting on Federal Reserve notes, so the government guarantee became meaningless. In theory, the Fed should have started accounting for dollars differently; but it didn't. Federal Reserve banks still pledge collateral for Federal Reserve notes.

The Statist Cycle

Why do libertarians complain so much about the Federal Reserve? Many people accept the fact that most developed nations have some form of central bank—and that the Fed is simply America's slightly complicated version of that.

The libertarian distrust of the Fed is based, in part, on its neither-fish-nor-fowl status as a privately-owned entity that does the government's bidding. There is something inherently cagey about the Fed's form…and, therefore, its role in American government and economy is difficult to monitor. It's difficult to explain.

Abuses and decadence are more likely to follow when ownership and control of a powerful institution are not transparent.

The Fed's cagey institutional decadence was on display during the big bailout of 2008. Chairman Bernanke supported the government's emergency plan, giving the Treasury Department what many people considered an "impartial" endorsement.

Of course, the Fed isn't impartial to the Treasury Department. The two are intimately intertwined.

But the big bailout proceeded, merely the greatest in a decades-long line of U.S. government intervention in capital markets. The second half of the 20th and early years of the 21st Centuries have seen what might be called a statist cycle in American economic policy.

The government uses the Fed to finance part of its deficit by creating money and spending it. The process is slightly more efficient than the ancient practice of melting down silver coins and mixing in lead but it's essentially the same.

For example, in 2003, the Fed increased the stock of Federal Reserve notes by $42 billion. That's debasement. Some economists and most politicians might argue that the Fed *created* $36 billion for the government in 2003 (the $42 billion change in the monetary base minus the $6 billion it cost to operate the Federal Reserve system that year). In fact, this "creation" didn't represent any real increase in assets of values; it was just a jump in the number of dollars printed. It was inflation, created by the Fed's debasement of the dollar.

That's a useful way to think of the Fed's role: It uses debasement to manage inflation. And, intertwined as it is with the political interests of the federal government, the Fed doesn't always manage inflation well.

Some quick history. The Fed inflated steadily through the 1920s and then, when the economy got in trouble in the early 1930s, it pushed hard to inflate out of that jam. Instead, the U.S. got deflation, anyway—a by-product of factors other than Fed policy. The public lost confidence in the banking system and fled to more stable forms of money (read: gold).

The volume of dollar transactions fell and so did prices, generally. The monetary contraction produced deflation; in a vicious spiral, deflation produced worsening depression.

Libertarians (and honest economists) believe that inflation is more than just an economic variable. Since it erodes the value of privately-owned assets, inflation is a subtle form of coercive taking by the government.

Governments invariably stumble back to the cycle of debasement and inflation because it is a politically-easy alternative—a third option to tax increases and budget cuts.

Statists will choose this third option first, whenever they can. And the Fed is their mechanism for pursuing it. We saw the pursuit in 2008 and 2009, in the consistent actions of the nominally conservative Bush administration and the nominally liberal Obama administration. This third option chosen first needs to be eliminated.

How do we reform the system? Can we disentangle America from the statist cycle? Is it possible to get the government out of the banking system—and *truly* privatize the Fed's operations—without inviting inflation or economic instability?

It may not be possible to do this during prosperous or even ordinary times. When business is good, citizens lack the political will for real reform. Change is possible when trouble's afoot. The statists of the FDR generation used the Great Depression to change America's approach to the economy. There was a chance, in the panic of 2008, to get America off of the statist track. That didn't happen. It may take another, bigger panic reform the Fed so that operates with greater transparency…and manages inflation and debasement more carefully.

This is a hard job that will require exceptional political circumstances. The allure of the statist cycle is strong.

One of recent history's great ironies is that, during much of the statist cycle's maturity, the chairman of the Federal Reserve was a professed libertarian and follower of Ayn Rand. What will historians decades from now make of Alan Greenspan? His management of Fed policy seemed to follow the predictable statist strategy of debasement of the dollar and the U.S. economy in general.

Greenspan's defenders argue that he did the best that anyone could to prevent the statist impulses of the various presidential administrations with which he worked. But a more accurate analysis

might be that he enabled, rather cynically, what he surely knew was an inevitable decline. He was the father (or, depending on your age, grandfather) figure who talked tough about responsible behavior …but kept giving the kids the keys, no matter how many speeding tickets they got.

One major point in favor of this analysis is the cryptic language that Greenspan preferred during his term as Fed chairman. Reasonable people acknowledged this cageyness. They looked forward to his post-Fed career, when he could speak more candidly about the economy. Sadly, Greenspan's post-Fed talk and writing haven't been any clearer.

The 2008 "Stimulus" Package

Greenspan oversaw the economy that collapsed in 2007 and 2008. But he left it to others to respond to those problems.

His immediate successor, Ben Bernanke, didn't have to the influence among Wall Street types that Greenspan had had during his tenure, Bernanke couldn't move the capital markets with a few vague remarks. So, Bush Treasury Secretary Henry Paulson steeped into the lead position on the government's response.

This response was a "stimulus plan" that included the direct bailout under the TARP, as well as a cash "tax rebate" to taxpayers and various other statist parlor tricks. The mere promise of hundreds of billions of newly-printed dollars available to troubled banks calmed the markets some. But the rest of the stimulus didn't accomplish much.

Credit markets and new loans remained tight through 2008; and consumer spending declined—appropriately, to a recession.

Statist politicians had hoped otherwise. George W. Bush, Nancy Pelosi and Barack Obama all hoped that so-called "tax rebate" checks (rebate from what? The federal government had been running annual deficits for years) would *encourage* consumer spending.

These bogus rebates—really, little more than petty bribes financed by Treasury Department borrowing—are a favorite trick of statist hacks confronted by hard economic times. The amounts of money that reached individual citizens (an average of less than $1,000 in the fall 2008 feeding) are usually trivial, compared to the mortgages, car loans and credit card debt that loom over households during a recession.

Before the Bush-Pelosi-Obama plan, the previous such bribe had been made during the late 1970s by the pious statist nitwit Jimmy Carter. Both programs were what could be called "demand-side" economics—based on the condescending premise that people are stupid and will rush to spend any money that Uncle Sam sends them.

In fact, people who are scared of bad economic times tend to *hoard* cash. A more rational impulse than politicians expect.

Bush promoted his rebate plan as responsible, accounting for "only" one percent of the Gross Domestic Product. In fact, the plan was profligate. The government doesn't account for or control the country's GDP; by most reliable measures, it accounts for between 20 and 25 percent.

More to the point: The federal budget deficit during the 2000s averaged about five percent of GDP; so the Bush rebate actually expanded the government's annual deficit by something like a fifth (and more red ink was coming in the months that followed).

Perversely, the Bush-Pelosi-Obama plan also increased the role of Fannie Mae, the government-backed mortgage giant that helped create the subprime real estate bubble. The plan gave Fannie Mae—whose management perpetrated an Enron-like accounting fraud—authority to make billions of dollars of risky loans in the most overpriced and volatile housing markets, by dramatically increasing the maximum dollar value of the loans it could repackage.

This didn't last long. By mid-2008, Fannie Mae admitted that it was insolvent and had to be taken over by the government.

Expanding the loan capacity of an agency that's months away from bankruptcy is a typical, addled statist maneuver. It's window dressing that distracts from even bigger problems. In a February 2008 press conference, Bush OMB Director Jim Nussle was supposed to defend the tax rebate as responsible statecraft. Instead, he stumbled inadvertently into an admission of the perilous direction that his administration was heading:

> *That bipartisan bill will raise the deficit by $145 billion, and obviously that will have an impact, but we believe that this up tick is temporary, and is also a manageable budget deficit if we keep taxes low, if we can keep the economy growing, and if we can keep spending in check. ...*
> *In addition, we need to make sure that mandatory spending, which is overwhelming the rest of the budget, is also held in check. ...the current*

trends are, frankly, not sustainable. In the next 35 years alone, the automatic spending portion of this budget will completely swallow all of the revenue that's available, which means there will be no money available for some of the basic responsibilities of the federal government, such as national defense and homeland security.

This was the OMB Director of a purportedly market-friendly Republican administration talking and defending a booming deficit as an "up tick" that wouldn't be a problem if, if...if. And one of those *ifs* involves turning around automatic spending programs.

Less than a year after Nussle's stumbling talk, his administration had been replaced by one *more* dedicated to government command and control of the economy. Mandatory spending wasn't likely to be reformed. Barack Obama's administration looked forward to trillion-dollar annual budget deficits for years to come.

This level of government borrowing was unprecedented in modern political history. And the most likely effect, hanging over the nation like a cloud, was the rapid debasement of the American dollar.

Debasement and America's Long-term Prospects

A government policy of currency debasement is nothing new. Throughout history, nations in a position of long-term economic advantage over their neighbors have used the strength of their money to purchase short-term benefits and luxuries.

This is a downside of international trade.

The English financier Sir Thomas Gresham wrote about the costs of weak currency the 16th Century. In a series of letters to Queen Elizabeth I explaining the bad effects that her father and brother's policies of debasing (literally, mixing cheaper metals into) gold and silver coins had had on the economy, Gresham wrote:

... good and bad coin cannot circulate together [and so] all your fine gold was convayed out of this your realm ...

(In fact, most economists agree that Gresham's advice to the Queen had a limited scope. A later English economist, Henry MacLeod, expanded on Gresham's original meaning—and coined the phrase "Gresham's Law.")

From these writings comes what we know today as Gresham's Law: Bad money drives out good.

Put more plainly, a nation with a relatively strong currency will always be tempted to use that strength by exchanging money (and goods) with weaker currencies…until its advantage has been diluted.

Why would any government familiar with Gresham's Law *allow* its good money to be diluted? Because governments are lazy. And institutionally decadent. American statists (like their Roman, French and English political ancestors) debase their currencies because that policy is easier than raising taxes or cutting benefits.

The American dollar has been the world's reserve currency for as long as today's statist policy makers have been alive. A reserve currency is supposed to be a store of value; but statists can't leave that value alone. By running big budget deficits, American politicians ground away at the dollar's foundation; between 2002 and 2007, it fell more than 24 percent against the most widely-used index of foreign currencies. Much of this decline was driven by economic fundamentals: specifically, America's need to borrow from abroad to finance its consumption.

The dollar's debasement hasn't been happening in secret. In late 2007, *The Economist* magazine wrote:

> *…For half a century the dollar has been the hegemonic currency. A large slice of global trade is counted in dollars. Central banks hold most of their foreign-exchange reserves in dollars, a boon for America that has allowed it to issue debt more cheaply. …But now, with the euro as an alternative, the fear is of a sudden shift in the global monetary system, with investors switching quickly from one currency to the other.*

In May 2007, during a debate among candidates for the Republican presidential nomination, Texas Rep. Ron Paul put this point plainly:

> *We live way beyond our means. We print money for it. The value of the money goes down, and poor people pay higher prices. That is a tax. That's a transfer of wealth from the poor and the middle class to Wall Street. … We need to get rid of the inflation tax with sound money.*

When America's growth prospects and interest rates fall relative to those elsewhere, a cheaper currency is inevitable.

The dollar lost even more value because the credit crunch of 2008 was concentrated in dollar assets. The belief that transparent

markets and vigilant regulators made America a safe place to store money wavered when it became clear that America had been funding a real estate bubble as a means of financing economic expansion.

Net private capital inflows into America evaporated once the credit turmoil began. As numerous economists noted, the subprime crisis combined with a history of debasement had turned the dollar into a subprime currency.

In 2008, faced with a declining currency and a stumbling economy, Americans voted like scared serfs. They elected Barack Obama—a statist politician dedicated to the same policies that had caused the problems—president. Why? Because they understood that the continued debasement of the dollar would worsen their woes? No. Because, in their fear, they believed that Obama's bromides about "change" would improve the economy.

Statism's premise holds that Americans are so easily victimized they must be regarded as wards of government.

Washington's intervention in the subprime mortgage market's predictable (and predicted) collapse was the tip of an enormous new entitlement: People who voluntarily take financial risks are entitled to government subsidy when they lose their bets.

So Little Savings...

U.S. government policy makers are most responsible for the steady debasement that the dollar suffered through the 2000s. But they aren't the *only* ones responsible. Americans could have shored up the dollar's value by saving more and spending less.

Instead, like serfs, they followed the Fed's direction and borrowed heavily to buy practically disposable consumer goods.

Borrowing money is bad; by borrowing, you surrender your economic liberty to contractual servitude designed to enrich someone else. A rational person should borrow as little as possible—and then only to acquire goods or make investments that have a reasonable likelihood to gain value more and faster than the cost of borrowing.

Borrowing to buy things like cars, vacations and consumer electronics is a recipe for bankruptcy.

Still, some economists (and even some *libertarian* economists), applaud America's debt-fueled consumerism as the epitome of individual liberty. These experts argue that saving money when interest rates are low is irrational, that a rational decision-maker *should*

take his cues from monetary policy. Their arguments generally go like this: If inflation is 3.0 percent and savings accounts generate after-tax profit of 1.5 percent, you will lose money on funds you put in a savings account. If you put $1,000 into a savings account, you'll earn $15 over the course of a year; but inflation will reduce the buying power of your $1,000 by $30. So, the net effect is that you lose $15 per $1,000 that you put away. Not much incentive to save.

But people are more than a sum of incentives. And fashionable, libertine arguments against saving money fall apart on the rocks of economic reality.

Economies follow cycles of boom and bust. A borrower relies on the goodwill or profit motives of others to maintain his lifestyle. When a hard turn in the economic cycle weakens goodwill and paralyzes profit motives, the borrower's life changes for the worse dramatically. And suddenly.

Having cash in reserve—savings—softens the effect of these bad changes. It gives the individual independence from economic cycles and government policies. A negative net yield from a savings account is bad ... but not saving any money is worse.

Of course, there's a disincentive to saving that's even greater (though less direct) than negative net yields: Mandatory government insurance and statist welfare programs discourage people from saving.

You should save money, even if Federal Reserve policy makes if difficult or costly. A free person should live by his or her own counsel. And the Fed doesn't always know what it's doing. Or why.

Example: Why did the Fed inflate the housing bubble that crashed in 2008 by keeping interest rates low during the 2000s? Because, during his long tenure as Fed Chairman, Alan Greenspan started to act like a politician. In the early 1990s, he raised interest rates—to encourage savings and curb inflation. This created some hardship for debt-reliant consumers. And Democrat presidential candidate Bill Clinton's ran a campaign based on the mantra: "It's the economy, stupid!" Voters responded to Slick Willie's promises of easy money and gave him the keys to the Treasury.

Greenspan learned his lesson; he eased up on easy credit.

Normally, loose credit leads fairly shortly to inflation. And, as Ron Paul said during a December 2007 presidential candidates' forum hosted by the *Des Moines Register*:

The most sinister of all taxes is the inflation tax and it is the most regressive. ...When you destroy a currency by creating money out of thin air to pay the bills, the value of the dollar goes down, and people get hit with a higher cost of living.

Greenspan's loose credit policy during the 2000s didn't cause inflation as directly as most economists would have expected. Why? Because the U.S. economy was not well...and needed the cheap money just to stay in place.

Tax Policy Games

During his 2008 campaign for the White House, Barack Obama repeatedly spoke of cutting taxes for "95 percent of American families." This promise was fairly meaningless—since, according to IRS statistics through 2006, about a third of all American tax filers *already* paid no personal income tax.

So, what did the cagey Obama actually mean? For some citizens, his promises meant "refunds" of moneys never paid in the first place. In other words, hand-outs. Direct government subsidies. His plans included various new tax credit provisions, including a "Making Work Pay" credit, a "Universal Mortgage Credit" and a credit that would eliminate income taxes for seniors earning less than $50,000 a year.

The Tax Foundation (a nonpartisan research group with a slight limited-government lean) estimated that, if all of the Obama tax provisions were enacted in 2009, the number of "nonpayers" would rise from 47 million to 63 million households.

The U.S. tax code is an excellent tool for lying politicians. It has always contained provisions (like the standard deduction, personal exemption and dependent exemption) that reduce the tax burden for low-income workers. Between 1950 and 1990, these gimmicky credits meant that one in five Americans paid no personal income tax.

After 1990, the number of Americans who paid nothing exploded, fueled by Clinton-era provisions like the earned income tax credit (EITC), the child tax credit, the HOPE credit and the lifetime learning credit.

Most tax credits can only reduce a taxpayer's amount due to zero; but the EITC and the child tax credit were *refundable*, which means that taxpayers who qualify are eligible to receive a check from the government even if they have paid no income tax during the year.

This was the mechanism that Barack Obama planned to use to redistribute wealth in America. Were Obama's plans radical? Or change? Hardly. Starting in the early 1990s, U.S. lawmakers had consistently used the tax code—instead of direct government spending—to funnel money to groups they wanted to subsidize.

The redistributionists were in place long before most Americans knew Obama's name. His plans merely expanded existing programs.

These ballooning government subsidies push America closer to hyperinflation and insolvency. In the meantime, statist policy makers hide in a fog of complexity. This complexity serves two groups: the bureaucrats who administer government programs and the service-providers (lawyers, CPAs and others) who navigate the bureaucracy for a fee.

One case in point: The EITC is so complicated that, according to the Tax Foundation, more than three-quarters of the people claiming it pay a tax preparer to complete their returns.

And there are other bad effects of subsidy by tax policy:

- Punitive marginal tax rates. To withhold the benefit of refundable tax credits from "rich people," most provisions have so-called "phase-out ranges," in which taxpayers have to pay back the credit that they can no longer receive. Taxpayers in the phase-out range face unexpectedly high effective marginal tax rates—severe penalties for every new dollar of income they earn. In 2006, the President's Tax Reform Panel found that taxpayers in the phase-out range of the EITC faced a higher effective marginal tax rate than even the wealthiest Americans.

- Narrowing the tax base makes revenue volatile. Expanding existing credits and adding new ones pushes people who used to pay taxes into the non-payer category, shrinking the tax base and requiring higher taxes on everyone else. Volatility in federal revenue follows, as the incomes of higher-income taxpayers include more business, dividend and capital gains income (which fluctuate more widely than wage income).

In 2009, Barack Obama—heir to Alan Greenspan and W. Bush and the cynical use of federal programs to encourage preferred economic outcome—sat at the center of all this tax policy trickery.

Meanwhile, entrepreneurial cookie makers were advised *not* to expand but to sit and wait. And the U.S. marched toward bankruptcy.

Chapter 9:

Regulation, the Mother's Milk of Statism

Imagine, one last time, that you're the entrepreneurial cookie maker. You've built your business into a successful regional brand. You've come close to taking your business national; but hard economic times have made raising growth capital nearly impossible. So, against your impulse to grow, you've settled back into running your business as a mid-size operation.

One night, while you're taking your kids to a movie, there's a fire during the second shift at your main bakery. Several of your employees die in the flames. You're devastated. But you get to work arranging temporary locations and solutions to keep your cookies getting to market while you rebuild your plant.

You also do what you can to help the families of the dead workers—above and beyond what's required by workers' comp and your employer's liability insurance.

But, in the days after the fire, things take an even worse turn. Local fire investigators and federal OSHA inspectors determine that several of the big bakery's fire doors had been tampered with to stay locked. They also have testimony from some "sources" that "everyone" knew the bakery hadn't be wired properly to run so many industrial ovens.

You cooperate with the investigators and inspectors because you know these things aren't true. Your main plant manager and several shift managers checked all entrances and exits multiple times every day. And your original architect's drawings for the building had up-to-code electricity; you'd made sure of that before you showed anyone the plans.

A few weeks later, when you're walking through the burned building with an insurance adjustor, several big SUVs full of federal marshals in loudly-marked windbreakers screech up to the front of

the building. The marshals arrest you for willful violations of the OSH Act, willful violations of the Consumer Product Safety Act, a series of tax fraud charges, criminal negligence and criminal fraud.

You call your lawyer. The insurance adjustor disappears. While you're on the phone with your lawyer, trying to stay calm, you notice a TV news truck behind the government SUVs.

Eventually, most of the charges are dropped and you settle the rest for a few thousand dollars in fines. But the insurance settlements take longer than expected complete and the bad publicity really damages sales. In the end, you decide to shut down the company.

Your husband, who's been a rock through the whole mess, says you can start another cookie company and get right back to where you were. But the E.V.P. of Marketing for a corporate food giant that you met a trade show a few years ago is always saying that if you ever got tired of "sweating payroll" to give him a call....

The Statist Fetish for Process Instead of Results

The statist's collectivist and, ultimately, dehumanizing approach to public policy takes many forms; the common theme to all is an aggressive bias against individual identity and rights. Of course, statists never admit that they're against individualism; instead, they promise that specific regulations will create benefits for certain groups. They focus more on the regulations—the *process* of public policy—rather than the actual outcomes. Or the people affected.

Perversely, many statists argue that this doling out of benefits is "humanism." And the keen among them invite the dullards among their political opponents to stand against this humanism.

This can be a winning strategy on a petty level. The dullards fume and fuss against the "humanists" (some prefer the term "secular humanists") and the level of political discourse sinks.

How to avoid this briar patch of trivial debate?

By focusing on *results* rather than process.

One useful way to talk about statism's collectivist overreach is to focus on the impracticality of statism's fetish for process. This impracticality is something most people instinctively suspect and distrust. With good reason.

Statists eagerly define "regulation" as the process by which the government controls marketplace activities to produce certain economic outcomes. But this definition assumes that government

attempts to control markets actually create outcomes. Modern economic history—from the Bretton Woods currency controls to OPEC cartel decisions to Richard Nixon's wage and price controls to California's late-1990s energy "deregulation" (actually a warped form of regulation) and the late 2000s demise of mortgage industry subsidizers Fannie Mae and Freddie Mac—shows that governments are *not* good at directing markets. As often as not, their efforts are inconsequential or backfire.

And, even when these efforts are modestly effective, unintended consequences often overwhelm any small achievement.

With their focus on process instead of results, statists are often willfully ignorant about the limits of regulation. In the United States, they assume that "regulation" inherently means an anti-corporate and pro-consumer agenda. This assumption is wrong.

As often as not, statist regulation will be conducted in *cooperation* with corporate interests—and wrap anti-consumer market controls in the rhetoric of populism.

And then, twisting forward from a bent start, the unintended consequences make things even worse.

Regulatory Tactics…and Anti-regulatory Philosophy

From a strict libertarian perspective, *any* government action in a marketplace is a form of regulation—whether or not government agents apply the term "regulation" to the action.

Taxes, wars and even the justified provision for reasonable externalities all influence the marketplace in some manner. In fact, the very *existence* of the state, even a limited one, affects decisions that individuals make about how they do business.

A practical libertarian accepts some role for a limited state in regulating the commercial transactions that take place among its citizens. The best mechanism of regulation is a fair, non-corrupt civil court system. It's important to the efficient function of most markets that—in the rare case that someone really abuses and injures someone else—the injured party has a place to go to seek lawful redress.

This system should exist so that the injured party can mitigate his or her loss. But—more importantly—it should exist to let everyone, particularly potential wrongdoers, know that they operate within a system that follows basic rules of fair conduct. In this way, a fair

court system is a deterrent to abusive behavior. It supports the general tendencies of a free market to avoid bad actors and corrupt locations.

This fair civil court system doesn't need to be as complex or extensive as the U.S. civil court system has become. It might take the form of merely one Supreme Court—which would supervise the actions of local civil courts or lawful, privately-run arbitration systems, church courts or other venues of legal redress.

But the state propagates itself beyond these limits. Government institutions can't seem to resist expansion and complexity of regulatory mechanisms; they often promulgate three, four or five rules or policies when one will do. Why? Because bureaucracies value their own kind. The leviathan state is self-propigating creature.

A Quick History of U.S. Governmental Regulation

In the United States, the 20th Century saw an explosion of statist regulatory agencies and apparatus.

The first wave of regulatory growth came during the "reform" era that peaked during Theodore Roosevelt's presidency. Teddy Roosevelt was famously skeptical of effect that large corporations had on the function of commercial and financial markets. He particularly criticized a favorite corporate tactic of the day—the establishment of corporate trusts that enabled cartel-like control over some industry sectors.

Roosevelt had supported (and gained political capital from) passage of the Sherman Antitrust Act and similar laws.

Teddy Roosevelt's passion for "trust-busting" might have been the last gasp of the free-market regulators. In his time, government regulations were intended to open access to markets and assure the greatest and freest volume of commercial activity.

Some libertarians (notably Richard Posner—but others, too) have questioned the philosophical legitimacy of antitrust laws. But they have a hard time questioning the laws' effectiveness. They prevent large corporations from gaming local markets (or, for that matter, things like the federal tax code) to their benefit and the detriment of their—usually smaller—competitors.

The problem was that, once Teddy Roosevelt and his allies popularized and legitimized government regulation, people of less goodwill toward free markets took over the levers of state.

Roosevelt's reform movement was hijacked by intellectuals and politicians of a more collectivist bent. These second-wave reformers were statists; and they cared less about using the levers of government to open up markets and more about dictating rules of operation to the markets.

The 1906 publication of Upton Sinclair's novel *The Jungle* may mark the start of this second wave. The bestselling book was highly critical of the meat industry—and use graphic images to play on readers' emotions. People around the United States called for "reform" of the good industry—which resulted in creation of the Food and Drug Administration and expansion of the Department of Agriculture. Rather than assuring fee market competition, these state agencies started to police the activities of market players.

These statist reformers had a friend in the White House when the loathsome Woodrow Wilson was elected in 1912. Among his many infamies, Wilson established the a lot of the bureaucratic framework for the federal regulatory apparatus that plagues America to this day.

When the Great Depression sacked the American economy in 1929, calls for statist "reform" took on greater urgency. When Franklin Roosevelt (Theodore's striving, socially-insecure second cousin) was elected president in 1932, he expanded on these statist notions of reform. And the apparatus of government regulation became truly gigantic.

The Second World War codified these statist "reforms" and the American economy adapted to massive regulation. The growth of government regulations (and regulators) plateaued. But it certainly didn't contract. The economy adapted and hummed along for some 25 years.

The 1970s saw a third wave of 20th Century regulatory growth. Poorly-drafted laws like the ridiculous Clean Water Act were passed without the kind of scrutiny that they deserved. Amendments to existing laws gave agencies like the Food and Drug Administration, the Federal Trade Commission and the Federal Communications Commission substantial control over how the industries operated.

Some historians tie this third wave to the childish social excesses of the 1960s. But, really, it's tough to prove a causal link. The president who signed the Clean Water Act into law was Richard Nixon—ostensibly, a pro-business Republican with little sympathy for '60s radicals.

This is an important point about statist regulations (and government spending, in general): It is surprisingly non-partisan. Both major American political parties support it.

There is something inherently statist about the executive branch of the government in the United States. No matter how much Republicans (or "conservative" Democrats) may talk about supporting limited government, when they get to the White House, they spend and regulate.

As some of my colleagues at *Liberty* magazine have pointed out, the periods of greatest government growth and regulatory overreach come *not* when the admittedly statist Democrat Party controls both elected branches of government—but when the supposedly free-market Republicans control the White House and the Democrats control congress.

The Commerce Clause

From a legal perspective, the main mechanism ("pretext" might be the more appropriate word) that U.S. courts have used to support the government's process-driven regulatory overreach is the so-called "Commerce Clause" of the Constitution.

Article I, Section 8 of the U.S. Constitution grants Congress power "to regulate Commerce with foreign nations, and among the several states, and with the Indian Tribes." Ambitious statists read this clause broadly. And, for most of the post-WWII era, the U.S. Supreme Court seemed to agree—interpreting the congressional power to regulate some types of commerce as a power to regulate anything, anytime, anywhere. But this Golden Age of American statism ran into trouble in the 1990s.

A modest reform started with the 1995 Supreme Court decision *United States v. Lopez*. In this case, the Supreme Court ruled that Congress could not use its power "to regulate Commerce...among the several states" as a pretext to ban the possession of firearms near schools.

Justice Clarence Thomas wrote that it was absurd to argue that the power to regulate interstate commerce was the power to regulate *everything*. If so, it would have been redundant for the founders to name certain regulatory powers (bankruptcies, copyrights, taxes)—since the power to regulate interstate commerce would have covered all of these.

Chief Justice William Rehnquist's majority opinion for the Court set forth the three circumstances under which Congress may use the interstate-commerce power:

(1) To regulate the channels of interstate commerce. This is really the essential purpose of the power, to give Congress the power to legislate against state barriers to interstate trade.

(2) To regulate the instrumentalities of interstate commerce. For example, setting labor and safety standards for railroads and airplanes.

(3) To regulate economic activity that has a substantial effect on interstate commerce. As Justice Sandra Day O'Connor had explained in an earlier decision, Congress can sometimes regulate local commerce because of its separate power "to make all Laws which shall be necessary and proper for carrying into Execution the foregoing Powers."

An example of the last point: If Congress wanted to prohibit the interstate sale of pelts from endangered animals, it might conclude that it was impossible, as a practical matter, to stop the interstate sale unless it also banned local sales.

Libertarians put a lot of importance in the *Lopez* decision, seeing it as a sign that the broad use of the Commerce Clause to justify statist regulatory schemes would come to an end. They hoped that the so-called "conservatives" on the Supreme Court would build upon *Lopez* to establish other clear limits on the ambitious regulation.

In this, they were too optimistic.

The Supreme Court's "conservatives" proved themselves to be partisans first and wise legal minds second.

In 2005, the Court—under the leadership of new Chief Justice John Roberts—considered the case *Gonzales v. Raich*, a convoluted dispute over Congress's ability to control a local government's policy on so-called "medical marijuana" (allowing marijuana possession by people with certain medical conditions). The Court ruled that Congress can regulate *any* activity with even the slightest, tenuous connection to "commerce."

This was a U-turn from the direction the Supreme Court seemed to set in *Lopez*. And it hinted that a second Golden Age in state regulation might be afoot. Some libertarians complained about the *Raich* decision; but most—like most Americans—didn't seem to appreciate the decision's importance.

One commentator who did understand the importance of the *Raich* U-turn was Ilya Somin, a law professor at Virginia-based George Mason University and regular contributor to the legal commentary Web site Volokh.com. In a lengthy (for the Internet) October 2007 posting, Somin wrote:

> Raich *(like previous decisions) gives Congress the power to regulate anything that might be considered "economic activity" and also any noneconomic activity that is part of a "broader regulatory scheme" that incorporates economic activity. …Not only did the Court allow Congress the power to regulate anything that counts as "economic activity," it also defined "economic" to include any activity that involves the "production, distribution, and consumption of commodities."*

The important point—for libertarians—in all of this is that the Supreme Court was willing to change broad direction in constitutional theory to realize specific, short-term political ends. In banking circles, they say you should never borrow short and lend long; your short-term gains can be wiped out by long-term losses. But that's precisely what the Supreme Court was doing in *Raich*. And the long-term losses could involve more than just marijuana.

Somin stressed the troubling point that *Raich* gave government regulators a lot of discretion to include non-economic activities in their "Commerce Clause" actions:

> *While earlier cases suggested that noneconomic activity can only be swept into a broader regulatory scheme if its inclusion is "essential,"* Raich *holds that it is enough for Congress to have a "rational basis" for believing that its inclusion is desirable. …the "rational basis" test in this context is a virtual blank check for Congress to do as it pleases.*

Statist regulators with a blank check? This is very bad.

A key element of the Court's ruling in *Raich* was that the prohibition on the possession of medical marijuana was an essential part of a broader, comprehensive regulatory scheme governing the distribution and production of marijuana. To maintain this scheme, the Court held, Congress could regulate *all* possession of marijuana, for whatever purpose.

Somin concluded with a last observation—namely, that the Court had noted repeatedly that:

Congress could regulate medical marijuana possession because Congress believed such regulation was necessary to control and limit illegal drug markets. [So, Raich*] could have the perverse effect of inducing Congress regulate more in order to reach a given target of regulation.*

This is just one, technical example of the self-propagating nature of the leviathan. It's a variation on the theme of the government bureaucrat who spends to the limits of his budget each fiscal year (even if he doesn't need to), for fear that any savings will result in a smaller budget the next year.

Lacking the hard efficiency of the profit motive, statist entities they "spend up" (or, in post-*Raich* scenario, "regulate up") to the limits their economies can bear. They are inherently inefficient.

The Roberts Court might have intended for new regulations allowed by *Raich* to undo the effects of previous regulations. But the solution to statism isn't more statism. Two wrongs don't make a right.

Regulating Financial Services

The subprime credit crisis of 2007 and 2008 resulted in media calls for "reform" of the credit and financial markets. Of course, most of these "reforms" involved more and new regulations.

The subprime crisis came after more than a decade of major changes in the way home mortgage loans were made and marketed.

The traditional model of mortgage lending had been that a local bank would finance home loans based on rational risk assessment and its knowledge of the local real estate market. A borrower would have to pay 10 or (more often) 20 percent of the purchase price in cash as a down payment and provide proof good credit and steady income. Mechanically, the home loan was a simple repackaging; others schedule across its lifetime.

The federal government subsidized these loans in two ways: allowing the borrower to deduct the interest portion of his mortgage payments from his income taxes and supporting Fannie Mae and Freddie Mac—mortgage repackagers that used the implied guarantee of the government to buy loans from local banks, combine them into geographically-diverse pools and resell the pools to investors as bond-like securities.

Fannie Mae and Freddie Mac added liquidity to the home loan marketplace by freeing local banks from having to carry mortgage

loans in their own financial books. As long as the mortgages conformed to standard guidelines for size, terms and borrower creditworthiness, the banks could focus on marketing and packaging loans rather than managing a portfolio.

Of course, not all loans conformed to those guidelines. Some were for amounts too large for repackaging ("jumbo" loans); others were made to borrowers with small down payments or questionable credit histories. Banks generally had to hold on to these non-confirming loans; they took some solace in this by charging higher interest rates on those loans.

Starting in the early 1990s, Wall Street firms saw an opportunity to play the role of Fannie Mae and Freddie Mac for non-conforming loans. They would repackage the higher interest-rate mortgages into bond-like securities that paid more money to investors. And they would stress the safety of the underlying assets—after all, these were people's homes securing the good returns.

This privatized loan repackaging worked especially well for the loans to people who couldn't document steady incomes or had shaky credit histories (or both); these subprime loans were the fastest-growing part of the mortgage market from the mid-1990s through the mid-2000s.

Some financial institutions emerged that looked more like marketing companies than banks. Companies like New Century Financial and Countrywide Home Loan marketed, initiated and packaged home loans—but didn't hold them any longer than they had to.

The boom in mortgage-backed securities made everyone happy. It created even more liquidity in the mortgage market, which meant that more people qualified for loans and smart borrowers had more options form which to choose. It made Wall Street happy—because investors liked the securities and the repackaging meant fees for investment banks. It helped U.S. consumers spend their way through several economic downturns that might otherwise have been recessions, which made politicians and economists happy.

Subprime loans financed the "irrational exuberance" that Federal Reserve Chairman Alan Greenspan described during a think tank speech in 1996. They financed a boom in real estate prices that lasted longer and reached higher than even experts predicted. By the mid 2000s, the boom was taking on the characteristics of a bubble.

All of the booming liquidity gave some Americans a false sense of wealth and security. Many consumers refinanced their homes with subprime loans that allowed them to "cash out" some of the market value of their homes. They used the proceeds to travel or buy consumer products; and lenders encouraged this behavior with slogans like "Harness the American Dream" and "It's your equity. Put it to work for you."

But few people were actually putting the equity to work. More were spending it on second cars and Sony Playstations.

By early 2007, the subprime mortgage bubble was getting ready to burst. Many borrowers had refinanced multiple times with less than five years; median home prices in most parts of the U.S. had reached six or eight times median income—far above the historical norm of three times median income. Home prices in markets like New York City, Las Vegas and southern California were simply unsupportable.

In February 2007, New Century Financial declared bankruptcy. It was defaulting on several agreements it had made with loan repackagers to re-purchase any if its mortgages that went into default or foreclosure. Some of the loans were, in fact, going bad; but New Century didn't have enough cash on hand to buy them back.

This announcement created a panic on Wall Street and in mortgage markets around the U.S. Investors stopped buying mortgage-backed securities. Lenders stopped approving loans. Home prices fell more than 25 percent in a few months in some places.

As the housing bubble burst, U.S. Treasury Secretary Henry Paulson unveiled a 200-page plan for replacing what he called a "collection of overlapping jurisdictions" with a streamlined regulatory apparatus managed primarily by the Federal Reserve and the Treasury Department. The new system would centralize the activities of dozens of federal and state agencies; and it would apply federal rules to Wall Street brokerages, as well as local insurance agents and mortgage brokers.

Despite the scope of this power grab, Paulson admitted that more bureaucracy wouldn't prevent future meltdowns:

I am not suggesting that more regulation is the answer or even that more effective regulation can prevent the periods of financial market stress that seem to occur every five to 10 years.

Many politicians made the Jesuitical argument that the credit meltdown of 2007 and 2008 was not a recession (recessions are bad for incumbent office holders). But they used a lot of the same rhetoric that politicians do when a recession is on. The complained about "speculators" and "price gouging" and proposed convoluted schemes for borrowing money to send citizens "economic stimulus" checks. (At least these political hacks avoided the anti-Semitic epithet "Jewish speculators"—a favorite among third-world statists.)

Beware statists who talk about speculators or price gouging. They are usually getting ready to tax profits out of existence and fix prices in uneconomic ways.

What is a speculator, other than an investor making a ration bet on the directions of a market? What is price gouging, other than pressing the limits of what the market will bear for a good or service? Speculators and price gougers may not be admirable people—they're often bad people and sometimes are criminals who break the law, steal information and disable competitors. But their actions in the marketplace are as constructive as more upstanding people's.

Speculators and price gougers help markets return to equilibrium after they rise too quickly or fall too far.

An additional point that few people understand: In the U.S., there's no federal law that bans price gouging. This is so, in part, because there's no legal definition of "price gouging" to prohibit. And this is a good thing. Laws prohibiting price-gouging violate the property rights of resource owners, they hinder the price system's signaling ability, they contribute to the misallocation of resources, and they cause shortages.

A limited government may decide that it will accept some misallocation of resources in order to prevent the extreme highs or lows of the price mechanism. This may be a compromise that a majority of the governed rationally accepts. The problem with statist regulation is that bureaucrats tend to treat such a rational trade-off as a *starting point* from which they insinuate controls into every corner of a marketplace.

The worst (and all-too-common) example of these excesses are the regulators and public officials who talk in Old West terms about treating industry groups or individuals like outlaws. Beware of any regulatory official or petty officeholder who calls himself a "sheriff" or "marshal."

Barack Obama's Securities and Exchange Commission chair, Mary Schapiro, welcomed the title "sheriff of Wall Street." So did Eliot Spitzer, the managers of the California Public Employee Retirement System, Ben Bernanke, Timothy Geithner (while president of the New York Federal Reserve Bank) and various other statists nitwits. One common thread among all of these pretenders: *uber*swindler Bernard Madoff was perpetrating the second-biggest Ponzi scheme in American history while the financial Keystone Kops were polishing their badges.

So it goes. A libertarian would rather have a free-enterprise-competing, profit-seeking financial services firm (in plain English, a bank or insurance company) take his money than a coercive, statist government agency. The various "sheriffs" of Wall Street have done little more than take taxpayers' money in order to protect their property and freedom—and end up protecting neither.

The Tyranny of Licenses and Permits

While statists are blind to crooks like Madoff, they're intent on regulating small businesses and entrepreneurs to the point of harassment. One way they do this is by demanding that small operators have various licenses and permits.

Licenses are a stealthy tactic that statist regulators use to expand their market controls. The citizens of a statist regime become accustomed to needing licenses—"papers"—to travel, work certain kinds of jobs or engage in particular activities.

A rational person should remain skeptical of needing government permission to engage in legal activities.

In March 2008, Chip Mellor of the Institute for Justice described the scope of the problem to *Reason* magazine:

…the standard of the law today is so abominable that the government virtually gets a free pass to regulate any activity it wants in almost any fashion. The legal standard is literally that any reasonably conceivable set of facts will suffice to justify an economic regulation, even if those facts weren't present or considered by the legislature when the law was enacted. …There was a proliferation of these licensing laws in the Progressive Era and an explosion of them after the New Deal. They've just continued to increase as the number of occupations has grown and enterprising people have created more niches.

Mellor went on to describe a 2003 case that his organization had supported. The state of Louisiana had decreed that anyone who arranged flowers—which meant, by local law, putting two flowers together—and then sold those flowers for any amount of money had to have a state florist's license. The state law was enforced by a floristry board comprised of licensed florists—and, like many such organizations, the floristry board practiced yield management. It controlled the number of new florists allowed into business each year, to keep competition to a minimum.

Part of the licensing process was a "practical exam" whereby an applicant had to prove proficiency in assembling a flower arrangement. Because the standards for the practical exam were entirely subjective, the board could admit only as many new florists as its members desired each month or year. Denied applicants were given vague feedback—things like an arrangement "doesn't have the proper sense of balance. It doesn't have the proper perspective. It's not artistic enough."

There was no standard of review. And there was no mechanism for appeal.

According to Mellor, many more people passed the bar exam in Louisiana than passed the floristry exam.

The Swampy Limits of Statist Regulation

Contradictory Supreme Court decisions, spendthrift bureaucrats, political power-grabs and tyrannical license or permit requirements all suggest the excess of government regulation in modern America. But the clearest example of statism passing as "regulation" is the Clean Water Act (CWA). I've mentioned this law before; but it's such a bad piece of federal regulation that it deserves another mention here.

The CWA's vague language has become an excuse for federal overreach into local decisions about real estate development, road and driveway construction and even agricultural policy.

What does road construction have to do with clean water?

The CWA requires the Feds to enforce a permitting process for any development that occurs within federal regulatory jurisdiction. But the scope of that "jurisdiction" isn't defined clearly. The permits are supposed to prevent pollutants from mixing in with protected waters. But the CWA doesn't distinguish among "pollutants" and applies the term to everything from toxic chemicals (understandably)

to solid waste—including rocks and sand—and even (less understandably) sunlight.

That's right. Statist bureaucrats have twisted the language of the CWA into the ludicrous conclusion that sunlight is a pollutant.

And the abuse gets worse. Statist judges and agencies have interpreted the CWA to mean that private property doesn't need to contain any actual water on its surface to qualify as a body of water. If a piece of land meets the definition of "wetland" according to the Army Corps of Engineers' *Wetlands Delineation Manual*, it might as well be Lake Michigan.

By this standard, if the soil one foot *below* your property is "saturated" with water for 5 percent of the local growing season, you own water—not land. If you discharge any pollutant (including rocks or sunshine) into this "water," you've taken two steps toward breaking the law.

The final step in prosecuting you involves determining whether the "water" you've polluted is "navigable."

In the 1824 decision *Gibbons v. Ogden*, the Supreme Court ruled that Congress' power to regulate interstate commerce extended to ferries providing transportation between New York and New Jersey. In keeping with the reasoning that their power derived from the Commerce Clause, the Feds limited their regulatory reach to waterways used (or capable of being used) as

highways for commerce, over which trade and travel are or may be conducted in the customary modes of trade and travel on water.

Among state governments, this was known as the "federal navigational servitude." This focus lasted through the 19th and most of the 20th Century.

Then, beginning in the 1960s, the Feds' focus shifted from protecting water for commerce's sake to protecting water for its own sake. This shift started with public officials touting rivers as national scenic treasures; it took full form with a series of "environmental" laws drafted in the late 1960s and early 1970s.

The CWA was one of these.

In keeping with 150 years of law and tradition, the Army Corps of Engineers—which enforces the CWA—initially applied the new law in the same manner as it had applied the older Rivers and

Harbors Act. This meant the Corps focused its regulatory efforts on waters that were:

1) subject to the ebb and flow of the tide, and
2) being used or could be used for interstate or foreign commerce.

As late as 1974, federal regulations emphasized that the Feds' jurisdiction was determined by "the water body's capability of use by the public for purposes of transportation or commerce." But that year—1974—is when things really changed. Citing the vague language of the CWA, the Natural Resources Defense Council (NRDC) sued the government, complaining that the Corps' "transportation or commerce" definition was too narrow.

This lawsuit was extremely important to the NRDC. The suit was a major boost to the organization's fund-raising efforts. And that money established the NRDC as a power among statist advocacy groups in Washington, D.C.

Federal Judge Aubrey Robinson, Jr., ruled in favor of the NRDC and struck down the Army Corps of Engineers' rules. The judge wrote that the term "navigable waters" was

not limited to the traditional tests of navigability [but required] federal jurisdiction over the nation's waters to the maximum extent permissible under the Commerce Clause.

Rather than appeal this ruling, the Army Corps of Engineers adopted new rules in 1975, asserting a breathtaking federal authority over everything from "traditionally navigable waters" and "tributaries of navigable waters" to "intrastate waters from which fish were removed and sold in interstate commerce" and any other waters the Corps "determines necessitate regulation" to protect water quality.

Some politicians recognized this as overreach. Efforts to modify the CWA and limit its terms passed the House of Representatives but died in the Senate. The bad law stayed on the books.

In 1985, the Supreme Court removed what few limits were left when it ruled in *United States v. Riverside Bayview Homes* that the CWA applied to wetlands "adjacent to" and "bound up with" any navigable river. Following this diktat, the Army Corps of Engineers adopted a new "clarifying" rule extending its regulatory jurisdiction over any "waters" that might be used by traveling migratory birds

or that might provide habitats for endangered species. These new rules implied that the CWA might extend federal control to irrigation ponds, ditches and even...swimming pools.

The web of Supreme Court decisions and bureaucratic policy allowed for bizarre rulings in lower courts. Some circuit courts tried to apply practical standards to CWA lawsuits; others applied a so-called "single molecule" standard to water pollution liability rulings.

In 2001, the Supreme Court stepped back into the mud to restore some sanity to CWA enforcement. In the decision *Solid Waste Authority of Northern Cook County v. Army Corps of Engineers*, the Court struck down the "Migratory Bird Rule" and established that the CWA does not "extend to ponds that are not adjacent to open water."

Otherwise, the Court concluded, the language of the CWA would be unconstitutionally broad.

But capricious enforcement of the CWA continues. In one high-profile case, a landowner who wanted to level a cornfield he owned had to spend more than two years and $270,000 to get a permit—and was prosecuted when he proceeded with his project while his permit application was being reviewed.

Federal prosecutors insisted John Rapanos should go to jail for moving sand within the limits of his own property. They compared his digging on his own property to the 1989 wreck of the *Exxon Valdez* oil tanker on the Alaskan coast. Judge Lawrence Zatkoff dismissed the ham-fisted rhetoric, writing that:

> the average U.S. citizen [would be] incredulous that it can be a crime for which the government demands prison for a person to move dirt or sand from one end of their property to the other end of their property and not impact the public in any way whatsoever.

Zatkoff gave Rapanos probation. The government lawyers appealed to the Supreme Court to intervene and increase the sentence. To its credit, the Supreme Court threw out the guilty verdict against Rapanos. Antonin Scalia wrote the one-page decision.

Madoff: The Last Word on Regulation

Statist regulators focus on process rather than results, so the end up harassing florists about licenses rather than recognizing swindlers in their midst.

In December 2008, news broke that law enforcement agents in New York had arrested Wall Street icon Bernard Madoff. As the details emerged, it became clear that—rather than being a savvy investment advisor—Madoff had been running a huge Ponzi scheme for nearly two decades. He didn't actually make the big, steady profits that he claimed; in fact, he didn't do *anything* productive with his investors' money. He just took it in, circulated it through various partnerships and trusts that he controlled, kept some of it for himself and distributed some of it as supposed "profits."

Ponzi schemes are among the oldest and crudest financial swindles. They usually don't last as long as Madoff's did. But, no matter how long they last, they *always* collapse.

Monied circles in New York and Palm Beach were stunned that a lion of the investment establishment was, really, a glorified grifter. How could this be? How could he have run the scheme for so long? And why didn't the regulators do something?

Because regulators are bullies by nature. They pick on small operators and leave lions alone.

Madoff's real skill was appearing to be a lion. As part of that appearance, he did something that the smartest crooks often do: He participated in the regulatory process. In the early 1990s, SEC chair Arthur Levitt appointed Madoff to what the *New York Times* called "a large advisory commission…that explored the rapidly changing structure of the financial markets." Madoff had served for a time as the chairman of the North American Security Dealers' Association. And he was among the first hedge fund operators who voluntarily registered with the SEC as an "investment advisor" (the preferred term) in the mid-2000s.

Because of his volunteer involvement with the SEC and other regulatory agencies, Madoff knew what enforcement departments were looking for in suspicious operators—churning, insider trading, short selling and holding derivatives. He made sure his investment portfolios and trading logs never showed any of that.

The statist regulators handed a master criminal the blueprint for keeping his crimes undetected. They were more useful to him than any accomplice.

Chapter 10:

Foreign Policy, Immigration and Security

Foreign policy is a difficult topic for libertarians. There is no "classical liberal" theory on interacting with other nations; and advocates of limited government tend to be skeptical about the multilateral organizations (like the hapless United Nations and the feckless World Affairs Council) that dominate the global scene.

To the extent that there is agreement among libertarians, it's that foreign policy should be an extension of a nation's domestic priorities—with a particular focus on domestic security. But this doesn't really answer as much as it might seem to. Statist domestic security actions produce more and greater unintended consequences than most other government activities.

For example: In the 1970s, Jimmy Carter created the National Security Agency and signed the Foreign Intelligence Security Act into law (which established the notorious FISA courts). Carter believed that these measures would help U.S. security abroad and limit aggressive actions by government agencies like the CIA and FBI.

Twenty-five years later, George W. Bush used the NSA and the FISA courts to manage one of the biggest power grabs in the history of the U.S. government—and considerable erosion of citizens' privacy rights.

(Statists like to manipulate existing laws and programs to achieve ever-changing ends.)

The pious peanut farmer criticized W., while ignoring that *he'd* given Bush the tools to expand the state's domestic surveillance activities in such troubling directions.

So, how should a libertarian nation handle foreign policy?

Start with security, of person and property. These immediate matters are the legitimate concern of the state; they combine elements of externalities and individual liberty. And they give

practical meaning to abstract terms like "freedom of speech" and "privacy rights."

A libertarian interested in foreign policy works outward from those individual security interest, looking first for domestic policies that will assure or enhance individual security—then for international policies within the nation's region that will do so. Only after all of this does a libertarian look for global policies that maximize personal and property rights.

Most of what statists consider "foreign policy" offers just an illusion of security and very little in the way of protected individual rights. It is, therefore, of dubious value.

Free individuals value *real* security. That doesn't usually have much to do with global or multilateral ambitions. It often has more to do with simple matters related to protecting yourself.

Free Nation's Focus; Multilateralist Refrain

A free state should let its citizens and their companies interact with those from other places as they wish—and only get involved when their interests are harmed or threatened directly.

A free state shouldn't be the world's rent-a-cop. It shouldn't presume to establish governments (even "good" ones) in foreign lands. And it shouldn't engage in bone-headed, utopian plans to tell other people what kind of cars to drive or how to recycle their garbage.

Statists are excited to do all of these things.

This excitement about foreign policy troubles libertarians for many reasons. Two stand out from the rest: first, by its nature, "policy" means regulation; second, the good intentions that most people bring to international affairs usually cause more harm than good.

Because they mean well, naive statists don't question their foreign policy presumptions as much as they should.

Good intentions—especially on the world stage—have always been a problem. Ayn Rand wrote often about her mistrust of altruism. H.L. Mencken famously wrote: "The urge to save humanity is almost always a false front for the urge to rule it."

Their skepticism is warranted. The arrogance and condescension of some "humanitarian" foreign aid groups is shocking. They portray foreign people in needy countries as helpless morons—which they

aren't. They also complain sanctimoniously that Americans don't pay enough attention to world affairs.

Part of the reason that Darfur and Rwanda get little attention in the U.S. is that foreign aid marketing campaigns cast Africans as bug-eyed children holding out rice bowls. Many naive statists cannot believe that Africans can survive without Western help. They expect intervention by developed countries in "trouble spots" around the world cures all.

Statist foreign policy is multilateral internationalism—the belief that the United States should refrain from global assertiveness without permission of the United Nations or some regional version thereof.

Despite their tactical alliance with left-wing pacifists, statists are not against war. In fact, they're often actively *for* it, if the war is dressed up in multilateral or humanitarian garb. They revere Woodrow Wilson among historical figures; he got America into World War I and created the feckless League of Nations, the ur-U.N. They ignore the fact that Wilson designed the post-War establishment that gave birth to the German Nazis and rise to Adolf Hitler, Benito Mussolini and Josef Stalin.

In many ways, Wilson was the model for Jimmy Carter, whose hapless adventures in utopian foreign policy created the Islamic Revolution in Iran and enabled the Baathist regimes in Iraq and Syria. Wilson's echoes can also be heard in the modern American Left's fixation on multilateral agreements.

Critics of libertarianism argue—with some good reason—that a philosophy built on individual liberty and minimal government breaks down on the way to foreign policy. The common saying is "libertarian politics stops at America's shores."

But this conclusion is based on a couple of false assumptions.

First, some people assume that foreign policy is nothing more than a sequence of military actions. Of course, there's more to it than that. Commerce should play a big role—in fact, the biggest role—in the way that counties get along with one another. And, somewhere between war and business, diplomacy has a role. Now, many small-government advocates are skeptical about the value of diplomacy—or, perhaps more precisely, skeptical about the value of career diplomats. In the United States (as in most countries), the foreign service corps tends toward a peculiar form of elitist bureaucracy. But

as long as a state's diplomatic efforts (and this includes economic sanctions enforced by one country or several) are made in the service of simple, clear policy ends, the stuffy diplomats can serve some useful purpose.

What should that simple, clearly-stated policy be? The primacy and integrity of each state's individual citizens. A "libertarian foreign policy" should be to encourage individual liberty everywhere. This might mean to encourage dissent wherever totalitarianism and statism exist—whether religious or socialist. Individuals will rebel against these anti-humanist regimes...we should help them.

Some statists insist that financial sanctions are enough to disable terrorist groups like al Queda. Like diplomacy, financial sanctions can be effective—if the governments using them act decisively and consistently. This has not been the track record of the U.S. in dealing with al Queda and its alleged moneymen.

In November 2007, the UN Security Council without explanation removed Ahmed Idris Nasreddin and 12 of his companies from the terrorist sanctions list, freeing them from sanctions on a global basis. The UN action followed a similar action by the United States Treasury Department.

These moves were a dramatic departure from previous assessments of Nasreddin.

In April 2002, the Treasury Department had reported that Nasreddin operated a financial network providing support for terrorist activities through "an extensive conglomeration of businesses." Treasury stated without qualification that "Nasreddin's corporate holdings and financial network provide direct support for Nada and Bank Al Taqwa," themselves designated as terrorist financiers by the U.S. and the UN.

The Feds also said that Nasreddin held a controlling interest in the Bahamas-based Akida Bank, which it described as not being a functional banking institution but a shell company lacking a physical presence, and which had had its license revoked by the Bahamian government.

The libertarian's idea of foreign policy is more about America minding its own business. However, when they've identified a foreign policy objective, libertarians have no qualms about moving toward without the international approval that "neoconservatives" on the Right and their "progressive" reflections on the Left both seek.

Libertarians have no qualms about defending American commercial interests abroad—whether that means oil or computers or bank accounts. This is one of the essential functions of a free state. Libertarians refer back to George Washington's *Farewell Address* for foreign policy advice. And Washington made it plain that business interests were the legitimate basis for a country's foreign policy.

The United States has the military means to topple totalitarian governments; but this doesn't mean it is obligated to trot the globe looking for well-intended fights. Knocking off one tyrant accomplishes nothing if the unintended consequence of a more-corrupt government emerges in his place.

No Nation-building

A libertarian is a person whose most important value is individual liberty. From this perspective, war may be necessary on occasion—but a free state should come at it slowly and deliberately. It should stand against many of the promiscuous notions of war (including "wars" on social ills like drug abuse or poverty...or diseases).

The most futile foreign policy end, often used to justify ill-advised military action, is so-called "nation-building." This terms for wasting money and human life was coined in the 1960s, as an effort to make sense of American foreign policy in Vietnam and Southeast Asia. The term was intended to be used ironically, a skeptical take on statist ambitions abroad.

A greater irony followed when neocon foreign policy advisors surrounding George W. Bush seized the term to justify their adventures in Iraq—and failed to understand the skepticism in its original use.

A nation should emerge organically from the citizens who comprise it. A nation can't be built from without.

Don't let the doltish policy wonks grind down the irony. The concept of nation-building is inherently condescending, a modernized twist on the "White Man's Burden" (a phrase which Rudyard Kipling, likewise, meant to be ironic).

Why are policy wonks so dense about the words they use? Because they're usually statists; and statists lack perspective and wisdom. They're limited by the collectivist impulse to think in terms of the group, rather than the individuals who compose a group—and this is humorless, unironic stuff.

Worse still, the statist focus on the group plays into the hands of totalitarian leaders. Nothing promotes the sacrifice of the individual to the alleged "greater good" more than war. On these grounds, government leaders successfully levy confiscatory taxes, impose harsh regulations, seize private property, and even enslave their own country's citizens to serve as soldiers, to kill or be killed in hideous ways. *Dulce et decorum est.*

The best way to avoid these collectivist abuses is to have—and keep—clarity of purpose when engaging in war (or any other foreign policy action). Defensive actions have the best clarity; actions in defense of national assets or interests have some clarity.

Actions justified on the basis of nation-building, multilateral agreements or "peacekeeping" (and its various woolly-headed versions) has little clarity. And, usually, much mendacity.

Is FDR to Blame for Statist Foreign Policy?

Many libertarians blame Franklin D. Roosevelt for pushing America into socialism and statist in the 1930s and early 1940s. And FDR was pretty bad when it came to contempt for individual liberty; but, in fact, the trend started about 20 years before he was elected president.

World War I changed American politics. Woodrow Wilson engaged in what he called "wartime socialism" during that Great War. Wilson's socialism had (or *has* had) a long-lasting effect:

- Wilson's administration started the War Food Administration, which became the model for the Roosevelt's agriculture program—which plagues consumers and taxpayers to the current day.
- Wilson's Railway Administration led to a near-nationalization of the railroad industry in 1920.
- Wilson's War Finance Corporation continued to operate until 1925 and then came back to life as the Reconstruction Finance Corporation in 1932. Later, in the 1950s, it became the Small Business Administration.
- Wilson's War Industries Board transformed in 1933 into the National Recovery Administration. When the Supreme Court struck down the NRA's most radical experiments in socialism in 1935, the NRA split into several parts—including the still-operating National Labor Relations Board

Before World War I, the federal government had spent more $747 million in a single year only twice—during the Civil War; after World War I, annual spending rose above $2.8 billion—and never looked back.

During World War I, the national debt jumped from just over $1 billion to more than $25 billion.

Starting in 1932, Roosevelt expanded on the program that Wilson had started. And his management of World War II, though militarily effective, brought Wilson's socialism to the American middle class.

Before World War II, fewer than 15 million people had to file an income-tax return; in 1945, approximately 50 million had to do so. The bottom income tax bracket rose from 4.4 percent on income in excess of $4,000 in 1940 to 23 percent on income in excess of $2,000 in 1945.

Withholding payroll income tax, which Roosevelt had imposed midway through World War II as a temporary policy ... wasn't temporary. It has become a central part of the federal government's tax infrastructure. (In the meantime, the national debt jumped from $54 billion in 1940 to $260 billion in 1945.)

Businessmen who had played roles in Roosevelt's wartime economic planning emerged from the experience with a taste for en "ordered economic world." They brought home an appreciation that government could provide a bottomless reservoir of subsidies, cozy deals and other spoils.

These businessmen came back from World War II with a bad case of what Friedrich Hayek famously called "**the fatal conceit**," the fallacious idea that central planners can produce a better social outcome than the free market.

This acceptance of government interference—which business has traditionally opposed—planted the seeds of the corporate welfare that would become a big part of the U.S. economy in the post-World War II era.

Terrorism and Misuse of the Word "War"

Statists welcome war because it allows them to trammel individuals' rights. As in Orwell's *1984*, the state creates discord in order to advance its interests. It's no accident that, in Orwell's great book, the most emphatic lies Oceania's government told its citizens involved its ongoing wars against Eurasia and Eastasia.

Following this logic, you can see why terrorism works so well as the enabling threat for statist foreign policy. Big Brother doesn't have lie so drastically about being at war—and *always having been* at war—with one enemy, then another. Since terrorist organizations are, by their nature, multinational, they're difficult to define, locate or engage. And this suits the changing needs of the statist apparatus.

The expression "war on terrorism," is as misleading as the expressions "war on poverty" and "war on drugs."

In the United States, the government can't wage a domestic "war"—or at least not without disregarding the Constitution. Domestic war and domestic law can't coexist in a constitutionally based legal framework.

The government can make changes in national security policy. It can encourage citizens to participate and assist with this new policy. It can commit resources and energy to achieve its policy ends. But none of that is "war."

Calling state policy "war" is condescending to the American people. It implies that they should expect to give up their liberties for the duration of "war."

To the extent that there's any "genius" to terrorism, it's *subversion*. Terrorists exploit or hide behind the legal and social protections that liberty offers in an attempt turn liberty against itself. This reaches back to the totalitarian dictator Nikita Khruschev—who said that his communist Russian would hang the western democracies...with rope that the democracies themselves would provide.

Some criminals mock constitutional protections America's system offers—and, if those criminals are armed with weapons of mass destruction, they can try to bring down the American political system by violent means. So, how does a libertarian nation deal with terrorists determined to destroy it?

Said another way: Are terrorists criminals? Or enemy combatants in a war? Or something altogether different?

The American Right has made the argument that terrorists are a special breed of enemy combatant—with neither the rights of a citizen or resident under America's system of criminal law nor the rights of conventional prisoners or war. (The W. Bush administration stumbled around this argument for years after the 9/11 attacks.) The American Left has, generally, argued that terrorists are criminals—and that terrorist attacks are simply a law enforcement matter.

Neither approach is effective or in keeping with American notions of liberty.

William Rehnquist (a "conservative" U.S. Supreme Court justice who showed a poor sense of limited government) famously wrote "The Constitution isn't a suicide pact." This argument appeals to the simplistic impulses of common sense. But it allows for all kinds of abuse—both by terrorists and the statists who oppose them.

Rehnquist should have remembered, if he'd eve known, that a free state understands absolute liberty and absolute security can't coexist. Because absolute security *doesn't* exist.

Liberty entails risk. Efforts to create a zero-risk existence are foolish and futile. Just as a dedicated criminal can invade your home, a dedicated terrorist can hijack the commercial jetliner you board. You can take steps to minimize these risks; and you can train yourself to respond actively if they occur. But you can't *prevent* them; and neither can the state. The local police can't patrol every home; the TSA can't vet every passenger.

If it means anything, liberty means that every citizen has to be able and inclined to make his or her own decisions about risk, safety and which jetliner he or she will board. And, faced with a terrorist act, he or she needs to act as a free citizen of a state that values individual liberty.

The passengers aboard United Airlines Flight 93 on 9/11 serve as an example and inspiration in this context because they—or at least some among them—acted as free citizens of a state that valued liberty. Confronted with fascist punks hijacking their flight, those passengers organized an ad hoc program to interrupt the hijacking. And did so. They rejected the terrorists ultimatums and ran the jet into the ground. If only the passengers on the other planes hijacked on 9/11 had acted so well....

Foreign Adventures: Al Queda, Afghanistan, Iraq, etc.

A free state should respect other people's rights to select their own regimes. A committed libertarian will believe in the marketplace of governments—people will vote with their feet or their guns if a government becomes too abusive of its citizens.

A libertarian nation follows what contemporary wonks would call an isolationist foreign policy. It would stay out of foreign disputes unless American citizens or financial interests were directly affected.

Sadly, American governments (like most other governments) since the 1940s have taken a more statist approach. When they see other countries violating parochial notions of "human rights," they interfere. Sometimes with envoys, sometimes with soldiers. This has been the consistent theme from America's entry into World War II through W. Bush's Second Gulf War.

The baying on the idiot end of the American Left that W. Bush should have been impeached or tried for "war crimes" because of his actions in the Persian Gulf region is a symptom of how stupid statists have become.

Whether operating on faulty intelligence or duplicitously pursuing a long-standing plan to avenge his father's geopolitical losses, W. had the permission of Congress to proceed with his military adventures in Afghanistan and Iraq. He was on firmer ground, legally, than Jack Kennedy and Lyndon Johnson were in Vietnam.

So, W. was within his rights to send the troops where he did; whether his actions were *wise* is another matter. They weren't.

W. Bush could have carved out a bold position for the United States to hold in the new world—a world in which national borders weren't as important as they'd been. Carving out this bold position would have required rejecting the multilateralism of groups like the United Nations and emphasizing America's ability to act unilaterally to protect itself, its citizens and its citizens' property.

W. wasn't up to this challenge.

He did come tantalizingly close to putting it right during his well-received speech immediately after the 9/11 attacks. In that speech, he rightly described al Queda as an unconventional enemy:

> *These terrorists kill not merely to end lives, but to disrupt and end a way of life. With every atrocity, they hope that America grows fearful, retreating from the world and forsaking our friends. ... We have seen their kind before. They're the heirs of all the murderous ideologies of the 20th century. By sacrificing human life to serve their radical visions, by abandoning every value except the will to power, they follow in the path of fascism, Nazism and totalitarianism. ... We're in a fight for our principles, and our first responsibility is to live by them. ... As long as the United States of America is determined and strong, this will not be an age of terror. This will be an age of liberty*

It was a pretty good speech, from a man not known for giving them. If his administration had lived up to the spirit of those words, Americans might be in a different—and better—place that they are some eight years later.

Instead, W. Bush's administration *did* grow fearful and retreated from large portions of the world. It sold out to statism (which may have been a comfortable and familiar trade-off, anyway) and began corralling individual liberty.

This is a recognizable, and predictable, pattern of behavior among the statists who gather like barnacles on the underside of the U.S. government.

Al Queda's tactical successes in the early 2000s follow from a crude but effective understanding of the patterns of statist behavior in the West. It understands statism because it is, at core, a statist organization itself. Its leaders hope their version of fascism (tinted with religious extremism) will fill the vacuum of power left after the end of the Cold War. And, with the bumbling and unintended help of statists in the W. Bush and Obama administrations, they've achieved more than their numbers or slapdash philosophy deserve.

How can a rational libertarian counteract so much bumbling and so many unintended consequences? First, see past al Queda's tint of religion and recognize its totalitarian nature. Some mainstream politicians know this and try to emphasize al Queda's true nature by describing is as an "Islamofascist" group.

But that phrase still puts "Islamo" first. Better to drop it altogether; al Queda's version of Islam doesn't deserve the name. Its political philosophy is dehumanizing—totalitarian, in a medieval manner. It enslaves women and kills people who live what it considers godless lives.

While the West was mired in its medieval ignorance, Islam was flourishing intellectually. As most students of history know, Islamic scholars helped preserve Greek and Roman writers (and, arguably, the Western traditions that produced modern liberalism) from religious purges of the Middle Ages. Libertarians have Islam to thank for this.

Al Queda's world view isn't particularly Islamic. It's childish statism. Totalitarianism. A tantrum thrown by insecure men who hate the idea of individual liberty. For anyone except themselves.

Instead, W. Bush and Barack Obama have pursued a patchwork policy that satisfies no one. They speak of building coalitions among

Western powers—but abandoned this idea when those powers questioned American strategies and tactics. Bush tried to justify his invasion of Iraq in legalistic terms, which invited legalistic scrutiny of his justifications. They didn't stand up.

Bush should positioned the United States against al Queda's fascist nature, rather than against specific countries or leaders. He should have stated simply, from the start, that he would protect the commercial and financial interests of U.S. citizens and corporations; he could have staked out this position with or without international cooperation. Political consensus would have followed him.

Bush erred in many ways; but one of the most important was that he tried to rationalize his impulse to war. This rationalization is a common thing among minor world leaders. It's a fool's errand.

War is never rational. It's never humane. It's ugly, bloody business that should be avoided at all costs. But, when it can't be avoided, there's no reason to pretend it's something as feckless as a college colloquium on feminist literary theory. War should be prosecuted brutally, powerfully…and quickly.

Immigration

Debates over American policy in Iraq, Afghanistan, Darfur or other hotspots are really trivial when compared to the foreign policy (and domestic security) issue that strikes closer to home—namely, U.S. immigration policy. This is the issue that a free nation must answer before it tries to influence the actions of far-away places.

The key part of understanding the immigration issue is that we should *want* people to come in…politics that focuses on keeping people out is statist and regulatory. Instead, we should focus on the how we can let the greatest number of people.

Also, we're going to need either more immigrants or a lot more babies to support the Social Security redistribution scheme.

People are an asset; and people's migration patterns are an indicator. Having people want to come to your country is a critical measure of its validity and legitimacy. Turning those people away at the gate is self-defeating, a kind of self-imposed tariff. It's dumb.

Politicians acknowledge the importance of human capital—but don't always understand what they are admitting. One ripe example of this confusion: In a July 2006 interview with the Rockford (Ill.) *Register Star*, Sen. Dick Durbin said:

I would oppose just opening the borders at this point. We now have between 400,000 and 800,000 coming across our southern border illegally each year. That number would increase. ... It's not just Mexicans; it's Central Americans, South Americans, many others ... come through Mexico into the U.S. The first thing we have to do is bring the border under control. That means not only border enforcement, but also workplace enforcement. What draws them here is jobs.

That last statement is right. Immigrants are drawn to the U.S. by jobs. Everything else Durbin said is—how to put this fairly?—stupid.

People are drawn to a nation because it has jobs. So, the Senator wants to increase the barriers those people have to clear to get the jobs. Demand for low-cost labor in the U.S. greater than the supply; so, the Honorable Gentleman is going to use statist measures reduce the supply further. He's smarter than the marketplace and the marketplace better obey him. He's a U.S. Senator!

Durbin's ignorance of U.S. immigration history is shocking. But perhaps it shouldn't be. Few Americans have any knowledge of sense of the country's history on this issue.

In fact, the United States had no quantitative immigration laws until 1921. It had no qualitative laws until 1875, when convicts and prostitutes were barred. "Mental defectives" and Chinese were barred in 1882—mental defectives because the country didn't want to import wards of the state and Chinese because they worked too hard and had too many kids; they were the fastest-growing segment of the population in some West Coast cities. This scared some people in the East and South.

Today's closed-border advocates are the intellectual heirs of those bigots. Closed-border advocates argue that immigration swells the ranks of the working poor—who pay less in taxes than they receive in benefits. They also argue, less effectively, that a nation's cultural fabric is fragile and must be protected from demographic stresses that might destroy it.

Let's rebut these arguments in reverse order.

A nation's culture (like its economy and politics) follows from its founding principles. America's founding principles value individual liberty, a limited state and free market economic policies. American culture follows from these first things. This can change gradually over time; but it's not easy to change it immediately.

At the nation's founding, that culture was based on Western European Protestant lineage, classical education and agricultural. A hundred years later, that culture had changed. It was industrial and urban; it had absorbed significant Catholic and Jewish influences. Its education was more technical than philosophical.

Two hundred and thirty years later, American culture has changed again. It's focused on information and entertainment, of little specific (or well-developed) religious orientation and intensely consumerist. It has absorbed Asian and Hispanic influences. A hundred years from today, that culture will have changed again.

But it's not at risk of being destroyed by immigrant hordes.

A nation's culture exists on a parallel track with its economy and politics. While each influences the others, none of those three attributes controls the equation. People who try to use one national attribute to control the others—or the nation, in general—are usually statists; and they often end up slipping down bloody paths to bogus "economic reforms," cracked notions of "cultural purity" and violent "ethnic cleansing." So, a rational libertarian need not fret about cultural demise. Culture is a liquid thing; it's *always* changing.

Do Immigrants Use More than They Produce?

What about the argument that immigrants use up more in government resources than they generate in tax revenues? It fails in two ways.

First, the numbers don't seem to bear out the theory. There's a lot of cant and political spin in the gathering of data and calculation of government benefits claimed and taxes paid by immigrants to the U.S. The idea that "illegal" aliens take more than they pay makes sense to many people on a common-sense level. After all, they usually don't pay income or payroll taxes; and they seem to be on the dole as much as other ethnic groups.

But this "common sense" conclusion may not make so much sense in fact. As a result of welfare reforms signed into law by Bill Clinton in the late 1990s, the benefits available to illegal immigrants in the U.S. were limited to emergency room medical care and K-12 education. Of course, these limits do not apply to children of illegal immigrants born in the U.S.; those children are born citizens.

At the same time, the Washington, D.C.-based Urban Institute has estimated, approximately two thirds of immigrants pay some

form of income, Medicare or Social Security taxes. And that statistic probably understates their total tax contributions. Even if the immigrants who clean your office or mow your lawn don't pay payroll taxes, they do pay sales taxes and property taxes (directly or indirectly, through their rent).

Again, these numbers—like most numbers thrown around in the immigration debate—are disputable. And disputed. In 2004, the Center for Immigration Studies published an often-cited study called *The High Cost of Cheap Labor* that concluded:

> *when all taxes paid (direct and indirect) and all costs are considered, illegal households created a net fiscal deficit at the federal level of more than $10 billion in 2002. ...contrary to the perceptions that illegal aliens don't pay payroll taxes, we estimate that more than half of illegals work "on the books." On average, illegal households pay more than $4,200 a year in all forms of federal taxes. Unfortunately, they impose costs of $6,950 per household.*

Ultimately, though, it doesn't matter which side has that statistics right; the best argument against the "welfare-cheat" immigrant stereotype doesn't need statistical support.

Assume the economic worst about immigrants—that they take more in state benefits than they pay in taxes. Assume that they come to the U.S. to take advantage of the social welfare system. Assume that they are a subsidy-seeking market distortion instead of a market indicator. Assume all of this is true. The nation's response should be to build a big wall around the benefits to keep newcomers out?

Won't that amount to greater scarcity of government benefits ... and, in result, even more intense demand for them?

The simpler solution, assuming the economic worst about immigrants, would be to reduce their incentive to immigrate by reducing the spoils and subsidies they seek. Reduce social welfare benefits for immigrants (and maybe for everyone).

The problem with "illegal" immigration to the United States isn't the immigrants. It's the "legal" part—specifically, the welfare state.

The relationship between the American welfare state and its troubled immigration policy is closer than most citizens realize; and it's resulted in all kinds of unintended consequences. Most important: The welfare state creates inefficiencies in the labor market, driving up labor costs and making work in the U.S. more attractive to workers

from other places. So, the inflow of workers (legal and not) is boosted higher than it would otherwise be. Statist policy makers then propose immigration laws—really, just import restrictions on labor—as the solution to the problem they created in the first place.

Immigration restrictions are, among other bad things, an erosion of individual property rights. The work you do in a day is your property; in all but the most depressed economies, it has a marketable value. Laws that limit how a man who's come to Los Angeles from Guatemala City can sell his labor are, simply, statist takings.

Elitism at the Core of Closed Border Arguments

Even if America cuts the size and scope of its welfare state, there will still be an influx of workers. The growing populations of Mexico and other developing countries, combined with an aging U.S. population, produce a market demand for labor in the States and a push of supply from the developing countries. The practical result: Through the 1990s, an average of nearly 300,000 workers arrived in the U.S. from Mexico each year.

As the U.S. becomes poorer and the developed countries (relatively) wealthier, this influx will slow. But it's likely to remain for decades to come.

Immigrants aren't slackers; in fact, their migration can be seen as a sort of human capital flight. The labor force participation rate of illegal immigrant men is 94 percent (that compares with rates of under 50 percent for American men without high school diplomas).

Who, other than statist politicians and bureaucrats, is for immigration restrictions? Racists. And labor unions. Some so-called "white supremicists" want walls up along the Mexican border because they don't want more people with brown skin moving north. Labor unions, seeking spoils for their members, want walls up along the Mexican border because they believe Americans should not have to compete for jobs—and are entitled to a higher income than workers in other countries.

In a free state, immigrants should have the same property rights as natural-born citizens. In the United States, we enforce the rights of immigrants in a scattershot manner. Our immigration policies have the effect of limiting immigrants' rights to own and sell property; these policies deny their individuality and erode the personal liberties assured all people by the U.S. Constitution.

Finally, there is a definite stink of elitism to U.S. immigration policy. The scheme comes with loopholes that allow certain categories of workers with "in demand" skills to jump ahead of everyone else waiting for "legal" immigration. The in-demand jobs include doctors, engineers, computer scientists and bankers. So, most of the arguments for immigration restrictions are really arguments against letting poor and unskilled people into the country.

Of course, doctors and entrepreneurs earn more money, do more business and generate more tax revenues than janitors, farm workers or yard men.

Does this mean that U.S. immigration policy (or any country's immigration policy) should be stacked against janitors, farm workers and yard men?

Stacking the policy this way creates an institutionally discriminatory system. Educated professionals can migrate more easily; unskilled laborers are kept in an "illegal" limbo of quasi-servitude. Surely, the founders did not envision this.

Some rational libertarians allow for some restrictions on immigration; they argue that the right to *im*migrate and the right to *e*migrate are not the same. They say that a free state must allow any citizen who wishes to leave; but a free state doesn't have to welcome any person who arrives. And, invariably, they bring up the Mariel "boat lift" of 1980—when Fidel Castro "allowed" the inmates of his overcrowded prisons and mental asylums to "emigrate" to the U.S.

The federal government, headed at that time by the hapless Jimmy Carter, didn't know what to do. And let most of the "Marielitos" (many of whom were violent or mentally-ill wards of the state) stay in Florida facilities that resembled concentration camps. Not a high moment, either in terms of idealism or *realpolitik*, for the U.S.

The "closed-border" libertarians raise legitimate points. Even a free nation may have national security and foreign policy interests in applying some modest restrictions on immigration.

During the 18th and 19th Centuries, when the U.S. had an "open borders" immigration policy, people with communicable illnesses, mental defects or proven criminal histories were quarantined or turned away.

But the more important point, today, is that statists frame the immigration debate in the false choice between open immigration

and the welfare state. Americans have another choice. Disassemble the welfare state and let more people in. Legally.

Inept Regulation: Terror Watch Lists

In the years since the attacks of 9/11/2001, much mischief has been made in the name of security. And entire, unnecessary governmental department—the Department of Homeland Security—was crated in short order after the attacks. The ineptitude of this new bureaucracy, particularly its Transportation Safety Administration (TSA) and Immigration/Customs Enforcement (ICE) units, has been widely reported.

The TSA, responsible for airport security in the U.S., is also responsible for the OFAC—the "watchlist" that's supposed to keep suspected terrorists off of airplanes. Implementation of this list has been…controversial.

At the broadest conceptual level, the TSA was unclear about the purpose of the watch list. Some offices claimed it was a "hard" list, meant to keep people out of the air; other offices said it was a "soft" list merely intended to flag certain people for closer scrutiny at security check points.

Then, there were technical implementation problems. When TSA assembled the various separate databases into the master watch list, some data fields transferred erratically. The result was a buggy system that produced false negatives (in other words, it failed to find names that should have come up). Consultants hired to fix this problem ended up duplicating some fields, which resulted in multiple positive responses. In other words, the pendulum of dysfunction swung from one extreme to the other.

Why the manic swings? Databases—whatever their content— always have to trade off between two types of statistical search errors: Type I (false positive result) and Type II (false negative result). So, people or agencies using databases like the OFAC watch list have to decide whether to err on the side of ensnaring the innocent or on the side of missing the guilty. This has been an issue for state agencies since the founding of the United States. Thomas Jefferson famously wrote that he would rather see a hundred guilty men go free than wrongly imprison one innocent man.

Another problem: No one knew how to use the OFAC list. Stuart Pratt, president of the Consumer Data Industry Association, said

Homeland Security didn't give subagencies and other parties adequate guidance on how to determine what constituted a name match: "Do you match just on the last name, on the first name, on the first name and middle initial?"

In the meantime, the watch list was used for more than just keeping people off planes (or not). Some private-sector companies were encouraged by sections of the USA Patriot Act to perform background checks on prospective employees that included asking credit bureaus who, in turn, asked Homeland Security whether the person's name appeared on the OFAC list.

These multi-party transactions were easily confused. A person whose name was similar to a name on the watchlist would sometimes be flagged by credit bureaus—who claimed that problems lay with the government reports full of false positives.

Some consumer advocacy groups claimed that, once the credit bureaus started handling OFAC data, they included it basic credit reports related to things like car loans or apartment rentals. And OFAC data wasn't supposed to be used for that.

The CDIA's Pratt said that private-sector creditors, lenders and employers knew even less that government agencies (who didn't know much) what to do if they *did* get a name match. "Clearly OFAC would say, you don't stop the transaction," he said. "You just look for a way to validate the consumer's identity." But CDIA experts worried that the easier response might be terminate the deal ... or not hire the potential employee.

Worse still, said Thomas Burke of The Lawyers Committee for Civil Rights, "There isn't a program [of redress]. There isn't an ombudsman. There isn't a procedure to help consumers clear their names."

How else could it be? The bureaucrats building the OFAC terror watch lists only were punished if they produced Type II—false negative—errors. So, they had no incentive to avoid Type I errors. Which is why they created easy procedures to put people's names on the list but no obvious way to remove them again.

Logic suggests that a massive database that government agencies aren't good at maintaining and no one's sure how to use would not thrive. But, by one simple metric, the OFAC list did. It kept growing.

But late February 2008, the Department of Homeland Security announced—with an inappropriate tone of positive achievement—

that the watchlist had grown to include more than 900,000 names. With no firm guidelines for use and no institutional check on its expansion, the list was bound to grow. People's thoughts about the "terrorist watch list" was, basically, better safe than sorry.

In March 2008, even Atlantic.com columnist (and self-styled libertarian) Megan McArdle wrote:

> *Terrorist watch lists are probably a good idea. But because the government is, well, the government, it doesn't really care whether the watch list is right. Their incentive is to make sure that absolutely nobody who might be a terrorist is able to do absolutely anything in the US.*

McArdle is a witty writer on many matters; and libertarians generally regard her as one of their own. But her thoughts on the OFAC watch list was self-contradicting. It is precisely because the government is the government that "terrorists watch lists" probably *aren't* a good idea.

If the OFAC watch list must exist, its mission should be clearly defined (on both conceptual and technical levels) by an agency more responsive to citizens than the Department of Homeland Security. There should be high standards placing names on it. And there should be a clear and structured process for removing names from it.

U.S. courts require warrants for government agencies to execute a searches of people's homes. Over time, Americans have developed a sophisticated understanding of what state agents have to show before they can search private property. Names are, among other things, private property; but they are treated with less respect, legally.

The state should have to meet a standard of proof at least as high as for a search warrant in order to enter a citizen's name one a "terror watch" database.

The Best Defense

Massive, centralized databases are a long way removed form personal security. So are global gatherings of statist diplomats in fancy resort towns. These things are like mirror images of mirror images of security—a needlessly complicated apparatus whose main purpose seems to be keeping bureaucrats employed.

What would help with personal security? The reality (or merely the prospect) of most Americans being armed.

The al Queda operatives who executed the September 2001 attacks on the United State chose commercial airliners as their immediate targets precisely because they knew the passengers on board would be unarmed and counting on others to provide security.

Seung-Hui Cho, a warped little man who killed 32 fellow students at Virginia Tech in April 2007 seemed to have thought the same way. He knew that students on campus to be unarmed and counting on others (namely, the university's private security forces) to provide security. He was able to kill so many because no so few so few were prepared to protect themselves.

This needs to change. While it may be impractical to allow armed passengers on commercial airplanes (armed law enforcement officers are another matter), students and staff on universities should be allowed and even encouraged to arm themselves. If more were, fewer would become victims of psychopaths.

If the suggestion that institutions encourage people to arm themselves sounds strange to you, you've been listening to too many statists.

America's founders believed strongly that an armed populace was the best deterrence to statist tyranny…and basic crimes.

The founders knew something that few citizens today do: Police are reactive. They come to your house after a crime is committed, investigate and do their best to bring the people who wronged you to justice. The police have little capacity to protect you against a crime that hasn't happened. You have to manage that for yourself.

Thomas Jefferson, far from the most militant of the founders, wrote in a collection of essays he called *The Commonplace Book*:

Laws that forbid the carrying of arms…disarm only those who are neither inclined nor determined to commit crimes…. Such laws make things worse for the assaulted and better for the assailants; they serve rather to encourage than to prevent homicides, for an unarmed man may be attacked with greater confidence than an armed man.

These words, more than 200 years old, effectively refute most of the gun control arguments that are made in the 2000s.

Statists who want to erode the right of free citizens to bear arms argue that the Second Amendment protects a collective right, not an individual one. Pressed, they may retreat to the argument that—while

the right to bear arms may apply to individuals—it only exists with predicate of a collective state right to keep that well-ordered militia.

One useful way to see through all of this cant is to think of all Americans as members of a large, informal militia. (This is how many of the founders thought of citizens…and militias.) The mere chance that many Americans are armed and proficient with their guns prevents the government from acting too arrogantly.

The idea of an informal militia has some practical application. On 9/11, when the passengers on hijacked United Flight 93 learned (from those among them who had cell phones) what had happened on the other planes, they organized and took action.

Realizing that their plane was heading for a suicide run on Washington, D.C., the passengers on United 93 rushed the cockpit and forced the plane into the ground in rural Pennsylvania. This was true heroism. The jet was stopped from reaching its target—but not by the Army, Navy or Air Force. Not by armed law enforcement officers. It was stopped by an informal militia of citizens.

Only an armed citizenry can be present in sufficient numbers to prevent or deter violent crime before it starts…or to reduce its spread.

Libertarians believe that every American has the right to decide how best to protect himself, his family and his property. This right to self ownership is pivotal for any libertarian; when the self that you own is in danger, you must be able to protect yourself. Laws that work against that ability do not serve individual citizens.

Gun control advocates believe the state can lower the rate of violent crime. They look at the facts: firearms are used in about two thirds of all murders. They reach a hasty conclusion: Get rid of the guns, and you can get rid of violent gun crime. This is a flawed approach.

Criminals like guns because they are lethal and convenient. The guns are lethal, but the criminal is the dangerous part. His gun isn't the problem, his *criminal behavior* is.

Bloody Consequences of Bad, Statist Law

The experience of Washington D.C. after its city council enacted a sweeping gun control law in 1976 offers a bloody example of unintended consequences. Between 1976 and 1991, D.C.'s annual

homicide rate rose 200 percent while the rate for the rest of the U.S. rose only 12 percent.

Finally, in late 2008, D.C.'s experiment in extreme statism was ordered to an end by the U.S. Supreme Court. In that decision, *District of Columbia et al. v. Heller*, the High Court ruled that the District's gun control laws were unconstitutional.

Writing for the five-person majority, Justice Antonin Scalia concluded clearly:

> *The Second Amendment guarantees an individual's right to possess a firearm unconnected with service in a militia, and to use that arm for traditionally lawful purposes, such as self-defense within the home.*

The decision was a good one for libertarians and anyone who loves liberty. The Second Amendment is America's bulwark against totalitarianism. And socialism.

In general, fewer laws against gun sales, ownership or possession makes people a little safer.

According to the U.S. Federal Bureau of Investigation report Crime in the United States 2003, the violent crime rates in states with so-called "right to carry" laws (the most encouraging of gun ownership among citizens) were lower than in states which restricted gun ownership. Specifically, murder rates were 32 percent lower in right to carry states; robberies were 45 percent lower.

Criminals are opportunistic; a burglar will think twice when approaching a house with a sign in the window reading, "this house is protected by Smith & Wesson." A responsible, well-armed and trained citizenry is the best protection against domestic crime.

And they may be the best foriegn policy tool a nation can have.

In the great film *Casablanca*, the villainous Major Strasser asks the antihero Rick Blaine what he would think of the Nazi army marching on Manhattan. Blaine answers, "Major, there are some parts of New York where even the Third Reich will be afraid to go."

The film's screenwriters probably didn't mean it this way, but Blaine's line sounds like the beginning of a libertarian foreign policy.

Chapter 11:

Ron Paul, James Watson and the Stink of Racism

The libertarian movement in the U.S. has been hindered by connections to some bigoted and racist individuals. These bad ties cropped up during—and effectively killed—Rep. Ron Paul's run for the Republican presidential nomination in 2008.

Just as Paul was assembling the money and votes to break out from the ranks of minor candidates, *The New Republic* magazine ran a story that drew attention to several columns that had appeared in newsletters published by Paul some 25 years earlier. The newsletter columns—which had not been written by Paul—included ham-fisted and bigoted comments about the voting habits of American "blacks."

The kooky columns weren't really news; other mainstream media outlets—notably, *Texas Monthly* magazine—had mentioned them in previous coverage of Paul. But the timing was critical. His bid for the GOP nomination faltered and never recovered.

Paul had strongly condemned all forms of institutional bigotry— pointing out the racist aspects of the War on Drugs, police brutality and capital punishment regularly on the campaign trail.

His diligence didn't undo the guilt by association.

Before the libertarian movement can move into the American political mainstream, it needs to shake off its ties to the racist kooks who loiter around its fringes. That may be difficult. Establishment political parties and their allies in the mainstream media use the stink of racism to keep libertarians stuck on the political margins. They don't like honest, idealist talk of a color-blind society.

The mainstream media's interest in the racist kooks seems to be a kind of punishment for the optimistic way that libertarians talk about public policy issues (including race) in America. Statists in the U.S. seem to believe that everyone should be nervous and defensive, especially when discussing the color of people's skin.

Nervous, defensive people are easy to control. Libertarians aren't.

A clear and wretched example of this statist manipulation came in the Fall of 2007, when renowned biologist James Watson was tarred with the brush of racism over comments that he made about the relative aptitudes of different groups.

Watson, a Nobel Prize winner and the former head of the Human Genome Project, gave an interview to the *Times of London* in October 2007, in connection with a speech he was scheduled to give at the Science Museum in London. According to the *Times*:

> [*Watson*] *is "inherently gloomy about the prospect of Africa" because "all our social policies are based on the fact that their intelligence is the same as ours—whereas all the testing says not really", and I know that this "hot potato" is going to be difficult to address.*
>
> *"...there is no firm reason to anticipate that the intellectual capacities of peoples geographically separated in their evolution should prove to have evolved identically. Our wanting to reserve equal powers of reason as some universal heritage of humanity will not be enough to make it so."*

Watson claimed that standardized testing had shown consistently lower intelligence scores among African people than among Europeans. And that there was some evidence that the difference might be at least in part genetic. This was an outrage to statist sensibilities; genes can't be controlled by public policy. Media outlets in both the U.K. and the U.S. dissected Watson's comments, demanded retraction and called for professional shunning of the esteemed scientist.

The Science Museum canceled Watson's scheduled speech—and added the unnecessary step of commenting that his claims were not only scientifically false but outside the realm of acceptable inquiry. In a statement, a Science Museum spokesperson said:

> *We know that eminent scientists can sometimes say things that cause controversy and the Science Museum does not shy away from debating controversial topics. However, the Science Museum feels that Nobel Prize winner James Watson's recent comments have gone beyond the point of acceptable debate....*

There's an old saying among people who study rhetoric: Everything before the "however" is false.

One thing was missing from the controversy: Any factual refutation of Watson's offending comments. There couldn't be. Watson's comments were true and valid. In a November 2007 article in the Internet magazine Slate.com, columnist William Saletan noted:

> *Tests do show an IQ deficit, not just for Africans relative to Europeans, but for Europeans relative to Asians. Economic and cultural theories have failed to explain most of the pattern, and there's strong preliminary evidence that part of it is genetic.*
>
> *It's time to prepare for the possibility that equality of intelligence, in the sense of racial averages on tests, will turn out not to be true. …Around the world, studies find the same general pattern…. White populations in Australia, Canada, Europe, New Zealand, South Africa, and the United States score closer to one another than to the worldwide black average. It's been that way for at least a century. …The lowest black IQ averages in the United States show up in the South, where the rate of genetic blending is lowest.*

(Saleton and other *bien pensant* commentators used the terms "racial" and "genetic" interchangeably, implying that they are the same. They aren't, exactly. More on this point later.)

The outrage over Watson's comments and less hysterical contempt for Saleton's illustrate a fundamental point: Candid talk about genetic tendencies matter most to those who see people primarily as members of groups. If you see people as individuals first, group traits are of relatively little importance. And what James Watson said doesn't matter much.

Watson had a problem because the media and government elite shared a statist view that sees people as group members first and most. The story was too rich for hacks to resist: An eminent, older white male said things that emotional morons would misconstrue as racism. For statists, the imbroglio offered the chance to "prove" that even a Nobel laureate was subject to collectivist pieties.

Watson made a public statement apologizing and adding that his words had been subject to misinterpretation. He tried to clarify that claims about racial intelligence differences are not claims about human worth; the mainstream media reported, wrongly, that he'd recanted his claims about intelligence differences.

The statist establishment would make Watson's comments an admission of guilt, no matter what he actually said. *The New York*

Times asserted *twice* in separate reports that Watson had retracted his original statements about race and intelligence.

Here is an excerpt from Watson's statement, as quoted in the British newspaper *The Independent*, which gives a truer context to what he said:

> *To those who have drawn the inference from my words that Africa, as a continent, is somehow genetically inferior, I can only apologise unreservedly. That is not what I meant. More importantly from my point of view, there is no scientific basis for such a belief...*
> *The overwhelming desire of society today is to assume that equal powers of reason are a universal heritage of humanity.... To question this is not to give in to racism. This is not a discussion about superiority or inferiority, it is about seeking to understand differences, about why some of us are great musicians and others great engineers.*

But the damage was done—and beyond control. A few weeks after the initial interview appeared, Watson announced his retirement as chancellor at New York-based Cold Spring Harbor Laboratory.

The practiced outrage was an overreaction, of course. Watson's point—both in his initial interview and his later statements—was that questioning whether artificially-designated groups of people are equal in intelligence (or any characteristic) is not racism.

Also, Watson had made no claims of racial "superiority" or "inferiority," either in terms of intelligence or any other quality. He simply recognized that people of different genetic backgrounds, exhibit different aptitudes. But this line of reasoning was a shock to race-obsessed collectivists. They couldn't tolerate it.

There was irony in this. The explanation that best accounts for the differences in genetic group traits? Evolution.

Evolution is something that American statists champion, at least when it stands opposed to religious views of human origins. But, forced to choose between Darwin's theory and collectivist orthodoxy on "equality" (among groups, not individuals) of genetic aptitude, the statists abandoned evolution as not utopian enough.

How does a pragmatic libertarian navigate the white waters of discussions about evolution, genes, race and intelligence? Two ways. First, question whether race really exists. Second, question whether intelligence really exists. The best way to counter manipulative statist pieties is to obliterate their foundations.

Race Does Not Exist

The pigment of your skin and acidity of your hair don't have much to do with your personal identity. And they don't make you similar to or different than anyone else.

Race is a social construct. And an old one. The idea that people can be categorized into supposedly objective—or, more recently, "scientific"—groups has been around for as long as human civilization. It's always been subject manipulation, usually by the state. And its categories are always shifting, usually according to the political needs of the people *running* the state.

When the ancient Greeks spoke of the various races of man, they had in mind distinctions that would be invisible to modern eyes. Socrates seemed to consider Cretans a different and lesser race than mainland Greeks. (This launched 3,000 years of jokey connotation of the term "cretin.")

Some archaeologists may argue slavishly that there *were* racial differences between those populations; but their arguments split thin hairs. The Cretans and mainland Greeks were substantially alike. So, why the intense distinction? The archons of Athens stood to gain by convincing their citizens that they were substantively—racially—different than other people around them.

Contemporary notions of race are more ... contemporary ... than most people (even some Nobel Prize-winning biologists) realize. Skin color wasn't the controlling characteristic of race until the end of the 16th Century; and then it had something to do with slavery and something to do with the birth of colonialism.

The states that stood to profit from the import of cheap materials and slave labor began a 500-year campaign to convince the world that Africans with dark brown skin were a different class of humans than Europeans with lighter brown or pink skin. They defined "race" to suit their needs. And their campaign took hold. It shaped the first hundred years of the United States' history as an independent nation.

America's determined fairly early in its history as a nation that slavery was immoral—a denial of individual humanity. It took almost 100 years and a Civil War to formally end slavery in the U.S. And, even after slavery had been abolished, the notions of race that had enabled that "peculiar institution" lingered. And still linger.

All people are a mix of genetic traits. This fact raises various questions—and the dread of both hard-core racists who lament "mongrelization" *and* race-obsessed multiculturalists (who, intellectual brothers of the racists, are heavily invested in the notion of distinct racial identities).

This leads to an important question: What's the relationship between genes and race?

Most anthropologists and biologists agree that race is a fuzzy concept. By various estimates, 20 to 30 percent of the genes in the average "black" American come from light-skinned European stock. As *Time* magazine has noted: "science has no agreed-upon definition of 'race': however you slice up the population, the categories look pretty arbitrary." And, in a similar vein, the *Chicago Tribune* reported:

> In a 1998 "Statement on 'Race'," the American Anthropological Association concluded that ordinary notions of race have little value for biological research in part because of the relatively minor genetic differences among racial groups.

And, the anthropologists might have added, the broad genetic variation that exists *within* racial groups. In the *New Statesman* magazine, the often-quoted science writer Steven Rose pointed out:

> ...the idea that there is a genetically meaningful African "race" is nonsense. There is wide cultural and genetic diversity amongst African populations from south to north, from Ethiopians to Nigerians. There are, for example probably genetic as well as environmental reasons why Ethiopians make good marathon runners whereas Nigerians on the whole do not.

Adding its editorial voice to the chorus of outrage over James Watson's remarks, the normally statist British newspaper *The Guardian* stumbled to the same conclusion:

> Other scientists point out that our species is so young—Homo sapiens emerged from its African homeland only 100,000 years ago—that it simply has not had time to evolve any significant differences in intellectual capacity as its various groups of people have spread round the globe and settled in different regions. Only the most superficial differences—notably skin colour—separate the world's different population groupings. Underneath that skin, people are remarkably alike.

So, the libertarian notion of a color-blind society (often dismissed by statists as an unrealistic ideal) is closer to reality than advocates of identity politics—racists and multiculturalists—like to admit.

Said another way: Population ancestry predicts the patterns of an individual's genotypical and phenotypical traits (what people commonly think of as "racial" appearance and characteristics) while any single variable—for example, skin color—does not. It may seem counter-intuitive, but skin color is a *poor* indicator of race, which is itself a questionable social construct that serves as a kind of short-cut for putting individuals into groups.

So, why do Americans talk about skin color so much? Duplicitous public figures (some flat-out racists, some mulitculturalists, some bureaucrats who count on racism as a justification for their ambitions—all statist spoils-seekers) conflate race and ski color to manufacture support for their schemes. They want Americans to talk about skin color; it distracts everyone from more serious stuff.

Of course, none of this refutes the idea that broad categories of people exist. They're just a lot harder to recognize from a distances than statists would like.

The best explanation of "race" that I've found comes from a 2005 paper by University of Michigan geneticist Noah Rosenberg (and three coauthors) published in the journal *PLoS Genetics*:

> ...*In one of the most extensive of these studies to date, considering 1,056 individuals from 52 human populations, with each individual genotyped for 377 autosomal microsatellite markers, we found that individuals could be partitioned into six main genetic clusters, five of which corresponded to Africa, Europe and the part of Asia south and west of the Himalayas, East Asia, Oceania, and the Americas.*

It's a little dry, granted; but that's appropriate. "Race" is an artificial construct created to pigeon-hole people. You can assign categories, if you wish; but what real purpose does it serve? There's as much diversity *within* human "racial" groups as *among* them.

Evolution isn't intelligent or profound—profound traits take no more time to evolve than superficial traits. Skin color is a superficial trait, not a profound one; the fact that evolution caused differences in skin color doesn't make them profound. This may come as a shock to pious statists who consider evolution a kind of religion and Charles Darwin a secular saint.

So, back to Watson's talk of racial differences and the righteous indignation that followed: If race is a social construct, who was right? Watson, who raised questions of race and intelligence? Or his critics, who screeched that his assumptions were "beyond the point of acceptable debate." (Every time I type that phrase, it seems more despicable.)

The short answer is that Watson was less wrong; there are some connections between race and the concentration of various aptitudes. The more complete answer is that they were both wrong because they equated, either implicitly or explicitly, race with skin color.

Watson was more careful on this count than his critics. He usually limited his references to the definition of "race" used by most anthropologists Others staggered sloppily into equating race and skin color. Consider Slate.com's William Saletan column on the respective roles of money and "race" in test performance:

> ...then you have to explain why, on the SAT, white kids from households with annual incomes of $20,000 to $30,000 easily outscore black kids from households with annual incomes of $80,000 to $100,000. You also have to explain why, on IQ tests, white kids of parents with low incomes—and low IQs—outscore black kids of parents with high incomes and high IQs.

He went on to note that IQ studies of children of one race adopted by families of another showed the IQ gaps were reduced—but persisted. This suggested several unsurprising conclusions: better environments produce better results; mothers make a difference; and, despite society's best efforts, racial disparities in test performance exist. (The last point was the one that got Watson in trouble.)

These conclusions may be relevant to debate over social policy and education. But it needs to be the right debate. Saleton's definition of "race" seemed stuck on skin color; and that definition would turn a debate in the wrong direction.

Screaming about skin color enriches people like Al Sharpton and David Duke, but it doesn't add anything to a debate about the limits of the state's ability to change genetic traits and characteristics of various sub-populations.

William Saleton is a lucid writer and, by all accounts, a smart guy. And he missed the point. Imagine what happens when stupid people try to make arguments about "race." But you don't have to imagine:

Stupid people have been leading the debate about "race" in America for more than 40 years.

IQ Does Not Exist

You'll infuriate one set of people if you suggest that race doesn't exist. To keep things interesting, try telling another group of people that IQ doesn't exist, either. (The overlap of people who are infuriated by the both ideas—that race *and* IQ don't exist—should be instructive. And a group to avoid in polite company.)

Sociologists and developmental psychologists don't agree on how to define intelligence quotient (IQ)—or intelligence in general, for that matter. Is it academic book smarts? Is it practical street smarts? Is it intensity? Is it maturity?

Since the experts can't agree, they have created an abstract way to discuss intelligence that treats it as a mathematical variable. In algebraic style, they call intelligence—whatever specific combination of characteristics it entails—"g." And, then, they spend a lot of time limiting how g can be managed or developed.

But life is more than g. If you look past people's fears and biases, several basic truths emerge:

- IQ is not a very useful metric of, well, anything. It's cited most faithfully as a kind of statistical baseline by politicians pushing other agendas—usually related to race or gender.
- An individual's IQ can't be predicted from race, gender or most other demographic groupings.
- The IQ traits of genetic subgroups can't be predicted from race. Whites do not come out on top in an IQ hierarchy— Asians do.

Anthropologists don't have many reliable ways to study so-called "race" and so-called "IQ." Standardized tests and other easily-available metrics are assaulted as being biased in favor of certain subgroups (whose members produce the tests and, according to some theories, fill them unintentional favors to people like them).

The more you read about progress in things other than g, the more you wonder: Does g expose the limits of the progress? Or does the progress expose the limits of g? If the progress were on g, the test-takers' lives would be easier, since g helps you apply what you've learned to new contexts. But that doesn't make other kinds of progress meaningless.

People with low IQs can learn, subject by subject. And, in a narrow sense, they may have compensating advantages; they may approach new information with fewer flawed preconceptions than their brighter fellows.

Of course, one common objection to standardized IQ tests is that they are racially biased. This is true in the broadest sense: On average, African and Asian kids have different advantages, and IQ tests focus on the things at which more Asian kids have the edge.

But, as we've seen, people generally invest too much meaning in the term "race."

The August 2007 issue of the *European Journal of Personality* featured a paper titled "The g-factor of international cognitive ability comparisons: the homogeneity of results in PISA, TIMSS, PIRLS and IQ-tests across nations" by German psychologist Heiner Rindermann. The paper included an open peer commentary by 31 international scholars, as well as a response by Rindermann. The target paper provided some good IQ data from sub-Saharan Africa:

> *...Starting in the 1960s and picking up pace in the early 1990s various well-implemented student assessment tests have been conducted for the purposes of international educational comparisons, including the Trends in International Mathematics and Science Study (TIMSS), the International Educational Achievement (IEA) measures, and the OECD's Programme for International Student Assessment (PISA). The cross-cultural test construction, sampling techniques, and quality control for these tests are exemplary. These international tests have also included half a dozen sub-Saharan African countries, and the test construction and sampling techniques are likewise very good. For example Ghana, Botswana, and South Africa were included in TIMSS 2003. For each tested grade level, at least 5,000 random students from 150 schools were tested in these countries.*

Rindermann advanced his analysis by collecting data from 20 international student assessment tests encompassing some 78 countries and comparing them with measured IQ data from 128 countries. He concluded, first, that the combined national student results correlated almost exactly with the combined national IQ data (an almost-perfect correlation factor of 0.98), demonstrating the assessment scores and the IQ scores are the same measured construct.

Next, Rindermann examined the diverse data together through factor analysis and concluded that the g factor of intelligence explained some 95 percent of the variance in the test results. He emphasized that, consistent with previous IQ testing, the g-loaded international assessment tests revealed sub-Saharan African IQ scores that ranged from 1.5 to more than 2.5 standard deviations below European and East Asian norms. About this, he wrote:

> ... *I do not believe that the [sub-Saharan testing] scores at the general level are largely incorrect: The low values correspond to too many other variables and aspects standing for low cognitive abilities like results of student assessment....*

Thus typical African IQ scores of 70 and below can still be taken as a reliable finding. It is not simply the manufactured data of racist researchers or a by-product of inadequate testing procedures.

More important, from the standpoint of the Watson controversy, no reliable body of evidence has shown anything like parity with typical European scores. According to the 1996 book *The g Factor:*

> ...*In the US, consistent with the normal bell curve, there are proportionately about five times as many blacks (16%) with an IQ of 70 or below than there are whites (3%). But basically the same proportional number of whites and blacks are organically retarded (whites 1.5%, blacks 2.0%).*

African scores indicate that there were, proportionately, about 17 times as many sub-Saharan Africans with IQs below 70 (50 percent) than American whites—and possibly even more. While retardation may be somewhat higher among Africans, due to more challenging health conditions (including poor nutrition), this should not be regarded as a characteristic of their *normal* intelligence variation.

There is nothing particularly meaningful or necessary about an IQ of 70 as a threshold for "retardation." The term is a label of convenience designed for normal within-population variation. But the real world academic and economic consequences of IQs of 70-85 and below are the same no matter what you label them.

Watson and Sternberg and others

Media reports and editorials were quick to attack James Watson on the premise that any statement about intelligence measures is

scientifically indefensible, because science cannot study something as indefinable as *intelligence*.

Robert Sternberg, a critic of traditional intelligence testing, took the led in these attacks, arguing that "intelligence" can mean different things for different cultures. For example: In parts of Africa, a good gauge of intelligence might be how well someone avoids infection with malaria—a test of cleverness that most Americans likely would flunk. Sternberg told the *Chicago Tribune* that, for many Africans who take Western IQ tests, "our problems aren't relevant to them."

Sternberg argued that standardized tests are biased because they didn't measure the sorts of abilities that are necessary for Africans to succeed in their environmental niche. This statement is not only a patronizing and primitive caricature of African life, it's also empirically false. One of the reasons anthropologists call intelligence "g" is to strip it of local, professorial connotations.

Intelligence is a universal human quality. And, universally, intelligent humans try not to live in squalor. To an intelligent kid born in the outer boroughs of New York, the impulse may be to get a Wall Street job and make bank; to an intelligent kid born in a rural sub-Saharan village, it might mean not getting malaria. But the quality of intelligence and the impulse to live well is the same.

The faultiness of Sternberg's "different kinds of smart" blarney was addressed by psychologist Earl Hunt in his peer commentary on Rindermann's *European Journal of Personality* article:

> *...economists Eric A. Hanushek and Ludger Woessmann report that the association between economic outcomes and measured intelligence appear to be even higher within developing African countries than within Western countries. Similarly, at the national level, psychologists Earl Hunt and Werner Wittmann found that the relationship between GDP and national average IQ was stronger for the mostly African developing countries than it was among the developed industrial countries.*

So, smart people—especially smart people living in poor countries—are key to their nations doing better economically.

There was another unintended consequence of Sternberg's condescension: It was intellectually consistent with the Watson comments that *bien pensant* statists had found so offensive. In previous academic writing, Sternberg had agreed that psychometric

general intelligence was low in Africa. He'd agreed that this intelligence had the economic consequences that Watson implied it did. He'd even agreed that people of European and Asian descent performed better on tests that measured the skills necessary to build a modern economy.

Despite all this, and in a self-righteous manner typical of statists, Sternberg seemed unaware of the parallels. He howled with practiced outrage at Watson's supposed insensitivities. The essence of this howling was that Watson had been wrong to call psychometric general intelligence "intelligence."

That's a pretty narrow branch on which to hang a man.

Of course, like most statists, Sternberg had a personal and career interest in stirring up the outrage. His "practical intelligence" theories had remained unpopular in anthropology and sociology circles, which are famously kind to all sorts of crackpot ideas. Most academics in those fields noted that Sternberg's theories on intelligence would likely become more popular if other theories (specifically, the psychometric model Watson embraced) became professionally dangerous to support.

Affirmative Action

Few people care much about the market for obscure, politically-correct academic theories of people like Robert Sternberg. And they don't care much about statements, racist or not, of people like James Watson. They might care a little bit about what candidates or elected officials like Ron Paul have to say about racial politics. They probably have a general idea that race-based spoils seekers like Jesse Jackson and Al Shaprton *want* racism to stay front and center in public discourse—because they profit from that.

What most people really care about is how all of this claptrap affects their daily lives and livelihood.

And the rubber of racial politics meets the road of people's livelihood in affirmation action.

Like Social Security, "affirmative action" is a phrase that originally applied to a specific government program but has come to have broader popular definition.

In the case of affirmation action, the original, specific meaning was a U.S. federal government program for favoring firms owned by

women or members of designated "racial minorities" in the awarding of lucrative government contracts. Then, the program was expanded to include preferences toward women and members of racial minorities in government hiring decisions (or the hiring decisions of firms that had those lucrative government contracts).

Later, the term encompassed *any* race or gender preference program—whether or not it involved government agencies or government contracts. It's also used often, if inexactly, to refer to race or gender preferences in college and university admissions.

The libertarian case against affirmative action programs is simple: The programs codify the statist fiction that humans can be identified primarily as members of groups. This is a lazy and, ultimately, dehumanizing approach to dealing with complex individuals. Affirmative action is statist laziness at its worst.

In essence, affirmation action means two wrongs make a right. Proponents of the programs believe that bigoted discrimination *in favor* of certain groups corrects past bigoted discrimination *against* them. In fact, all it does is perpetuate bigoted discrimination.

One unintended consequence of these programs are the "affirmative action babies" that writers like Thomas Sowell, Stephen Carter and even Barack Obama have described. These "babies" are members of racial minorities whose academic, professional and career achievements are constantly questioned and undermined by the assumption that they're the result of favoritism rather than intelligence and hard work.

That's the dehumanizing fallout of statist efforts to manage "race" and "intelligence." It's very hard to make good outcomes for real people from sociological and legal fictions.

Chapter 12:

Statists Rely Too Much on Judges

It's a major failing of the present age that American citizens look for profundity from lawyers and judges. Attorneys are, at best, technicians who keep the machinery of the Social Contract running. At worst, they are clerks with an undue sense of importance. In either case, they are not usually profound people.

Still, pressing for a libertarian nation means battling the influence of jurists; so, some understanding of lawyers and judges is important.

In his 2007 essay *Justifying Originalism*, University of Chicago law professor Brian Lieter wrote:

> *When it comes to constitutional interpretation in the United States, there is no convergent practice of behavior by judges. They tend towards opportunism. Sometimes they appeal to original intent, sometimes to original meaning, sometimes to structural considerations, sometimes to plain meaning, sometimes to animating moral principles, and so on.*

But this much is certain: Judges are lawyers. And lawyers usually make enthusiastic statists. This is something to be expected; after all, the machinery of the Social Contract that lawyers manage *is* the state. The state gives them their livelihood.

This, in turn, may explain why statists encourage citizens to look for brilliance and guidance from lawyers. (And this is what's really bad, in the eyes of a libertarian.) Statists don't trust the wisdom of the citizens or the marketplace of ideas; they prefer strong leaders or leader castes—because they believe *they* belong to those elite groups.

This is all dubious stuff. Looking to statist leaders for personal affirmation is the kind of feeblemindedness that leads to fascism.

What is the proper role of judges in a libertarian nation? The courts should be something other than a tool by which ambitious statists and a grasping political elite impose their wills on free citizens.

Most people agree about what a governor or legislator does—or should do—but few agree about what a judge does. Civics textbooks say that the job is the judiciary is to interpret the law. But what does that mean, practically? The answer doesn't come easily.

When the founders drafted the documents on which American is built, the judiciary seemed designed to play an advisory—almost academic—role in the running of the nation. According to Article III of the U.S. Constitution:

> *Section 1. The judicial power of the United States, shall be vested in one Supreme Court, and in such inferior courts as the Congress may from time to time ordain and establish.....*
>
> *Section 2. The judicial power shall extend to all cases, in law and equity, arising under this Constitution, the laws of the United States, and treaties made, or which shall be made, under their authority; to all cases affecting ambassadors, other public ministers and consuls; to all cases of admiralty and maritime jurisdiction; to controversies to which the United States shall be a party; to controversies between two or more states; between a state and citizens of another state; between citizens of different states; between citizens of the same state claiming lands under grants of different states, and between a state, or the citizens thereof, and foreign states, citizens or subjects. ...In all cases affecting ambassadors, other public ministers and consuls, and those in which a state shall be party, the Supreme Court shall have original jurisdiction. In all the other cases before mentioned, the Supreme Court shall have appellate jurisdiction, both as to law and fact, with such exceptions, and under such regulations as the Congress shall make.*

That's it. The entire U.S. federal court system was described in a couple of paragraphs. (There is a Section 3 of the Article; it deals with the definition of "treason." You can read it in the Appendix.)

George Washington believed that determining the constitutionality of a law was the president's job—that the presidential should veto laws that he thought were unconstitutional. Importantly, he also thought that congress should pay attention to the Constitution and not *pass* laws that were unconstitutional. That was probably expecting too much of politicians.

A few years after the Constitution had been ratified, John Marshall—the U.S. Supreme Court's first Chief Justice—wrote the

1803 decision *Marbury v. Madison*—which carved out a bigger role for judges.

Marshall didn't have the towering intellect of Jefferson or Hamilton; he didn't have the practical genius of Washington or Adams. But he understood politics and power; and he made sure his branch of government would have an equal stand with the others.

In *Marbury v. Madison* the U.S. Supreme Court dictated that it had the authority to review the constitutionality of laws passed by the congress and signed by the president. This created a kind of political loophole, through which future Courts could force their politics on citizens to whom they didn't directly answer.

By pressing for a bigger role for his branch, Marshall may have been the first American statist.

Judges Aren't Democratic

Americans acquiesce to the courts' practice of exercising political power. Maybe this isn't such a bad thing—people trained in the law know how to make the mechanics of the state work. But it's not democratic.

The problem is that, in their acquiescence, Americans have allowed a small number of unaccountable lawyers to exercise enormous power over the size and shape of the state.

The effects of this acquiescence are many. One is the litigious pose that many semi-literate people strike when faced with life' slightest problems. Another—a little higher up the ladder of intellectual development—is the unfocused emotion that many people show when a court makes a decision they don't like. Self-professed "conservatives" turn livid when Republican-appointed judges don't reach politically conservative results; supposed liberals turn vicious when "their" courts rein in the expanding state. Both responses (and, really, they are two versions of the same response) are childish and naïve.

Judges are functionaries of the state, drawn from a pool of ambitious clerks. Rarely—*very* rarely—are they brilliant leaders or wise teachers.

The political Right in the U.S. has tried to hold up the U.S. Supreme Court Justice Antonin Scalia as one such rare leader. And Scalia is a pivotal figure in American legal circles. He has been a lightning rod for controversy, an influence on his colleagues and the

only Supreme Court Justice of his generation who has written and spoken consistently about the role of judges in the nation. (His left-leaning colleague Stephen Breyer has been the only other Supreme Court Justice worth mentioning in this regard.)

Ronald Reagan appointed Scalia to the Supreme Court in 1986. Early in his tenure, Scalia was heralded by his supporters in Washington, the media and the general population as a "strict constructionist."

Strict constructionists were supposed to be intellectually-disciplined judges who limit themselves to a review of the facts, the "black letter" law and direct precedent when considering a case. (This description sounds good to most libertarians—which may explain why some statist Conservatives have decided they *don't* like it so much.) Strict constructionists were supposed to be an antidote to the effect of so-called "activist" judges on the federal bench.

And, in the 1980s, an antidote was needed. The Supreme Court's activists had been pushing a statist agenda since the 1930s—when Franklin Roosevelt had remade the Court as a tool for social and political experimentation. In the spirit of John Marshall, Roosevelt's Court (and the ones that followed for some 50 years) aimed to use precedent decisions to shape politics and public policy broadly.

When Scalia was first appointed to the Supreme Court, the question of how "strict construction" should be defined was a hot topic in legal and academic circles. Conservatives who'd been advocating strict construction as a check on Liberal activism gradually realized that they didn't want the courts to show discipline or restraint; they wanted to replace one kind of activism with another—namely, their own.

So the debate over the role of judges in society changed from the definition of strict construction to the differences between "originalism" and "interpretation."

Originalism treated the original intention of the people who ratified the Constitution as authoritative. This theory was subjected to several academic objections. On the subject of these objections, Brian Lieter has written:

> *According to what I will call the "M&E Objection," there either does not exist a collective intention of the requisite kind or we have no reliable method for acquiring knowledge of such an intention. According*

*to the "Self-Contradiction Objection," the original intent of the
framers/ratifiers was that their original intent about the Constitution
should not be controlling; ergo, anyone who assumes original intent is
authoritative has a reason not to consider original intent in interpreting
the Constitution.*

*According to what [Georgetown University professor Randy] Barnett
called the "Dead Hand Objection," why should the intentions of long-
dead ancestors bind us?*

In fact, Scalia claimed that his perspective was slightly
different—what law professors eventually called "New Originalism."
This version (which was also embraced by Barnett and Princeton
University political science professor Keith Whittington) held that
what is important is the original public meaning of the text of the
Constitution at the time of adoption or amendment.

There are some problems with this version. At some point,
original public meaning runs out—and then judges must engage
in "construction" of the Constitution. They should execute this
construction in a way that doesn't contradict original public meaning.
But they don't always follow that principle.

While Scalia has generally opposed statist ambition in the courts,
he has denied being a strict constructionist and hasn't ever been
keen on the term "New Originalism." He described himself as a
"textualist." Here is Scalia describing the difference:

*Textualism should not be confused with so-called strict constructionism,
a degraded form of textualism that brings the whole philosophy into
disrepute. I am not a strict constructionist, and no one ought to be—
though better that, I suppose, than a nontextualist. A text should not
be construed strictly, and it should not be construed leniently; it should
be constructed reasonably, to contain all that it fairly means.... If strict
construction were taken seriously, for example, the First Amendment
could only be violated by a law passed by Congress—nothing else. No
one thinks that's sensible....*

Tricky word, that "reasonably." It allows more judicial activism
than most libertarians would like to see. And it gives Scalia room to
engage in a Conservative version of judicial activism.

Scalia realizes what he's doing here. He admits that most of the
people who say they want judges who believe in strict construction

really want judges who will bring a politically Conservative perspective to their decisions. And when these people use the word "activist," they're really using code for "Liberal."

Scalia has suggested a better distinction in judicial philosophies, pointing to the writing of Justice Stephen Markman of the Michigan state Supreme Court. Markman has written that the real divide in American legal reasoning is between "interpretivists" and "instrumentalists." And this distinction does seem to work better than the various alternatives.

According to Markman, interpretivists believe judges should read an authoritative text (a statute, a constitution, a precedent, etc.) and try to determine from that what the law is; instrumentalists believe that courts should be used as a tool for figuring out what's wrong in society and fixing it.

Some of these instrumentalists call their philosophy "active liberty" or the belief in a so-called "living Constitution." U.S. Supreme Court Justice Stephen Breyer—perhaps the country's highest-profile instrumentalist—even wrote a book titled *Active Liberty*.

But the idea of using the courts as a tool for fixing what's wrong in society has little to do with liberty, active or otherwise. It is fundamentally statist.

Live by the Sword, Die by the Sword

Statist reliance on the support of instrumentalist judges can backfire. In the 2000 U.S. Supreme Court decision *Bush v. Gore*, the hifalutin' talk of judicial philosophy was shown for what it really was—camouflage for partisan politics.

Bush v. Gore involved an unlikely set of facts: a national election that ended up in a virtual tie; the final outcome resting on the resolution of one state's inefficient and confusing election practices; that state's courts making rulings that contradicted guidelines set by the U.S. Supreme Court—thus forcing the Feds to get involved.

When they finally did, the U.S. Supreme Court Justices issued their decision in *Bush v. Gore* as a *per curiam* opinion. *Per curiam* (meaning "by the Court") is a designation used to avoid tying a decision to a specific Justice and to put a united face on the Court. But the Court was hardly unified—it split along political lines. The four "liberals" all signed a dissent that slammed the narrow majority's

conclusion ordering a quick conclusion to Florida's disputed vote count—and confirming George W. Bush's razor-thin electoral college victory.

Al Gore supporters and Democrat Party partisans howled that the Court was being improperly partisan and activist. They screeched that the Court had "coronated" W. rather than supporting a democratic result. But these cries rang hollow; these same partisans hadn't complained about undemocratic activism when the Court had made decisions (on topics from abortion to affirmative action) that they'd liked.

Ultimately, judges aren't democratic. And the more instrumentalist they are, the less democratic.

Aside from coronating presidents, what does judicial instrumentalism look like? There are numerous examples; but one of the most interesting is the 1965 U.S. Supreme Court decision *Griswold v. Connecticut*. This precedent decision reached what a libertarian might call the right conclusion for the wrong reasons.

In *Griswold*, the Court concluded that states do not have the right to outlaw the use of contraceptive devices. The Connecticut law in question—which made contraceptives illegal for anyone, even married couples, to buy or own—was an absurd statist invasion of citizens' private lives. But the court's reasoning for why the Connecticut law couldn't stand was just as bad. Justice William O. Douglas, who wrote the decision, had to bend logic to get around the fact that the U.S. Constitution doesn't describe a specific right to privacy. Douglas argued that a right to privacy was implied by "penumbras, formed by emanations from [the] guarantees" of the Bill of Rights.

Douglas was doing more than interpreting a document; he was beginning with the conclusion he supported and then reaching backwards to justify it. He was acting as an instrument for social change. This wasn't reason; it was an *ex post facto* rationalization.

In a separate decision, William J. Brennan—one Douglas's colleagues on the Supreme Court—showed how instrumentalists think of the founding documents:

> *Our amended Constitution is the lodestar for our aspirations. Like every text worth reading, it is not crystalline.... Its majestic generalities and ennobling pronouncements are both luminous and obscure...*

Lodestar for our aspirations? Sounds like something from of Oprah Winfrey's hysterical TV talk show episodes.

Reflecting on this claptrap, Antonin Scalia wrote:

...this is the kind of reasoning that the Supreme Court actually uses, as it daily substitutes its own wisdom for the meanings originally inscribed in the Constitution and the laws. Often its actions are immediately damaging to individual liberty; but every action that renders the Constitution malleable to imaginative reconstruction renders it less capable of defining and protecting liberty in the future.

Constitutions are written and ratified with the expectation that their meaning will not be changed—except by regular and deliberate process, as described in the documents themselves. Scalia went on to conclude:

Constitutional guarantees may not extend as far as we might like, but they are no guarantees at all if we grant the idea that the Constitution can legitimately be treated as something that is always evolving new meanings, even if a particular new "meaning" momentarily expands the scope of individual freedom. And during the past seven decades, most of the Supreme Court's new "meanings" have contracted that scope, by licensing new assumptions of power by the federal government.

The debate over whether influential judges like Scalia are or aren't "strict constructionists" reflects the larger debate over how to describe the various kinds of judges who preside over American courts. In a widely-read 2007 essay, University of Illinois law professor Lawrence Solum considered this a matter of semantics:

The central idea is that the meaning of the constitution is the "original public meaning" or the "conventional semantic meaning" of the text (the clauses, phrases, and words) in context. ...Of course, there might be other semantic theories of constitutional meaning. For example, someone might argue that the semantic meaning of the clauses is the conventional semantic meaning they have at the time of application—call this "contemporary public meaning." Or it might be argued that the meaning of the Constitution is whatever meaning a judge wishes to assign to it—on this theory, the Constitution is an empty vessel into which judges can pour any semantic content they wish.

These differences in semantic approach may seem trivial. They *are* trivial. But they become more important if the federal system is the only court of justice available to citizens. In fact, the founders didn't think of courts this way. They considered the federal courts just one of several systems available—in addition to state courts, local courts or councils, religious or tribal courts and mercantile organizations like guilds and chambers of commerce.

Americans have lost their appreciation for this variety of avenues to justice. These days, if someone mentions "justice pluralism," he's usually referring to some relativist or multi-cultural notion of different citizens having different concepts of what constitutes a just outcome to a given dispute.

The founders thought of justice pluralism as a kind of free market for court systems—over which the federal system acted as a referee.

Some recent political philosophers have echoed the founders' thinking on these matters. John Rawls (by no means a libertarian) has written that citizens with different conceptions of justice could form an "overlapping consensus" on the "constitutional essentials." And even more recently, Harvard law professor Cass Sunstein (again, not a libertarian—though *he* might argue that he is) has written that citizens only ever have an "incompletely theorized agreement" on the legitimacy of courts and constitutions.

And, perhaps most relevant to this discussion, the decidedly libertarian professor and legal scholar Randy Barnett has described a process by which citizens continually (though informally) ratify a constitution by applying its rules to their daily transactions— including legal actions that may or may not ever reach a federal court. While Barnett does not start from the position of supporting a free market in courts of justice, he gets to that point indirectly by asking how a constitution can be valid if specific citizens haven't specifically voted for it.

Judges Claim to be Practical, Usually Aren't

Even the most nuanced approach to applying the Constitution runs into various problems in day-to-day application. The problem that comes up most often is Randy Barnett's "Dead Hand Objection." Barnett pointed out that any theory of constitutional *legitimacy* is a constraint on any theory of constitutional *interpretation*.

Resolving the conflicts between legitimacy and interpretation is important because the Constitution needs to maintain the first in order for judges to do the second—and legitimately exercise coercive power over citizens. Constitutional legitimacy tells judges how they should decide cases. But, according to Brian Lieter:

the written constitution is, at best, a proxy for what is constitutionally legitimate or is relevant because of its effect on the reasonable expectations of citizens (the latter being a factor bearing on constitutional legitimacy).

The logic here becomes somewhat circular. Barnett makes the best sense of the circles. He argues that a constitution is legitimate as long as it reflects a rights-based view of justice with which citizens can live and which is basically libertarian in character.

A free market for courts of justice requires something that's lacking in most federal courts today—judicial modesty. We need more of this.

Like the terms "strict construction" or "original intent," "judicial modesty" means different things to different people. To some, it means not reaching out beyond the facts of a particular case in order to comment on broad principles. To others, it means reading the facts and law in a case in a way that doesn't unnecessarily interfere with the political branches.

Most people agree that "judicial modesty" means not unnecessarily interfering with the political branches, and they agree that it is necessary to enforce those constitutional constraints that the constitutional text actually imposes.

One way that a country can enforce judicial modesty is to elect its judges. But does making judges explicitly political increase the prospects that they won't interfere with the executive branch?

Besides, the appointment of judges is already political enough.

In April 2008, University of Wisconsin law professor and popular internet pundit Ann Althouse wrote about a controversial political race involving judges that had grabbed the attention of voters in her state:

It's surprising to hear how little [Gov. Jim Doyle] thinks of his constituents, who had the sense to depose one of the [Wisconsin supreme] court's ultra-liberal justices and in the process helped toughen

the standards for judicial accountability. …The election was a referendum on Louis Butler and the high court's sharp political turn. Justice Butler was appointed by Governor Doyle, a Democrat, to fill a vacancy in 2004. But Mr. Butler was required to stand for election, and he narrowly lost to district court Judge Michael Gableman. Mr. Gableman's 10-year term will begin in August and probably tip the balance of the court to a 4-3 conservative majority.

Althouse quickly focused on the key underlying question to the controversial election:

Should the people directly affect judicial ideology through elections, or is it better to restrict them to picking the governor and then allow the governor's ideology to affect judicial appointments?

Some libertarians have become so disillusioned with judicial activism—from the Left and from the Right—that they throw up their hands and argue for the direct election of judges.

The Political Reality of Powerful Judges

The system in most states—and at the federal level, in the U.S.—is that the executive (the president or governor) has to moderate his extreme inclinations if he intends to keep his elected office. Although almost every politician claims a "mandate" when elected to a position, few actually have that kind political capital. So, a politician's policies and actions will usually reflect the moderating influence of the voters.

Because judicial appointments are removed from direct political response, judges can be more extreme. And perhaps more true to the elected politician's own unmodified beliefs. This is one reason that U.S. presidential elections involve so much talk about the judges each candidate might appoint—these judges are a signal to voters of what each politician really thinks.

Some people (including some libertarians) look at this process, full of politics, moderation and signals—and conclude that the matter would be simpler and more straightforward if judges were simply elected, like presidents, governors or legislators.

Some states elect their state-level judges.

The founders didn't see things this way. In their system, judges were appointed to lifetime positions by the executive and approved

by the legislature. The founders wanted judges to be free from the moderating (or any other) influence of voters. As I mentioned earlier in this chapter, their vision of the judiciary was as an almost academic check on the actions of the legislative and executive branches.

And some might conclude that, despite the election-year rhetoric and occasional activist decisions, that's pretty much what the judiciary has been. So why fix a process that isn't broken?

Because times change; and sometimes changes in our practices are required to stay close to the founders' vision. For example, the Constitution originally called for the appointment of U.S. senators by each state's governor. The change to direct election of senators was seen as a something consistent with the Founder's original intent.

It's likely that the founders would have been troubled by *Bush v. Gore*—but not completely surprised. They didn't likely envision a close presidential election being decided by a Supreme Court vote along party lines. (The Electoral College was supposed to resolve that kind of controversy.) But they did envision various tyrannical erosions of the mechanisms of democracy.

There's no particularly libertarian side in the debate over whether judges should be appointed or elected. Some libertarians might defend appointment as the system the founders' established; others might support election as a simpler and less Machiavellian solution.

One point to consider: The appointment of judges is supposed to emphasize qualification over ideology or popularity. Any change should allow the executive to appoint bright and distinguished (but not necessarily fashionable) legal minds to the bench.

Said another way, ordinary voters aren't qualified or inclined to evaluate candidates for the bench on their legal or intellectual merits. These voters may prefer to elect presidents or governors who make these evaluations for them.

If the goal of reform is to get the political dysfunction—signals, semantics and charges of "activism" Left and Right—out of the process, a compromise reform that combines appointment and election might work effectively. Some states already use this combined approach (as Prof. Althouse's description of the Wisconsin controversy illustrated).

Following this compromise, the president would appoint judges, who would then stand for election to keep their posts on a regular basis—say, every eight or 10 years. A lengthy term would give judges

some insulation from the fleeting whims of the voters. But it would allow those voters to get rid of judges whose decisions had proved either mechanically terrible or egregiously out of step with the majority of their fellow citizens.

As many proponents of election note, the prospect of facing voters—even if it's years away—is likely to "keep judges honest."

A good case in point: Voters in California tend to be disturbingly statist. This usually translates into a "progressive" position on the spectrum of conventional U.S. politics. But there are a few exceptions. Californians consistently support the death penalty. (Which is statist, even thought it's not conventionally "liberal.") However, the California state supreme court was dominated by judges who opposed the death penalty—from the libertarian perspective, the right conclusion reached for the wrong reasons.

In a series of elections during the late 1990s and early 2000s, California voters gradually turned out the judges who'd voted against using the death penalty. And the sitting governors, understanding how determined Californians were in support of the death penalty, appointed replacements who better reflected this support.

Why Aren't Judges Democratic?

One final thought on the role of judges in American politics. They may not to be democratic because they know that the Constitution isn't as democratic as most Americans believe.

Richard Posner—a federal appeals court judge in Illinois and one of the handful of judges who really *is* a profound person— mentioned this hard truth in an article criticizing Supreme Court Justice Stephen Breyer's arguments for a "democracy-enhancing presumption" in the Constitution:

> *The primarily democratic nature of the Constitution's governmental structure has not always seemed obvious [because] the structure is not "primarily democratic." It is republican, with a democratic component. The Constitution's rejection of monarchy (no king), aristocracy (no titles of nobility), and a national church (no religious oaths of office) was revolutionary; but the governmental structure that it created bore no resemblance to that of ancient Athens and was, and remains, incompletely democratic.*

How do Americans counter the anti-democratic impulses of their judges?

The 1995 Supreme Court decision *United States v. Lopez* considered the question of the relative roles of the federal and state courts. While some legal scholars consider *Lopez* a contemporary or even radical decision, it really just restates very old theories of how the state should function:

> *We start with first principles. The Constitution creates a Federal Government of enumerated powers. As James Madison wrote, "[t]he powers delegated by the proposed Constitution to the federal government are few and defined. Those which are to remain in the State governments are numerous and indefinite." This constitutionally mandated division of authority "was adopted by the Framers to ensure protection of our fundamental liberties....Just as the separation and independence of the coordinate branches of the Federal Government serves to prevent the accumulation of excessive power in any one branch, a healthy balance of power between the States and the Federal Government will reduce the risk of tyranny and abuse from either front."*

Every federal judge should have to recite this paragraph—like students recite the Pledge of Allegiance—before starting work each day.

Chapter 13:

Coercion and Prohibition, Life and Death

It makes sense to follow a discussion of America's excessive reliance on judges with a discussion of the most important subjects judges handle.

Libertarians—and most Americans—don't like coercion. By "coercion," they mean one person or group initiating force to impose its will, agenda or beliefs on another. Coercion can involve property: If I steal your car, I am forcing you to give the vehicle to me. Coercion can involve behavior: If a city passes an ordinance banning smoking tobacco in public places, it is forcing citizens to behave in a specific way. Coercion can involve idea: If a teacher gives higher grades to students who praise Barack Obama, she's forcing her ideas on the classroom.

A just society minimizes coercion. Laws and courts of law exist to prevent people or groups from going too far in forcing their wills on others. As the U.S. Supreme Court Justice Louis Brandeis famously wrote, one of the signs of a civilized society is its recognition of a citizen's right to be left alone.

But it's not always one person who coerces another. Sometimes, a nation's government initiates the force. And that's the thing, more than any other, that libertarians stand against.

A government can coerce individuals in many ways. And it probably doesn't call this coercion *coercion*; it probably calls the coercion *policy*. Whatever the name, it can take property—either directly or indirectly, through taxes. It can control behavior by encouraging or, more often, prohibiting activities.

But the most blatant way that a government can coerce people is by killing them.

This is a key political topic for libertarians: the state's efforts to coerce its citizens in matters of life and death.

These efforts aren't always as plain as a government agent barging into your house and shooting you (although that does happen; for details, access the Internet and search the term "no-knock raid"). Often, the government will coerce you in matters of life an death by prohibiting scientific efforts—a ready example, stem cell research—that might save or lengthen people's lives. It can also endanger citizens' lives by abusing its power to declare war or bungling government practices like the death penalty.

And then there's abortion. A life-and-death issue through which the state stumbles, coercing citizens in ways it neither intends nor even considers. More than other such issues, abortion seems to combine different strains of American culture together in a particularly volatile mix.

The confluence of state coercion and life and death will always make for choppy water. The best practice would be for the state to stay away from matters of life and death; but, practically, it can't. So, the libertarian approach is to minimize the state's role and reduce the white water rather than trying to navigate through a lot of trouble.

Life, Death, Abortion and "Rights"

Abortion is the most divisive issue in American politics. It's an issue in most nations; but its combination of religion and sex and privacy and class make it a flash point in the U.S. Some groups argue that the surgical or chemical termination of a pregnancy is the murder of a person; others insist that a woman's ability to make her own decision about completing or terminating a pregnancy is an essential privacy right.

Abortion doesn't burn so controversially for most libertarians. To them, it's a matter of property rights. They see a woman's body as her own property—and her decision to have or abort a child as a clear example of ownership of self. And the laws recognizing the killing of a fetus against the pregnant woman's wishes as murder also match up.

After all, the fetus was the property of the woman carrying it.

To this answer, critics of libertarian political philosophy ask: Is *everything* a property issue? At some point, doesn't a fetus have the same fundamental, positive liberty rights that any person has? And what is that point?

Some perspective on all this talk of "rights": Abortion is not guaranteed as a right in the Constitution or any other founding

document. The U.S. Congress has never passed a law supporting abortion as a legal right or privilege. The legality of abortion in America rests on the thin branch of a split decision from the Supreme Court.

The 1973 decision *Roe v. Wade* made abortion legal. But the decision did not drawn on any notion—legal or otherwise—of "choice." It was based on the notion of privacy implied, though never explicitly stated, in the Constitution's Bill of Rights.

And the arguments against legal abortion don't rest on any notion of life in the cosmic or biblical sense. They are based on the word "life" in the legal sense, as set forth explicitly in the Fifth and Fourteenth Amendments.

So, the real debate over abortion—which is rarely heard—is whether the right to privacy or the right to life should prevail.

The abortion debate is responsible for one of the most remarkable bits of confusion in mainstream American politics. Republicans usually oppose government regulation in the name of free choice; the party's strategists call the GOP the "leave-us-alone coalition." But, on a very personal matter—reproduction—it endorses a statist coercion against abortion.

Democrats aren't any more coherent: The party that will do anything to protect a "woman's right to choose" an abortion treats citizens as if they are too feeble-minded to look after themselves in matters of health care, consumer product safety, school choice, retirement planning and which vehicles they drive.

By highlighting rare practices like so-called "partial-birth abortion" that most people find repugnant, anti-abortion partisans believe that they're winning the battle for Americans' minds. Technology has helped; modern sonograms are so powerful that they can illustrate tiny fingers and toes. Expectant parents take sonogram "photographs" of their future offspring and keep them with other baby pictures.

The net effect? According to one Gallup poll, only one in five Americans believe that abortion should be legal in all cases.

But there's a limit to how far the legal system—and perhaps even the cultural systems—will allow abortion rights to erode. Despite the polls, surveys and political spin, most Americans seem to want to preserve some form of legal abortion. They don't celebrate abortion; but they also don't want a return to prohibition of abortion. Bill

Clinton's rejoinder that abortion should be "safe, legal and rare" does seem to reflect the majority sentiment.

Many of the restrictions on abortion rights imposed by anti-abortionists had the paradoxical effect of making the practice more acceptable. In 2002, more than half of all abortions were performed in the first eight weeks of pregnancy. And 89 percent of all abortions took place in the first 12 weeks.

Roe v. Wade included an important caveat: The legal principles that justify abortion only apply until the fetus is viable, or able to live outside of the womb. The court accepted the conventional medical opinion that a fetus becomes viable at the start of the third trimester—around the 28th week of a normal 38-week pregnancy.

Because the point of viability varies from case to case, the court ruled it could only be determined on an individual basis and by the woman's doctor. Basically, *Roe* says while a woman has the right to abort a fetus that right does not extend to include the right to abort a child. So, does a fetus become a child at 24 weeks?

Since ruling on *Roe*, the Supreme Court has slowly defined how abortion can be practiced in the states. Specifically:

- The Supreme Court has ruled that states were free to choose not to fund abortion with government money.
- It's ruled that states can pass laws requiring parental notification for minors having abortions; however, those states have to provide "judicial bypass" whereby a girl can avoid notifying her parents if she goes before a judge.
- It's ruled that states can require a woman and her doctor to prove a fetus is not viable before performing an abortion.
- It has upheld Montana's statute requiring that only licensed physicians perform abortions.
- It struck down Nebraska's ban on partial-birth abortion—not because it banned late term procedures but because its vague wording also affected second-trimester abortions.

So, the current abortion debate centers not on whether a woman can have abortion but on who has right to *regulate* abortion.

Another challenge to clear thinking on abortion is that the mainstream media misrepresents the issue as a kind of morality play: You either believe that aborting fetuses is murder or you believe in a woman's life and happiness. The people who are quoted for and against certain elements of the discussion echo this crude choice.

The real debate about abortion in politics is the same debate that's currently going on about abortion in science. It asks: When does pregnancy end and motherhood begin?

The Libertarian Definition of "Pro-Life"

Pro-abortion activists often assume that religious fundamentalists are the biggest threat to "a woman's right to choose." They're mistaken. Smart doctors and medical technicians are the biggest risk to legal abortion; they keep pushing the point of viability back toward the beginning of pregnancy.

The problem with the point-of-viability legal standard is that doctors can't determine a precise point. In the early 1970s, when *Roe v. Wade* was decided, 28 weeks was standard; 35 years later, almost 60 percent of babies born in the 25th week survived to childhood.

This is the reason that, in 1983, Justice Sandra Day O'Connor wrote that *Roe v. Wade* was on a "collision course with itself." Even then, she saw that advances in technology were pushing the point of fetal viability closer to the beginning of the pregnancy.

Libertarians tend to be enthusiastic about technology. Technological advances usually vindicate of human individuality and intellect. In this sense, libertarians are pro-life—but not in the moralizing sense that religious fundamentalists are pro-life. Libertarians realize that, as medical technology (particularly the ventilators that help premature babies breathe) improves, fetuses become viable at earlier dates. This puts abortion rights in a precarious position; if a 22-week-old preemie is fully human, so is the 28-week-old fetus that can be legally killed by abortion.

As a result, most of the hospitals that will perform abortions only do so through the 22nd week of a woman's pregnancy. This isn't much of a hardship, since nine out of 10 abortions are performed during the first trimester.

In short, although anti-abortion activists had success with the "partial-birth abortion" issue, it's largely a political fiction. Most late-term abortions are performed because of some, usually serious, threat to the pregnant woman's health.

The statistical trends of the early 2000s suggest that abortion may be on the decline as a focal point of controversy. Anti-abortion advocates claim victory in reducing the numbers of the procedures; pro-abortion activists claim victory in keeping increasingly rare

abortions safe and legal. Citizens, in poll after poll, indicate they're weary of the overheated rhetoric of the abortion debate; and they show some common sense in this weariness.

The focus of political intensity will move on to other topics that define contemporary notions of life and death.

Stem Cells and Clones

Statist bureaucrats anxiously regulate life sciences whenever they can. Through most of the 20th Century in the U.S., they did this by means of the quasi-public system of university funding and grant awards.

While many consumer-protection activists and political partisans on the Left blame Big Pharma for the problems that beset free scientific research in the U.S, the real villains can be found at the National Institutes of Health, the Centers for Disease Control and Prevention and Department of Health and Human Services. These bureaucrats manipulate and control much of the public discourse—informed or ignorant, as it may be—on life science research.

The debate over stem cell research falls into this category.

Federal government regulations have restricted scientific research on human stem cells to a handful of genetic material controlled by the Wisconsin-based National Stem Cell Bank. This results in an almost surreal level of artificial scarcity, something that a statist would naturally tend toward supporting.

This manipulation of free inquiry is, surely, a form of coercion. It's telling scientists what they can and can't study—just as much a violation of free speech as if the federal government prohibited you "by law" from talking about how much you despise the New York Yankees.

The real answer to bogus complaints of the insults to human dignity that stem cell research should have been to get the government our of the labs.

TV actor Michael J. Fox and other celebrities pressing for unrestricted stem cell research should have rejected the frame and false choices established by statist medical research policy and refined by cynical "pro-life" political hacks.

The truth that few experts are willing to admit is that the stem cell research controversy is really a stand-in for a more frightening topic: clones. The use if "therapeutic" clones—that is, people created

for the purpose of generating organs and other body parts for their parents—is closer than many people realize.

The prospect of using human beings as sources of replacement parts generates a lot of political outrage. And with good cause. It denies the clone's individuality and humanity. It's worse than abortion, even to "pro-choice" liberals, and as bad as murder to people who consider the matter seriously for any amount of time.

An important point: Real-world cloning won't look like something out of the *Star Wars* movies. There's no magic way to raise a clone more quickly that raising a traditional child. Cloning (referred to by scientists as "somatic cell nuclear transfer") involves fertilization not much different than current *in vitro* procedures. Then, it requires hiring a surrogate mother to carry and bear the clone child—again, a fairly standard arrangement these days.

The clone child will be a genetic twin of his or her parent; but there won't be any of the hocus pocus from pulp sci-fi novels or films. No shared consciousness. No spiritual transfer (other than the connection most traditional parents feel for their children).

A clone child is a human being. Its social status and political rights must be identical to those of any other human. It has to be fed and clothed and burped and walked at 2 am just like any other child. To suggest that a child created through reproductive cloning is somehow the "property" of the parent is like suggesting that all identical twins are eligible for slavery.

Contemporary American society doesn't consider the decision to have children through any of the methods available—whether it be the old-fashioned way or using IVF—to be a *moral* decision.

The only difference that a clone would have from a natural twin is that, according to some geneticists, the clone might have a higher propensity various kinds of genetic defects and diseases.

For all of these reasons, there isn't much cause to have a clone child instead of a traditional child; and, if the gene experts are right, the higher propensity for genetic problems is a reason *not* to have a clone child.

That leaves having a source of replacement organs or other "spare parts" as the main reason for someone to have a clone child. Conventional replacement organs, harvested form recently-deceased donors, often have problems with genetic rejection by the recipient body. A cloned organ wouldn't have these rejection problems.

It's hard to imagine that anyone could look on a child, especially a child who's your genetic twin, in such a cold-hearted way. But people facing desperate health problems might consider extraordinary measures.

The consensus among medical ethicists (a growing field, with the United States tottering ever closer to government-run medical services) holds that cloning for spare parts is only defensible if no viable individual is destroyed in the process. Here, the subject comes back to stem cells. Stem cells might be cloned to use in growing individual organs in an artificial environment designed to resemble the inside of a human body.

The technology already exists for developing organs in this way. Scientists at Wake Forest University have grown and implanted "artificial" bladders grown from patient's own cells.

If there is way to clone a human body—but prevent its brain from ever developing—fewer people might object to these duplicates, preserved for when our original parts fail. This should be no more objectionable than replacing knee joints with mechanical devices.

Technology carries advanced societies to a common critical point: an impasse between the rights of existing human beings to have a high quality of life and the rights of developing beings to exist with dignity. (This reaches back, again, to the philosophical problem with legalized abortion.)

Whatever people say and courts rule, there is no stopping science and the advance of technology. Modern history has proven that new definitions of "life" are only a matter of time.

Libertarians are usually optimistic that these changes will improve human life more than they harm or complicate it. Their concerns tend to focus on the potential for unintended consequences of expanding life.

Already, in the late 2000s, longer life expectancy has created havoc with the mortality assumptions and actuarial tables that shape benefits programs like Social Security in the U.S.

But these problems are, in fact, a necessary correction to America's dependence on statist welfare programs. So broader definitions of "life" and longer life expectancy are good for individual citizens on multiple levels—first, their own longer lives and, second, population trends that will force government programs to be more fiscally sensible.

Ongoing Problems with the Death Penalty

The death penalty is a statist excess.

There is an impulse in most Americans to support use of the death penalty in dealing with society's worst, most violent criminals. There's a simple moralizing satisfaction in turnabout justice. This harkens back to the "eye for an eye" notion of justice that pervades the first half of the Bible.

But the state should not be allowed to mete out vengeance. Its interest is in assuring safe commerce in its public places. Its aim should be to discourage criminal behavior generally—not to punish specifically or individually.

Here, again, the libertarian definition of "pro-life" obliges skepticism about the state's ability to handle complex matters well. And it leads even the most practical libertarian to question conventional wisdom about government policy. In this case, the death penalty is the policy libertarians question.

Allowing the state's prosecutors to seek the death penalty puts undue authority over life and death in their hands. It invites various corruptions—from the institutional bias that the Maryland study found to more conscious, cynical choices made for political gain.

To ask the state to administer complex systems gives it license to expand and, eventually to interfere and coerce. The institutional decadence of a state agency will—from the beginning—corrupt the best intentions of the complex programs. It's better for everyone to solve the problem by not asking the state to do too much.

Just as it's important to limit the state's ability to imprison suspects without charges, it is important to limit the ability to put criminals to death. Habeas corpus abuses are relatively easy to remedy—you let people out of jail. Death penalty abuses are harder to repair.

In October 2007, the American Bar Association released a report which concluded that serious problems in state courts compromised fairness and accuracy in capital punishment cases and justified a nationwide freeze on executions.

The ABA is a politically-partisan organization, with a marked bias toward statism generally and the Democrat Party specifically. So, it's somewhat...inconsistent...that the lawyers' group would come out so strongly against state-administered death for certain criminals.

The ABA death penalty report included the following common problems:

- Spotty collection and preservation of DNA evidence, which has been used to exonerate more than 200 inmates;
- Misidentification by eyewitnesses;
- False confessions from defendants; and
- Persistent racial disparities that make death sentences more likely when victims are white.

The report was a compilation of separate reviews of how the death penalty was applied in eight states: Alabama, Arizona, Georgia, Florida, Indiana, Ohio, Pennsylvania and Tennessee.

Prosecutors and death penalty supporters said the eight state studies were flawed because the ABA teams were made up mainly of death penalty opponents.

At his web site, *Sentencing Law & Policy*, attorney Doug Berman writes frequently on the efforts of the American Bar Association's Death Penalty Moratorium Implementation Project. Berman's bottom line:

> *In short, someone wanting to feel good about their pre-existing opposition to the death penalty will enjoy reviewing the thousands of pages produced by the ABA's research. But someone who is genuinely agnostic about capital punishment is likely to find the ABA's work more frustrating than enlightening.*

In this narrow context, the ABA was skeptical of government fairness and efficiency. Why would lawyers trust the state with regulatory authority, tax authority, military authority ... but not trust to execute violent criminals fairly? Because, it seems, the ABA follows orthodox views of Democrat Party more than the dictates of logic

How can an objective observer reach this conclusion? Because the simplest and best argument against the death penalty is one that ABA lawyers aren't inclined to make: Do you trust the same government that has trouble managing its budget or running the Department of Motor Vehicles to kill people fairly and efficiently?

Prohibition Is the Worst Kind of Coercion

When Albert Einstein first came to America, he made the following observation about the government's ban on alcohol:

The prestige of government has undoubtedly been lowered considerably by the prohibition law. For nothing is more destructive of respect for the government and the law of the land than passing laws which cannot be enforced. It is an open secret that the dangerous increase of crime in this country is closely connected with this.

Soon enough, ordinary Americans came to see things as the genius immigrant did. They voted to repeal the Volstead Act and end what they knew as "Prohibition."

As I've written elsewhere in this book, statist coercion doesn't only mean forcing citizens to do things they'd rather not; it can also mean forcing citizens *not* to do things they'd rather.

Eventually, that Prohibition gave way to other prohibitions: particularly bans on recreational drug use and certain sexual acts, including prostitution. Like the "laws which cannot be enforced" that Einstein saw in the 1920s, these prohibitions are ill-advised and ineffective. But statists favor them because they make more work for the state.

America's so-called "drug control policy" is an ineffectual statist farce that imposes a $19 billion-a-year federal tax burden on a nation that can't afford it, results in over 1.6 million arrests each year and only seizes about 10 percent of all illicit drugs sold in the U.S.

As several different political writers have noted: If you had a roof that only stops 10 percent of the rain, wouldn't you get a new roof?

Statist prohibitions are marketplace manipulations that warp or eliminate normal market signals. As a result, America has a disconnect between official drug policy and the practical realities of the drug business.

This market disconnect can be explained in a series of conflicting expectations and realities. Parents expect that U.S. drug policy keeps controlled substances out of their kids' hands. In reality, marijuana use more than doubled between 1990 and 2004, according to the U.S. federal government's National Home Survey of Drug Abuse.

In reality, 40 percent of Americans over 12 years of age have tried marijuana at some point—15 percent have used within the past year, and 8 percent within the month.

Why does anyone support policies that blind citizens to the real world around them? The statist ideal behind prohibition is that, by making the thing or action illegal, the government can prevent an

individual from having to make the choice whether or not to use it or do it. Statist prohibitionists assume you are too irrational to follow a moral compass. The state can and should intervene because you're too stupid to know what's best for you.

It's not drugs that are behind our drug control problems—it's control policy that's behind our drug control problems. The government is having trouble controlling American drug use because the government is having problems controlling Americans.

The philosophy behind drug prohibition is fundamentally opposed to the principles on which America was founded. Control policy is against American heritage.

The great political philosopher John Locke wrote that liberty

consists in a power to do, or not to do; to do, or forbear doing, as we will… Freedom is a power to act or not to act, according as the mind directs.

Essentially, this means citizens of a free nation should have both the freedom to do and the freedom not to do as they please.

Unintended Consequences of Prohibition

Prohibition runs against the American system of checks and balances. When Congress passes a bum law, individuals, political action groups and the free press can appeal to the courts or the executive branch.

America's dysfunctional, statist drug control policy has managed to fly under the radar of popular criticism by paralyzing these checks and balances.

The state tries to control the drug market from two directions: supply and demand. It aims to lower consumption of drugs and lower production of drugs. A key element of this two-prong strategy is the targeting of drug suppliers.

The government believes that by attacking the supply-side economic basis of the illegal drug market, it can reduce the profitability of the drug trade while increasing the cost of drugs to consumers. "In other words," according to the President's National Drug Control Strategy (2005), "we seek to inflict on this business what every legal business fears—escalating costs, diminishing profits, and unreliable suppliers."

There have been other, unintended, consequences.

The most striking of these is that the War on Drugs has made America a prison nation.

Why? Because the primary weapon of supply-side drug policy is imprisonment. Between the early 1980s and mid 2000s, the U.S. prison population in every state grew. While the nation's population increased by about 20 percent, the number of Americans held in local, state, and federal prisons quadrupled.

This is Big Business. One construction industry trade magazine estimated that some 3,900 new prisons were built in the U.S. during the 1990s at a cost of nearly $30 billion.

During the same period, the number of inmates in American prisons grew seven-fold. New prisons cost California taxpayers nearly $5.3 billion and another $4.8 billion annually to keep running.

After two decades of unprecedented prison building and a drug prohibition policy, California's prison population had ballooned from 20,000 to 160,000. This statist agenda is part of the reason that California faced insolvency in 2008 and 2009.

With only 5 percent of the world's population, the U.S. prison systems hold 25 percent of the world's prisoners. Federal surveys show there are more than 246,000 drug offenders in state prisons, a number that grew more than fifteen-fold over two decades.

By targeting suppliers, the statist War on Drugs exposes and expands the social barriers that divide American society. Of the 246,000 state prison inmates serving time for drug offenses in 2001, 139,700 (nearly 57 percent) were "black;" this, despite the fact that blacks only make up about 12 percent of the American population.

By far, the most ironic characteristic of the War on Drugs is the federal government's addiction to tax dollars. The Drug Policy Alliance estimates that enforcing state and federal drug laws costs something like $40 billion a year. Like I said, Big Business. What's more, this War is a protracted one; the U.S. has spent roughly the same amount annually for more than a decade. And counting.

From an economist's perspective, prohibition is an extreme form of regulation. And, like regulation, it distorts free market movements and warps equilibrium.

An example: In January 2008, the *Philadelphia Inquirer* credulously reported some delirious claims by the Philadelphia Police Department about a drug seizure. Specifically:

> *Today, police laid out 16 pounds of the stuff they said they confiscated from a high-level dealer who supplied the suburbs.... Police put the value of the marijuana at $812,000. On Tuesday, as the probe continued, investigators seized 12 pounds of hallucinogenic mushrooms worth $614,000 and more than $439,000 in cash, police said.*

Some simple calculations call those numbers into question. If 16 pounds of marijuana was worth $812,000, then the pot was worth a little more than $112 per gram. Since an average marijuana cigarette weighs about one gram, the Philly police valued a single joint at over $100. That's high. Probably 10 times the actual going price for marijuana in that region at that time.

Exaggerating the financial value of drug seizures is an old tactic among law enforcement agencies. They have little incentive *not* to inflate their numbers. Media outlets played along with the sensationalist elements of War on Drugs. Plus, the state's official prohibition against widely-used drugs like marijuana makes effective price signaling impossible. There are few mechanisms by which citizens can question a zealous police department's drug-bust boasts.

This is a recurring theme. The main flaw of statist policies on regulation, health issues and anything else involving risk is that statists believe risk can be eliminated. It can't. Still, ambitious statists amble about the countryside, prohibiting substances and activities of which they don't approve.

A libertarian nation knows that life is risky and that risk can't be eliminated completely. It doesn't use coercion and prohibition in a futile pursuit of zero risk. To the extent possible, it avoids getting involved in personal matters of life and death. But, when that involvement is inevitable, it encourages life. That doesn't mean a slavish opposition to particular procedures—like abortion or stem cell research.

It means defending individuals and their personal integrity, which means accepting life's complexities and imperfections as well as its inherent value.

Chapter 14:

Social Security: The Statist Fraud That Undermines Everything Else

The group of government-run social welfare programs that Americans know commonly as "Social Security" is a cancer on our nation and any chance it has to be the free state that the founders envisioned. Taken together, the programs constitute a moral hazard that discourages people from behaving with ordinary wisdom and prudence.

The core Social Security programs began as a temporary process for curing some of the economic problems of the Great Depression. But they have expanded and metastasized into something different. They transfer money from younger and poorer people to older and wealthier ones. They subsidize the wrong people for engaging the wrong activities. They encourage government borrowing and consumption rather than private-sector productivity. And, despite the Jesuitical arguments of their overfed advocates, they *are* actuarially unsound.

More important than all of this, Social Security is a fraud that undermines the legitimacy of all other government activities—from domestic benefits programs to foreign policy.

One inescapable conclusion about Social Security stands out from the political cant that surrounds the programs like a fog: At some point, some generation is going to pay twice—once for its parents (who had not paid sufficiently for the benefits they received) and once for itself.

In the meantime, the federal government borrows heavily to forestall this reckoning. And even a statist politician like Barack Obama talks ominously about the difficulty of financing "the growing obligations of Social Security."

This borrowing was bad enough through the late 1990s and early 2000s; it became absurd during the bailout mania that started during

the 2007-2008 recession. The U.S. federal budget deficit for 2009 is projected to be over $1 trillion—for that one year alone.

Credit rating agencies understand what the federal government is trying to do. In early 2008, Moody's warned that if the United States didn't control the soaring debt related to Social Security, Medicare and Medicaid, the nation's credit rating would be downgraded within a decade. Within six months, the Feds had arranged to borrow hundreds of billions more.

The federal government's refusal to acknowledge the actuarial problems with Social Security is indefensible. In his March 2007 column "Texas Straight Talk," Texas congressman Ron Paul wrote:

> *Don't believe for a second that we can grow our way out of the problem.... To close the long-term entitlement gap, the U.S. economy would have to grow by double digits every year for the next 75 years. ... We must rethink the very role of government in our society. Anything less, any tinkering or "reform," won't cut it.*

Yet the denial goes on. And the unintended consequences are already afoot. Americans over 65 are subsidized by Americans under 40; and this inverted generational allowance is being spent on things like sex pills and motorized wheelchairs. In other words, this is another scheme for running up national debt to tread consumerist water—and then counting on debasement to lower the impact of the borrowing.

History and Economics

From a broader economic perspective, the problem with Social Security is that its structural incentives (or, more precisely, *dis*incentives) depress labor force participation in a way that makes it harder to pay for the system—especially the health care benefit portion of its basket of goodies. In other words, the scheme discourages the productive activities that might help cover its costs.

It was designed to do this. One of the explicit purposes of the Old Age Pension (OASDI) portion of the scheme—enacted in the 1930s—was to get people *out* of the labor force. The idea was that, if older workers got a check from the government, they would retire and make room for younger workers in the depressed job market.

With people living well past Social Security's scheduled retirement age, the part of their lives that is spent outside the workforce

(growing up, schooling and retirement) has changed from 31 percent pre-OASDI to 45 percent—and growing—in the late 2000s.

This amount of leisure time is unsustainable.

This rigging of the work force isn't what the American economy needs anymore. It needs more (taxable) productivity. But Social Security discourages labor force participation among both older workers and…less directly…younger ones.

The effect on older workers is simple to see. Defined-benefit pension plans always encourage vested workers to retire as early as possible. And all Americans over 65 are vested in Social Security.

The effect on younger workers isn't so easy to see. It follows from the main (but not only) financing mechanism for Social Security—payroll taxes.

Because all beneficiaries receive the same menu of benefits, the Old Age Pension is a crude form of income redistribution. If you contribute payroll tax on an average salary of $100,000 for 30 years, you get the same payments when your old that your brother—who contributed payroll tax on an average salary of $30,000 for 10 years.

This is a good deal for your brother and bad one for you.

One of the most corrupting influences of this redistribution is that it encourages people not to save.

Payroll taxes are the most destructive form of state revenue; they deny the reality of rational labor markets. Every time payroll taxes are increased, workers have a greater incentive to move into the informal sector. What policy would acknowledge these realities? Getting rid of payroll taxes completely.

Keeping Seniors Out of Poorhouses

Social Security's defenders point out that the scheme has done one important thing: It has reduced poverty among the elderly. And this claim is true. Poverty among the elderly dropped from over 60 percent before World War II to about 8 percent in the early 2000s.

But here's an inconvenient truth: Eradicating poverty among the elderly is stupid way to spend a population's money. Social Security shifted the distribution of wealth; it taxed and regulated the young in order to give money to the old. This is perverse. Young people create wealth by working and creating commerce—and there's leverage in their activities because the decisions young people make in business and career have effects for 40 or 50 years.

If anyone should be subsidized instead of taxed, it's the young. They have more productive years ahead of them.

In a free market, the elderly will often be poorer than everyone else—because they produce less, consume less and their choices usually have smaller economic impact. For these reasons, it's important to save money (or build wealth in property, business or family) in your youth to see you through your old age.

Social Security tells people that they don't need to save or build wealth. The state will provide.

This message—a disincentive to productivity that economists graph on excellently-named indifference curves—does real damage to individuals and the economy in general.

You've probably read about Baby Boomers who are continuing to work past scheduled Social Security age. People in that generational cohort started reaching retirement age in mid-2000s; many kept working because they didn't have enough money saved away to support the lives of leisure that have defined post-WWII notions of retirement. And, in most cases, the stock market losses of 2007 and 2008 only made the Boomers' financial circumstances worse.

You can see the results in restaurants and retail stores, where gray-haired people welcome you and wait on you.

Some statist policy makers treat older people working these jobs as a horror; others come a little closer to reality by interpreting seniors who are still economically productive as a good thing.

But that frame is the wrong way of thinking about age and work. The popular notion of "retirement" is ridiculous—a statist fiction, created by New Deal hucksters to convince older workers that they shouldn't be taking jobs away from younger ones.

This fiction will cost the American economy. And the worst of the actuarial reckoning hasn't even happened yet.

A practical libertarian considers work something he'll do—in some form—his whole life. And he isn't afraid of this prospect.

You should want to be productive and add value as long as you can. The insolvent Social Security system simply gives you more incentive to remain productive.

Medicare

Money troubles connected with the Old Age Pension part of Social Security will change the way people think of work and

retirement over an arc of decades and generations. But there's another part of Social Security that poses a more immediate problem.

Medicare—the main U.S. government program for providing subsidized medical care services to poor and old people—is going to cause acute money problems sooner. Its actuarial insolvency is more severe than that of the other state benefits programs.

The mechanics of Medicare hide the program's cost in a web of transactions and budgetary maneuvers that take place between federal and local government agencies. Parts of the program are administered and funded by the federal government in Washington, D.C.; parts are administered and funded by each state in its capitol. In general, the money is collected and distributed by the Feds while the benefits and services are doled out by the states. Typical of bureaucratic programs, this complexity makes close scrutiny of the program difficult.

But some hard facts stand out. As predicted for years, Medicare went into deficit sometime in mid-2008. For the first time in the program's 70-year history, its general fund started sending out more money to the states than it brought in from tax revenues. These deficits had been predicted for decades; the news in the story was that they'd come sooner than many government experts had expected.

And there's no actuarial scenario in which the deficits will go away—unless the program's basic structure changes. In fact, the deficits will only accelerate as the U.S. population in general ages and a larger proportion of Americans becomes eligible for Medicare coverage.

This is the dirty secret of the debate over "socialized medicine." While politicians and policy makers go back and forth over the merits of various government-run health services proposals, Americans are making socialized medicine a reality by aging into the existing—and insolvent—Medicare system.

(One side note: A January 2008 report from the Congressional Budget Office concluded that the sooner-than-expected Medicare deficits were caused primarily by rising health care costs and only secondarily by the aging population. Some experts debated the CBO's methods and conclusion. But arguing over the causes of a problem is trivial; acknowledging the problem and doing something about it important.)

There's no solution to Medicare's actuarial and budgetary problems other than reducing its benefits. No matter how effectively its beneficiaries lobby, pumping up Medicare's budget is only a temporary fix—at best. The demographic trends in the United States (and most countries) all point to an aging general population. At some point, there won't be enough tax revenue available to boost the budget fast enough to cover all the newly eligible beneficiaries.

Government benefit programs are hard to reform on anything less than a 20-30 year time scale. So while the next administration can repeal tax cuts rapidly, whatever you do to Social Security will endure for decades.

This introduces a lot of rigidity into government policy.

The "Stockman Strategy"

Since 2008 was a presidential election year *and* the point at which Medicare started running in the red, you might think the topic would have been a hot one among and between presidential candidates. It wasn't.

Advocates of government-run medicine argued weakly that any "fix" of Medicare had to involve a fix of the medical system in general. This is like a bankrupt Wall Street investment bank hoping to resolve its problems by finding a wealthy foreign buyer; the transaction doesn't resolve the underlying insolvency problems—it merely hides them.

Opponents of government-run medicine did…nothing. Their goal (even if they wouldn't admit this, especially during an election year) was to eliminate both Medicare and Social Security. And why do anything about programs that are killing themselves off?

This is, in effect, the Stockman Strategy—first articulated by Ronald Reagan's Office of Management and Budget director, David Stockman. The Strategy holds that statist benefits programs are practically impossible to eliminate through the political process. But these programs are, usually, actuarially unsound. So, the most promising way to eliminate them is to leave them to their dissolute ways and let them stagger toward insolvency.

At some point, eventually, the money really does run out.

Defenders of state benefits programs can play games with budgetary accounting. They will argue that there is no Social Security crisis…or no Medicare crisis…that there is only a general account

crisis—and that the general account, the federal government itself, can never go bankrupt. But this is another framing trick, an effort to hide the financial problems posed by the benefits programs in a confusingly large context.

This trick started in 1967 and 1968, when Lyndon Johnson drafted what he called the "guns and butter" budget (more formally called the "Unified Federal Budget"). This budget drew on the Medicare and Social Security surpluses that existed at that time to fund other statist programs. Since then, it's only been a matter of time until the budget would go unsustainably into the red.

It may be that American citizens won't allow the federal government to go bankrupt; but the fact remains that U.S. benefits programs are the main reason for ongoing federal budget deficits. Besides, there are many terrible things that can happen short of federal bankruptcy—a plummeting currency, an unstable banking and financial services sectors, volatile interest rates and recession. And the late 2000s are seeing all of these.

Allow, for the sake of argument, that Medicare's deficits are only a small part of the federal government's general account—and a part more than covered by overall payroll tax revenues. Deficits (like savings) grow at a compounded rate. At some point, these deficits are going to overwhelm even payroll taxes. In 2008, statists were arguing that point wouldn't come until near the year 2020; Medicare critics were arguing that it would come sooner.

But the undisputed fact was that the program was insolvent—and pushing the general account toward insolvency. To a libertarian—to any rational person—this is a bad thing.

Pretend for a moment that you're a turnaround consultant who has been brought in to work out the solvency problems faced by the U.S. federal government's general account. A good workout expert will start by studying the balance sheet of the troubled entity to understand how its liabilities can be managed or reduced and how its assets can be grown or turned into cash.

From this perspective, the United States is far from bankrupt. The federal government owns something like $40 trillion in marketable assets, including massive amounts of real estate in Alaska, Arizona and Nevada. This land could be sold off over several decades to fund the operating shortfalls caused by Medicare and other benefit programs.

But would environmentalist subsidy-seekers and the halfwit naifs who support them allow a free-market liquidation of public lands? In 2007, the answer to that question would have been a resounding "no." In 2009, after two years of economic contraction, the answer was more nuanced. If the recession that began in 2007 continues as predicted until 2010 or 2011, the millions who rely on Medicare will line up against the few hundred who have any real investment interest in "green" malarkey.

And what if Medicare is simply folded into a more ambitious government-run health care system? The reckoning may be delayed a few years but it will come just as hard. When the choice is between weeks-long waiting lists for basic surgeries at state-run hospitals and selling drilling rights in ANWR…or selling off land altogether…the vox populi won't hesitate to sell the land.

Present a person with the choice between a specific benefit and a general positive externality and that person will choose the specific benefit. This may not be the wisest choice; but self-interest is deeply rooted in human nature. For these reasons, sneaky statists will work hard to avoid giving citizens choices between specific benefits and general externalities.

Private Retirement Accounts

One of the unfulfilled promises of George W. Bush's presidency was his plan to privatize at least part of Social Security's Old Age Pension program. His plan had been that workers would keep a portion of their payroll taxes in an investment account—structurally similar to a 401(k) account—that the worker would control. The accounts would have been tax advantaged, which meant that if you took money out of your account before you reached a designated retirement age, you'd owe a big tax penalty.

This plan met with near-universal opposition in Washington, D.C. It was quickly diluted and then defeated by hostile statists.

The main argument against privatizing the Old Age Pension element of Social Security was that it shifted investment risk from the federal government to individuals. This was supposed to be a bad thing—which assumes that placing investment risk with the federal government is a better thing.

The critics of privatization also make some unintentionally instructive moral equivalency arguments. They believed that

privatization was a crooked scheme, designed to benefit the stock brokerages and other financial services companies that would have administered the private accounts.

Then (and this was the telling part) they argued that the U.S. shouldn't replace one crooked scheme with another crooked scheme because the new crooked scheme was too risky. Some called this the "deeper hole" argument: If people misused their retirement accounts, they'd be broke when they got old and need government aid. This would mean switching a deep hole for a deeper hole. The "responsible" thing to do was be content with the first deep hole.

If you can't follow the logic of this—that's right.

The real reason that statists don't want to privatize pension benefits is that they count on using the worker's money. All the noise that American politicians make about "Social Security trust funs" and "lock boxes" is just that. Noise. There are no trust funds; there are no lock boxes. The government spends Social Security pension dollars as soon as it gets it grasping hands on them.

And it leaves the future pension obligations those dollars represent to future administrations.

This is a critical point: The dollars workers pay into the Social Security system today aren't put away somewhere; they're used to pay pensioners *today*. The money that today's retirees paid was squandered on statist boondoggles decades ago.

Mendacious statists obscure these hard truths by calling Social Security a pay as you go program. And insisting that it always has been so.

Bear in mind that the "you" in the "pay as you go" OASDI program is *not* you, the taxpayer. The you is the federal government. Under the program, taxpayers pay a usurious overhead cost for the federal government to launder their money. What rational person would voluntarily pay a state agency 40 or 50 percent of his invested capital to do for less return than a local bank would pay in savings account interest? None.

That's why the federal government exerts its coercive power to force citizens to participate in the program. And it's the reason that the citizens remain dubious about the value of their forced participation.

Another point: The inefficient bureaucracy that administers the Social Security system is, itself, a kind of welfare program. By most

estimates, the system's overhead costs—counting the agencies at both the federal and local levels—runs between 40 and 60 percent of its total budget.

For simplicity's sake, we can split difference in this range and say that the overhead costs are half of all the money spent in the programs. In other words: For every dollar that Social Security pays out to an old or poor person (or her health care providers), it pays a dollar to employees, contractors, suppliers, landlords and others.

Few private-sector firms that produce actual things run a 50 percent overhead cost. Those that do are usually high-end services companies like law firms, advertising agencies and investment banks. This may explain government bureaucrats' consistent (and confounding arrogance).

Washington policy makers know that the running of these redistribution plans is itself a form of redistribution. Occasionally, some admit this. The *Reinvention Roundtable*, a newsletter published by the "Reinventing Government" workgroup chaired by Vice President Al Gore during the 1990s, caused tempests in several teapots when it gently nudged the Social security Administration and other gargantuan bureaucracies to cut down on "busywork" and boost their efficiency (how that would be measured remained vague). The newsletter and the workgroup were eventually terminated.

Other flashes of insight come from outside the federal bureaucracy's walls. The Web site of Accellos, a Colorado-based "supply chain management" services company, describes work that it did for the Social Security Administration:

> *The entire SSA warehousing operation was running on a paper-based system characterized by marginal customer service, a month long order process and inefficient inventory management.*
> *The method for order entry was cumbersome and prone to data entry errors. ...Excessive manual effort was required to manage the inventory levels and process customer orders through what amounted to a fragmented supply and warehouse process. ...The staff often arrived at empty bins as inventory adjustments and stock updates took as long as three weeks to process.*

To its credit, Accellos helped the SSA improve some of these problems. But, as recently as early 2009, the SSA was renewing

Accellos contracts on a "sole-source provider" basis, which suggests heavy dependence on a single contractor. Not a sign of efficiency.

The federal government adds no value to the Social Security programs—in fact, it removes value.

This is the moral hazard of Social Security: The scheme is seen as a lie by younger workers who invest not expecting to see a dollar in return when they retire. This is the big fraud; it's a prime reason for dissatisfaction with and suspicion of the federal government.

Emotional Defenses of Social Security

The core Social Security program, OASDI, didn't start out as a simple wealth transfer. It required 40 quarters of participation to receive a full benefit (with the exception of the disability component). However, life expectancy was far shorter when the program started.

Medicare, on the other hand, began its life as a wealth transfer program—with benefits flowing immediately to people who had contributed nothing to the scheme.

Statists say many stupid things about Social Security and other wealth redistribution schemes. Here are a few common delusions (some courtesy of the Nobel prize winning logic scrambler and Big Government apologist Paul Krugman):

America is the rich. We don't need to be a country where people are still working at 80. We can afford to let old people retire.

There are several flaws in these emotional arguments. First, America isn't as rich as most emoting statists think. Second—and, really, more important—there is no "we."

Baby Boomers have paid more in Social Security taxes than their parents have collected in benefits, in order to build up a trust fund for their own retirements. If you decide not to honor the bargain, you have taken their money.

Depends who "you" is. This kind of argument is usually directed at young workers who are (rightly) skeptical about the scheme. Actually, the Boomers' parents took their money—not the younger workers who haven't benefited from the scheme. If anyone took the Boomers' money, it was their parents.

The Social Security system will pay your money back, plus interest, when you retire, unless the government scraps the system before you retire, in which case you will lose the money you have paid in.

This is, basically, a threat. If you try to end the bad scheme, you'll lose the money you put in. But that money is *already* lost.

Also, this argument echoes the classic money-losing investment strategy of chasing losses. Lost money is gone; there's no sense—and very little profit—in trying to win it back by investing more.

And, finally, this argument is inconsistent with the previous one in at least one critical way. In the previous argument, money in the scheme belonged to the people withdrawing from it; in this argument, the money belongs to the people contributing to it. So, who actually has the moral claim to the money in the scheme?

As the Boomer bulge moves through the system, the ratio of workers to retirees will stop declining, and the problem will go away.

At least this argument admits there's a problem.

This solution presumes several dubious things. First, life expectancy is fixed. It's not. People, including Boomers, are living longer; this creates an ongoing shortfall in the finances of the pension scheme. Second, there's a fixed in-flow new workers to support the scheme's retiree-to-worker ratio. This may happen but can't be *assumed* to happen. Third, when the ongoing shortfalls need to be funded, citizens will identify more as members of the national Social Security scheme than they do as members of smaller social units—families, neighborhoods, etc.

This last assumption may be the most oblique. But it's also the most important.

The self-interest that's part of the human condition prefers local social units to national ones. As Social Security lumbers toward financial crisis, Americans will face the politically-difficult proposition that—with the ratio of workers to retirees declining—families with one or two children become free riders on larger families. At some point, the larger families may buck from this system.

Who Supports This Wretched Scheme?

The only people who should like Social Security are people banking its checks right now and the inefficient bureaucrats who

issue them. "Progressives" should dislike the scheme because it takes money from relatively-poor young people with children and gives it to relatively-rich and usually childless old people. Libertarians should dislike that it treats individuals as a means (of state-administered wealth redistribution) rather than an end. Conservatives should dislike that it discourages savings and personal financial responsibility.

And everyone should dislike that it's a legalized Ponzi scheme.

Still, some support the scheme. As I've mentioned before, loudest among the mendacious statists for Social Security is the *New York Times* columnist Paul Krugman. Why? No rational person can be sure; but the statists who support Social Security seem to do so because they believe Big Government programs affirm the existing social and economic order—which, they believe, works to their personal advantage.

So, the answer to "Why?" is "A warped sense of self-interest."

Something's warped, anyway. When some of these Social Security acolytes are confronted with hard truths and honest questions about what to do with the scheme, they respond—red-eyed and fuming— with vitriolic attacks.

In November 2007, Krugman attacked then-presidential candidate Barack Obama (a staunch statist) for questioning the viability of the scheme. He fumed that Obama had been misled by "decades of scare-mongering about Social Security's future from conservative ideologues."

By "conservative ideologues" Krugman must have meant some customized definition of the term that includes former president Bill Clinton (another staunch statist) who, in 1998, said:

> *This fiscal crisis in Social Security affects every generation. ...it not only affects the generation of the baby boomers and whether they'll have enough to live on when they retire, it raises the question of whether they will have enough to live on by unfairly burdening their children and, therefore, unfairly burdening their children's ability to raise their grandchildren. ...if nothing is done by 2029, there will be a deficit in the Social Security trust fund, which will either require ... a huge increase in the payroll tax or about a 25 percent cut in Social Security benefits.*

Where did Clinton get his information? Conservative ideologues? Er, no. His own Advisory Council on Social Security, chaired by left-leaning economist Edward Gramlich, which wrote:

> *While the Council has not found any short-term financing problems*
> *with the [OASDI] program, there are serious problems in the long run.*
> *Because of the time required for workers to prepare for their retirement,*
> *and the greater fairness of gradual changes, even long-run problems*
> *require attention in the near term.*

The statist hacks and *New York Times* sophists who support Social Security rely on a handful of rhetorical and legerdemain tricks to make their case look less shabby than it is. One of these tricks: They'll treat Social Security as part of the U.S. federal budget one moment and an off-budget item the next. It's as if they don't know anything about government finance (or money in general) and argue whatever they think proves the point they're making at the moment.

This is the kind of accounting that sent Enron into bankruptcy and its accounting firm out of existence.

Nobel Prize-winning Nonsense

In a typical column, the wild-eyed Paul Krugman wrote:

> *...2017—the projected date at which payroll taxes no longer cover benefit*
> *payments—has raised its ugly head. But there is no interpretation*
> *under which 2017 matters. Social Security legally has its own dedicated*
> *funding; if you believe the government will honor the law, the surpluses*
> *the system is now running are building up a trust fund, which will*
> *finance the system for decades after 2017, and maybe forever. If you*
> *think the law will be ignored, then Social Security doesn't really have its*
> *own budget—the payroll tax is just one of many taxes, and SS benefits*
> *are just one of many government costs. In that case the relationship*
> *between payroll taxes and benefits is irrelevant.*

As long as Social Security runs a "surplus," the Feds will show its trust fund as a debt. Increasing payroll taxes would only increase this "debt" (in fact, an IOU that the general fund makes to the Social Security trust fund). That kind of accounting invites moral hazard.

Again, Krugman:

> *...we could wait until the Trust Fund is fully paid out... what Bush*
> *calls "bankrupt"... then raise the tax 2 percent for each worker, or*
> *about 15 dollars per week for a worker earning 37,000 per year.*
> *Except that by then the average worker will be earning more like*

50,000 per year... in real dollars, according to the Trustees projection of a 1.1 percent increase in real wages per year.

Sound familiar? This is just another version of statists counting on debasement to erode its obligations. This approach to accounting leads to perpetual inflation and a kind of economic musical chairs that leaves future generations without anywhere to sit.

Sometimes, Social Security's critics get drawn into the same inconsistent analyses created by the program's proponents and creators. It's a kind of statist briar batch—once your enter it, the on-budget/off-budget trickery makes all comments equally incoherent. And, as we've seen before, statist use this kind of moral equivalence to justify their schemes. More Krugman:

> *The incoherence of the "crisis" arguments is what first convinced me that the "crisis" was fake—no need to lie and distort if you have a real argument after all.*

Here's the real argument: Social Security burdens future generations of American taxpayers with the obligation to transfer non-trivial amounts of their wealth to a substantial number of retirees who thought their government was saving for retirement when, in fact, it wasn't.

As I move away from the statists arguments of Paul Krugman, one closing observation: The so-called "Nobel Prize" in economics isn't a real Nobel Prize. It's a kind of red-haired step-award given by the Bank of Sweden.

What's the Truth?

U.S. government spending on Social Security, Medicare, Medicaid, and related benefit programs is unsustainably high. The scheme is luxury the nation can't afford. Purchased on a credit cards. With a very high interest rate.

A Congressional Budget Office study published in the summer of 2008 projected that maintaining the scheme at an actuarily-sound manner would require tax increases of 150 percent, with the lowest income-tax bracket jumping from 10 to 25 percent and top rates from 35 to 88 percent.

Perhaps being drole, the anonymous CBO authors concluded that such high "tax rates would significantly reduce economic activity."

The Brits tried that kind of tax policy in the 1970s. It was a disaster. The country chased away all its best earners; just ask Mick Jagger and Elton John.

Having read the CBO study, the newspaper *Investor's Business Daily* editorialized:

> *Allowed to grind on without real reform, Social Security, Medicare and Medicaid will do what no invading army or cabal of terrorists has done or will ever do: bring this mighty republic to its knees. ...It's unfair to ask—actually, to force—Americans to begin living ascetic existences when our heritage is the promise of prosperity.*

The paper noted that an 88 percent top rate would not be the highest ever. During World War II, the top tax rate was 94 percent. This was during the statist's paradise when the government coerced and rationed just about everything. It controlled the markets for cars, gasoline, tires, butter, sugar and shoes. It also put citizens of Japanese ancestry in prison camps. With the Supreme Court's blessing.

Raising top tax rates to confiscatory levels may excite a few statists, but it doesn't do much good for anyone else. The rule of diminishing returns takes effect and the high rates don't generate any additional revenue. Besides, boosting tax rates all the way up to 100 percent won't finance the Social Security scheme's shortfalls as the beneficiary population grows—especially after 2050, when the demographics of the U.S. will reach the point that beneficiaries *outnumber* workers.

The most confiscatory tax policy in Paul Krugman's excitable brain won't make that model work. The Chinese won't be willing or able to buy enough U.S. government bonds to keep the transfers going. The scheme will finally collapse.

The only alternative to raising taxes is debasing the currency. And this, as we've seen before, is a policy that statists can *really* get behind Debasement "solves" the government's obligation problems in two ways that are attractive to statists:

- It keeps the state in the middle of things by making the money supply (which the government controls) instead of interest rates the main mechanism of economic policy.

- It reduces the real cost—and value—of the obligations it has made to beneficiaries. The government keeps the letter of its

promises (to pensioners as well as bondholders), even though the citizens who count on government pensions are pushed into poverty.

This may sound like some hypothetical discussion from an undergraduate course in macroeconomics. But it's not just academic. People who depend on government wealth transfers will starve or die of preventable disease, unless they find work or private charity.

More likely: Families will have to reassume the responsibility of caring for their own. So, old and uneducated people without families will be in particular trouble.

The Flash Point

So, Social Security is a scheme that's heading for a brutal reckoning. When does it get there? Conventional wisdom predicts the pain will come sometime between 2012 and 2029.

Critics of the Social Security scheme often focus on the nearer end of that range, because 2012 corresponds with the highest point in the bell curve of Baby Boomer retirement.

However, this assumes that "retirement" is a standard thing that people start at a fixed aged. It's not. The recession that started in 2007 has convinced many Baby Boomers that they will have to keep working beyond early retirement age to replace the money they lost when their 401(k)s and other retirement accounts took a beating during 2007 and 2008.

This is a rational response. And a libertarian should be heartened that at least some individuals are sophisticated and self-reliant enough to recognize that they need to stay productive.

But this may be the kind of good thing that enables a bad system. Boomers who keep working, like families that choose to have grandparents live at home, may just forestall the reckoning. And make the trouble even greater when it comes.

There's another reason that the reckoning might come sooner. Starting in 2014, the $53 trillion of accumulated debt associated with Social Security and Medicaid starts coming due. Annual tax revenues for the programs will drop below annual obligations—and all of the IOUs that Congress has been writing against the Social Security "trust fund" will need to be repaid into order to keep the transfer checks flowing.

Of course, elected politicians have an animal-like sense for averting trouble. Several times (including once during Ronald Reagan's administration and once during Bill Clinton's) the president has cooperated with congress to revise, refinance and recalculate the terms of the Social Security scheme to push its reckoning out a few years. Barack Obama is a smart and pragmatic politician whose political debts are to specific government-employee unions rather than the retired demographic at large.

Obama may settle for some short-term solutions. Or, perhaps, he'll aim higher and try to make major systematic reforms to the Social Security scheme. The pain-minimizing strategy, from an economic and human-misery point of view, would be to crash the programs sooner—institute 30 or 40 percent cuts in OASDI benefits as the "trust fund" IOUs become due.

These cuts will put a major dent in the lifestyle of retired America. Groups like the AARP will howl. But deep cuts in benefits are the only meaningful reform. The sum of benefit payouts and debt service has to be cut to a level that current tax revenues can sustain indefinitely. Since the federal government has been borrowing to fund entitlements since the 1960s, it's rational to expect that entitlements would have to be cut to pre-Great-Society levels before they would be sustainable again.

This means no Medicare. No Medicaid. No AFDC. OASDI might be salvageable—but only as the income-banking program it was originally intended to be.

By the early 1990s, most sensible younger Americans had already written off their government old-age entitlements; but this produced no slowdown in the growth of those entitlements.

The actuarial problems with the U.S. social welfare system don't mean the government will go bankrupt suddenly. In the lifetime of anyone reading this book, entitlements will become a growing—but supportable—drain on resources.

Subsidizing the poor may make sense to those who seek the facile satisfaction of social justice. But subsidizing the best paid, most invested class of retirees the world has ever known is simply perverse.

The nefarious part of Social Security is that it convinces rational people to trust an unsound state program *and* not to save.

Chapter 15:

Public Faces and Private Lives

A libertarian nation thrives when citizens have a strong sense of the distinction between the public and private realms of their lives. Statists constantly work to erode the distinction between individuals' public and private selves. In this regard, in 21st Century America, the statists certainly seem to have the upper hand.

Privacy is an essential aspect of liberty. In fact, liberty is *meaningless* without privacy. Yet uninformed people are willing to trade their privacy for illusions like fame, popularity or importance.

Few Americans (or citizens of other developed nations) have any sense left of public and private realms in their lives. They watch video entertainment that claims, falsely, to be "reality programming." Many believe they "know" public figures created and packaged by mass media outlets. Some write and post private images on the Internet, ignorant of the permanent and decidedly *non*-private nature of online forums.

Libertarians need to encourage citizens to rediscover privacy and their private selves. This is a major bulwark against ambitious statists and the creeping state.

I started this book by describing the nature of individuality and how important it is to any practical definition of liberty or society. The private self is that which comes before the Social Contract; the public self is that which lives within the Social Contract.

Your *private self* is how you are, left to your own desires and devices—and free of social constraints. Your *public self* is how you are when you're fulfilling your end of the Social Contract. It's more restrained and responsive to the complex demands of society. By some reckoning, it's a compromise.

For that reason, some argue that the private self is more honest or genuine than the public; but that argument misses the point. One

personal realm isn't more genuine than the other. The public self is *genuine*; it's just different than the private.

The writer and philosopher Hannah Arendt considered the relationship between public and private lives. In her great essay *Public Rights and Private Interests*, Arendt outlined the difference between a person's private life as an individual and public life as a citizen. She concluded that a person's public interest as citizens is distinct from that person's private interest as an individual; the public interest is not the sum of private interests or even the total of enlightened self-interest. It has little to do with private interest, since it concerns the world that lies beyond the self. It involves the interests of a public world which people share as citizens and which they can experience only by going beyond private self-interest.

She pointed out that the question of how to reconcile public and private lives traced back to the ancient Greeks (specifically, the Athenian Greeks of Plato's time) and Romans. The Greeks—perhaps the ancient world's libertarians—considered private life essential and public life an occasional duty.

The Romans—more in line with today's statists—believed that public and private realms were equal aspects of a citizen's life.

If you don't like compromise and restraint, you should minimize the role of your public self in your daily life; if you seek a public life—and, especially, political office—you should be comfortable with compromise and restraint.

At the founding of the United States, citizens had a strong sense of the restraint that public life—and, especially, holding public office—required. The founders were fond of the word "rectitude," which doesn't get much use anymore but may be an even more precise word for the quality that people who hold public office *should* exhibit.

Too few today do. Contemporary politicians do a disservice to the notion public and private selves by claiming distinction when it suits them—but denying it when it doesn't.

When Someone Confuses Public and Private

New York governor Eliot Spitzer had always been an asshole in public; in 2008, it came to light that he'd long been an asshole in private, too. His mishandling of the two realms cost Spitzer his political career.

You might say, reasonably, that a man's private assholery should have no bearing on his public life or political career. And it shouldn't. But statist politicians make a point of blurring and combining the public and private realms of their lives. And, if you'd rather not know about Spitzer's private life…then you were out of luck during the spring of 2008.

Like many aggressive New Yorkers, Spitzer had taken degrees from top schools—in his case, Princeton and Harvard—to a fast-track early career with a Wall Street law firm. Like many of the self-anointed elite from Princeton and Harvard, he wanted to tell other people how they should live—what ambitious social strivers call "public service." He left Wall Street for the Manhattan District Attorney's office. The whole time, he angled for elected office.

In Spitzer's case, Princeton and Harvard probably didn't make the monster. He came to them fully formed. His father—a wealthy real estate speculator with a parvenu's urgent sense of social standing—had raised his son from boyhood to be "a Jewish Kennedy."

Elected New York's state attorney general in 1999, Spitzer made it clear that he intended to use his legal powers to force the financial world to conform to a statist notion of "fair play." A key part of this "fair play" was that businesses should behave as though performing a public service for their customers.

In short, Spitzer had a medieval…even feudal…notion of work as a duty. A person should do a job as an expression of his or her place in society. Not to make money.

Spitzer used the Martin Act, a vaguely-worded New York anti-fraud law, to prosecute bankers and stock brokers for activities that may not have been against any better-known law. The (not particularly pro-business) magazine *Legal Times* described the Martin Act skeptically:

> *It empowers [the New York attorney general] to subpoena any document from anyone doing business in the state; to keep an investigation totally secret or to make it totally public; and to choose between filing civil or criminal charges whenever he wants. People called in for questioning during Martin Act investigations do not have a right to counsel or a right against self-incrimination.*

Talk about feudal.

Spitzer cultivated a public image as the "sheriff" of Wall Street, prosecuting Ivy League sharpies and grifters in Brioni suits that even the Feds were afraid to confront. His preferred legal strategy was to file Martin Act charges with maximum publicity and then negotiate settlements from brokerages and banks that didn't want the bad press of protracted court battles. (This approach resembled the corporate "shakedowns" perfected by race-based agitators like one-time presidential candidate Jesse Jackson.)

Some free-market think tanks criticized Spitzer's crude, anti-business technique. In November 2006, the *New Individualist* magazine wrote:

> *Spitzer fails when his victims spurn his moral premises. He cannot control businessmen through "public shamings" when the businessmen are not ashamed. That is why people opposed to Spitzer need to attack the moral foundations of his career. ...Spitzer's opponents must uphold the morality and legality of pursuing one's self-interest.*

This turned out to be a prescient take on the asshole.

Spitzer countered any criticism with tough guy rhetoric, telling one reporter: "The financing behind the Cato Institute and the Federalist Society is a group that doesn't want and never wanted any government enforcement of the rules."

Who's that financing? The Illuminati? Probably not—Spitzer probably would like the Illuminati's utopian world view.

The tough guy talk and his father's money got Spitzer elected governor in 2006 on a platform of cleaning up institutional corruption in Albany. As soon as he'd sworn his oath of office, Spitzer picked a fight with Joseph Bruno, the Republican Party's leader in the state senate. Spitzer made bold accusations about Bruno's use of state cars and supposed expense-account abuses. (There may have been some merit to these accusations; Albany—like many state capitols—has a long traditional of sleazy dealings.)

Apparently half-joking, Spitzer warned Bruno "I'm a fucking steamroller;" and, apparently serious, he told his political opponents not to challenge his reform agenda.

At first, Gov. Spitzer was the object of media speculation: How long until he ran for president? But he alienated the Albany establishment so quickly that he wasn't terribly effective running the

state. Whether or not he padded his expense report, Bruno was an effective bare-knuckle political brawler. And Spitzer had some dirty secrets....

On March 10, 2008, the *New York Times* reported that Spitzer had been identified as a frequent patron a high-end prostitution ring based in New York City. Worse, Spitzer seemed to have broken various federal laws by obscuring the origins of the money he paid the expensive whores behind various sham transactions (or "structuring," a law-enforcement term of art that he should have known from his days as attorney general) and by paying them to travel across state lines for assignations. In other words, the "sheriff of Wall Street" was acting like a sleazy drug kingpin or Mafia don.

In the early hours after the story broke, Spitzer and his wife considered their options—including staying and fighting the charges, in the style of the Clintons during the 1990s. His first press conference—which many expected to be his resignation announcement—was a bizarre performance in which he admitted to nonspecific wrongdoing and apologized to his wife and children.

But this wasn't the 1990s and the Spitzers weren't the Clintons. There was no way to spin the governor's whoring as a Clintonian excess of roguish charm. Spitzer had broken too many of the same kind of transaction laws he'd arrested Wall Street traders for breaking. He wasn't a womanizer—he was a hypocrite.

On March 12, he announced his resignation from public office.

Statists Confounded by the Confusion They Created

Good riddance to bad rubbish. But some statists saw the story differently. University of Chicago professor and recycler of conventional wisdom Martha Nussbaum raged about what she saw as unfair treatment:

> ...Eliot Spitzer, one of the nation's most gifted and dedicated politicians, was hounded into resignation by a Puritanism and mean-spiritedness that are quintessentially American. My European colleagues (I write from an academic conference in Belgium) have a hard time understanding what happened, but they know that it is one of those things that could only happen in America, where the topic of sex drives otherwise reasonable people insane. ... If Spitzer broke any laws, they were bad laws, laws that should never have existed.

That's a strange defense—few people considered Spitzer "one of the nation's most gifted and dedicated politicians. " And the closing bit about "bad laws" was a strange line of reasoning from a woman who normally advocated laws to control every sort of human behavior.

Nussbaum is right about the futility of laws against prostitution. But she reaches the right conclusion for the wrong reasons, stumbling through politically partisan rationalizations. Her sloppy logic and factual...detachment...are common in academia. This is part of the reason that American academia is in such trouble.

Besides, from the law enforcement perspective, the hookers were of secondary importance.

The lawyers prosecuting the former prosecutor said they'd first been drawn to the case because of the steps that Spitzer had taken to hide his money trail. The series of transfers and transactions (a kind of one-man money laundering scheme) fit the model of what the Feds call "structuring." Drug dealers and mafiosi use structuring to confuse government investigators; whore mongers do it, more often, to hide their financial dealings from spouses, family and business partners. Spitzer's motive seemed to be a combination of the two.

Like many stupid or reckless people who choose public lives, Spitzer tripped over the line between his public and private selves. Maybe these stumbles are to be expected. As the federal government has grown through the late 20th and early 21st Centuries, American culture has systematically blurred the distinction between public and private. We need to recover the clarity of that distinction.

A related point: A limited state requires less public life of each citizen. This, by itself, is a good reason to keep government as small as possible. Public office holders who keep mistresses, accept favorable mortgages from banks they regulate or profit from legal-but-shady investments should be advocates of a humble, limited government. Often, they aren't. They justify their inconsistencies of behavior and advocacy by using public and private selectively.

Hypocrisy Isn't the Worst Transgression

Then again, hypocrisy may not always be the greatest transgression. For most people, public and private lives do not always align perfectly. You may support values and advocate virtues in public that you fall short of in private. Many of us do.

Small minds focus on hypocrisy of public figures. All public life is hypocrisy…or, at best, is compromise.

If anything needs change, it's not sexually selfish or money-grubbing "private lives" of supposedly altruistic public figures. What needs to change is their pretense of altruism.

Traditionally, a notion of distinct public and private lives tempered how American laws were enforced. This applied particularly to so-called "morals legislation." Laws against gambling halls, strip clubs, sodomy, etc., tended to prevent the public exercise of these things—even though most citizens expected them to go on in private.

The purpose of morals laws is to move certain behaviors out of public life. And that, by itself, can be an important element of the Social Contract. For some citizens, it is the *most* important element.

Some statists make a lot of noise about "tolerance" as public virtue. It's not; it's an essentially private virtue.

Tolerance for people's private lives is an important attribute of a free society. But tolerance—if it means anything—requires a strong sense of the distinction between public and private.

Tolerance isn't the same thing as support or endorsement. The statists who whine for tolerance are often being disingenuous. They don't really want tolerance; they want endorsement.

The modern American master of blurring the lines between public and private selves was Bill Clinton. In the manner of confidence artists and television emoters, he begged the public to confuse his public and private lives—and then danced between the two, asking for privacy sometimes and intimate response others.

Clinton behaved bestially throughout his years of public service. As governor of Arkansas, he apparently used state troopers assigned to his security detail as pimps and procurers. His sexual affairs may have been his own business—but he used the trappings and mechanics of his public office to enable those private, er, ends.

Clinton relied heavily on his wife to provide political support to him as a kind of character witness. And he used his daughter in the same way.

Social discourse on adultery doesn't often mention the damage that it does to the cheater's children. Especially when the cheater is the father of daughters close to the age of his mistress (as in the case of Clinton's Oval Office trysts with the zaftig nitwit Monica

Lewinsky, nearly the same age as his daughter Chelsea), an affair injects Freudian sexual tension into parent-child relations.

If he were an honorable man, Bill Clinton would have respected his college-age daughter enough not to diddle a recent college graduate. But, in his private life, Clinton seemed not much of an honorable man. Instead, he dragged his daughter into the results of his sordid sexual impulses.

All the while, he insisted that the public and the media respect a "zone of privacy" around his daughter. If *he* didn't, why should *they*?

It's difficult to imagine life from Bill Clinton's perspective. It must be a confusing blur of private impulses and public sentiments. In 2008, when his wife was running for the presidential nomination of the Democratic Party, many observers noted that Clinton seemed disoriented at times. Some chalked this up to the heart surgery he'd recently had. But there's another explanation: The old con artist had spent so many years traipsing between his public and private selves that he wasn't sure which was which any more.

Blurring the Lines

It isn't just public figures who blur the lines between private and public. Many citizens do, too. People identify personally with celebrities and public figures. Celebrities use this misplaced identification to their advantage as endorsers and promoters of consumer products.

Politicians use it to get and hold public office.

There are numerous bad results of all this. Worse, perhaps, is the dysfunctional personal connection that many citizens feel toward public figures they've never met. A vivid example of this dysfunction: In March 2008, the U.S. State Department admitted that the passport files of three presidential candidates—Sens. Hillary Clinton, John McCain and Barack Obama—had been breached by employees.

The passport files included basic information like birth dates and background on where candidates have traveled. But they also contained sensitive information like Social Security numbers, which could be used to access credit reports and other personal information stored by other agencies or organizations.

With media outlets buzzing about the security breaches, State Department officials held a news conference to explain what they knew and try to contain the damage. Spokesman Sean McCormack

confirmed the breaches and said that Secretary of State Condoleezza Rice had made it clear to the passport agency's inspector general that determining how the files had been breached was a "top priority."

McCormack said that three people had been caught accessing the candidates' files. All three were employees of a private-sector contracting company hired by the State Department to manage passport data files. According to McCormack, two of the workers had been dismissed and the third had been disciplined but not fired.

According to the State Department officials, such breaches had happened several times before with nonpolitical celebrities. On at least two occasions during the eight months before the Clinton-McCain-Obama story broke, government contractors had been fired for accessing records of Hollywood celebrities.

This blurring of public and private selves cheapens political debate. During W. Bush's presidency, some ignoramuses hated the president (whom they'd never met) so passionately that they raved about killing him or—more often—ranted about "trying him for war crimes" because of his alleged manipulation of intelligence data in the run-up to the invasion of Iraq.

Let's be clear: The Iraqi war and occupation was an ill-advised, essentially un-American proposition. It was nation-building. It was the kind of statist ambition that debases liberty. And Bush's advisors certainly seem to have manipulated and distorted intelligence data to bolster their case for invasion.

A variation of the celebrity-driven confusion of public and private lives is the way that many people confuse the virtual reality of the Internet for real reality.

Spitzer, Clinton and minor-league liars like John Edwards blur public and private selves in service of their selfishness, greed and adultery. And, as some pundits argue, that's almost defendable. Cheating spouses have been lying about their private lives for time immemorial—in the interest of keeping amity (or the appearance of amity) in their homes.

The legitimate question may be why so many faithless spouses seek public office. To obscure their infidelities behind the screen of public service? To enable their infidelities? Who knows? Who cares?

The confusion of public and private comes to a more absurd point when people make bold public statements and then are shocked that there's negative response.

The archetype of this phenomenon is the attractive but seemingly dull actress Susan Sarandon. Given valuable media platforms, she feels obligated to make political statements—but these follow no coherent pattern. Their common threads are a cartoonish anti-authoritarian stance that draws moral equivalence between democratically-elected U.S. politicians and the committee of tyrants that runs China.

But criticizing half-wit Hollywood celebrities for vapidity and hypocrisy isn't sporting. The great film actor Marlon Brando may have gotten close to an answer about why celebrities feel driven to make goofy political statements when he called movie acting a "silly" way for an adult to earn a living.

A more troubling example of addled confusion about public and private came in the winter of 2007-2008 when the Vermont town of Brattleboro became one of the several sanctimonious municipalities to make meaningless legislative gestures to show their dislike of the president. In Brattleboro's case, the town council passed a petition that called for the arrest of George W. Bush and Dick Cheney for "crimes against the Constitution."

(To get it out of the way from the start, the town had no actual legal jurisdiction to arrest the president—or anyone else—for crimes against the federal Constitution. The local Solons admitted their petition was merely symbolic; which is good reason to question symbolic legislation.)

Vermont is well known for its shallow hipster radicalism. Natives complain about the people (many from New York) who move north for the small-town charm and verdant surroundings—and then start pushing lefty statist agendas. The results are often less coherent than the ravings of the gray-ponytailed Trotskyite from Brooklyn. And the people pushing them are often ridiculously thin-skinned.

Brattleboro's local government can pass whatever meaningless petitions it pleases. It can—as it did—issue press releases touting the gestures. Its aging hipster burghers can assure each other that they are sparking revolution.

And the rest of the world can ridicule them for being buffoons.

That's what happened. When word of Brattleboro's petition hit the Internet during a slow news period in January 2008, most bloggers and commenters made fun of the town and its residents. Some of this leaked onto talk radio and TV.

Then there was a second wave of reaction that was nastier. People started calling Brattleboro's local government (town clerk Annette Cappy seemed to get most of the calls), lambasting the locals for being "dumbasses" and calling them worse names.

Suddenly the wannabe radicals had delicate sensibilities. Town agencies stopped answering their phones; the local police said they would prosecute anyone whose messages "crossed the line" and harassed town officials.

And Brattleboro locals gave interviews to the national media, which happily exploited their hypocrisy. They treated it as comic relief to the more serious news of the day.

The locals were so confused about public and private realms that they didn't understand how their symbolic gesture could evoke such nasty reaction. They equated nastiness with private lives—and public life with…well, no accountability. This was absurd. Their meaningless public call for the president's arrest was exactly the sort of thing that should result in public ridicule. In this case, the Internet served a good public purpose in exposing Brattleboro's gesture to the scorn it deserved.

Does the Information Economy Help of Hinder?

Statist elites have long underestimated the democratic power of the Internet. And, a decade into the Internet's ascendancy, they remain bone-headed about it. They seem constitutionally unable to appreciate immediate and unfiltered public response.

One good example: the magazine writer Lee Siegel was a typical mediocrity produced by elite education and social networking. He built a media career on restating conventional wisdom in articles and books that few people read. In 2006, he started a "culture blog" for the web site of *The New Republic* magazine. It was a dangerous mix of an old-media personality with a new media platform. And reaction wasn't good; readers criticized Siegel's stuffy and, worse, badly written attempts at high-mindedness.

Siegel wasn't accustomed to being criticized. Evidently, he panicked. In a move that most teenage web surfers would know was stupid, he created fake online personas that defended his writing. Writing under one of these aliases, the dolt wrote of himself: "Siegel is brave, brilliant, and wittier than [television pundit Jon] Stewart will ever be.…You couldn't tie Siegel's shoelaces."

This move (aptly called "sock puppetry" by Web users) was crude, ill-advised and easily discovered. When alert readers traced the sock puppet's comments to Siegel's own Internet accounts, *The New Republic* suspended him and cancelled his blog.

Among other mistakes, Siegel confused the public self that had worked adequately in the old media work he'd done for years with the private nature of new media platforms.

In the wake of his sock puppet humiliation, Siegel withdrew into his familiar old media enclaves and wrote a book called *Against the Machine* about his experience. The subtitle of the book was *Being Human in the Age of the Mob* (a valid sentiment)—which his editors probably should have reconsidered. Clearly, the book was aimed at people afraid of the Internet (a dumb thing) and uneasy about the post-Clinton ethic of blurring public and private lives (a not-so-dumb thing).

In a sympathetic profile timed to the release of Siegel's book, the statist Web site Salon.com quoted Siegel: "the Internet is possibly the most radical transformation of private and public life in the history of humankind." And this seemed like a bad thing to him, still wounded from his childishness attempts to tell people what to think.

Why are statists so uncomfortable with democratic media like the Internet? Because they don't trust their fellow citizens. Why don't they trust their fellows? Maybe they can't appreciate the complexity of so many individuals living and working in their own small societies. In simplifying people into crude categories, they think they can understand and control millions—even billions of people.

This is a weak and egocentric way to think of the world.

Many statists (and many people, in general) are uncomfortable with the blurring of public and private selves because they worry that, at their cores, they are bad people. And their true natures will be found out if their private selves are made public.

This is rational.

It's also the reason that intellectual frauds, con men and mau-mau artists like Hillary Clinton, John Edwards and Noam Chomsky follow a "true for thee but not for me" philosophy in which other people's personal lives may be scrutinized closely—but their own may not.

Chomsky is notorious among his academic colleagues for his feuds and long-standing personal grudges. He's like Ayn Rand, in this way. Most prominent among these tempests in teapots are his

feuds with professors Ellis Rivkin (a Marxist historian who eventually embraced capitalism) and Selig Harris (a linguist, like Chomsky).

Chomsky's feuds are partly personal and partly professional; in the cases of Rivkin and Harris, Chomsky has drawn heavily on their work—sometimes refuting, sometimes embracing. *Very* heavily.

Clear Distinctions May Help Some Scoundrels

A clear distinction between public and private lives may give comfort to some scoundrels. For example, House Speaker Nancy Pelosi—a committed statist representing a left-wing congressional district near San Francisco—is a veritable walking contradiction.

Pelosi earns high ratings from groups like the AFL-CIO, the Americans for Democratic Action and the League of Conservation Voters. But she and her husband have built a net worth of over $50 million, primarily from real estate development ventures around northern California. They have used her political power—or, more precisely, the *threat* of her political power—to push a big golf course and several commercial projects to completion, against local environmentalist and "social justice" objections. In this way, Pelosi has behaved more like Donald Trump or some other fat-cat developer than a champion of statist wealth redistribution.

Local environmentalists complained that Pelosi's real estate company failed to honor various "guarantees" of environmentalist make-good efforts that were supposed to counter the effects of its development projects. At one point, the San Jose Planning Commission took preliminary steps toward investigating whether Pelosi's company had committed fraud in the promises it had made but not kept. But Pelosi's company hired local lobbyists who were able to finesse the issue and quash the investigation.

Now, a rational libertarian usually sides with a lawful developer negotiating her way around a ravenous planning bureaucracy. It's just ironic that, in this case, the entrepreneur is someone whose base of power comes from creating the bureaucracies that obstruct lawful development. It suggests something disingenuous in her public self.

And Nancy Pelosi's hypocrisy goes beyond real estate development. She and her husband own a vineyard—and use non-union contractors to pick their grapes. Of course, they are acting rationally in choosing the cheapest contractor who can harvest their crop ably. The problem isn't that the Pelosi's make that choice; the

problem is her public persona, which claim allegiance to the United Farm Workers and other spoils-seeking collectives.

The hypocrisy of devoted statists like Eliot Spitzer, John Edwards, Noam Chomsky, Nancy Pelosi and this week's gaggle of nitwit Hollywood starlets is based on weakness. They're afraid; and that fear makes them weak.

What do they fear? Their own shallowness. Losing their wealth and privilege. The millions who have less banding together and... revolting. Karma or an "evil eye" that will recognize their moral or intellectual emptiness. In their fear, they believe they can fool the faceless, monolithic masses by striking compassionate poses.

Friedrich Nietzsche argued that slave morality—the morality of bogus compassion and altruism—was devised by the spiritually weak out of envy of the strong. Ayn Rand also wrote a lot about this bogus, fear-driven altruism. It's a kind of philosophical toxic waste created by an otherwise successful society. Psychologists call it urban neurosis. The blurring of public and private lives encourages it.

A rational, well-adjusted person wishes his fellow citizens well and helps when he can—but he doesn't fear the resentment of those less well-off. If they revolt, he's prepared to protect his family and his property. If they take over the mechanisms of the state, he will adapt so that the state can't harm him and his.

He's an individual, not looking to initiate force to get his way and not willing to have other people's ways forced on him. In other words, a decent individual.

And perhaps the best definition of "decenct" comes from the great H.L. Mencken, in his 1928 book *Notes on Democracy*:

> *By this common decency I mean the habit, in the individual, of viewing with tolerance and charity the acts and ideas of other individuals—the habit which makes a man a reliable friend, a generous opponent, and a good citizen.*

That's a good policy, for a libertarian and a libertarian nation. Be decent.

Appendix:

The Declaration of Independence

IN CONGRESS, JULY 4, 1776

The unanimous Declaration of the thirteen united States of America

When in the Course of human events it becomes necessary for one people to dissolve the political bands which have connected them with another and to assume among the powers of the earth, the separate and equal station to which the Laws of Nature and of Nature's God entitle them, a decent respect to the opinions of mankind requires that they should declare the causes which impel them to the separation.

We hold these truths to be self-evident, that all men are created equal, that they are endowed by their Creator with certain unalienable Rights, that among these are Life, Liberty and the pursuit of Happiness. — That to secure these rights, Governments are instituted among Men, deriving their just powers from the consent of the governed, — That whenever any Form of Government becomes destructive of these ends, it is the Right of the People to alter or to abolish it, and to institute new Government, laying its foundation on such principles and organizing its powers in such form, as to them shall seem most likely to effect their Safety and Happiness. Prudence, indeed, will dictate that Governments long established should not be changed for light and transient causes; and accordingly all experience hath shown that mankind are more disposed to suffer, while evils are sufferable than to right themselves by abolishing the forms to which they are accustomed. But when a long train of abuses and usurpations, pursuing invariably the same Object evinces a design to reduce them under absolute Despotism, it is their right, it is their duty, to throw off such Government, and to provide new Guards for their future security. — Such has been the patient sufferance

of these Colonies; and such is now the necessity which constrains them to alter their former Systems of Government. The history of the present King of Great Britain is a history of repeated injuries and usurpations, all having in direct object the establishment of an absolute Tyranny over these States. To prove this, let Facts be submitted to a candid world.

He has refused his Assent to Laws, the most wholesome and necessary for the public good.

He has forbidden his Governors to pass Laws of immediate and pressing importance, unless suspended in their operation till his Assent should be obtained; and when so suspended, he has utterly neglected to attend to them.

He has refused to pass other Laws for the accommodation of large districts of people, unless those people would relinquish the right of Representation in the Legislature, a right inestimable to them and formidable to tyrants only.

He has called together legislative bodies at places unusual, uncomfortable, and distant from the depository of their Public Records, for the sole purpose of fatiguing them into compliance with his measures.

He has dissolved Representative Houses repeatedly, for opposing with manly firmness his invasions on the rights of the people.

He has refused for a long time, after such dissolutions, to cause others to be elected, whereby the Legislative Powers, incapable of Annihilation, have returned to the People at large for their exercise; the State remaining in the mean time exposed to all the dangers of invasion from without, and convulsions within.

He has endeavored to prevent the population of these States; for that purpose obstructing the Laws for Naturalization of Foreigners; refusing to pass others to encourage their migrations hither, and raising the conditions of new Appropriations of Lands.

He has obstructed the Administration of Justice by refusing his Assent to Laws for establishing Judiciary Powers.

He has made Judges dependent on his Will alone for the tenure of their offices, and the amount and payment of their salaries.

He has erected a multitude of New Offices, and sent hither swarms of Officers to harass our people and eat out their substance.

He has kept among us, in times of peace, Standing Armies without the Consent of our legislatures.

He has affected to render the Military independent of and superior to the Civil Power.

He has combined with others to subject us to a jurisdiction foreign to our constitution, and unacknowledged by our laws; giving his Assent to their Acts of pretended Legislation:

For quartering large bodies of armed troops among us:

For protecting them, by a mock Trial from punishment for any Murders which they should commit on the Inhabitants of these States:

For cutting off our Trade with all parts of the world:

For imposing Taxes on us without our Consent:

For depriving us in many cases, of the benefit of Trial by Jury:

For transporting us beyond Seas to be tried for pretended offences:

For abolishing the free System of English Laws in a neighboring Province, establishing therein an Arbitrary government, and enlarging its Boundaries so as to render it at once an example and fit instrument for introducing the same absolute rule into these Colonies

For taking away our Charters, abolishing our most valuable Laws and altering fundamentally the Forms of our Governments:

For suspending our own Legislatures, and declaring themselves invested with power to legislate for us in all cases whatsoever.

He has abdicated Government here, by declaring us out of his Protection and waging War against us.

He has plundered our seas, ravaged our coasts, burnt our towns, and destroyed the lives of our people.

He is at this time transporting large Armies of foreign Mercenaries to complete the works of death, desolation, and tyranny, already begun with circumstances of Cruelty & Perfidy scarcely paralleled in the most barbarous ages, and totally unworthy the Head of a civilized nation.

He has constrained our fellow Citizens taken Captive on the high Seas to bear Arms against their Country, to become the executioners of their friends and Brethren, or to fall themselves by their Hands.

He has excited domestic insurrections amongst us, and has endeavored to bring on the inhabitants of our frontiers, the merciless Indian Savages whose known rule of warfare, is an undistinguished destruction of all ages, sexes and conditions.

In every stage of these Oppressions We have Petitioned for

Redress in the most humble terms: Our repeated Petitions have been answered only by repeated injury. A Prince, whose character is thus marked by every act which may define a Tyrant, is unfit to be the ruler of a free people.

Nor have We been wanting in attentions to our British brethren. We have warned them from time to time of attempts by their legislature to extend an unwarrantable jurisdiction over us. We have reminded them of the circumstances of our emigration and settlement here. We have appealed to their native justice and magnanimity, and we have conjured them by the ties of our common kindred to disavow these usurpations, which would inevitably interrupt our connections and correspondence. They too have been deaf to the voice of justice and of consanguinity. We must, therefore, acquiesce in the necessity, which denounces our Separation, and hold them, as we hold the rest of mankind, Enemies in War, in Peace Friends.

We, therefore, the Representatives of the united States of America, in General Congress, Assembled, appealing to the Supreme Judge of the world for the rectitude of our intentions, do, in the Name, and by Authority of the good People of these Colonies, solemnly publish and declare, That these united Colonies are, and of Right ought to be Free and Independent States, that they are Absolved from all Allegiance to the British Crown, and that all political connection between them and the State of Great Britain, is and ought to be totally dissolved; and that as Free and Independent States, they have full Power to levy War, conclude Peace, contract Alliances, establish Commerce, and to do all other Acts and Things which Independent States may of right do. — And for the support of this Declaration, with a firm reliance on the protection of Divine Providence, we mutually pledge to each other our Lives, our Fortunes, and our sacred Honor.

The United States Constitution

Preamble

We the People of the United States, in Order to form a more perfect Union, establish Justice, insure domestic Tranquility, provide for the common defense, promote the general Welfare, and secure the Blessings of Liberty to ourselves and our Posterity, do ordain and establish this Constitution for the United States of America.

Article I. The Legislative Branch

Section 1—The Legislature

All legislative Powers herein granted shall be vested in a Congress of the United States, which shall consist of a Senate and House of Representatives.

Section 2—The House

The House of Representatives shall be composed of Members chosen every second Year by the People of the several States, and the Electors in each State shall have the Qualifications requisite for Electors of the most numerous Branch of the State Legislature.

No Person shall be a Representative who shall not have attained to the Age of twenty five Years, and been seven Years a Citizen of the United States, and who shall not, when elected, be an Inhabitant of that State in which he shall be chosen.

(Representatives and direct Taxes shall be apportioned among the several States which may be included within this Union, according to their respective Numbers, which shall be determined by adding to the whole Number of free Persons, including those bound to Service for a Term of Years, and excluding Indians not taxed, three fifths of all other Persons. *Note: This sentence was modified by the 14th Amendment.*) The actual Enumeration shall be made within three Years after the

first Meeting of the Congress of the United States, and within every subsequent Term of ten Years, in such Manner as they shall by Law direct. The Number of Representatives shall not exceed one for every thirty Thousand, but each State shall have at Least one Representative; and until such enumeration shall be made, the State of New Hampshire shall be entitled to choose three, Massachusetts eight, Rhode Island and Providence Plantations one, Connecticut five, New York six, New Jersey four, Pennsylvania eight, Delaware one, Maryland six, Virginia ten, North Carolina five, South Carolina five and Georgia three.

When vacancies happen in the Representation from any State, the Executive Authority thereof shall issue Writs of Election to fill such Vacancies.

The House of Representatives shall choose their Speaker and other Officers; and shall have the sole Power of Impeachment.

Section 3—The Senate

The Senate of the United States shall be composed of two Senators from each State, (chosen by the Legislature thereof, *Note: The preceding words were superseded by 17th Amendment*) for six Years; and each Senator shall have one Vote.

Immediately after they shall be assembled in Consequence of the first Election, they shall be divided as equally as may be into three Classes. The Seats of the Senators of the first Class shall be vacated at the Expiration of the second Year, of the second Class at the Expiration of the fourth Year, and of the third Class at the Expiration of the sixth Year, so that one third may be chosen every second Year; (and if Vacancies happen by Resignation, or otherwise, during the Recess of the Legislature of any State, the Executive thereof may make temporary Appointments until the next Meeting of the Legislature, which shall then fill such Vacancies. *Note: The preceding words were superseded by the 17th Amendment.*)

No person shall be a Senator who shall not have attained to the Age of thirty Years, and been nine Years a Citizen of the United States, and who shall not, when elected, be an Inhabitant of that State for which he shall be chosen.

The Vice President of the United States shall be President of the Senate, but shall have no Vote, unless they be equally divided.

The Senate shall choose their other Officers, and also a President pro tempore, in the absence of the Vice President, or when he shall exercise the Office of President of the United States.

The Senate shall have the sole Power to try all Impeachments. When sitting for that Purpose, they shall be on Oath or Affirmation. When the President of the United States is tried, the Chief Justice shall preside: And no Person shall be convicted without the Concurrence of two thirds of the Members present.

Judgment in Cases of Impeachment shall not extend further than to removal from Office, and disqualification to hold and enjoy any Office of honor, Trust or Profit under the United States: but the Party convicted shall nevertheless be liable and subject to Indictment, Trial, Judgment and Punishment, according to Law.

Section 4—Elections, Meetings

The Times, Places and Manner of holding Elections for Senators and Representatives, shall be prescribed in each State by the Legislature thereof; but the Congress may at any time by Law make or alter such Regulations, except as to the Place of Choosing Senators.

The Congress shall assemble at least once in every Year, and such Meeting shall (be on the first Monday in December, *Note: The preceding words were superseded by the 20th Amendment.*) unless they shall by Law appoint a different Day.

Section 5—Membership, Rules, Journals, Adjournment

Each House shall be the Judge of the Elections, Returns and Qualifications of its own Members, and a Majority of each shall constitute a Quorum to do Business; but a smaller number may adjourn from day to day, and may be authorized to compel the Attendance of absent Members, in such Manner, and under such Penalties as each House may provide.

Each House may determine the Rules of its Proceedings, punish its Members for disorderly Behavior, and, with the Concurrence of two-thirds, expel a Member.

Each House shall keep a Journal of its Proceedings, and from time to time publish the same, excepting such Parts as may in their Judgment require Secrecy; and the Yeas and Nays of the Members of either House on any question shall, at the Desire of one fifth of those Present, be entered on the Journal.

Neither House, during the Session of Congress, shall, without the Consent of the other, adjourn for more than three days, nor to any other Place than that in which the two Houses shall be sitting.

Section 6—Compensation

(The Senators and Representatives shall receive a Compensation for their Services, to be ascertained by Law, and paid out of the Treasury of the United States. *Note: The preceding words were modified by the 27th Amendment.*) They shall in all Cases, except Treason, Felony and Breach of the Peace, be privileged from Arrest during their Attendance at the Session of their respective Houses, and in going to and returning from the same; and for any Speech or Debate in either House, they shall not be questioned in any other Place.

No Senator or Representative shall, during the Time for which he was elected, be appointed to any civil Office under the Authority of the United States which shall have been created, or the Emoluments whereof shall have been increased during such time; and no Person holding any Office under the United States, shall be a Member of either House during his Continuance in Office.

Section 7—Revenue Bills, Legislative Process, Presidential Veto

All bills for raising Revenue shall originate in the House of Representatives; but the Senate may propose or concur with Amendments as on other Bills.

Every Bill which shall have passed the House of Representatives and the Senate, shall, before it become a Law, be presented to the President of the United States; If he approve he shall sign it, but if not he shall return it, with his Objections to that House in which it shall have originated, who shall enter the Objections at large on their Journal, and proceed to reconsider it. If after such Reconsideration two thirds of that House shall agree to pass the Bill, it shall be sent, together with the Objections, to the other House, by which it shall likewise be reconsidered, and if approved by two thirds of that House, it shall become a Law. But in all such Cases the Votes of both Houses shall be determined by Yeas and Nays, and the Names of the Persons voting for and against the Bill shall be entered on the Journal of each House respectively. If any Bill shall not be returned by the President within ten Days (Sundays excepted) after it shall have been presented to him, the Same shall be a Law, in like Manner as if he had signed it, unless the Congress by their Adjournment prevent its Return, in which Case it shall not be a Law.

Every Order, Resolution, or Vote to which the Concurrence of the Senate and House of Representatives may be necessary (except on a question of Adjournment) shall be presented to the President

of the United States; and before the Same shall take Effect, shall be approved by him, or being disapproved by him, shall be repassed by two thirds of the Senate and House of Representatives, according to the Rules and Limitations prescribed in the Case of a Bill.

Section 8—Powers of Congress

The Congress shall have Power To lay and collect Taxes, Duties, Imposts and Excises, to pay the Debts and provide for the common Defense and general Welfare of the United States; but all Duties, Imposts and Excises shall be uniform throughout the United States;

To borrow money on the credit of the United States;

To regulate Commerce with foreign Nations, and among the several States, and with the Indian Tribes;

To establish an uniform Rule of Naturalization, and uniform Laws on the subject of Bankruptcies throughout the United States;

To coin Money, regulate the Value thereof, and of foreign Coin, and fix the Standard of Weights and Measures;

To provide for the Punishment of counterfeiting the Securities and current Coin of the United States;

To establish Post Offices and Post Roads;

To promote the Progress of Science and useful Arts, by securing for limited Times to Authors and Inventors the exclusive Right to their respective Writings and Discoveries;

To constitute Tribunals inferior to the supreme Court;

To define and punish Piracies and Felonies committed on the high Seas, and Offenses against the Law of Nations;

To declare War, grant Letters of Marque and Reprisal, and make Rules concerning Captures on Land and Water;

To raise and support Armies, but no Appropriation of Money to that Use shall be for a longer Term than two Years;

To provide and maintain a Navy;

To make Rules for the Government and Regulation of the land and naval Forces;

To provide for calling forth the Militia to execute the Laws of the Union, suppress Insurrections and repel Invasions;

To provide for organizing, arming, and disciplining the Militia, and for governing such Part of them as may be employed in the Service of the United States, reserving to the States respectively, the Appointment of the Officers, and the Authority of training the Militia according to the discipline prescribed by Congress;

To exercise exclusive Legislation in all Cases whatsoever, over such District (not exceeding ten Miles square) as may, by Cession of particular States, and the acceptance of Congress, become the Seat of the Government of the United States, and to exercise like Authority over all Places purchased by the Consent of the Legislature of the State in which the Same shall be, for the Erection of Forts, Magazines, Arsenals, dock-Yards, and other needful Buildings; And

To make all Laws which shall be necessary and proper for carrying into Execution the foregoing Powers, and all other Powers vested by this Constitution in the Government of the United States, or in any Department or Officer thereof.

Section 9—Limits on Congress

The Migration or Importation of such Persons as any of the States now existing shall think proper to admit, shall not be prohibited by the Congress prior to the Year one thousand eight hundred and eight, but a tax or duty may be imposed on such Importation, not exceeding ten dollars for each Person.

The privilege of the Writ of Habeas Corpus shall not be suspended, unless when in Cases of Rebellion or Invasion the public Safety may require it.

No Bill of Attainder or ex post facto Law shall be passed.

(No capitation, or other direct, Tax shall be laid, unless in Proportion to the Census or Enumeration herein before directed to be taken. *Note: This section was modified by the 16th Amendment.*)

No Tax or Duty shall be laid on Articles exported from any State.

No Preference shall be given by any Regulation of Commerce or Revenue to the Ports of one State over those of another: nor shall Vessels bound to, or from, one State, be obliged to enter, clear, or pay Duties in another.

No Money shall be drawn from the Treasury, but in Consequence of Appropriations made by Law; and a regular Statement and Account of the Receipts and Expenditures of all public Money shall be published from time to time.

No Title of Nobility shall be granted by the United States: And no Person holding any Office of Profit or Trust under them, shall, without the Consent of the Congress, accept of any present, Emolument, Office, or Title, of any kind whatever, from any King, Prince or foreign State.

Section 10—Powers prohibited of States

No State shall enter into any Treaty, Alliance, or Confederation; grant Letters of Marque and Reprisal; coin Money; emit Bills of Credit; make any Thing but gold and silver Coin a Tender in Payment of Debts; pass any Bill of Attainder, ex post facto Law, or Law impairing the Obligation of Contracts, or grant any Title of Nobility.

No State shall, without the Consent of the Congress, lay any Imposts or Duties on Imports or Exports, except what may be absolutely necessary for executing it's inspection Laws: and the net Produce of all Duties and Imposts, laid by any State on Imports or Exports, shall be for the Use of the Treasury of the United States; and all such Laws shall be subject to the Revision and Controul of the Congress.

No State shall, without the Consent of Congress, lay any duty of Tonnage, keep Troops, or Ships of War in time of Peace, enter into any Agreement or Compact with another State, or with a foreign Power, or engage in War, unless actually invaded, or in such imminent Danger as will not admit of delay.

Article II. The Executive Branch

Section 1—The President

The executive Power shall be vested in a President of the United States of America. He shall hold his Office during the Term of four Years, and, together with the Vice-President chosen for the same Term, be elected, as follows:

Each State shall appoint, in such Manner as the Legislature thereof may direct, a Number of Electors, equal to the whole Number of Senators and Representatives to which the State may be entitled in the Congress: but no Senator or Representative, or Person holding an Office of Trust or Profit under the United States, shall be appointed an Elector.

(The Electors shall meet in their respective States, and vote by Ballot for two persons, of whom one at least shall not lie an Inhabitant of the same State with themselves. And they shall make a List of all the Persons voted for, and of the Number of Votes for each; which List they shall sign and certify, and transmit sealed to the Seat of the Government of the United States, directed to the President of the Senate. The President of the Senate shall, in the Presence of the Senate and House of Representatives, open all

the Certificates, and the Votes shall then be counted. The Person having the greatest Number of Votes shall be the President, if such Number be a Majority of the whole Number of Electors appointed; and if there be more than one who have such Majority, and have an equal Number of Votes, then the House of Representatives shall immediately choose by Ballot one of them for President; and if no Person have a Majority, then from the five highest on the List the said House shall in like Manner choose the President. But in choosing the President, the Votes shall be taken by States, the Representation from each State having one Vote; a quorum for this Purpose shall consist of a Member or Members from two-thirds of the States, and a Majority of all the States shall be necessary to a Choice. In every Case, after the Choice of the President, the Person having the greatest Number of Votes of the Electors shall be the Vice President. But if there should remain two or more who have equal Votes, the Senate shall choose from them by Ballot the Vice-President. *Note: This clause was superseded by the 12th Amendment.)*

The Congress may determine the Time of choosing the Electors, and the Day on which they shall give their Votes; which Day shall be the same throughout the United States.

No person except a natural born Citizen, or a Citizen of the United States, at the time of the Adoption of this Constitution, shall be eligible to the Office of President; neither shall any Person be eligible to that Office who shall not have attained to the Age of thirty-five Years, and been fourteen Years a Resident within the United States.

(In Case of the Removal of the President from Office, or of his Death, Resignation, or Inability to discharge the Powers and Duties of the said Office, the same shall devolve on the Vice President, and the Congress may by Law provide for the Case of Removal, Death, Resignation or Inability, both of the President and Vice President, declaring what Officer shall then act as President, and such Officer shall act accordingly, until the Disability be removed, or a President shall be elected. *Note: This clause was modified by the 20th and 25th Amendments.)*

The President shall, at stated Times, receive for his Services, a Compensation, which shall neither be increased nor diminished during the Period for which he shall have been elected, and he shall not receive within that Period any other Emolument from the United States, or any of them.

Before he enter on the Execution of his Office, he shall take the following Oath or Affirmation:

> "I do solemnly swear (or affirm) that I will faithfully execute the Office of President of the United States, and will to the best of my Ability, preserve, protect and defend the Constitution of the United States."

Section 2—Civilian Power over Military, Cabinet, Pardon Power, Appointments

The President shall be Commander in Chief of the Army and Navy of the United States, and of the Militia of the several States, when called into the actual Service of the United States; he may require the Opinion, in writing, of the principal Officer in each of the executive Departments, upon any subject relating to the Duties of their respective Offices, and he shall have Power to Grant Reprieves and Pardons for Offenses against the United States, except in Cases of Impeachment.

He shall have Power, by and with the Advice and Consent of the Senate, to make Treaties, provided two thirds of the Senators present concur; and he shall nominate, and by and with the Advice and Consent of the Senate, shall appoint Ambassadors, other public Ministers and Consuls, Judges of the supreme Court, and all other Officers of the United States, whose Appointments are not herein otherwise provided for, and which shall be established by Law: but the Congress may by Law vest the Appointment of such inferior Officers, as they think proper, in the President alone, in the Courts of Law, or in the Heads of Departments.

The President shall have Power to fill up all Vacancies that may happen during the Recess of the Senate, by granting Commissions which shall expire at the End of their next Session.

Section 3—State of the Union, Convening Congress

He shall from time to time give to the Congress Information of the State of the Union, and recommend to their Consideration such Measures as he shall judge necessary and expedient; he may, on extraordinary Occasions, convene both Houses, or either of them, and in Case of Disagreement between them, with Respect to the Time of Adjournment, he may adjourn them to such Time as he shall think proper; he shall receive Ambassadors and other public

Ministers; he shall take Care that the Laws be faithfully executed, and shall Commission all the Officers of the United States.

Section 4—Disqualification

The President, Vice President and all civil Officers of the United States, shall be removed from Office on Impeachment for, and Conviction of, Treason, Bribery, or other high Crimes and Misdemeanors.

Article III. The Judicial Branch

Section 1—Judicial powers

The judicial Power of the United States, shall be vested in one supreme Court, and in such inferior Courts as the Congress may from time to time ordain and establish. The Judges, both of the supreme and inferior Courts, shall hold their Offices during good Behavior, and shall, at stated Times, receive for their Services a Compensation which shall not be diminished during their Continuance in Office.

Section 2—Trial by Jury, Original Jurisdiction, Jury Trials

(The judicial Power shall extend to all Cases, in Law and Equity, arising under this Constitution, the Laws of the United States, and Treaties made, or which shall be made, under their Authority; to all Cases affecting Ambassadors, other public Ministers and Consuls; to all Cases of admiralty and maritime Jurisdiction; to Controversies to which the United States shall be a Party; to Controversies between two or more States; between a State and Citizens of another State; between Citizens of different States; between Citizens of the same State claiming Lands under Grants of different States, and between a State, or the Citizens thereof, and foreign States, Citizens or Subjects. *Note: This section was modified by the 11th Amendment.*)

In all Cases affecting Ambassadors, other public Ministers and Consuls, and those in which a State shall be Party, the supreme Court shall have original Jurisdiction. In all the other Cases before mentioned, the supreme Court shall have appellate Jurisdiction, both as to Law and Fact, with such Exceptions, and under such Regulations as the Congress shall make.

The Trial of all Crimes, except in Cases of Impeachment, shall be by Jury; and such Trial shall be held in the State where the said

Crimes shall have been committed; but when not committed within any State, the Trial shall be at such Place or Places as the Congress may by Law have directed.

Section 3—Treason

Treason against the United States, shall consist only in levying War against them, or in adhering to their Enemies, giving them Aid and Comfort. No Person shall be convicted of Treason unless on the Testimony of two Witnesses to the same overt Act, or on Confession in open Court.

The Congress shall have power to declare the Punishment of Treason, but no Attainder of Treason shall work Corruption of Blood, or Forfeiture except during the Life of the Person attainted.

Article IV. The States

Section 1—Each State to Honor all others

Full Faith and Credit shall be given in each State to the public Acts, Records, and judicial Proceedings of every other State. And the Congress may by general Laws prescribe the Manner in which such Acts, Records and Proceedings shall be proved, and the Effect thereof.

Section 2—State citizens, Extradition

The Citizens of each State shall be entitled to all Privileges and Immunities of Citizens in the several States.

A Person charged in any State with Treason, Felony, or other Crime, who shall flee from Justice, and be found in another State, shall on demand of the executive Authority of the State from which he fled, be delivered up, to be removed to the State having Jurisdiction of the Crime.

(No Person held to Service or Labour in one State, under the Laws thereof, escaping into another, shall, in Consequence of any Law or Regulation therein, be discharged from such Service or Labour, But shall be delivered up on Claim of the Party to whom such Service or Labour may be due. *Note: This clause was superseded by the 13th Amendment.*)

Section 3—New States

New States may be admitted by the Congress into this Union; but no new States shall be formed or erected within the Jurisdiction of any other State; nor any State be formed by the Junction of

two or more States, or parts of States, without the Consent of the Legislatures of the States concerned as well as of the Congress.

The Congress shall have Power to dispose of and make all needful Rules and Regulations respecting the Territory or other Property belonging to the United States; and nothing in this Constitution shall be so construed as to Prejudice any Claims of the United States, or of any particular State.

Section 4—Republican government

The United States shall guarantee to every State in this Union a Republican Form of Government, and shall protect each of them against Invasion; and on Application of the Legislature, or of the Executive (when the Legislature cannot be convened) against domestic Violence.

Article V. Amendment

The Congress, whenever two thirds of both Houses shall deem it necessary, shall propose Amendments to this Constitution, or, on the Application of the Legislatures of two thirds of the several States, shall call a Convention for proposing Amendments, which, in either Case, shall be valid to all Intents and Purposes, as part of this Constitution, when ratified by the Legislatures of three fourths of the several States, or by Conventions in three fourths thereof, as the one or the other Mode of Ratification may be proposed by the Congress; Provided that no Amendment which may be made prior to the Year One thousand eight hundred and eight shall in any Manner affect the first and fourth Clauses in the Ninth Section of the first Article; and that no State, without its Consent, shall be deprived of its equal Suffrage in the Senate.

Article VI. Debts, Supremacy, Oaths

All Debts contracted and Engagements entered into, before the Adoption of this Constitution, shall be as valid against the United States under this Constitution, as under the Confederation.

This Constitution, and the Laws of the United States which shall be made in Pursuance thereof; and all Treaties made, or which shall be made, under the Authority of the United States, shall be the supreme Law of the Land; and the Judges in every State shall be bound thereby, any Thing in the Constitution or Laws of any State to the Contrary notwithstanding.

The Senators and Representatives before mentioned, and the Members of the several State Legislatures, and all executive and judicial Officers, both of the United States and of the several States, shall be bound by Oath or Affirmation, to support this Constitution; but no religious Test shall ever be required as a Qualification to any Office or public Trust under the United States.

Article VII. Ratification Documents

The Ratification of the Conventions of nine States, shall be sufficient for the Establishment of this Constitution between the States so ratifying the Same.

Done in Convention by the Unanimous Consent of the States present the Seventeenth Day of September in the Year of our Lord one thousand seven hundred and Eighty seven and of the Independence of the United States of America the Twelfth. In Witness whereof We have hereunto subscribed our Names.

Geo. Washington, President and deputy from Virginia
New Hampshire—John Langdon, Nicholas Gilman
Massachusetts—Nathaniel Gorham, Rufus King
Connecticut—Wm Saml Johnson, Roger Sherman
New York—Alexander Hamilton
New Jersey—Wil Livingston, David Brearley, Wm Paterson, Jona. Dayton
Pensylvania—B Franklin, Thomas Mifflin, Robt Morris, Geo. Clymer, Thos FitzSimons, Jared Ingersoll, James Wilson, Gouv Morris
Delaware—Geo. Read, Gunning Bedford jun, John Dickinson, Richard Bassett, Jaco. Broom
Maryland—James McHenry, Dan of St Tho Jenifer, Danl Carroll
Virginia—John Blair, James Madison Jr.
North Carolina—Wm Blount, Richd Dobbs Spaight, Hu Williamson
South Carolina—J. Rutledge, Charles Cotesworth Pinckney, Charles Pinckney, Pierce Butler
Georgia—William Few, Abr Baldwin
Attest: William Jackson, Secretary

Amendments

The first ten Amendments are known commonly as the Bill of Rights. They were ratified together soon after the Constitution. Later Amendements are noted with the date each was ratified.

Amendment 1. Freedom of Religion, Press, Expression.

Congress shall make no law respecting an establishment of religion, or prohibiting the free exercise thereof; or abridging the freedom of speech, or of the press; or the right of the people peaceably to assemble, and to petition the Government for a redress of grievances.

Amendment 2. Right to Bear Arms.

A well regulated Militia, being necessary to the security of a free State, the right of the people to keep and bear Arms, shall not be infringed.

Amendment 3. Quartering of Soldiers.

No Soldier shall, in time of peace be quartered in any house, without the consent of the Owner, nor in time of war, but in a manner to be prescribed by law.

Amendment 4. Search and Seizure.

The right of the people to be secure in their persons, houses, papers, and effects, against unreasonable searches and seizures, shall not be violated, and no Warrants shall issue, but upon probable cause, supported by Oath or affirmation, and particularly describing the place to be searched, and the persons or things to be seized.

Amendment 5. Trial and Punishment, Compensation for Takings.

No person shall be held to answer for a capital, or otherwise infamous crime, unless on a presentment or indictment of a Grand Jury, except in cases arising in the land or naval forces, or in the Militia, when in actual service in time of War or public danger; nor shall any person be subject for the same offense to be twice put in jeopardy of life or limb; nor shall be compelled in any criminal case to be a witness against himself, nor be deprived of life, liberty, or property, without due process of law; nor shall private property be taken for public use, without just compensation.

Amendment 6. Right to Speedy Trial, Confrontation of Witnesses.

In all criminal prosecutions, the accused shall enjoy the right to a speedy and public trial, by an impartial jury of the State and district wherein the crime shall have been committed, which district shall have been previously ascertained by law, and to be informed of the nature and cause of the accusation; to be confronted with the witnesses against him; to have compulsory process for obtaining witnesses in his favor, and to have the Assistance of Counsel for his defense.

Amendment 7. Trial by Jury in Civil Cases.

In Suits at common law, where the value in controversy shall exceed twenty dollars, the right of trial by jury shall be preserved, and no fact tried by a jury, shall be otherwise re-examined in any Court of the United States, than according to the rules of the common law.

Amendment 8. Cruel and Unusual Punishment.

Excessive bail shall not be required, nor excessive fines imposed, nor cruel and unusual punishments inflicted.

Amendment 9. Construction of Constitution.

The enumeration in the Constitution, of certain rights, shall not be construed to deny or disparage others retained by the people.

Amendment 10. Powers of the States and People.

The powers not delegated to the United States by the Constitution, nor prohibited by it to the States, are reserved to the States respectively, or to the people.

Amendment 11. Judicial Limits. Ratified 2/7/1795.

The Judicial power of the United States shall not be construed to extend to any suit in law or equity, commenced or prosecuted against one of the United States by Citizens of another State, or by Citizens or Subjects of any Foreign State.

Amendment 12. Choosing the President, Vice-President. Ratified 6/15/1804.

The Electoral College

The Electors shall meet in their respective states, and vote by ballot for President and Vice-President, one of whom, at least, shall

not be an inhabitant of the same state with themselves; they shall name in their ballots the person voted for as President, and in distinct ballots the person voted for as Vice-President, and they shall make distinct lists of all persons voted for as President, and of all persons voted for as Vice-President and of the number of votes for each, which lists they shall sign and certify, and transmit sealed to the seat of the government of the United States, directed to the President of the Senate;

The President of the Senate shall, in the presence of the Senate and House of Representatives, open all the certificates and the votes shall then be counted;

The person having the greatest Number of votes for President, shall be the President, if such number be a majority of the whole number of Electors appointed; and if no person have such majority, then from the persons having the highest numbers not exceeding three on the list of those voted for as President, the House of Representatives shall choose immediately, by ballot, the President. But in choosing the President, the votes shall be taken by states, the representation from each state having one vote; a quorum for this purpose shall consist of a member or members from two-thirds of the states, and a majority of all the states shall be necessary to a choice. And if the House of Representatives shall not choose a President whenever the right of choice shall devolve upon them, before the fourth day of March next following, then the Vice-President shall act as President, as in the case of the death or other constitutional disability of the President.

The person having the greatest number of votes as Vice-President, shall be the Vice-President, if such number be a majority of the whole number of Electors appointed, and if no person have a majority, then from the two highest numbers on the list, the Senate shall choose the Vice-President; a quorum for the purpose shall consist of two-thirds of the whole number of Senators, and a majority of the whole number shall be necessary to a choice. But no person constitutionally ineligible to the office of President shall be eligible to that of Vice-President of the United States.

Amendment 13. Slavery Abolished. Ratified 12/6/1865.

1. Neither slavery nor involuntary servitude, except as a punishment for crime whereof the party shall have been duly convicted, shall exist within the United States, or any place subject to their jurisdiction.

2. Congress shall have power to enforce this article by appropriate legislation.

Amendment 14. Citizenship Rights. Ratified 7/9/1868.

1. All persons born or naturalized in the United States, and subject to the jurisdiction thereof, are citizens of the United States and of the State wherein they reside. No State shall make or enforce any law which shall abridge the privileges or immunities of citizens of the United States; nor shall any State deprive any person of life, liberty, or property, without due process of law; nor deny to any person within its jurisdiction the equal protection of the laws.

2. Representatives shall be apportioned among the several States according to their respective numbers, counting the whole number of persons in each State, excluding Indians not taxed. But when the right to vote at any election for the choice of electors for President and Vice-President of the United States, Representatives in Congress, the Executive and Judicial officers of a State, or the members of the Legislature thereof, is denied to any of the male inhabitants of such State, being twenty-one years of age, and citizens of the United States, or in any way abridged, except for participation in rebellion, or other crime, the basis of representation therein shall be reduced in the proportion which the number of such male citizens shall bear to the whole number of male citizens twenty-one years of age in such State.

3. No person shall be a Senator or Representative in Congress, or elector of President and Vice-President, or hold any office, civil or military, under the United States, or under any State, who, having previously taken an oath, as a member of Congress, or as an officer of the United States, or as a member of any State legislature, or as an executive or judicial officer of any State, to support the Constitution of the United States, shall have engaged in insurrection or rebellion against the same, or given aid or comfort to the enemies thereof. But Congress may by a vote of two-thirds of each House, remove such disability.

4. The validity of the public debt of the United States, authorized by law, including debts incurred for payment of pensions and bounties for services in suppressing insurrection or rebellion, shall not be questioned. But neither the United States nor any State shall assume or pay any debt or obligation incurred in aid of insurrection or rebellion against the United States, or any claim for the loss or emancipation of any slave; but all such debts, obligations and claims shall be held illegal and void.

5. The Congress shall have power to enforce, by appropriate legislation, the provisions of this article.

Amendment 15. Race No Bar to Vote. Ratified 2/3/1870.

1. The right of citizens of the United States to vote shall not be denied or abridged by the United States or by any State on account of race, color, or previous condition of servitude.

2. The Congress shall have power to enforce this article by appropriate legislation.

Amendment 16. Status of Income Tax Clarified. Ratified 2/3/1913.

The Congress shall have power to lay and collect taxes on incomes, from whatever source derived, without apportionment among the several States, and without regard to any census or enumeration.

Amendment 17. Senators Elected by Popular Vote. Ratified 4/8/1913.

The Senate of the United States shall be composed of two Senators from each State, elected by the people thereof, for six years; and each Senator shall have one vote. The electors in each State shall have the qualifications requisite for electors of the most numerous branch of the State legislatures.

When vacancies happen in the representation of any State in the Senate, the executive authority of such State shall issue writs of election to fill such vacancies: Provided, That the legislature of any State may empower the executive thereof to make temporary appointments until the people fill the vacancies by election as the legislature may direct.

This amendment shall not be so construed as to affect the election or term of any Senator chosen before it becomes valid as part of the Constitution.

Amendment 18. Liquor Abolished. Ratified 1/16/1919. Repealed by Amendment 21, 12/5/1933.

1. After one year from the ratification of this article the manufacture, sale, or transportation of intoxicating liquors within, the importation thereof into, or the exportation thereof from the United States and all territory subject to the jurisdiction thereof for beverage purposes is hereby prohibited.

2. The Congress and the several States shall have concurrent power to enforce this article by appropriate legislation.

3. This article shall be inoperative unless it shall have been ratified as an amendment to the Constitution by the legislatures of the several States, as provided in the Constitution, within seven years from the date of the submission hereof to the States by the Congress.

Amendment 19. Women's Suffrage. Ratified 8/18/1920.

The right of citizens of the United States to vote shall not be denied or abridged by the United States or by any State on account of sex.

Congress shall have power to enforce this article by appropriate legislation.

Amendment 20. Presidential, Congressional Terms. Ratified 1/23/1933.

1. The terms of the President and Vice President shall end at noon on the 20th day of January, and the terms of Senators and Representatives at noon on the 3d day of January, of the years in which such terms would have ended if this article had not been ratified; and the terms of their successors shall then begin.

2. The Congress shall assemble at least once in every year, and such meeting shall begin at noon on the 3d day of January, unless they shall by law appoint a different day.

3. If, at the time fixed for the beginning of the term of the President, the President elect shall have died, the Vice President elect shall become President. If a President shall not have been chosen before the time fixed for the beginning of his term, or if the President elect shall have failed to qualify, then the Vice President elect shall act as President until a President shall have qualified; and the Congress may by law provide for the case wherein neither a President elect nor a Vice President elect shall have qualified, declaring who shall then act as President, or the manner in which one who is to act shall be selected, and such person shall act accordingly until a President or Vice President shall have qualified.

4. The Congress may by law provide for the case of the death of any of the persons from whom the House of Representatives may choose a President whenever the right of choice shall have devolved upon them, and for the case of the death of any of the persons from whom the Senate may choose a Vice President whenever the right of choice shall have devolved upon them.

5. Sections 1 and 2 shall take effect on the 15th day of October following the ratification of this article.

6. This article shall be inoperative unless it shall have been ratified as an amendment to the Constitution by the legislatures of three-fourths of the several States within seven years from the date of its submission.

Amendment 21. Amendment 18 Repealed. Ratified 12/5/1933.

1. The eighteenth article of amendment to the Constitution of the United States is hereby repealed.

2. The transportation or importation into any State, Territory, or possession of the United States for delivery or use therein of intoxicating liquors, in violation of the laws thereof, is hereby prohibited.

3. The article shall be inoperative unless it shall have been ratified as an amendment to the Constitution by conventions in the several States, as provided in the Constitution, within seven years from the date of the submission hereof to the States by the Congress.

Amendment 22. Presidential Term Limits. Ratified 2/27/1951.

1. No person shall be elected to the office of the President more than twice, and no person who has held the office of President, or acted as President, for more than two years of a term to which some other person was elected President shall be elected to the office of the President more than once. But this Article shall not apply to any person holding the office of President, when this Article was proposed by the Congress, and shall not prevent any person who may be holding the office of President, or acting as President, during the term within which this Article becomes operative from holding the office of President or acting as President during the remainder of such term.

2. This article shall be inoperative unless it shall have been ratified as an amendment to the Constitution by the legislatures of three-fourths of the several States within seven years from the date of its submission to the States by the Congress.

Amendment 23. Presidential Vote for District of Columbia. Ratified 3/29/1961.

1. The District constituting the seat of Government of the United States shall appoint in such manner as the Congress may direct: A number of electors of President and Vice President equal to the whole number of Senators and Representatives in Congress to which the District would be entitled if it were a State, but in no event more than the least populous State; they shall be in addition to those appointed by the States, but they shall be considered, for

the purposes of the election of President and Vice President, to be electors appointed by a State; and they shall meet in the District and perform such duties as provided by the twelfth article of amendment.

2. The Congress shall have power to enforce this article by appropriate legislation.

Amendment 24. Poll Tax Barred. Ratified 1/23/1964.

1. The right of citizens of the United States to vote in any primary or other election for President or Vice President, for electors for President or Vice President, or for Senator or Representative in Congress, shall not be denied or abridged by the United States or any State by reason of failure to pay any poll tax or other tax.

2. The Congress shall have power to enforce this article by appropriate legislation.

Amendment 25. Presidential Disability and Succession. Ratified 2/10/1967.

1. In case of the removal of the President from office or of his death or resignation, the Vice President shall become President.

2. Whenever there is a vacancy in the office of the Vice President, the President shall nominate a Vice President who shall take office upon confirmation by a majority vote of both Houses of Congress.

3. Whenever the President transmits to the President pro tempore of the Senate and the Speaker of the House of Representatives his written declaration that he is unable to discharge the powers and duties of his office, and until he transmits to them a written declaration to the contrary, such powers and duties shall be discharged by the Vice President as Acting President.

4. Whenever the Vice President and a majority of either the principal officers of the executive departments or of such other body as Congress may by law provide, transmit to the President pro tempore of the Senate and the Speaker of the House of Representatives their written declaration that the President is unable to discharge the powers and duties of his office, the Vice President shall immediately assume the powers and duties of the office as Acting President.

Thereafter, when the President transmits to the President pro tempore of the Senate and the Speaker of the House of Representatives his written declaration that no inability exists, he shall resume the powers and duties of his office unless the Vice President and a majority of either the principal officers of the executive

department or of such other body as Congress may by law provide, transmit within four days to the President pro tempore of the Senate and the Speaker of the House of Representatives their written declaration that the President is unable to discharge the powers and duties of his office. Thereupon Congress shall decide the issue, assembling within forty eight hours for that purpose if not in session. If the Congress, within twenty one days after receipt of the latter written declaration, or, if Congress is not in session, within twenty one days after Congress is required to assemble, determines by two thirds vote of both Houses that the President is unable to discharge the powers and duties of his office, the Vice President shall continue to discharge the same as Acting President; otherwise, the President shall resume the powers and duties of his office.

Amendment 26. Voting Age Set to 18 Years. Ratified 7/1/1971.

1. The right of citizens of the United States, who are eighteen years of age or older, to vote shall not be denied or abridged by the United States or by any State on account of age.

2. The Congress shall have power to enforce this article by appropriate legislation.

Amendment 27. Limiting Congressional Pay Increases. Ratified 5/7/1992.

No law, varying the compensation for the services of the Senators and Representatives, shall take effect, until an election of Representatives shall have intervened.